Digital Compositing with Blackmagic Fusion

Create complex composites with Blackmagic Design Fusion. Learn the basics of node-based compositing and get up to speed quickly so you can undertake your own compositing projects.

In *Digital Compositing with Blackmagic Fusion: Essential Techniques*, industry veteran Lee Lanier covers the most important components, tools, and workflows any serious compositor needs to know. Practice your knowledge and skill as you read the book with the included mini-tutorials and longer chapter tutorials. An accompanying eResource (`www.routledge.com/9781138668287`) features video image sequences, 3D renders, and other tutorial materials, allowing you to immediately practice the discussed techniques.

Critical topics in this book include:

- Tool / Node networks
- Color space and color channels
- Transformations
- Masking and rotoscoping
- Keyframing and animation splines
- Green screen keying
- The Fusion 3D environment
- Color grading and color manipulation
- Filter tools
- Motion tracking
- Particle simulation
- Stereoscopic workflow

Lee Lanier has worked as a professional computer animator and VFX (visual effects) artist since 1994. He has more than 70 features, shorts, music videos, trailers, and commercials to his credit. Lee has written ten high-end software books that have sold more than 30,000 copies, has authored VFX training videos for lynda.com, has taught VFX compositing at the Gnomon School of Visual Effects in Hollywood, and is a member of VES (Visual Effects Society). A strong supporter of the arts, Lee co-founded the Dam Short Film Festival—Nevada's largest film festival—and continues to serve as its executive director. He also co-manages the Boulder City branch of Dr. Sketchy's Anti-Art School, curates several art gallery spaces, and is an avid painter. You can see his work at `beezlebugbit.com` and `diabolica-art.com`.

Digital Compositing with Blackmagic Fusion

Essential Techniques

Lee Lanier

Routledge
Taylor & Francis Group

NEW YORK AND LONDON

First published 2017
by Routledge
711 Third Avenue, New York, NY 10017

and by Routledge
2 Park Square, Milton Park, Abingdon, Oxon OX14 4RN

Routledge is an imprint of the Taylor & Francis Group, an informa business

© 2017 Lee Lanier

Library of Congress Cataloging in Publication Data
A catalog record for this book has been requested.

ISBN: 978-1-138-66827-0 (hbk)
ISBN: 978-1-138-66828-7 (pbk)
ISBN: 978-1-315-61872-2 (ebk)

Publisher's note: This book has been prepared from camera-ready copy prepared by the author.

Typeset in Myriad Pro
by BeezleBug Bit, LLC

Contents

Introduction --- xiii
 You, the Reader -- xiii
 Topics Covered --- xiii
 Required Software --- xiv
 Downloading the Tutorial Files -- xiv
 About the Source Files --- xiv
 Using the Tutorial Files with Windows and Mac Systems -------------------- xiv
 Updates --- xv
 Naming Conventions -- xv
 Fusion and Visual Effects Terminology ------------------------------------ xv
 Contacting the Author -- xv

Chapter 1: Working with Tool Networks ---------------------------------- 1
 Understanding the Fusion Interface --------------------------------------- 2
 Exploring Panels, Tabs, and Views ---------------------------------- 2
 Navigating within Views -- 3
 Using the Menus -- 3
 Setting Up a Project --- 3
 Choosing Critical Project Settings ---------------------------------- 4
 Sidebar: Integer vs. Floating-point Color Space ------------------- 4
 Creating Tool Networks --- 5
 Connecting Tools --- 5
 Rearranging and Disabling Tools ------------------------------------- 6
 Importing Footage -- 6
 Sidebar: Reloading Missing Footage -------------------------------- 7
 Mini-Tutorial 1: Creating a Simple Tool Network ------------------- 7
 Sidebar: Reconnecting Left and Right Display Views --------------- 10
 Playing Back --- 10
 Rendering a Preview -- 11
 Setting the Time Ranges --- 11
 Setting Playback Quality -- 12

Chapter 2: Manipulating Colors, Channels, and Spaces ---------- 15
 Working with Channels --- 16
 Filtering Specific Channels -- 16

Contents

Accessing Auxiliary Channels ------------------------------------ 17
Interpreting the Color Space of Footage ------------------------- 18
Sidebar: Color Spaces and Color Models ------------------------ 18
Converting a Color Space within a Network -------------------- 19
Mini-Tutorial 2: Working in Linear Color Space ---------------- 20
Working with Gamma in Fusion ------------------------------- 21
Sidebar: Using the Gamut Tool to Preview Output Color Spaces ----- 22
Sidebar: Changing Bit-Depth within the Tool Network -------------- 23
Applying Color Filters -- 23
Adjusting Brightness / Darkness ------------------------------ 24
Sidebar: Resetting and Raising Parameter Sliders --------------------- 25
Adjusting Contrast--- 25
Using Histograms and Subviews ----------------------------- 25
Adjusting Saturation -------------------------------------- 27
Adjusting Hue --- 27
Chapter Tutorial: Color Grading a Sequence ------------------------ 28

Chapter 3: Combining Inputs and Recombining Render Passes -- 37
Layer- vs. Node-based Compositing ----------------------------- 38
Merging Inputs -- 38
Transforming with the Merge Tool ----------------------------- 39
Altering Apply Modes ------------------------------------- 40
Sidebar: Choosing Alpha Operators ------------------------------ 41
Premultiplying and Adjusting Alpha --------------------------- 42
Chaining Together Multiple Merge Tools ---------------------- 43
Recombining Render Passes --------------------------------- 44
Overview of Common Render Passes --------------------------- 44
Sidebar: Render Pass Flexibility ------------------------------- 46
Mini-Tutorial 3: Recombining Basic Render Passes ---------------- 46
Working with Z-Depth -------------------------------------- 49
Adding Depth-of-Field ------------------------------------- 49
Adding Fog in Depth --------------------------------------- 52
Applying Motion Blur in the Composite ----------------------- 52
Sidebar: Examining Channel Values ----------------------------- 54
Sidebar: Deep Pixel, Deep Image, and WPP ----------------------- 54
Chapter Tutorial: Assembling a Shot ------------------------------ 54

Chapter 4: Transforming and Motion Tracking ---------------------- 59
Altering and Animating Transforms ------------------------------ 60
Using the Transform Tool ----------------------------------- 60
Sidebar: Project and Frame Resolutions ----------------------------- 61

Contents

Choosing a Filter Method --- 62
Transforming with Scale, Resize, and DVE ----------------------------- 62
Letterboxing and Cropping --- 63
Adding Camera Shake --- 64
Activating Motion Blur -- 65
Animating Transformations -- 66
Motion Tracking -- 67
Using the Tracker Tool -- 67
Sidebar: Placing a Pattern Window ------------------------------------- 69
Employing a Second Pattern Window to Capture Rotation / Scale ---- 70
Using Tracking Data To Stabilize Footage ---------------------------- 70
Applying Transform Tracking -- 72
Sidebar: Adding Motion Blur to Motion Tracking ---------------------- 73
Refining Motion Tracking Data -- 74
Sidebar: Tracking Multiple Patterns ------------------------------------ 75
Linking Motion Tracking Data between Tools ----------------------- 76
Chapter Tutorial: Corner-pin Motion Tracking ------------------------- 77

Chapter 5: Keyframing and Adjusting Animation Splines ------- 81
Keyframing Parameters --- 82
Sidebar: Approaches to Keyframing ------------------------------------- 83
Shifting Keys and Altering Speed with the Timeline ----------------- 84
Altering Animation Splines with the Spline View ----------------- 84
Sidebar: Working with Displacement Splines and XY Paths ----------- 85
Adjusting, Adding, and Deleting Keyframes ------------------------- 86
Working with Tangent Handles -- 86
Mini-Tutorial 4: Fine-tuning a Keyframe Animation ---------------- 87
Using Specialized Spline Options ------------------------------------- 89
Chapter Tutorial: Fixing Animation and Adding a Camera Move ---------- 91

Chapter 6: Masking and Rotoscoping --------------------------------- 97
Masking --- 98
Adding and Connecting a Primitive Mask ---------------------------- 98
Drawing a Polygon or BSpline Mask ----------------------------------- 99
Using the Polygon Toolbar -- 100
Adjusting the Polyline Matte Edge ------------------------------------- 102
Employing Bitmap Masks -- 102
Mini-Tutorial 5: Creating a Luma Mask ------------------------------- 103
Creating Primitive and Polyline Masks with Mask Paint ---------- 105
Sidebar: Filling a Polyline Stroke Mask --------------------------------- 106
Painting a Mask with Mask Paint -------------------------------------- 107

Contents

Sidebar: Combining Masks --- 109
Converting Sampled Values into a Mask --------------------------- 109
Rotoscoping --- 111
Rotoscoping with the BSpline and Polygon Tool ----------------- 111
Rotoscoping with the Mask Paint Tool ------------------------------ 112
Multistroke -- 112
Clone Multistroke -- 112
Polyline Stroke and Stroke --------------------------------------- 112
Using Advanced Polygon and Mask Paint Rotoscoping Tools --- 113
Publish Menu -- 114
Make Points Follow Nearby Published Nearby Points--- 114
Onion Skin --- 114
Roto Assist -- 115
Chapter Tutorial A: Color Grading within a Mask ------------------------- 115
Chapter Tutorial B: Masking a New Art Element --------------------------- 117

Chapter 7: Altering Outputs with Filters --------------------------- 121
Overview of Filters -- 122
Blurring and Sharpening --- 122
Blur -- 122
Directional Blur --- 122
VariBlur --- 123
Sharpen -- 123
Unsharp Mask -- 124
Replicating Camera Artifacts -- 124
Defocus --- 124
Glow -- 124
Soft Glow --- 125
Sidebar: Choosing a Clipping Mode and a Domain ------------------ 125
Highlight --- 125
Hot Spot -- 126
Sidebar: Choosing a Filter Apply Mode --------------------------------- 126
Rays --- 127
Lens Distort --- 127
Filtering Alpha Mattes -- 127
Alpha Divide and Alpha Multiply --------------------------------------- 127
Matte Control --- 128
Time Warping --- 129
Time Speed -- 129
Sidebar: Optical Flow Tools -- 130
Time Stretcher -- 130

Contents

Adding Distortion -- 132
 Sidebar: Distortion Aliasing -- *134*
 Mini-Tutorial 6: Morphing with the Grid Warp Tool --------------- 135
Adding Stylistic Effects -- 138
 Sidebar: Review of Procedural Tools ---------------------------------- *139*
Chapter Tutorial A: Time Warping a 3D Render ------------------------------140
Chapter Tutorial B: Creating Complex Results with Multiple Effect Filters ----------143

Chapter 8: Chroma Keying -- **147**
The Chroma Key Process -- 148
Keying with Keyer Tools -- 148
 Applying the Primatte Tool -- 148
 Removing Spill with Primatte -- 150
 Adjusting the Matte Edge with Primatte ---------------------------- 150
 Sidebar: Choosing a Primatte Algorithm in Fusion Studio ---------- *152*
 Using Additional Primatte Options -------------------------------------- 153
 Sidebar: Optional Primatte Tool Inputs -------------------------------- *154*
Keying with Other Fusion Keyers -- 154
 Keying with Chroma Keyer -- 154
 Keying with Ultra Keyer -- 155
 Keying with Luma Keyer --- 155
 Keying with Difference Keyer -- 156
 Sidebar: Taking Additional Steps to Improve the Matte ------------- *157*
Chapter Tutorial: Keying a Green Screen ------------------------------- 157

Chapter 9: Working in the Fusion 3D Environment ------------- **163**
Overview of the Fusion 3D Environment -------------------------------- 164
Constructing a Basic 3D Scene -- 164
 Controlling Camera Views in 3D Space ------------------------------ 165
 Transforming Cameras and Geometry ----------------------------- 165
 Rendering the 3D Scene -- 166
Working with Geometry --- 167
 Sidebar: 3D Display Modes -- *167*
 Mini-Tutorial 7: Creating a Flying Logo ---------------------------- *167*
 Altering Geometry -- 169
 Adjusting Geometry Materials -- 171
 Sidebar: Bitmap Transparency -- *173*
 Connecting Material Tools -- 173
 Adding Textures -- 174
 Working with 3D Textures and Projections ----------------------- 175
 Sidebar: Projecting Animated Geometry ------------------------------- *177*

Contents

Using Environment Textures -- 177
Lighting and Shadowing -- 178
Importing Geometry and Cameras --- 179
Simulating Particles -- 181
 Creating a Basic Particle Scene -- 181
 Changing the Particle Style, Size, and Color ------------------------------ 182
 Sidebar: Hiding the Checkerboard --- 183
 Moving, Rotating, and Spinning Particles ------------------------------- 183
 Sidebar: Adding Randomness with Variance --------------------------- 183
 Affecting Particles with Forces -- 183
 Working with Force Positions and Regions ------------------------------ 185
 Sidebar: Additional 3D Tools and Techniques ------------------------- 185
 Sidebar: Changing the pEmitter Shape and Using pKill and pBounce -- 186
 Sidebar: Generating Sub-particles and Sub-styles ------------------- 186
 Sidebar: Emitting Particles from an Image -------------------------- 187
 Chapter Tutorial: Adding Textures and Particles to a Flying Logo ------------ 187

Chapter 10: Repairing, Painting, and Distressing ---------------- **191**
Repairing and Distressing Footage --- 192
 Sidebar: Artifact Terminology --- 192
 Reducing Grain and Noise -- 192
 Adding Grain and Noise --- 193
 Adding Television Artifacts --- 194
 Sidebar: Cineon Tools --- 195
Making Paint Fixes --- 195
 Using the Paint Tool -- 195
 Sidebar: The Paint Toolbar and Paint Apply Mode ------------------ 196
 Removing Wires -- 197
 Sidebar: Animating Stroke Positions --------------------------------- 197
 Chapter Tutorial A: Reducing Noise Per Channel ------------------------------ 198
 Chapter Tutorial B: Paint Fixing Dirt, Dust, and Scratches -------------------- 201

Chapter 11: Rendering, Scripting, and Customizing -------------- **205**
Rendering --- 206
 Using the Fusion Studio Render Manager ------------------------- 207
Customizing Your Workspace -- 208
 Main Toolbar --- 208
 Bins -- 208
Organizing the Flow View --- 209
 Grouping Tools --- 209
 Adding Macros --- 210

Contents

Finding Tools -- 210
Flow Display Options -- 210
Adding and Reading Comments --- 210
Automating Parameter Values --- 211
Applying Fusion Modifiers --- 211
Working with Expressions and Linking ----------------------------------- 212
Scripting Overview --- 213
Lua Scripting Examples -- 213
Using Plug-ins and Fuses --- 214
Sidebar: Hacking `.comp` *Files* ------------------------------------- 215
Stereoscopic Overview --- 215
Working with Miscellaneous Tools --------------------------------------- 216
Using Metadata -- 217
Book Wrap-up -- 217

Final Tutorial: Creating the Cover Art ------------------------------- **218**
Sidebar: Speeding Up the Playback ----------------------------------- *224*

Appendix A: Additional 3D Tools and Techniques ------------------ **228**
Custom Vertex 3D -- 228
Locator 3D --- 229
Point Cloud 3D -- 229
Image Plane 3D -- 229
FBX Exporter 3D --- 230
Ribbon 3D -- 230
Sidebar: Projecting Textures from a 3D Camera ----------------------- *230*
Projector 3D --- 230
Catcher -- 231
SoftClip -- 231
Fog 3D --- 231

Appendix B: After Effects to Fusion Chart --------------------------- 232

Index --- **235**

Introduction

As I often say, compositing is rarely boring and is often surprising. It doesn't matter what field you are working within, whether it's feature visual effects, commercial television production, original web content, or independent filmmaking. Many compositing tasks are universal, such as green screen removal, rotoscoping, and motion tracking. Many of the challenges are the same and often require the clever use of compositing tools. Blackmagic Design Fusion offers its own robust set of node-based tools to tackle every compositing challenge. Keep in mind that there is no way to cover every option within Fusion in the limited space of this book. Instead, I discuss the most critical tools, components, and workflows so that you can start compositing successfully within a relatively short period of time.

I encourage you to work through the book's mini-tutorials, as well as chapter-end tutorials, to add the practice you need to become a talented Fusion artist. Note that I've included matching project files for many of the book's figures; this offers an additional means to learn node-based compositing techniques.

You, the Reader

Digital Compositing with Blackmagic Fusion: Essential Techniques is aimed at any artist who would like to learn Blackmagic Design Fusion in order to composite. This includes novices who are new to compositing in general and professionals who would like to transition from a similar program, such as The Foundry Nuke. Although some experience with node-based compositing is certainly helpful, it is not mandatory to use this book.

Topics Covered

Digital Compositing with Blackmagic Fusion: Essential Techniques covers critical program components and compositing workflows, which include:

- Tool / Node networks
- Color space and color channels
- Transformations
- Masking and rotoscoping
- Keyframing and animation splines
- Green screen keying
- The Fusion 3D environment
- Color grading and color manipulation
- Filter tools
- Motion tracking
- Particle simulation
- Stereoscopic workflow

Required Software

This book was written with the free version of Fusion 8. Differences between Fusion 8 and Fusion Studio 8 are noted in the text. Screen snapshots were taken with Fusion 8 running on a 64-bit Windows 10 system. Free versions of Fusion are available at the Blackmagic Design website (`www.blackmagicdesign.com`).

Downloading the Tutorial Files

Example project files and ancillary materials are provided for this book and may be downloaded from the following website:

`www.routledge.com/9781138668287`

These include several gigabytes of Fusion project files, video image sequences, 3D renders, Autodesk Maya 3D camera, light, and geometry files, static artwork, and matte paintings. The files are organized in the following directory structure:

ProjectFiles\FusionFiles\Chapter*n*\	Fusion project files (`.comp`)
ProjectFiles\Plates*Plate Name*\	Video and 3D render image sequences (`.png` and `.exr`)
ProjectFiles\3D\	Autodesk Maya camera, light, and geometry files (`.ma`, `.obj`, and `.abc`), plus bitmap textures (`.tif`)
ProjectFiles\Art\	Static images and matte paintings (`.tif`, `.png`, `.exr`, and `.psd`)

About the Source Files

Video image sequences used in this book are culled from material shot by BeezleBug Bit, LLC (`www.beezlebugbit.com`), Light Forge Studios (`www.Light Forgestudios.com`), and students at the Universidad de Monterrey (`www.udem.edu.mx`). The reader may use these image sequences for educational purposes but may not redistribute the sequences in any fashion. Commercial use of the sequences is not granted. In addition, several still images and image sequences are derived from WikiMedia Commons (`commons.wikimedia.org`) while other image sequences are derived from the Prelinger Archives (`archive.org`). Where appropriate, license information is included with the figure captions.

Using the Tutorial Files with Windows and Mac Systems

I recommend that you copy the project files, with their current directory structure, directly to your root directory (C: on a Windows systems or / on a Mac system). If Fusion is unable to load a movie, static image, or image sequence because the file or files have moved to a new location, you can reload the files by opening the associated Loader tool in the Tools tab and browsing for the files via the Filename Browse button. (Such an error is indicated with a red coloration of the Loader tool icon.) The Loader tool is discussed in more detail in Chapter 1. You can also manually edit the Fusion project file—this is discussed in Chapter 11.

Updates

For updates associated with this book, please visit `www.routledge.com/9781138668287`.

Naming Conventions

Digital Compositing with Blackmagic Fusion: Essential Techniques uses common conventions when describing mouse and keyboard operation. Note that Fusion is dependent on a three-button mouse. A few examples follow:

MMB-drag	Drag while pressing the middle mouse button
RMB-click	Right mouse button click
LMB+MMB-drag	Drag while pressing both the left and middle mouse button

Calls to press a specific key that carries a different name on a Windows and Mac system are written like this: Ctrl/Cmd and Alt/Opt.

Fusion and Visual Effects Terminology

When referring to components of Fusion, I've used terminology established by the help files and support documentation. When discussing compositing techniques, I've used words and phrases commonly employed in the animation and visual effects industries. Note that many terms were originally developed to describe techniques applied to motion picture film. For example, here are a few words and phrases used throughout this book:

Live-action Film or video of actors in a real-world location. Live-action does not refer to documentary or news gathering footage of real events, nor does it include animation.

Footage Motion picture film shot for a particular scene or at a particular location. You can also use this term to refer to digital video.

Shot A single camera set-up of a multi-shot scene. For example, a shot may be a close-up of an actress or a wide-angle of a street. With film or video, a **scene** is series of shots captured at one location that represents a particular period of time.

Plate A shot intended for visual effects work. For example, a plate may be a shot of a city street that requires the addition of an explosion or an animated robot. A plate may be static or may contain movement. Plates often include green screen and may be shot at an extra-high resolution (such as 70mm with motion picture film or 4K with digital video).

Contacting the Author

Feedback and questions are always welcome. You can contact me at `comp@beezlebugbit.com` or find me on popular social media networks.

(Loader, LD)

Defocus, Dfo)

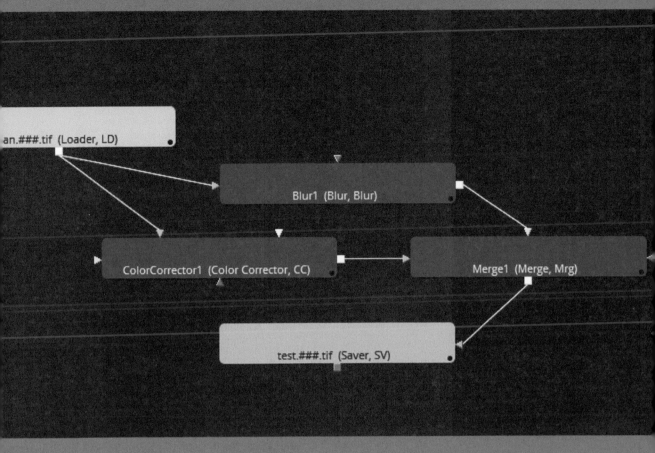

Working with Tool Networks

At first glance, node networks appear to be strange, spaghetti-like tangles of tiny boxes. However, with a little practice and thoughtful application, they become a powerful means to create custom composites. Much like layer-based compositing programs, node networks provide a means to read and write footage, apply specialized filters, and undertake common compositing tasks such as green screen removal, rotoscoping, and motion tracking. You can connect nodes in an almost infinite number of ways when you follow the basic rules of input and output connections. Working with various resolutions and frames rates carries the same flexibility.

This chapter includes the following critical information:

- Overview of the Fusion interface
- Introduction to tool / node networks
- Project set-up
- Working with resolutions and frame rates
- Approaches to playback

Understanding the Fusion Interface

Before reviewing the Fusion interface, it helps to understand what a tool is in the program. A Fusion **tool** is a node that appears as a box in the Flow view and forms the basis of node networks (also called **tool networks** or **flows**). In turn, a **node** is a discrete construct that carries out a particular task. Nodes have inputs and outputs so that they can accept data, alter the data, and export the altered data. Each of the boxes shown on the first page of this chapter is a node *and* a tool. The creation and connection of tools is discussed later in this chapter.

Exploring Panels, Tabs, and Views

The Fusion interface is broken up into panels. A panel can carry multiple tabs, where each tab carries a specific view. A **view** provides a unique means to examine or alter tool networks, individual tools, or tool parameters. The overall configuration is referred to as a **layout**. When you launch the program, you are given a new, empty project with a default panel, tab, and view layout (Figure 1.1).

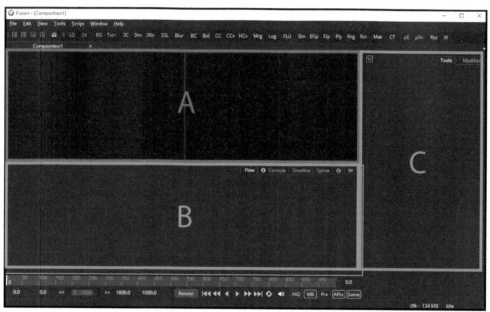

Figure 1.1 Fusion 8 program window in its default state. The Left and Right Display views are located in panel A (the Viewers panel). Flow, Console, Timeline, and Spline tabs are located in panel B (the Work panel). The Tools and Modifiers tabs are located in panel C (the Control panel). The TimeView is at the bottom of the program window.

Here's a brief description of commonly used views:

> **Left and Right Display** (in panel A of Figure 1.1) allow you to see the outputs of two tools. The tools may be part of the same tool network or may be from different networks. These views are discussed in more detail in the next section.

> **Flow** (a tab in panel B of Figure 1.1) serves as the work area for constructing and altering tool networks.

Console (a tab in panel B of Figure 1.1) supports Lua and Python scripting and prints out program error messages.

Timeline (a tab in panel B of Figure 1.1) shows a keyframe view of animation. You can use the view to alter keyframe spacing and animation timing.

Spline (a tab in panel B of Figure 1.1) displays animation splines for animated parameters, which you can alter.

Tools (in panel C of Figure 1.1) reveals tool parameters when one or more tools are selected. This is where you alter parameter values and set parameter keyframes. **Parameters**, which control how a tool functions, are displayed as sliders, fields, checkboxes, gradients, or rows of buttons. The Tools tab reveals sub-tabs for a tool, such as the Controls tab. Throughout this book, I will refer to such a sub-tab as Tools > Controls.

Modifiers (in panel C of Figure 1.1) reveals applied modifiers. Modifiers are added to tool parameters to alter their values.

TimeView (at the bottom of the program window) carries the time ruler and playback controls. (This area is commonly called a "timeline" in other compositing and 3D programs.)

Navigating within Views

You can use camera shortcuts to scroll or zoom within most views. To scroll left / right or up / down, MMB-drag. To zoom in or out, press the + or – key on the keyboard or LMB+MMB-drag left and right. You can also zoom by scrolling with a MMB scroll wheel while pressing the Ctrl/Cmd key. Note that you must select the view for a camera shortcut to work. To select a view, LMB-click anywhere within the view.

Using the Menus

The main menu at the top of the program window carries all the file, tool, and layout options you need to create a composite. The same set of menus is accessible within the Flow view by selecting the Flow view and RMB-clicking (Figure 1.2). RMB-clicking in other views, such as the Left and Right Display view or Spline view, brings up a context-sensitive menu with a different set of options.

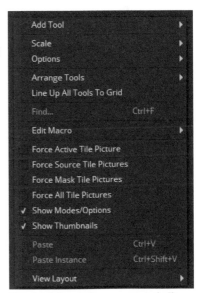

Setting Up a Project

As previously mentioned, when you launch Fusion, a new, empty Fusion project is provided. You can choose to work within this project, make a new project, or open an old one. Fusion projects are saved in a text format with the `.comp` extension. New projects are automatically named composition*n*.comp. You can save a project at any time via the File > Save or File> Save As menu. You can open a project at any time with File > Open.

Figure 1.2 RMB context menu, as seen in the Flow view.

Chapter 1

Note that you can open multiple projects within Fusion. With Fusion 8, each project receives a tab at the top-left of the Viewers panel. However, you can only work on one project at a time in the various views. To switch between open projects, select the project tab or choose Window > *project name*. To close the project that is currently visible, choose File > Close or click the project tab's × symbol.

Choosing Critical Project Settings

Before constructing tool networks, it's important to set the project's desired resolution, frame rate, and working color space. To do so, choose File > Preferences. In the Preferences window, select the Frame Format section from the left column (Figure 1.3). You can manually enter the resolution through the Width and Height fields or choose a preset through the Default Format menu. You can set the Frame Rate field to the desired rate. In general, you want to match the resolution and frame rate to the material you are importing, such as digital video footage. (Working with mismatched resolutions is discussed in Chapter 4.) Note that each Fusion project can carry its own unique resolution, frame rate, and color space choice.

By default, Fusion operates in 8-bit color space, where each color channel (red, green, and blue) can carry a maximum of 256 colors. However, you can choose to work in a 16-bit or 32-bit color space by changing the Full Render, Preview Render, and Interactive menus to the color space of your choice. The Full Render and Preview Render menus alter the quality of frames rendered to disk. The interactive menu affects the Left and Right Display view quality.

Loader tools, which are used to import footage, also carry their own color controls. These are discussed in Chapter 2.

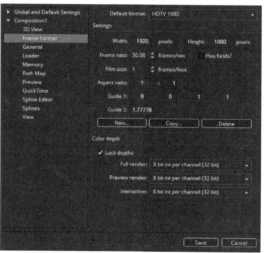

Figure 1.3 The Frame Format section of the Preferences window.

Integer vs. Floating-point Color Space

The 16-bit and 32-bit color spaces in Fusion have two variations: integer and float. Integer color space rounds off values and does not allow for decimal-place accuracy. Float uses floating-point architecture and can hold extremely small and extremely large values (for example, 0.000037625 and 3×10^{48}). Floating-point color space is often used with HDR (High-Dynamic Range) footage, photographs, renders, and static art. The 32-bit float offers the most accurate color space in Fusion; at the same time, this is also the most computationally expensive color space. Keep in mind that most computer monitors operate in 8- or 10-bit color space, so the full range of values in 16- or 32-bit cannot be seen simultaneously. Color and color spaces are discussed in more detail in Chapter 2. Whereas it's best to select a resolution and frame rate at the start of a project, you are free to change the color space at any time (although there may be visible changes to the quality of a tool's output).

Creating Tool Networks

You can create a tool by choosing the tool name through the Tools menu at the top of the program window or through the RMB > Add Tool context menu in the Flow view. Tools are grouped into categories such as Tools > Color or Tools > Blur. Many of the tools carry out common compositing tasks and are similar to filters or functions found in compositing programs such as Adobe After Effects or The Foundry Nuke.

Connecting Tools

Each tool carries one or more inputs and one output. An **input** accepts data from another tool. An **output** exports the data altered by the tool. A specific input can only accept one incoming connection. You can connect an output to multiple inputs of other tools. Any given input or output is composed of multiple channels. By default, these channels are red, green, blue, and alpha; however, other channel variations exist and are discussed in Chapter 2.

There are several methods you can use to connect two tools together:

Connecting Stubs LMB-drag the output stub of a tool to the input stub of a second tool and release the mouse button. The output stubs appear along the tool box edges as small red squares. The input stubs appear as different-colored triangles (described later in this section). This method works even if the output is already connected to another tool. You can connect a single output to an unlimited number of inputs. Alternatively, LMB-drag the output stub of a tool to the center of second tool and release the mouse button. The output of the selected tool is connected automatically to a default input of the new tool. The default input is the most commonly used input on multi-input tools. In fact, the default input is often named *Input* (the output is always named *Output*).

Inserting Select the tool whose output you wish to connect in the Flow view. RMB-click over the tool and choose Insert Tool > *tool*. The tool is automatically connected. If a connection already exists, the new tool is inserted *in-between* the pre-existing tools. Alternatively, RMB-click over the output side of a connection line (the line segment turns blue) and choose Add Tool > *tool*. The new tool is inserted *in-between* the pre-existing tools.

When a connection is made between two tools, a connection line (also known as a **pipe**) is drawn between the two tools. The flow of information is indicated by an arrow on the line. The arrow points towards the tool accepting the input (Figure 1.4). While output stubs are drawn as red squares, input stubs are drawn as color-coded triangles. Here are a few common colors:

Purple triangle: Effect Mask input (used with masking and rotoscoping)
Green triangle: Foreground input of Merge and keyer tools
Orange triangle: The default input (named *Input* or a specific name, such as *Background*)

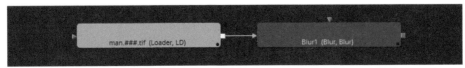

Figure 1.4 A Loader tool is connected to a Blur tool. The connection line appears between them. Note the various input and output stubs at the tool icon edges.

If you are unsure of the identity of an input or output, place the mouse arrow over the small triangle or square stub. The channel name is displayed in a small dialog box, plus as a message at the bottom-left of the program window. The channel name follows the naming convention *tool name.input/output name* (Figure 1.5). If you place the mouse arrow over the center of a connection line, the connection is displayed as *output tool*.Output->*input tool.input*.

To disconnect two tools, LMB-drag the connection line from the input triangle to an empty area of the Flow view and release the mouse button. To delete a tool, select it in the Flow view and press the Delete key.

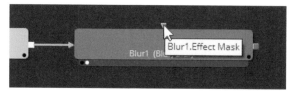

Figure 1.5 The name of an input is revealed by placing the mouse arrow over it. The tool's connection to the Right Display view is indicated by the white dot.

To see the output of a particular tool, you must connect it to the Left or Right Display view. There are several ways to do this:

- Select the tool icon in the Flow view (LMB-click the box so it turns yellow and appears in the Tools tab). Press the 1 keyboard key to connect its output to the Left Display view or the 2 key to connect its output to the Right Display view.
- LMB-drag the tool box from the Flow view to a Display view and release the mouse button.
- Press one of the two dots that appear at the bottom-left to the tool icon. The left dot connects to the Left Display view and the right dot connects to the Right Display view. A white dot indicates an active connection.

To disconnect a tool so its output is no longer visible, select the tool and press the 1 or 2 key again or click the icon dot so that it turns black.

Rearranging and Disabling Tools

You can move tools in the Flow view by selecting the tool icons and LMB-dragging. The connection lines update to maintain the prior connections. The input and output stubs also reposition themselves around the edge to the tools icons; this does not affect the resulting composition. If you'd like to keep the tools arranged in a rigid horizontal and vertical fashion, you force them to snap to a hidden grid. To activate the grid snap, RMB-click in the Flow view and choose Arrange Tools > To Grid. You can automatically arrange all the tools along the grid lines by RMB-clicking and choosing Line Up All Tools To Grid.

You can temporarily disable a tool by selecting it and pressing Ctrl/Cmd+P. A disabled tool passes the input to the output without altering any values. To enable a disabled tool, select it and press Ctrl/Cmd+P. A disabled tool icon is colored dark gray.

Importing Footage

You can import footage by adding a Loader tool to the Flow view. Choose Tools > I/O > Loader. With this selection, the Open File window opens. Navigate to the directory where the desired footage is stored and select the footage name and click the Open button.

Fusion is able to read self-contained QuickTime movie files, as well as static bitmap images, such as PNG and TIFF. In addition, Fusion recognizes numbered image sequences and imports them as a single unit. For example, you can choose test.001.png of a 100-frame PNG sequence and Fusion automatically loads the appropriate frame as you play back the time ruler in the TimeView. The frame numbering must follow the basic format *name.000.ext*, where *000* represents the numeric placeholders. With three placeholders, frame 1 is listed as 001, frame 10 is listed as 010, and so on.

After a Loader is added and the footage is selected, you can connect the Loader to a Display view and play back the footage with the TimeView controls. (Playback is discussed in detail at the end of this chapter.)

Reloading Missing Footage

If the location of a movie, static image, or image sequence on a drive changes, a Loader tool will fail to load the footage. You can reload missing footage by selecting the Loader, going to the Tools > File tab, clicking the Filename Browse button, and navigating to the footage. If a Loader is unable to find footage, its box icon is colored red in the Flow view. It's also possible to update the Fusion `.comp` file outside the Fusion program—this is discussed in Chapter 11.

Mini-Tutorial 1: Creating a Simple Tool Network

With this tutorial, you'll create a new Fusion project, import an image sequence through a Loader tool, connect the output to a Defocus filter tool, and view the output through the Left and Right Display views. You can follow these steps:

1. Launch Fusion. A new, empty project is provided to you but no tools exist. The project is automatically named *composition1*. Choose File > Preferences from the main program menu. In the Preferences window, switch to the Frame Format section through the left column. Change Width and Height to 4096 and 2160 respectively. This is the 4K resolution of the footage we'll be working with in this tutorial. (There is no preset that matches this particular resolution through the Default Format menu.) Change the Frame Rate field to 24. This is also the frame rate of the original video footage. Note that image sequences, which are used commonly for visual effects compositing, do not carry an inherent frame rate. Hence, the project frame rate becomes the frame rate of imported image sequences.
2. LMB-click in an empty area of the Flow view. The view is selected. In Fusion 8, the selection is indicated with a gray line at the edges of the view. RMB-click in the view and choose Add Tool > I/O > Loader from the context menu. Alternatively, you can choose Tools > I/O > Loader from the main program menu.
3. When the tool is selected from either menu, the Open File window opens (Figure 1.6). Navigate to the `\ProjectFiles\Plates\Car\` directory. (See the Introduction for information on the project files provided for this book.) Select `car.00.png` and click Open. The image sequence, as a single unit, is brought into the Loader and the browser window closes.

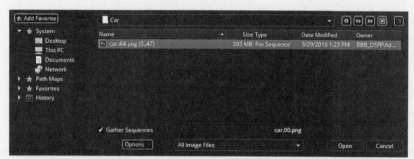

Figure 1.6 The Open File window. The image sequence named *Car.##.png* is selected. Note that the numeric placeholders are represented by # symbols in the directory field and *O* symbols in the name field.

4. The contents of the Loader are not visible until you connect it to the Left or Right Display view. Select the Loader tool in the Flow view by LMB-clicking it so it turns yellow. Press the 1 key to connect the tool to the Left Display view or the 2 key to connect the tool to the Right Display view. You can temporarily alter the width of the Left or Right view by LMB-dragging the vertical bar that separates the views to the left or right.

5. While the Loader is selected, the file parameters appear in the Tools > File tab at the right side of the program window. The parameters include the Filename, which lists the name and directory path of the imported image sequence (top of Figure 1.7). You can use the Browse button to replace or reload the footage. (Fusion `.comp` files include the footage name and directory path but do not carry the bitmap images themselves.) The duration of the footage is indicated as a number between the Global In and Global Out fields. `car.##.png` is 48 frames long. However, the time ruler within the TimeView has a default duration of 1000 frames. Using the fields below the time ruler, change the Global Start Time field to 1 and Global End Time field to 48 (Bottom of Figure 1.7). This removes the empty portion of the playback and matches the numbering of the image sequence (numbered 0 to 47).

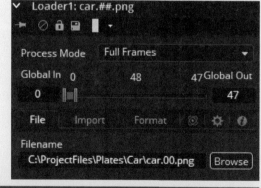

Figure 1.7 Top: A portion of a Loader tool's parameters, as seen in the Tools > File tab. The footage duration appears between the Global In and Global Out fields. Bottom: The time ruler and Time fields of the TimeView.

6. Play back the footage by using the playback controls in the TimeView. The first time the footage plays, it is loaded into memory. The memory load is indicated by a green line that's drawn underneath the frame numbers. Additional playbacks after the green line is drawn are in real-time. The achieved playback frame rate is written out as a message at the bottom of the TimeView (see Figure 1.14 later in this chapter).

7. Because the resolution of the image sequence is far greater than the screen resolution of the Display view, only a portion of each image sequence frame is seen. To fit the footage to the view frame, click the Fit (Fit To View) button along the Left or Right Display view's lower option bar (Figure 1.8). To zoom in and out, you can also choose a zoom percentage though the Set Viewer Scale menu button (the menu also has a Fit option, which is identical to the Fit button). In addition, you can use the + or − keys on your keyboard or press Ctrl/Cmd while scrolling with your MMB scroll wheel. Note that the +, −, and scroll wheel method only work if the view is selected.

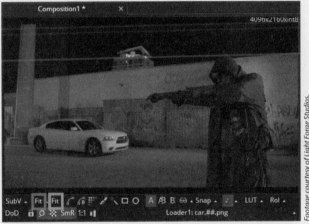

Figure 1.8 The 4096x2160 footage is fit to a smaller Left view. The Fit Viewer Scale button is outlined in red. The Fit button is outlined in blue.

8. RMB-click in the Flow view and choose Add Tool > Blur > Defocus. A Defocus tool is added to the Flow view. The Defocus tool creates a realistic blur that matches the optical parameters of a real-world camera. LMB-drag the Loader's red Output square stub and drop the new connection line on top of the Defocus tool's orange Input triangle. If the connection is successful, the connection line stays visible (Figure 1.9).

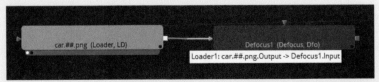

Figure 1.9 The Output of the Loader is connected to the Input of the Defocus tool. When you place your mouse over the resulting connection line, the connection is listed in a dialog box.

9. The output of the Defocus is not visible until you connect it to a Display view. Connect the Loader to the Left Display view and the Defocus tool to the Right Display view. Initially, the views appear identical. Select the Defocus tool so that its parameters appear in the Tools > Controls tab. Click the Gaussian Blur button to switch to the Gaussian filter options. Set the Defocus Size to 10. The image becomes blurry in the Right Display view (Figure 1.10). To create a more realistic, camera-style blur, click the Lens button to return to the Lens filter options and raise the Defocus Size value. Although more accurate, the Lens filter is significantly slower (especially with 4K footage). To make the calculation more efficient, you can activate the Prx (Proxy) mode and choose a lower proxy resolution (this is described in the section "Setting Playback Quality" at the end of this chapter).

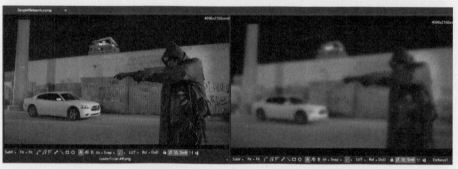

Figure 1.10 The unblurred footage is displayed in the Left view while the Gaussian-blurred result is displayed in the Right view.

The tutorial is complete! More complex tool networks are discussed throughout this book. A finished version of this tutorial is saved as `\ProjectFiles\FusionFiles\Chapter1\SimpleNetwork.comp`.

Reconnecting Left and Right Display Views

When you open a Fusion `.comp` file, the Left and Right Display views are not connected. You will have to reconnect the views each time you open a Fusion project regardless of the state the file was in when it was saved.

Playing Back

To play back a range of frames, use the playback controls within the TimeView. The first time the frames are played, they are written to memory. This is indicated by a green line below the frame numbers on the time ruler. The second time the frames are played, the playback attempts to achieve real-time playback. The target fps (frames-per-second) is set by the Frame Rate field in the Preferences window.

Rendering a Preview

Alternatively, you can create a playback by rendering reduced-quality frames to disk. To do this, RMB-click on top of a tool whose output you'd like to see and choose Create/Play Preview On > *location* from the menu. The Render Settings window opens (Figure 1.11). The render quality is set to Preview by the Configurations section. This setting allows you to choose a reduced resolution, such as Quarter Size, from the Size section. You can further adjust the quality by choosing HiQ (High Quality), MB (Motion Blur), and Some / All buttons through the Settings section. These options are described in the next section.

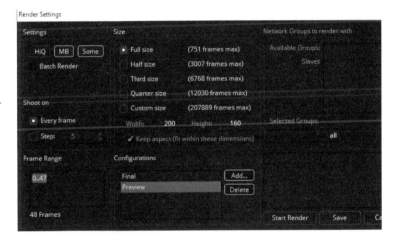

Figure 1.11 The Render Settings window with preview settings.

To launch the playback render, click the Start Render button. The Render Settings window closes and the time ruler plays forward. When the end of the playback is reached, the TransportView is added to the bottom right of the program window (Figure 1.12). You can use the transport's built-in playback controls to play the rendered preview through a Display view. The selected Display view also carries a small frame number. The TransportView carries its own Rate (FPS) field, which you can change to the desired real-time playback speed independent of the Preferences window settings. To remove the rendered preview from a selected view, RMB-click in that view and choose Remove Preview from the context menu.

Figure 1.12 The TransportView. Note that the Rate (FPS) field may not (or need not) match the Frame Rate set by the Preferences window.

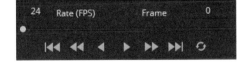

Setting the Time Ranges

As demonstrated by this chapter's mini-tutorial, you can alter the duration of the time ruler by updating the values of the Global Start Time and Global End Time fields. (See Figure 1.7 earlier in this chapter.) You can also "zoom" into a small area of the range by updating the Render Start Time and Render End Time field values; this offers a means to temporarily examine a small section of the entire time ruler.

In addition, you can alter the range of imported footage. By default, a Loader tool imports all the frames contained within a movie or all the frames of a numbered image sequence. You have the option to skip frames by changing the Global In and Global Out fields (Figure 1.7 earlier in this chapter). For example, if you change Global In to 10, the footage starts at frame 10, and frames 1 to 9 are ignored. If you change Global Out to 36, frame numbers higher than 36 are ignored. Note that each piece of footage you import, whether it's a movie or image sequence, must be brought into the program through its own Loader tool.

You can further adjust the footage range by altering the Loader tool's Trim In and Trim Out fields (Figure 1.13). Raising Trim In and lowering Trim Out further reduces the total number of frames the Loader tool outputs to other parts of the network. You can also create a "freeze frame," where one frame is repeated, by entering a non-0 number into the Hold First Frame or Hold Last Frame field. Hold First Frame repeats the first frame before moving on to the second, third, fourth, and so on. Hold Last Frame repeats the last frame of the current Loader frame range and is useful for extending footage that may be too short for the time ruler range. The duration of the "freeze" is the number of frames you enter into the Hold First Frame or Hold Last Frame fields.

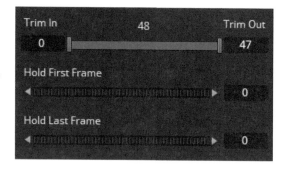

Figure 1.13 The Trim In, Trim Out, Hold First Frame, and Hold Last Frame parameters of a Loader tool.

Setting Playback Quality

The TimeView carries a set of quality settings that you can adjust to maximize the efficiency of the Display view refresh (Figure 1.14).

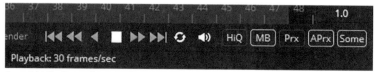

Figure 1.14 The five quality setting buttons are located at the middle-right side of the TimeView. The achieved playback speed, when the time ruler is playing, is indicated in the Playback field at the bottom-center of the TimeView.

The program must calculate the pixel values of each frame using all the components of the tool network. Hence, with complex networks, the Display view refresh or initial playback of the entire time ruler may be extremely slow unless the quality settings are adjusted. The settings described here have the same functionality of those seen in the Render Settings window.

HiQ (High Quality) Toggles off or on high-quality. If on, the Left and Right Display views show the maximum quality as based on the current tool network. If off, Fusion saves processing time by skipping advanced anti-aliasing and related filtering steps.

MB (Motion Blur) When on, activates motion blur for any input that includes animated trans-formations. Calculating motion blur can be costly, so turning this button off may speed up initial play back. Motion blur is described in more detail in Chapter 4.

Prx (Proxy) When on, applies a proxy mode where pixels are discarded to speed up processing time. You can set the proxy resolution by RMB-clicking the Prx button and choosing a value from the menu. For example, if you choose 3, every third pixel is calculated while other pixels are discarded. High proxy values, such as 20, make the image significantly degraded.

APrx (Auto Proxy) When on, switches to proxy mode while parameter controls (such as sliders and fields) are adjusted. The proxy is also applied if you are interactively transforming an image in a Display view, such as moving, scaling, or rotating. (Transformations are discussed in Chapter 4.) You can set the quality of the Auto Proxy by RMB-clicking the APrx button and choosing a value from the menu.

Selective Update Carries three modes: Some, All, and None. When set to Some, Fusion only integrates the calculations of tools that are used directly for the output. When set to All, Fusion integrates the calculations of all tools in the network. While Some is best suited for complex, multi-branch networks, All is appropriate for small, efficient networks. When set to None, Fusion turns off all calculations. The None mode may be useful when reconstructing portions of a complex network where the output does not need to be seen immediately. The Render Settings window offers the Some and All options via the Some / All button in the Settings section.

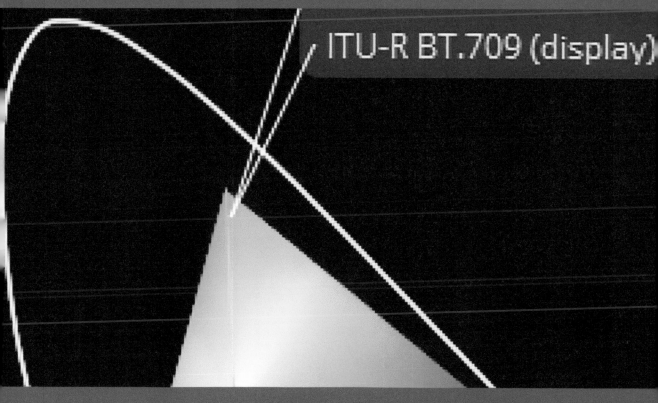

ITU-R BT.709 (display)

Manipulating Colors, Channels, and Spaces

Digital images employ color spaces, color models, bit-depths, gamma correction, and color channels in order to determine the intensity of any given pixel. As such, you have a great deal of flexibility when working with colors in Fusion. You can convert one color space to another, change the image bit-depth, or alter color values with filters to achieve specific aesthetic or technical goals. When working with color channels, you are not limited to red, green, blue, and alpha channels but can import, view, and alter a wide variety of auxiliary channels.

This chapter includes the following critical information:

- Filtering specific color channels
- Accessing auxiliary channels
- Altering color spaces and gamma
- Working in linear color space
- Applying color filters

Working with Channels

Any given input or output in a tool network carries multiple channels. Common channels include red, green, blue, and alpha. A single channel carries values that represent the intensity of each pixel of that channel. You can examine a single channel of an output by switching the Left or Right Display view's Color menu to something other than Color. For example, switching the menu to Red displays the pixel intensities for the red channel. The channel appears in grayscale with white pixels representing the maximum amount of red available in the current color space (Figure 2.1). A black pixel indicates that there is no red used for that pixel (hence, in the Color view, the pixel will appear more blue-green). If you switch the menu to Alpha, transparency is indicated with white pixels creating opaqueness, gray pixels creating semi-transparency, and black pixels creating 100% transparency (Figure 2.2).

Figure 2.1 The red channel of a color image displayed in the Right Display view. The Color menu is outlined in red.

Figure 2.2 Close-up of alpha channel for 3D render of falling lemons. The black region is 100% transparent.

Footage courtesy of Light Forge Studios.

In general, 3D renders carry alpha channels, as is illustrated by Figure 2.2. Video footage, in the form of self-contained movies or image sequences, rarely carries an alpha channel. You can also view the channels in a Display view by pressing the R, G, B, and A keys when the Display view is selected. To return to the RGB view, press the C key. Alpha transparency, when present, is indicated with a gray checkerboard pattern behind the opaque areas of the frame. The checkerboard is for reference and will not appear when rendering to disk.

Filtering Specific Channels

By default, any given filter tool affects the red, green, blue, and alpha channels (referred to as **RGBA**). However, you can alter this behavior and force the tool to affect specific channels. To do this, deselect or select the Red, Green, Blue, and / or Alpha checkboxes. The checkboxes may appear within the Tools > Controls or Tools > Common Controls tabs (Figure 2.3). For example, if you're using a Blur tool, you can deselect the Red, Green, and Blue checkboxes and select the Alpha checkbox and thus only blur the alpha channel.

Figure 2.3 Red, Green, Blue, and Alpha checkboxes carried by filter tools.

Accessing Auxiliary Channels

Some file formats, such as Maya IFF and OpenEXR, can carry custom channels in addition to RGBA. These channels may be designed for Z-depth, motion blur, or other specialized tasks. Render passes, generated by 3D programs, may also appear as a long list of additional channels.

By default, Fusion does not use the auxiliary channels. However, you can activate the channels through a Loader tool. To do so, switch from the Tools > File tab to the Tools > Format tab. Expand the Channels drop-down. A long list of supported channels are listed but only Red, Green, Blue, and Alpha are functional. An example OpenEXR image sequence, illustrated by Figure 2.4, is included with the tutorial files as `\ProjectFiles\Plates\EXR\ship.##.exr`. This sequence features a 3D flying saucer that appears on frame 2.

To activate a specific auxiliary channel, go to the Fusion channel menu that matches and change it to the auxiliary channel name. For example, if you'd like to use a Z-depth channel, go to the Z menu and change it to the Z-depth channel name. A Z-depth channel produced by the mental ray renderer might have a name such as *CAMZ. depthremapped.persp.Z*, where *persp* is the camera name. (The name will vary depending on the 3D program and the renderer used.) The menu shows all the auxiliary channels the image or image sequence carries. To add additional auxiliary channels, change additional channel menus.

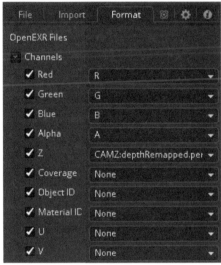

Figure 2.4 The Tools > Format tab of a Loader tool reveals the auxiliary channel list. With this example, the Z menu is set to a Z-depth auxiliary channel. An additional example is included in Chapter 3.

Auxiliary channels created for 3D render passes may not have a matching channel menu in the Format tab. To use a render pass auxiliary channel, you must connect the channel to the Red, Green, and Blue menus. When Red is set to R, Green is set to G, and Blue is set to B, the Loader connects the image's beauty pass to RGB. A **beauty pass** is a default render pass produced by a 3D renderer that contains all the shading elements and appears as a complete render of the 3D scene. A non-beauty render pass is often a single shading component, such as specularity, reflectivity, diffuse (color without specularity or shadows), and so on.

For example, to use a specular render pass, set Red to *specularpass*.R, Blue to *specularpass*.B, and Green to *specularpass*.G. The exact name of the specular pass will vary. For the example illustrated by Figure 2.4, the names possess a *SPECNS:specularNoS* prefix and end in *R*, *G*, or *B*. After the Red, Green, and Blue menus are set, you can view the render pass in the connected Display view.

If you wish to use multiple render pass auxiliary channels in a tool network, you must use multiple Loader tools with the same footage. In this case, each Loader retrieves the red, green, and blue channels of a single render pass. The recombination of render passes is explored in Chapter 3.

Interpreting the Color Space of Footage

The interpreted color space of imported footage, whether it is a bitmap image, movie, or image sequence, is set by the Depth and Color Space Type parameters of the Loader tool. You can find these parameters in the Tools > Import tab (Figure 2.5).

Figure 2.5 The Depth and Color Space Type buttons carried a Loader tool.

By default, Depth is set to Format. With this setting, the program uses the bit depth information stored within the file's header. If this information is missing, the program applies an interpretation that is commonly associated with the file format. For example, many digital image formats are created in 8-bit color space.

You have the option to choose the Int8 (8-bit integer), Int16 (16-bit integer), Float16 (16-bit floating-point), or Float32 (32-bit floating-point) buttons—this removes the mystery of bit-depth interpretation. On the other hand, you can use these buttons to intentionally ignore the original bit depth. For example, you can interpret a 32-bit floating point file as 8-bit, which might be suitable if the project is intended for 8-bit output. (Note that restricting the bit-depth may cause color data loss, although this is not always visible on screen.) Alternatively, you can match the bit-depth to the project bit-depth (set by the Preferences window) by choosing the Default button.

The Color Space Type parameter, located in the Source Color Space drop-down section, has two options: Auto and Space. Auto bases the color space interpretation on the file format. This is most commonly sRGB. The Space button allows you to choose your own color space interpretation through the Color Space menu. If you choose Custom from the menu, a new section is added that allows you to enter the Red Primary, Green Primary, Blue Primary, and White Point coordinates. This may be useful if a particular color space is missing from the list. The x and y values establish where the primary colors and white point are located within the horseshoe-shaped chromaticity chart, which represents all the colors an average human can see (Figure 2.6). In contrast, the triangle area displayed within the chart is the **gamut**—the range of colors a color space can carry. A **white point** establishes what is considered pure "white."

Color Spaces and Color Models

A **color space** is a range of colors that a particular device can display. A color space uses a specific **color model**, which uses a limited set of color primaries to create all other colors. For example, CMYK and RGB are color models. Digital image processing generally uses the RGB model, where red, green, and blue are primary colors. With RGB, equal contributions of red, green, and blue produce gray. The maximum contribution of all three colors produces white. In this way, RGB is additive. In contrast, CMYK, used for printing, is subtractive.

Numerous color spaces exist. Many are designed for specific industries or tasks. sRGB is the most common color space for digital image processing. However, other color spaces are often used in digital compositing. Two common color space categories are explored here:

Camera-specific: High-end digital camera often provide their own color space. For example, Fusion includes a default set of Arri and Sony camera color spaces. These are useful for accurately importing footage shot with a particular camera.

Video broadcast: A number of color spaces have been standardized for video broadcast. Older ones, such as SMPTE, NTSC, and PAL/SECAM , are designed for SDTV (Standard-Definition Television). HDTV uses the ITU BT.709 color space (this is generally referred to as Rec. 709). Using one of these color spaces allows you to limit the color space of imported footage in order to match a particular output format.

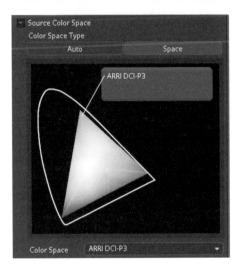

Figure 2.6 The chromaticity chart shown by the Space button with the Color Space menu set to camera-specific Arri DCI-P3. The horseshoe-shaped area represents colors visible to the human eye. The triangular area (the gamut) indicates the colors supported by the current color space. The three white lines extending from the corners intersect at the white point.

Converting a Color Space within a Network

You can convert the color space of a particular tool output with a Color Space tool. You can find this tool in the Tools > Color menu. This may be useful for accessing specific channels or accessing a new color component, such as saturation.

For example, you can convert a standard sRGB color space, carried by most digital image files, to HSV. HSV breaks color values into hue, saturation, and value. **Hue** is the more technically accurate name for color. Saturation is the intensity of a primary color, such as red, in contrast to other primary colors. **Value** is the pixel intensity and is often referred to as **brightness**.

To do this, connect the output of the tool you wish to convert to the Input of a Color Space tool. Connect the Color Space tool to a Display view. In the Tools > Controls tab, click the Color Space tool's To Color and HSV buttons (Figure 2.7). H (hue) values are displayed in the red channel, S (saturation) values are displayed in the green channel, and V (value) values are displayed in the blue channel (Figure 2.8). Accessing saturation or brightness values may be useful for green screen removal or other matte operations (discussed further in Chapter 8).

Figure 2.7 The color space conversion buttons of a Color Space tool.

Figure 2.8 Saturation is displayed by converting an image to HSV and switching to the Green channel view. This project is included with the tutorial files as `\FusionFiles\Chapter2\Color-Space.comp`.

Other color space options, located in the Color Type section, include XYZ, used for DCP (Digital Cinema Projection) and YUV (used in video production where color components are separated from **luminance**, which is gamma-adjusted brightness). To convert a portion of the network back into RGB, add a second Color Space tool and choose the To RGB button. You can also alter in-network color spaces by adding a Gamut tool. This is explored in the following mini-tutorial.

Mini-Tutorial 2: Working in Linear Color Space

It is sometimes useful to work in linear color space when compositing visual effects. Linear color space does not apply gamma correction. (Gamma is explored further in the next section.) Linear color space may prevent the loss of color information or the unwanted distortion of color values. To create a linear workflow in Fusion, you can follow these steps:

1. Import footage though a Loader tool. You can use `\ProjectFiles\Plates\Man\Man.##.jpg` as test footage.
2. With the Loader selected, go to the Tools tab. Switch to the Import tab. Click the Float32 button. To guarantee that color calculations are as accurate as possible, it's best to work in 16- or 32-bit floating-point color space. Clicking the Float32 button transfers the 8-bit values of the image sequence into 32-bit space.
3. Choose Tools > Color > Gamut. Connect the Output of the Loader tool to the input of the new Gamut tool. Connect the Gamut to the Left or Right Display view.

4. With the Gamut tool selected, go to the Tools > Controls tab. Change the Source Space menu to sRGB (Figure 2.9). This menu should match the color space of the imported footage. Note that changing the Source Space menu instantly darkens the footage (see Figure 2.11 in the next section). This is due to the default selection of the Remove Gamma checkbox. Leave the Output Space menu set to No Change.

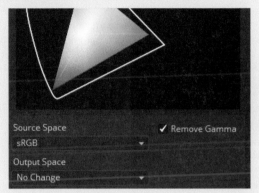

Figure 2.9 A Gamut tool is set to bring a Loader tool into linear color space. The Remove Gamma parameter removes the sRGB gamma curve.

5. You can add additional tools to the network. Any calculations downstream of the Gamut tool will remain in linear color space. If you wish to return to non-linear space that uses gamma correction, you can add an additional Gamut tool and set the Output Space menu to sRGB. Setting this menu to a color space reveals the Add Gamma checkbox. Add Gamma applies a gamma value typically associated with the chosen color space. For example, sRGB uses a gamma value of 2.2.

To properly gauge the results of a tool network while working in linear color space, it may be necessary to apply a viewer LUT (Look-Up Table). This is discussed in the next section.

Working with Gamma in Fusion

Gamma, as used in digital imaging, is an inverse power function that remaps incoming pixel values. Gamma is generally represented by a single value, such as 2.2, which is shorthand for 1/2.2. Historically, gamma has been applied for various reasons, including human sensitivity to variations in dark tones and insensitivity to bright tones, as well as the non-linear parameters of computer monitors.

When a Loader tool applies a color space interpretation to imported footage, it applies a gamma value associated with the color space. For example, sRGB color space typically uses a gamma value of 2.2. Hence, the footage looks correct in a Display view. When you view the image without gamma correction, the image loses contrast and may appear significantly darker.

Loader tools carry a Source Gamma Space section in the Tools > Import tab. This section is designed to apply different gamma values to the imported footage. However, due to difficulties viewing the results in a Display view, I suggest using the Gamut tool described in the previous mini-tutorial.

You can temporarily view different gamma values, and different color space interpretations, through a Display view. Each Display view carries a LUT (Look-Up Table) button. When activated (the button turns light gray), a color space transform with a particular gamma value is applied to the pixels in the view. This affects the view only, and does not affect the pixel values within the tool network. The color space used by the LUT button is set by the menu to the button's immediate right.

By default, the LUT menu carries a short list of color spaces. However, if you activate the LUT button and choose Edit from the LUT menu, you can create a custom LUT through the LUT Editor window (Figure 2.10). For example, if you are working in linear color space with the help of a Gamut tool, you can set the LUT Editor's Color Gamma parameter to 2.2 and thus see the network as if it is using a sRGB 2.2 gamma curve (see Figure 2.11). After you set the Color Gamma value, you can close the window. The LUT button remembers the settings. Hence, you can turn on or off the LUT button to apply the previous settings of the LUT menu and the LUT Editor.

The LUT Editor gives you the option of importing a LUT text file with the LUT File browse button. Color grading programs, such as Autodesk Lustre and FilmLight TrueLight, can produce LUT files. You can also import color spaces for the LUT menu through custom fuses (Fusion plug-ins). Fuses are discussed in Chapter 11. The Editor includes an interactive curve editor that you can use to remap the color channels. By default, RGBA channels are affected equally. Nevertheless, you can select or deselect Edit Red, Edit Green, Edit Blue, and Edit Alpha checkboxes. The curve editor works in a similar fashion to Color Curves tool, which is discussed later in this chapter.

Figure 2.10 The top and bottom portions of the LUT Editor window. Color Gamma is set to 2.2, emulating sRGB color space.

Using the Gamut Tool to Preview Output Color Spaces

If a desired color space is not present in the LUT menu of a Display view, you can use the Gamut tool to preview the space. To do so, follow these steps:

1. Connect a Gamut tool to the part of the network you wish to preview.
2. Set the Gamut tool's Source Space to the space you are currently working in (generally sRGB). Set the Output Space to the space you wish to preview. For example, if you need to check the output to see how it might look when broadcast to HDTV, set the menu to ITU-R BT.709 (Display).
3. Connect the Gamut tool to the Left or Right Display view. Deactivate the view's LUT button (otherwise, it will apply an additional color space conversion). The view displays the network with the ITU-R BT.709 color space. To toggle off the preview, change the Gamut tool's Output Space menu to No Change and deselect the Remove Gamma checkbox.

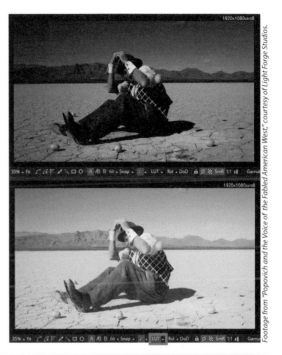

Figure 2.11 Top: The gamma correction of an image sequence is removed with a Gamut tool, making the image appear darker and possessing a greater degree of contrast. Bottom: Gamma correction is temporarily applied with the LUT button (outlined in red), making the balance of brightness and darkness more aesthetic. For this to work, the Color Gamma parameter in the LUT Editor window is set to 2.2. This footage is included with the tutorial files as `\ProjectFiles\Plates\Man\man.###.tga`.

Footage from "Popovich and the Voice of the Fabled American West," courtesy of Light Forge Studios.

Changing Bit-Depth within the Tool Network

You can alter the bit-depth of a portion of the tool network by connecting a Change Depth tool (in the Tools > Miscellaneous menu). The change occurs independently of the project bit-depth. This may be useful for increasing the efficiency of a portion of the network. For example, you can connect this tool to an output that is working in 32-bit project bit-depth, and select the tool's16bit Float button. You can always return a portion of the network to the project bit-depth by adding a second Change Depth tool and selecting a matching bit-depth button.

Applying Color Filters

The colors of imported footage are rarely usable in their imported state. When compositing, it's often necessary to adjust colors for one or more of the following reasons:

Aesthetic Adjusting the brightness, contrast, and color cast (dominant color) of footage can change the overall "mood." For example, if the color cast is changed to blue and the shadows are darkened, the footage may feel cold or foreboding. Along similar lines, you can alter brightness, contrast, and color cast to emulate a certain time of day, such as sunset or night.

Matching When combining footage from different sources, it's generally necessary to adjust colors so the footage blends together seamlessly. For example, you might alter the colors of a 3D render to better match it to live-action video.

Technical: Altering colors may help increase the success of other tools. For example, you might adjust the colors of a green screen image sequence so that the green screen removal becomes easier. Similar color adjustments might help to generate mattes or masks.

The process of adjusting colors for aesthetic reasons is called **color grading**. Regardless of the goal, Fusion offers a set of color filters in the Tools > Color menu. You can break the functionality of the tools into the following categories: brightness / darkness, contrast, saturation, and hue. The categories are explored in the following four sections. Fusion color filters often operate on three ranges of color values: shadows, midtones, and highlights.

Adjusting Brightness / Darkness

Brightness, which is also referred to as **intensity**, indicates how many pixels are close to the maximum allowable value within a particular bit-depth. With a 8-bit space, the maximum value a pixel can carry is 255. (8-bit is a 0-to-255 scale with a total of 256 possible values.) If an image has many pixels with high values, the image is considered bright. If few pixels have high values, the image is considered dark. You can use color filters to push values higher, towards the highlights, or lower, towards the shadows.

For example, if you connect a Brightness / Contrast tool and raise the Brightness slider, all the pixel values are pushed towards the highlights. Reduce the Brightness value and the opposite occurs. If a pixel carries a value of 0, it appears black.

The Color Corrector tool also carries a Brightness slider (Figure 2.12). In addition, the Color Corrector includes Gain and Lift parameters. Gain increases the brightness of an image while maintaining the darkness of the shadow areas (center of Figure 2.13). Lift increases the brightness of an image while maintaining the pre-existing brightness of the highlight areas (bottom of Figure 2.13). If Gain goes below 1.0, its effect is opposite. If Lift goes below 0, its effect is opposite. The Color Corrector also includes a Gamma slider that applies a gamma function. Gamma values above 1.0 brighten the image while values below 1.0 darken the image. Gamma adjustment is similar to contrast adjustment; however, gamma adjustment is not linear and creates a more subtle result with more graduated steps between pixel values.

Alternatively, the Color Gain tool offers a means to adjust gain, lift, and gamma per RGBA channel by including sliders for each channel. The Auto Gain tool, on the other hand, remaps the color range so that the lowest input value is pushed down to 0 and the highest input value is pushed up to the bit-depth maximum, such as 255 on an 8-bit scale. You can choose a new low and high value by altering the Auto Gain tool's Low and High parameters.

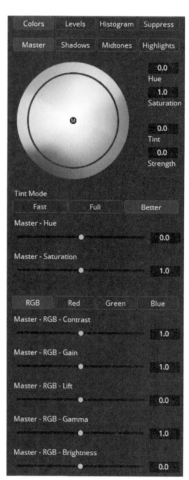

Figure 2.12 Parameters of the Color Corrector tool.

Resetting and Raising Parameter Sliders

When you alter a slider value, a small dot appears below the slider. The dot indicates the slider position of the default value. To reset the slider to the default value, LMB-click the dot.

With many parameters, you can exceed the default maximum of the slider by entering a value into the matching field.

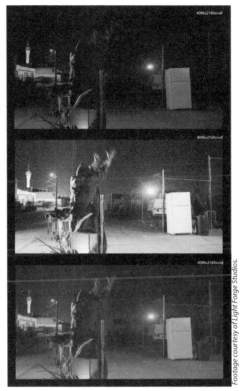

Figure 2.13 Top: A video shot at night is slightly underexposed and dark. Center: A Color Corrector tool is added and the Gain is set to 1.5, brightening the midtones and highlights while maintaining the darkest shadow areas. Bottom: Lift is set to 0.1, brightening the shadow areas while maintaining the highlights. This footage is included with the tutorial files as `\ProjectFiles\Plates\Night\night.##.tga`.

Footage courtesy of Light Forge Studios.

Adjusting Contrast

Contrast affects the disparity between pixel values. High-contrast leads to many pixels with highlight values, many pixels with shadow values, but few pixels with midtone values. Low-contrast leads to a more even distribution of pixel values with the majority in the midtone area. The Brightness / Contrast and Color Corrector tools carry Contrast sliders.

Using Histograms and Subviews

You can visualize the effect of a color filter by examining a histogram. A **histogram**, as used in digital image processing, is a graphical representation of the distribution of pixel values. The left side of a histogram is the shadow area. The center is the midtone area. The right is the highlight area. A 0-value is at the far-left and a maximum value, such as 255 on a 8-bit scale, is at the far-right. Histograms are often rendered with vertical bars. The bars represent the number of pixels that carry a particular value, such as 23 or 121. The higher a bar, the more pixels carry a particular value.

You can display a histogram in a Display view through a subview. A subview is a view that is inset within the Left or Right Display view. To activate the histogram subview, activate the Display view's SubV button and change the SubV menu, directly to the right of the button, to Histogram (Figure 2.14). You can resize the subview by LMB-dragging its bottom-right corner.

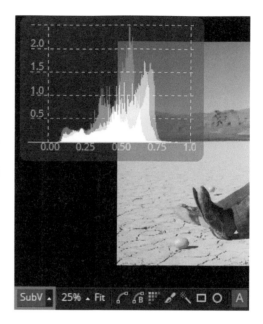

Figure 2.14 A histogram is displayed as a subview in the Right Display view. With this example, there are few pixels with values close to 0-black or 1.0-white while the majority of pixels carry midtone values. The SubV button and menu are outlined in red. This footage is included with the tutorial files as `\ProjectFiles\Plates\Man\ man.##.tga`.

The horizontal axis of the histogram is marked with pixel values, running from 0 to 1.0. In this situation, 1.0 represents the maximum value allowable by the current bit-depth. The vertical axis represents the number of pixels that carry a particular value. Separate bars are drawn for the red, green, and blue channels and are color-coded to match. The histogram updates as you make changes with color filter tools. For example, if you view the output of a Brightness / Contrast tool and adjust the Contrast slider, significant changes to the histogram occur (Figure 2.15). An awareness of value distribution will help you make sound decisions when color grading.

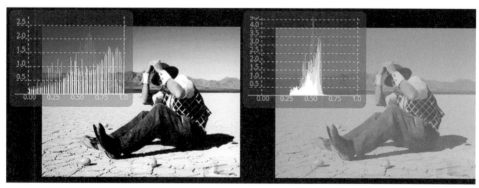

Figure 2.15 Left: Contrast is set to 1.0, stretching the midtone values towards the left and right of the histogram. Right: Contrast is set to −0.5, compressing the value range towards the histogram center.

In addition to Histogram, the SubV menu offers other means to gauge color and value distribution. These are discussed briefly here:

3D Histogram Color and value distribution is drawn within a 3D cube. This provides a more accurate way to examine floating-point HDR images. You can move about the cube using the 3D camera shortcuts (discussed in Chapter 9).

Vectorscope Traditional video test equipment is replicated with a circular chart indicating the chrominance values. **Chrominance** is a signal used by video systems to encode color (along with luma).

Waveform A secondary type of video test equipment is replicated. With this option, luminance distribution is drawn with waveform outline. **Luminance** is a more scientifically accurate term for brightness.

Adjusting Saturation

Saturation establishes the contrast between color channels. For example, if an image has a high-degree of saturation, the difference in values between the red, green, and blue channels is significant, with one or two channels having much higher values than the third channel. With a low-saturation image, the difference in values between channels is low. If the color values between channels are identical, the image becomes grayscale and no particular color is visible. The Color Corrector and Brightness / Contrast tools offer a Saturation slider. Raise the slider value, and prominent colors become more intense. Lower the slider and the colors become less intense.

Adjusting Hue

Hue is a more accurate term for color. A particular hue can be identified and is visually different from another hue. For example, red and orange are hues. You can alter the hue of an image with the Color Corrector tool. The tool provides an interactive color wheel that automatically drives Hue, Saturation, Tint, and Strength parameters (right side of Figure 2.16). You can interactively LMB-drag the color wheel's circular, central handle or enter values into the parameter fields.

If you LMB-drag the handle towards the edge of the color wheel, the Strength value is increased and the saturation increases for a specific hue (Figure 2.16). The hue is determined by the handle's placement within the 360-degree circle. The degrees are measured on a 0-to-1 scale, with red located at 0, green located at 0.33, and blue located at 0.66.

Figure 2.16 The color wheel handle is LMB-dragged so that Tint is roughly −0.4 and Strength is roughly 0.8. This increases the blue saturation for the entire image.

You can increase or decrease the resulting saturation by adjusting the Saturation field or Master - Saturation slider (these parameters are linked together). The Hue field and Master - Hue slider are also linked together. If you alter either, you "spin" the color wheel. For example, if you change the Hue field value to 0.75, blue shifts to green and yellow shifts to pink (Figure 2.17). A value of 0.75 offsets the rotation of the color wheel by 75 percent.

Figure 2.17 Yellow lemons become pink when a Color Corrector tool's Hue is set to 0.75.

By default, Color Corrector parameter adjustments affect the entire color range within the image. However, you can click the Shadows, Midtones, or Highlights buttons to make adjustments on smaller sections of the color range. At the same time, you can alter the saturation, contrast, gain, lift, and gamma of a single channel by clicking the Red, Green, or Blue buttons.

Chapter Tutorial: Color Grading a Sequence

In this tutorial, we'll import an image sequence and connect a series of color filter tools to improve the aesthetic and stylistic quality of the footage. We'll use the Color Corrector tool, as well as the more advanced Color Curves and Hue Curves tools. You can follow these steps:

1. Create a new Fusion project. Add a Loader tool. Import the `\ProjectFiles\Plates\Night\night.##.tga` footage. (See the Introduction for more information on the tutorial files provided for this book.) Connect the Loader tool to the Left Display view. Click the Left Display view's Fit button to view the entire frame.
2. In the TimeView, set the Global Start Time to 1 and Global End Frame field to 48. The image sequence is only 48 frames long and is numbered 1 to 48. Play back the time ruler. The footage features a homeless man gesturing towards an old refrigerator. The footage is slightly underexposed and appears quite dark.
3. RMB-click in the Flow view and choose Add Tool > Color > Color Corrector. Connect the output of the Loader to the input of the Color Corrector. Connect the Color Corrector to the Right Display view. The Color Corrector tool carries an extensive set of color filter parameters suitable for color grading.
4. Activate the Right Display view's SubV button. Change the SubV menu to Histogram. The histogram appears at the top-left of the Right Display view. Feel free to adjust the histogram size by LMB-dragging the bottom-right corner. Note that most of the histogram's bars are at the far-left side, indicating that relatively few pixels possess high values (Figure 2.18).

Figure 2.18 The initial histogram of the night footage.

5. With the Color Corrector tool selected, go to the Tools > Correction tab and click the tool's Midtones button. Slowly raise the MidTone - RGB - Gain slider. The midtone pixel values are slowly pushed towards the right side of the histogram. As the Gain surpasses a value of 2.5, more and more pixels are given a maximum value of 1.0; this is visible as a bar that increases in height along the far-right side of the histogram. Set the Gain value to 2.5. The midtone area becomes brighter, revealing more detail on the man and other objects in the scene. Note that raising the Gain value reveals video grain and noise. We will discuss noise suppression in Chapter 10.

6. Click the Shadows button. Adjust the Shadows - RGB - Contrast, Shadows - RGB - Gain, and Shadows - RGB - Lift sliders so that more detail is visible in the shadow areas. Avoid overexposing the image by keeping Lift at a low value. For example, set the Contrast to 1.1, Gain to 2.0, and Lift to 0.05 (Figure 2.19). Ultimately, you can use any combination of sliders that gives you a suitably aesthetic result.

Figure 2.19 Top: Unadjusted footage. Bottom: Midtone - RGB - Gain is set to 2.5, Shadows - RGB - Contrast is set to 1.1, Shadows - RGB - Gain is set to 2.0, and Shadows - RGB - Lift is set to 0.05.

7. With the Color Corrector tool selected, choose Tools > Color > Color Curves. A Color Curves tool is automatically connected to the output of the Color Corrector tool (see Figure 2.25 later in this tutorial). Connect the Color Curves tool to the Right Display view. The Color Curves tool provides a set of interactive curves that you can use to adjust brightness, contrast, and overall pixel value distribution. By default, a master curve runs from the bottom-left of the graph to the top-right of the graph in a straight line (Figure 2.20).

This indicates that the tool has no affect on the input. The bottom-left of the graph represents 0-pixel values. The top-right represents maximum bit-depth values, such as 255 on an 8-bit scale. Thus, the left-third of the graph is the shadow area, the center-third is the midtone area, and the right-third is the highlight area. When you adjust the curve, the input values are remapped and new output values are achieved. For example, LMB-drag the center of the curve up—the midtones are brightened. LMB-dragging the curve inserts a control point on the curve. You can LMB-drag the control point's tangent handles to create a smoother curve. You can create more complex results by LMB-dragging the curve in several places, thus creating several control points. For example, pull the bottom-left of the curve slightly up while pushing the curve center slightly down (Figure 2.21). This brightens the shadow area while darkening the midtones (Figure 2.22). Adjust the tangent handles to make the transitions around the control points smoother. (To independently move the left or right side of a tangent handle, press Ctrl/Cmd while LMB-dragging.)

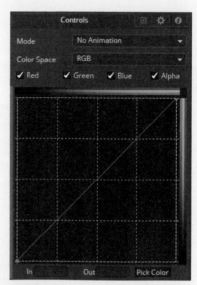

Figure 2.20 The Color Curves tool in its default state.

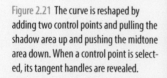

Figure 2.21 The curve is reshaped by adding two control points and pulling the shadow area up and pushing the midtone area down. When a control point is selected, its tangent handles are revealed.

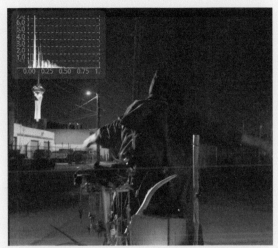

Figure 2.22 Result of the custom Color Curves curve. Additional detail is visible in the shadow areas.

8. When a control point is deselected, its tangent handles disappears. You can reselect a control point at any time and adjust its position. Any time you LMB-click on a new portion of the curve, a new control point is added. By default, the curve affects RGBA channels equally. However, you can selectively adjust individual channels. For example, deselect the Red, Blue, and Alpha checkboxes above the curve. The curve turns green, indicating the remaining active channel. Select the center control point and pull it upwards (Figure 2.23). The intensity of the green channel midtone values increases and gives the midtone areas a greenish cast. This creates a stylistic result and makes the scene appear as if it was lit with a green light in the foreground. In such a way you can address the color balance of a shot within a limited area of the frame. Note that color corrections should be tested on multiple frames. For example, the result of the green channel adjustment is seen on frame 39 in Figure 2.24.

Figure 2.23 The green channel curve is adjusted to raise the midtone values. Thus, the green curve gains a unique shape while the red, blue, and alpha curves remain identical.

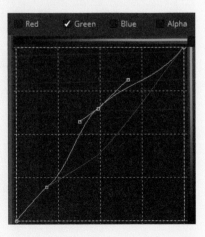

Figure 2.24 Result of the green channel curve adjustment. The midtone areas are given a green cast.

9. With no tools selected in the Flow view, choose Tools > Color > Hue Curves. Connect the output of the Color Corrector tool to the Input of the new Hue Curves tool. You can connect the output of a tool to an unlimited number of inputs. Thus, the tool network branches into multiple directions (Figure 2.25). Branching is often useful for testing different tools or different combinations of tool settings. Connect the Hue Curves tool to the Left Display view. Leave the Color Curves tool connected to the Right Display View.

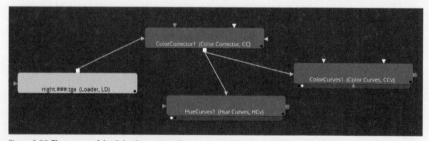

Figure 2.25 The output of the Color Corrector tool is sent in two directions. This is a natural advantage of working with tool or node networks.

10. The Hue Curves tool allows you to interactively adjust hue, saturation, and luminance of the input. The tool's graph includes a color gradient along its top. This runs from red to green to blue in a left-to-right direction. The graph includes a horizontal curve with a number of control points that correspond to colors on the gradient (Figure 2.26). When you adjust the position of these control points, you alter a specific color's hue, saturation, or luminance. For example, you can shift the reddish area of the image to green and alter the relative saturation of red, greens, and blues.

To do so, select the Hue checkbox and deselect all the other checkboxes. LMB-drag the left-most control point, under the red portion of the gradient, upwards. The red is reduced and the image is shifted towards greenish-yellow. If you pull the point downwards, the red is increased and the image shifts towards magenta. Alternatively, you can alter the balance of a specific color by using the Red, Green, or Blue curves. For example, return the Hue curve to its flat, default state, deselect the Hue checkbox and select the Green checkbox. A green curve appears. This affects the amount of green inserted into areas of the image that might carry another dominate color, such as red, yellow, cyan, and so on. To insert green into the red area of the image, pull the left-most point, under the red part of the gradient, upwards (Figure 2.27). The addition of green will create a color cast similar to Figure 2.24 earlier in this tutorial, although the saturation is less intense. (Note that extreme adjustments to the image's color balance may increase the visibility of grain.)

Figure 2.26 The Hue Curves tool is set to alter the hue of the image with the selected Hue checkbox. The color gradient runs along the top of the graph. The hue curve includes a number of control points that correspond to colors on the gradient. The curve has no affect on the image while the curve is flat.

Figure 2.27 The Green curve of the Hue Curves tool is revealed. Pulling the left control point upwards inserts additional green into the red portions of the image. The left control point is linked to the right control point.

11. If you'd like to insert green into other areas of the image, adjust other control points. For example, pull the second control point, under the yellow portion of the gradient, upwards to insert more green in the yellow areas of the image. Conversely, you can reduce the amount of green by pulling control points downwards. (Reducing green will increase the relative amount of red and blue.) Alternatively, you can use the Red Suppress, Green Suppress, or Blue Suppress checkboxes and accompanying curves. The Suppress curves will reduce the amount of red, green, or blue from an area if you pull the control points downwards. After you have adjusted the green balance of the image so that it appears as if the foreground was lit with a green light, you can adjust the saturation of the image. To do so, select the Sat check box. (You can leave the Green checkbox selected and thus see both curves.) To increase the intensity of the reddish-orange light that appears on the background building, right-hand floodlight, and foreground box near the man, pull the control point under the yellow portion of the gradient upwards (Figures 2.28 and 2.29).

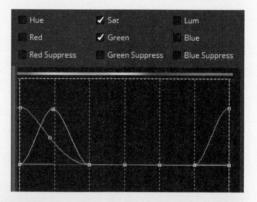

Figure 2.28 The green channel curve and the saturation curve (drawn in yellow) are altered.

Figure 2.29 Final color grading, as applied by the Color Corrector and Hue Curves tools. The brightness, contrast, color cast, and saturation for the shadow, midtone, and highlight areas have been altered. Compare this to Figure 2.19.

You can edit any combination of curves carried by the Hue Curves tool. You are not limited to existing control points. In fact, you can sample a specific color within the frame by LMB-dragging from the Pick Color button (below the area where the curves are displayed) to the Left or Right Display view; when you release the mouse button, the color under the eyedropper mouse icon is sampled and a new control point is inserted under the matching part of the color gradient.

The tutorial is complete! A finished version of this tutorial is saved as `\ProjectFiles\FusionFiles\Chapter2\ColorGrading.comp`. We will return to this tutorial in Chapter 6 to add rotoscoping. Note that you have the option to render any portion of a tool network. Thus, you can render the output of the Hue Curves tool and / or the Color Curves tool. Rendering is discussed in Chapter 11.

OpenEXR Files

- [⌄] Channels
 - ☑ Red
 - ☑ Green
 - ☑ Blue
 - ☑ Alpha
 - ☑ Z
 - ☑ Covera
 - ☑ Object
 - ☑ Materi:
 - ☑ U
 - ☑ V
 - ☑ X Norm

DIFFNS:diffuseNoShadow.
DIFFNS:diffuseNoShadow.
INC:incandescence.persp.
INC:incandescence.persp.
INC:incandescence.persp.
MATTE:matte.persp.B
MATTE:matte.persp.G
MATTE:matte.persp.R
MV2N:mv2DNormRemap.
MV2N:mv2DNormRemap.
MV2N:mv2DNormRemap.
NORMAL:normalCam.pers
NORMAL:normalCam.pers
NORMAL:normalCam.pers
OPACTY:opacity.persp.B

Combining Inputs and Recombining Render Passes

A critical part of compositing is the ability to combine different source materials into a single render-able output. Fort example, you might combine a 3D render, a QuickTime video of stock footage, and a video image sequence into a single composite. In Fusion, the Merge tool provides the main means of achieving this task. In order to recombine multiple 3D render passes, you can use a series of Merge tools. You can use Merge tools to add depth-of-field blurriness, atmospheric fog, and motion blur as part of the composite.

This chapter includes the following critical information:

- Combining two inputs with a Merge or Dissolve tool
- Chaining together multiple Merge tools
- Recombining render passes in Fusion
- Adjusting Apply Modes and Merge transforms
- Adding depth-of-field, fog, and motion blur with render passes

Layer- vs. Node-based Compositing

Adobe After Effects and Adobe Photoshop, two widely used digital compositing programs, employ layer-based systems. With a layer-based system, the top-most layer occludes lower layers except where alpha transparency exists. You can adjust the occlusion by using different blending modes, which are mathematical formulas used to determine the color values of overlapping pixels on higher and lower layers. In contrast, node-base compositing programs, such a Fusion, do not use a vertical layer stack. Instead, a "foreground" input is combined with a "background" input through a Merge or Dissolve tool. The background or foreground inputs can be a single tool, such as a Loader, or a complex portion of a network with a long string of tools. You can connect a series of Merge tools together to create more complex results. Merge tools use their own form of blending modes through an Apply Mode menu.

Merging Inputs

To combine two inputs in Fusion, you can use the Merge tool. You can follow these steps:

1. Choose Tools > Composite > Merge or RMB-click in the Flow view and choose Add Tool > Composite > Merge.
2. Connect the first output to the Background input of the new Merge tool. For example, connect a Loader tool with video footage to the Background input. The Background input appears "below" the Foreground input. Thus, the Background input is equivalent to the lowest layer of a layer-based system. The Background input arrow is colored orange and is the default input for the Merge tool.
3. Connect a second output to the green Foreground input. As a test, you can place text over the background. To do so, choose Tools > Creator > Text+. Type a test message in the Text+ tool's Styled Text field and increase the text size with the Size slider. Connect the output of the Text+ tool to the Foreground of the Merge tool (Figure 3.1). Connect the Merge tool to a Display view. The Foreground input occludes the Background input except where there is alpha transparency (Figure 3.2). Empty space around the letters generated by the Text+ tool receives 100% transparent alpha values.

Figure 3.1 A Merge tool combines two inputs: video footage imported by a Loader and text generated by a Text+ tool.

Figure 3.2 The output of the Merge tool. The empty area around the text is assigned 100% transparent alpha, thereby letting the video footage to show through. The footage is included with the tutorial files as `\ProjectFiles\Plates\Man\man.###.tga`.

The Dissolve tool varies from the Merge tool in that it combines the Background and Foreground inputs through a simple manipulation of transparency. For example, if the Dissolve tool's Operation menu is set to Dissolve, you can use the Background / Foreground slider to alter the relative transparency of each input. Other options provided by the Operation menu follow this basic approach. For example, the SMPTE Wipe option lets you switch between the Background and Foreground with a **wipe** (vertical division line).

Transforming with the Merge Tool

The Merge tool includes integrated transform parameters that affect the Foreground input. When the Merge tool is selected, an interactive transform handle is drawn in the connected Display view (Figure 3.3).

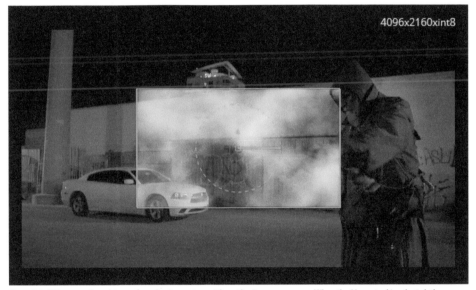

Figure 3.3 A Merge tool combines a fractal noise pattern with a video image sequence. When the Merge tool is selected, the green interactive transform handle for the Foreground input (the fractal) is revealed. With this example, the resolution of the fractal is significantly smaller than the image sequence. This project is included with the tutorial files as `\ProjectFiles\FusionFiles\Chapter3\TransformHandle.comp`.

To move the Foreground input left / right or up / down, LMB-drag the axis handle arrows or the axis handle center. To rotate the Foreground, LMB-drag the circular rotation handle. To scale the Foreground, LMB-drag the green bounding box corners or edges. (The bounding box represents the outer edges of the Foreground input.) Any interactive changes automatically update the values of the Merge tool's Center XY, Size, and Angle parameters (Figure 3.4). You can alter the parameter values directly within the Tools > Merge tab. These parameters are identical to those carried by the Transform tool, which is detailed in Chapter 4.

If the Foreground input is smaller than the Background, the empty area outside its bounding box is left transparent. For example, with Figure 3.3 earlier in this section, the Foreground input is 1920×1080 while the Background input is 4096×2160. In this situation, the Foreground input was generated with the FastNoise tool (Tools > Generate > FastNoise). This tool generates a procedural fractal noise pattern and converts the darkest parts of the noise to transparent or semi-transparent alpha. When the Foreground and Background resolutions don't match, you have the option to wrap (repeat), duplicate (vertically and horizontally stretch edge pixels), or mirror (repeat with a horizontal flip) the Foreground by using the Edges buttons with the same names (Figure 3.4). To return to the default state, click the Canvas button.

Figure 3.4 Merge tool parameters with default values.

Altering Apply Modes

By default, the Foreground input of a Merge tool occludes the Background input except where alpha transparency exists for the Foreground. This occurs when the Merge tool's Apply Mode menu is set to Normal. You can write the mathematical formula for the Normal mode in the following way:

```
A+(B×(1-a))=C
```

With this formula, A is the Foreground pixel value, B is the Background pixel value, a is the alpha value for the Foreground pixel, and C is the resulting output pixel value. Fusion compares overlapping pixel values one pair at a time and does this for each of the color channels. If you change the Apply Mode menu, you can choose a different mathematical formula with which to combine the Foreground and Background.

A few commonly used Apply Mode modes are described here:

Multiply ($A \times B = C$) The Foreground pixel value is multiplied by the Background pixel values.

Screen ($1 - (1 - A) \times (1 - B) = C$) A and B are multiplied in such a way that the brightest value are kept; however, no value is permitted to exceed 1.0. Any values above 1.0 are considered to be superwhite and cannot be displayed by a monitor without special adjustment.

Darken ($\min(A, B) = C$) A and B pixels are compared and the lowest value is kept.

Lighten ($\max(A, B) = C$) A and B pixels are compared and the highest value is kept.

Additional Apply Mode options create stylized results. Although these modes are not used as often with digital compositing, they employ interesting mathematical formulas. A few are described here:

Soft Light Applies the Screen mode on brighter pixels and the Multiply mode on darker pixels.

Hue Combines the hue values of the Foreground with the luminance and saturation values of the Background.

Color Burn ($1 - (1 - B) \div A$) The result of this mode is similar to the Hue mode but the resulting Foreground colors are generally darker and with greater contrast.

The formulas for these modes use the RGB channels. The alpha channels are combined with the formula $a + (b \times (1 - a)) = c$, where b is the Background alpha value and c is the resulting alpha value.

The easiest way to see the result of a mode is to change the Apply Mode menu to that mode. Nevertheless, practical examples of Apply Mode use are included in the section "Recombining Render Passes" later in this chapter.

Choosing Alpha Operators

When the Apply Mode menu of the Merge tool is set to Normal, the Operator menu is available. This menu determines how alpha values of the Foreground and Background inputs are combined.

When Operator is set to Over, Foreground A occludes Background B except where A carries transparent alpha. This is the same method used by the Merge tool when other, non-Normal Apply Mode modes are chosen. However, if you change the Operator menu while Apply Mode is set to Normal, you can generate different results. For example, when Operator is set to Atop, A is cut out by the alpha of B. If Operator is set to Xor, overlapping areas of A and B are made transparent. Note that the Operator menu is only useful when the Background input carries variations in alpha value (and is not 100% opaque).

Premultiplying and Adjusting Alpha

Premultiplication is the process by which RGB color values are multiplied by alpha values to increase mathematical efficiency within a compositing program. Many 3D programs, such as Autodesk Maya, automatically premultiply RGB and alpha values as they render. (Video footage, which may be in the form of a self-contained movie or an image sequence, rarely carries an alpha channel.)

Fusion's Loader tool can read premultiplied or unpremultiplied footage. If the footage is unpremultiplied, you have the option to add premultiplication by selecting the Post-Multiply By Alpha checkbox at the bottom of the Loader tool's Tools > Import tab. In general, premultiplication produces superior results when merging semi-transparent renders (Figure 3.5).

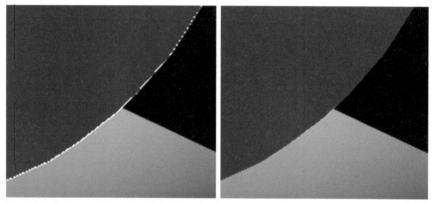

Figure 3.5 Left: Close-up of an unpremultiplied 3D render of a transparent, refractive sphere over a checkered opaque ground plane. When the sphere is merged over a blue background in Fusion, a white fringe appears along the sphere edge. Right: When the Merge tool's Post-Multiply By Alpha checkbox is selected, the render is premultiplied and the fringing disappears. A sample Fusion project is saved as `\ProjectFiles\FusionFiles\Chapter3\PremultiplyDemo.comp`.

You can remove premultiplication, and thereby make a portion of the tool network unpremultiplied, by employing the Alpha Divide tool. This is sometimes useful for green screen and similar masking operations. Alpha Divide is discussed in Chapter 7.

By default, the Merge tool assumes that the Foreground input is premultiplied. As such, the tool's Subtractive / Additive slider is set to 1.0. However, if the Foreground input is unpremultiplied, you can set the Subtractive / Additive slider to 0; when the slider is set to 0, the Merge tool applies premultiplication to the Foreground before combining it with the Background. Setting the slider to a middle value, such as 0.5, mixes the incoming Foreground with a premultiplied version of the Foreground. This may be useful for refining the alpha edge quality of the Foreground.

The Merge tool provides additional options to affect the Foreground input alpha channel. The Alpha Gain slider serves as a multiplier. When Alpha Gain is set to 1.0, the Foreground alpha is unchanged. If you reduce the parameter value, the alpha values are reduced and the Foreground becomes semi-transparent. This causes Foreground RGB values to become brighter, however, unless you reduce the Subtractive / Additive slider value at the same time.

You can express the influence of the Alpha Gain parameter with the following formula (G is the Alpha Gain value): $A + (B \times (1 - (a \ast G)) = C$. The Burn In parameter also affects the Foreground alpha. However, it uses a different approach (I is the Burn In value): $A + (B \times (1 - a) \times (1 - I)) = C$. Note that the Subtractive / Additive, Alpha Gain, and Burn In parameters are only available when Apply Mode is set to Normal.

In contrast, the Blend parameter affects the Foreground alpha values regardless of the Apply Mode setting. Reducing the Blend value reduces the opacity of the Foreground without altering the Foreground colors. Hence, the Blend parameter offers a superior means to "fade out" the Foreground.

Chaining Together Multiple Merge Tools

A Merge tool can only accept a single Foreground input. If you need to combine more than two inputs, you must use more than one Merge tool. As such, you can follow these basic rules:

- Connect the output of the 1st Merge to the Background of a 2nd Merge tool
- Connect the output of the 2nd Merge to the Background of a 3rd Merge tool and so on

For example, in Figure 3.6, three Merge tools are connected together. Remember that the orange input triangles represent the Background input. The green input triangles represent the Foreground input. Any given Foreground input is a new element that is placed over the net result flowing into the matching Background.

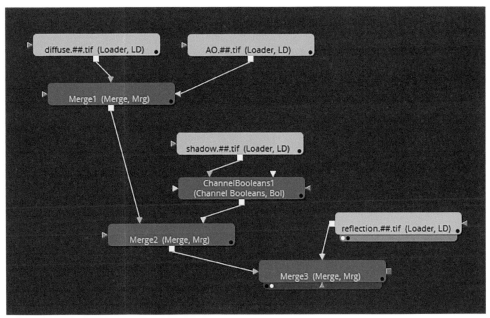

Figure 3.6 Three Merge tools are used to combine the inputs of four Loader tools. Merge3 is the furthest tool downstream and is the tool that serves as the final output. This network is discussed in more detail in the section "Mini-Tutorial 3: Recombining Basic Render Passes" later in this chapter.

Recombining Render Passes

A common compositing task is the recombination of 3D render passes. **Render passes** split a 3D render into multiple scene elements or shading components. Scene elements may range from characters, to sets, to props, to special effect elements such as fire or water, and so on. Shading components, on the other hand, split a render into base surface qualities, such as color, specularity, reflectivity, and shadows. Render passes may be created as separate image sequences or may be contained within a single image sequence as custom auxiliary channels or as Adobe Photoshop layers. Hence, the first compositing challenge is to import or access the various render passes. The second challenge is to recombine the passes so that they are equivalent to a beauty render (a default render where all the shading components are present).

Overview of Common Render Passes

Before working with render passes, it pays to be familiar with common render pass categories. These are discussed in this section. Example image sequences are included in the `\ProjectFiles\Plates\Passes\` tutorial directory.

Beauty This pass is the default render within 3D programs and includes all the shading components (left of Figure 3.7). When render passes are not used, the render is the beauty pass.

Diffuse Color without specularity. This pass may not include self-shadowing (right of Figure 3.7).

Figure 3.7 Left: A 3D render of a bowling ball and pin created as a beauty pass. Right: A diffuse render pass of the same scene; note the lack of shadows, self-shadowing, reflections, and specular highlights.

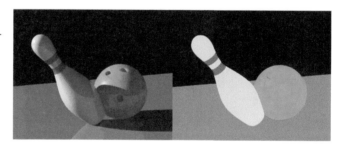

Specular Isolated specular highlights, which are intense, concentrated reflections. Specular highlights appear as "hot spots" on shiny surfaces such as glass. A related render pass, glossiness, may be used to capture the specular component.

Shadow Cast shadows rendered by themselves (Figure 3.8). The shadows may appear in the RGB channels or in the alpha channel. When included in the RGB channels, the shadow may appear inverted.

Figure 3.8 Detail of a shadow render pass. With this style of shadow pass, the non-shadow areas are rendered black in RGB while the cast shadows are rendered in grayscale.

Reflectivity If a surface is reflective, the reflection can be rendered by itself (left of Figure 3.9).

Matte A matte pass renders opaque surfaces with a solid color. This can be used in a compositing program as new information for an alpha channel. This render pass is also referred to as a **holdout** (right of Figure 3.9).

Figure 3.9 Left: A reflection render pass showing reflections on the bowling ball, bowling pin, and ground plane; when reflections are weak, this pass appears dark. Right: A matte render pass.

Incandescence Surface shaders within 3D programs have the option to create incandescence, which creates the illusion that part of the surface is emitting light. This can be rendered by itself and may appear as glow.

Ambient Occlusion Often referred to as **AO**, this pass captures soft shadows in convolutions of surfaces or areas where surfaces are close together (Figure 3.10). Using an AO pass can help improve the realism of a 3D scene as such shadow information is not generally included as part of a beauty pass render unless an advanced rendering system, such as global illumination, is used. A related render pass, albedo, captures surface brightness without material color and includes cast shadows.

Figure 3.10 Detail of an ambient occlusion render pass.

Z-Depth Depth information (the distance objects are from the camera) is encoded in grayscale. You can use this information to insert depth-of-field (narrow focus) or atmospheric effects (smoke or fog) into the scene as part of the compositing process. See "Working with Z-Depth" later in the chapter.

Motion Blur The motion of 3D objects is encoded into the color channels. You can use this information to add motion blur to otherwise unblurred renders as part of the compositing process. See "Applying Motion Blur in the Composite" later in the chapter.

Render Pass Flexibility

On professional 3D productions, such as feature film work or visual effects projects, the use of render passes is common. Render passes offer the following advantages over the use of standard renders that produce a single beauty pass:

- Renders may become more efficient if scene elements are separated into different renders. For example, rendering a character separate from the background may make each frame easier to render. At the same time, splitting the scene up into multiple renders means that re-rendering an individual element becomes more efficient than re-rendering the entire scene. If 3D lights are rendered as separate passes, it's possible to "re-light" within the composite by balancing the light pass intensities.
- Rendering shading component passes gives the compositor a tremendous amount of flexibility when recombining the passes. Each pass imported into the composite can be color graded, filtered, and otherwise adjusted separate from all the other passes. For example, you can blur, tint, and reduce the opacity of the specular pass without affecting any other pass. This helps prevent the need to re-render 3D scenes in order to make adjustments to the renders.

Mini-Tutorial 3: Recombining Basic Render Passes

If a 3D render is delivered to the compositor as render passes, the render passes must be recombined. With this tutorial, we'll import several common render passes and recombine them with multiple Merge tools and custom Apply Mode settings. Follow these steps:

1. Create a new project. Create a Loader tool (Tools > I/O > Loader). Through the tool, import `\ProjectFiles\Plates\Passes\diffuse\diffuse.##.png`. Connect the Loader to a Display view. Play back the time ruler. The image sequence features a 3D render of a bowling ball knocking over a bowling pin. The particular type of diffuse render pass excludes specularity, reflectivity, cast shadows, and self-shadowing. The sequence is 20 frames long and is numbered 0 to 19. Set the TimeView's Global Start Time and Global End Time to match this numbering and duration.
2. With the Loader tool selected, press Ctrl/Cmd+C. Deselect the Loader tool and press Ctrl/Cmd+V. A copy of the Loader is pasted into the Flow view. You can copy any tool with this technique. Note that the new copy has the same settings as the original tool. Hence, the new Loader is importing the diffuse render pass. Select the new Loader and go to the Tools > File tab. (A copied tool is automatically named *tool_n*.) Click the Browse button and choose the following image sequence: `\ProjectFiles\Plates\Passes\AO\AO.##.png`.
3. Create a Merge tool (Tools > Composite > Merge). Connect the output of Loader1 to the Background of the Merge tool. Connect the output of Loader1_1 to the Foreground of the Merge tool. Use Figure 3.12, later in this section, as reference. Connect the Merge tool to a Display view. The AO render, connected to the Foreground, completely occludes the diffuse render. The AO pass is pure white except where there are soft shadows below and between the bowling ball and pin.

4. Select the Merge tool and go to the Tools > Merge tab. Change the Apply Mode menu to Multiply. The AO shadows appear over the diffuse render and the white background disappears (Figure 3.11). The pixel values in the diffuse render are multiplied by the pixel values of the AO render. Hence, dark pixels within the AO render darken the diffuse render. White pixels within the AO render that have a maximum value (considered 1.0) have no affect on pixel values within the diffuse render. For example, 0.5×1.0=0.5. You can adjust the darkness of the new shadows by adjusting the Blend slider. Reducing the Blend value reduces the shadow opacity and makes them appear lighter.

Figure 3.11 An AO (Ambient Occlusion) render pass is combined with a diffuse render pass by setting a Merge tool's Apply Mode menu to Multiply. Compare this to the isolated diffuse pass on the right side of Figure 3.7.

5. AO render passes do not include cast shadows. However, we can import a separate shadow pass. To do so, select the Loader1 tool, copy it, and paste it in the Flow view. Load `\ProjectFiles\Plates\Passes\shadow\shadow.##.png` through the new Loader1_2 tool. Create a new Merge tool. Connect the output of the first Merge tool, Merge1, to the Background of the new Merge tool, Merge2. Connect the output of the newest Loader, Loader1_2, to the Foreground of Merge2. Use Figure 3.12 as reference. Connect Merge2 to a Display view. Set the Apply Mode menu of Merge2 to Multiply. The diffuse and AO render passes are affected by the cast shadow render; however, the shadow render is inverted and the bowling ball is visible only in the shadow area. (This is one style of shadow render pass created by the mental ray renderer.)

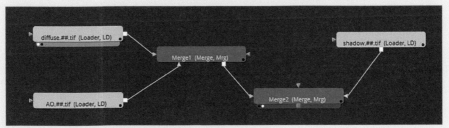

Figure 3.12 Two Merge tools recombine diffuse, AO, and shadow render passes.

6. Select the Loader1_2 tool and choose Tools > Color > Channel Booleans. A Channel Booleans tool is automatically inserted between the Load1_2 and Merge2 tools (the output is connected to the Background input). You can use a Channel Booleans tool to transfer information between existing channels, apply simple mathematical operations to a particular channel, or invert a particular channel. Select the new tool, go to the Tools > Color Channels tab, and set the Operation menu to Negative. This inverts the pixel values of the incoming RGBA channels (1.0 – *incoming pixel value*). This causes the cast shadow to disappear completely as the alpha channel is also inverted. To fix this, set the Channel Booleans tool's To Alpha menu to Do Nothing. The cast shadow appears over the diffuse and AO render passes (Figure 3.13). You can adjust the opacity of the cast shadow by altering the Merge2 tool's Blend slider. (For another example of the Channel Booleans tool, see the next section.)

Figure 3.13 Cast shadows are added with a second Merge tool and a Channel Booleans tool.

7. At this point, there is no specularity or reflectivity. Make a copy of Loader1 and import `\ProjectFiles\Plates\Passes\reflection\reflection.##.png`. Create a third Merge tool. Connect the output of Merge2 to the Background of Merge3. Connect the newest Loader, Loader1_3, to the Foreground of Merge3. See Figure 3.6, earlier in this chapter, as reference for the final tool network. Connect Merge3 to a Display view. Set the Merge3 tool's Apply Mode menu to Screen. The Screen mode places the brightest parts of the Foreground over the Background. A faint reflection appears over the bowling pin, bowling ball, and ground plane (Figure 3.14). The Screen mode is suitable for adding specular highlights, reflections, halos, and other bright renders over the top of darker renders. If you want to brighten the reflection, insert a color tool, such as Brightness / Contrast, between Loader1_3 and Merge3.

The tutorial is complete! A finished version of this tutorial is saved as `\ProjectFiles\ FusionFiles\Chapter3\RecombinePasses.comp`. Note that some render passes may carry a solid alpha channel (where all the pixel values are 1.0 or 100% opaque). With this tutorial, the diffuse and reflection render passes have solid alpha channels. Nevertheless, the use of non-default Apply Mode options sidesteps the need to worry about alpha values.

Figure 3.14 Reflections are added with a third Merge tool with its Apply Mode set to Screen.

Working with Z-Depth

A Z-depth render pass, also known as **depth** or **Z-buffer pass**, allows you to create an effect along the Z axis. The Z axis extends away from the rendering camera into the distance. For example, you can use a Z-depth pass to add artificial depth-of-field or atmospheric fog in the composite. Depth-of-field, seen as a narrow field of focus, is a natural artifact of a real-world camera. While a depth-of-field simulation can be expensive to render within a 3D program, it is fairly efficient to apply it in a compositing program like Fusion.

There are several methods for importing a Z-depth channel into Fusion:

- Import a file format that supports auxiliary channels. For example, import an OpenEXR sequence that carries RGBA and Z-depth channels. To access the Z-depth channel, you must use the auxiliary channels section of the Tools > Format tab carried by the Loader tool. This section is described in Chapter 2.
- Import a Z-depth information through the RGB channels of a standard file format (Figure 3.15). For example, you can render a TIFF image that carries the depth information in RGB through a mental ray render pass in Autodesk Maya. You can then combine this render with a separate beauty render pass of the scene.

Figure 3.15 A Z-depth render pass of a line of spheres that captures the depth information within RGB.

Adding Depth-of-Field

Fusion provides the Depth Blur tool (Tools > Deep Pixel > Depth Blur) to create depth-of-field using a Z-depth channel. A simple way to use the tool is to connect a beauty render pass to its Background input and a Z-depth RGB render to its Foreground input. To activate the blur, click the Red button for the Blur Channel parameter. (Because Z-depth renders are grayscale, you can use red, green, or blue channel as each channel is identical.) To increase the degree of blur, raise the Blur Size slider.

One difficult aspect of using the Depth Blur tool is interpreting the Z-depth values correctly. The Depth Blur tool expects the depth values to increase in value for objects farther from the camera. For example, a close object might have a value of 0.1 while a distant object might have a value of 0.9. Although some 3D programs or 3D renderers may produce depth renders with similar values, others do not. For example, with Figure 3.15, the close sphere carries values around 0.9 while the back sphere carries a value around 0.6. Hence, it may be necessary to massage the depth values before passing them to the Depth Blur tool. For example, in Figure 3.16 the values of a RGB Z-depth render are inverted with a Channel Booleans tool before the values are passed to the Foreground of the Depth Blur tool. In this case, the Channel Booleans tool's Operation is set to Negative and To Alpha is set to Do Nothing (Figure 3.17). (Inverting the solid alpha channel will make the alpha 100% transparent.) The Channel Booleans tool is located in the Tools > Color menu.

49

Figure 3.16 A Channel Booleans tool inverts the values of an RGB Z-depth render before it passes the values to the Foreground input of a Depth Blur tool. A beauty render pass is connected to the Depth Blur tool's Background input.

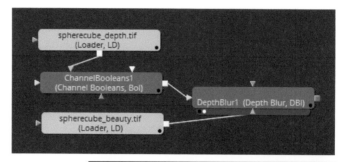

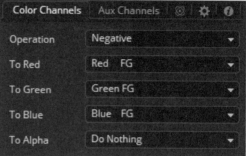

Figure 3.17 The input to the Channel Booleans tool is inverted by setting Operation to Negative. The alpha channel remains untouched as To Alpha is set to Do nothing.

The Depth Blur tool offers three types of blur: Box, Soften, and Super Soften. Box is a crude filter but is suitable for testing. Soften produces high-quality results and is similar to a Gaussian blur (Figure 3.18). Super Soften is more aggressive but may create artifacts with a large Blur Size.

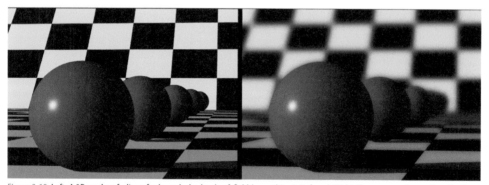

Figure 3.18 Left: A 3D render of a line of spheres lacks depth-of-field (everything is in focus). Right: The same render receives depth-of-field blur with a Depth Blur tool set to Soften. This project is included with the tutorial files as `\ProjectFiles\FusionFiles\Chapter3\DepthBlur.comp`.

As an alternate approach, you can connect a render that carries RGBA and a Z-depth channel directly to the Depth Blur tool's Background input and click the Z button under Blur Channel. This requires the use of an auxiliary channel format, like OpenEXR, or the combination of channels through a Channel Booleans tool. For example, in Figure 3.19, a depth render is connected to the Foreground of a Channel Booleans tool and a beauty render pass is connected to the Background of the same tool. To add the Z-depth channel, the Channel Booleans tool's Enable Extra channels checkbox is selected and the To Z Buffer menu is set to Red BG; you can find these options in the Aux Channels tab.

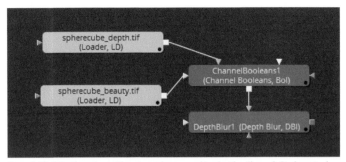

Figure 3.19 A depth render and beauty render are combined with a Channels Booleans tool. This project is included with the tutorial files as \ProjectFiles\FusionFiles\ Chapter3\DepthBlurBoolean.comp.

When using a Z channel to determine the depth-of-field, additional Depth Blur parameters become available (Figure 3.20). The Focal Point parameter allows you to select a Z-depth value that becomes the center of the focal plane. Changing this value allows you to slide the area of focus closer or further away from the camera (Figure 3.21). You can interactively select a Z value by LMB-dragging the mouse from the Pick button to a Display view and releasing the mouse button. As you drag the mouse, the depth-of-field updates in the Display view.

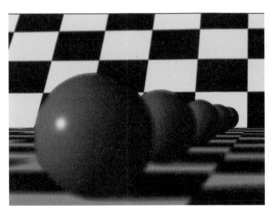

Figure 3.20 Focus is shifted to the background by setting the Depth Blur tool's Focal Point to −400.

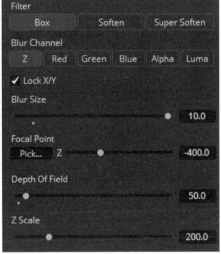

Figure 3.21 Depth Blur tool parameters when Blur Channel is set to Z.

The Depth Of Field parameter controls the size of area in focus with large values creating a larger area of focus and smaller values creating a more narrow area of focus. The Z Scale slider serves as a multiplier for Z values. Adjusting this value may be useful when using a Z-depth render that has small variations in value from foreground to background.

Note that using the Depth Blur tool with an input that carries RGBA and depth channels may remove the necessity to alter the Z-depth values in advance. In fact, combining a beauty pass with a Z-depth pass with the Channel Booleans tool automatically remaps the Z values. For example, a Z range of 0.9 to 0.5 becomes a new Z range of −70 to −540. As such, objects that are farther from the camera receive larger *negative* values.

Adding Fog in Depth

The Fog tool (Tools > Deep Pixel > Fog) works in a similar fashion to Depth Blur. However, it adds atmospheric fog based on Z values (Figure 3.22). The tool requires that the input connected to its Input channel carry RGBA and depth channels. You can control where the fog starts with the Z Near Plane parameter and where the fog ends with the Z Far Plane parameter. The fog appears denser with distance. You can also adjust the fog color and overall opacity with the parameters of the same name. The tool carries a Z Scale parameter, which works in the same fashion as the one carried by the Depth Blur.

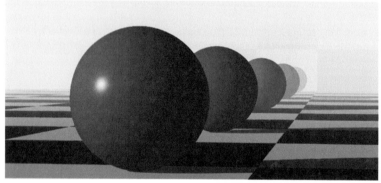

Figure 3.22 White atmospheric fog is added with the Fog tool. This project is included with the tutorial files as \ProjectFiles\FusionFiles\Chapter3\DepthFog.comp.

Applying Motion Blur in the Composite

You can use a motion vector render pass to add motion blur in the composite. Fusion supplies the Vector Motion Blur tool (Tools > Blur > Vector Motion Blur) for this purpose. To set up a network, connect a beauty render pass to the Vector Motion Blur tool's Input input. Connect a motion vector render pass to the tool's Vectors input (Figure 3.23).

Figure 3.23 Motion vector and beauty render passes are connected to a Vector Motion Blur tool.

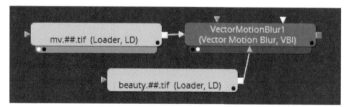

In general, motion vector passes encode left / right X-direction motion in the red channel and up / down Y motion in the blue channel of an RGB render. As such, change the tool's X Channel parameter to Red and Y Channel parameter to Green (Figure 3.24). You can set the magnitude of the blur by adjusting the Scale parameter (Figure 3.25). The blue channel of a motion vector pass is not used.

Figure 3.24 The Vector Motion Blur tool is set to read X vector information from the red channel and Y vector information from the green channel.

Figure 3.25 Close-up of blur created by Vector Motion Blur tool with Scale set to 200. This project is included with the tutorial files as `\ProjectFiles\FusionFiles\Chapter3\VectorBlur.comp`.

Motion vector renders vary with the 3D program and 3D renderer used. As such, the renders may need adjustment in a similar fashion to Z-depth render passes. For example, you can insert a Channel Booleans, Color Corrector, Color Curves, or other color tool between the motion vector Loader and the Vector Motion Blur tool and thus adjust color values before they are used for the blur. Ideally, a motion vector pass should appear red / green / yellow where objects are in motion and appear black where there is no motion (Figure 3.26). For maximum quality consider working within 32-bit floating point color space in Fusion and using renders that are in a 32-bit floating-point format. It's also possible to exert greater control of the color adjustment by using the Custom Tool; this tool allows you to write mathematical formulas for each channel and is discussed in Chapter 11.

Figure 3.26 Close-up of a motion vector pass. X motion is encoded in the red channel and Y motion is encoded in the green channel. The brighter the red or green the more motion in that direction. Where X and Y motion overlap, the render appears yellowish.

Examining Channel Values

You can examine the numeric values of channels at any time by placing your mouse in a Display view and watching the value readout at the bottom-left of the program window (Figure 3.27). This includes Z-depth. For example, if you activate a Z-depth channel through a Loader, the Z values are printed to the right of the RGBA values.

Color R **0.30005** G **0.30005** B **0.30005** A **1.0** Z: **17.82546616**

Figure 3.27 The value readout for RGBA and Z-depth channels.

All activated auxiliary channels are also listed in the Color menu of the Display views. If the channel you are viewing has superwhite values, you can force the view to normalize the values so that they fit within the standard 0-to-1 range by clicking the Show Normalised Image button (the last button on the right). This only affects the view and does not alter values within the tool network.

Deep Pixel, Deep Image, and WPP

Fusion includes the Deep Pixel menu that lists such tools as Depth Blur and Fog. This menu should not be confused with the deep image compositing, which uses deep channels that encode the depth of multiple surfaces for each pixel. Nevertheless, Fusion does support World Position Pass (WPP) information in its workflows. WPP encodes the XYZ position of each pixel in a special channel. You can use this information as part of Fusion's 3D environment, which is discussed in Chapter 9.

Chapter Tutorial: Assembling a Shot

Compositing tasks need not always involve photorealistic source materials. The techniques are equally valid for stylistic projects. In this tutorial, we'll assemble the elements created for a 3D animation that's designed to look like hand-painted artwork. You can follow these steps:

1. Create a new Fusion project. Add a Loader tool. Import the `\ProjectFiles\Plates\`
 `Taxi\taxi.##.tga` footage. (See the Introduction for more information on the tutorial files provided for this book.) Connect the Loader to a Display view and play back the time ruler. The image sequence features a 3D render of a taxi and a man in silhouette. The empty space behind the man and taxi is transparent per the alpha channel. Note that the sequence is 143 frames in duration. Set the Global Start Time to 0 and Global End time to 142.

2. Create a new Loader tool and import `\ProjectFiles\Art\theatre.png`. Connect the new Loader, Loader2, to a Display view. This is a static digital matte painting of a movie theater.

3. Create a new Loader tool and import `\ProjectFiles\Art\crowd.png`. Connect the new Loader, Loader3, to a Display view. This is static artwork of an abstracted group of people. Note that Fusion correctly interprets the transparency of a PNG file.

4. The imported footage carries different resolutions. The taxi render and theatre painting are 1920×1080 while the crowd art has a resolution of 2463×1238. Before building the tool network, it's important to set the project resolution and frame rate. Choose File > Preferences. Go to the Frame Format section in the left column of the Preferences window. Set Frame Rate to 24; this matches the original animation frame rate. Set the Default Format to 1920×1080; this is a suitable size for eventual render to disk. Click the Save button to close the window.

5. Create two Merge tools. Connect the theater painting to the Background of Merge1. Connect the crowd art to the Foreground of Merge1. Connect Merge1 to a Display view. The crowd art overhangs the painting (Figure 3.28). While the Merge1 tool is selected, the green transform handle for the foreground input is visible. Interactively scale and move the crowd so that it appears in front of the theater entrance on the left side of frame (Figure 3.29).

Figure 3.28 The crowd art overhangs the theater matte painting when the two elements are combined with a Merge tool. The frame resolution is set to the resolution of the Background input, which is 1920×1080.

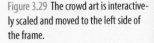

Figure 3.29 The crowd art is interactively scaled and moved to the left side of the frame.

6. Connect the output Merge1 to the Background of Merge2. Connect the taxi render to the Foreground of Merge2. Connect Merge2 to a Display view. Play back the time ruler. Note that the silhouetted man becomes disconnected from the ground and appears to walk up into the air. This is due to a mismatch in perspective between the theatre painting and the 3D render of the man and taxi. To reduce this problem, you can move the taxi render down in the Y direction. For example, change the Merge2 tool's Center Y field to 0.3. Play back the time ruler. The connection between the man and the ground is better, but the taxi is pushed out of frame and some of its doors are no longer visible. To see the frame as it will render, deselect the Merge2 tool so no tools are selected. To avoid the cropping, we can animate the Size and Center parameters over time (discussed in Chapter 5).

7. The scene takes place at night. Hence it may be nice to add glow to the bright parts of the frames, such as the wall fixtures, marquees, and taxi sign. You can emulate a glow by merging an additional copy of the network. Create a new Merge tool. Connect the output of Merge2 to the Background of Merge3 *and* the Foreground of Merge3. You can connect an output to an unlimited number of inputs, even if they are connected to the same tool.

8. RMB-click the connection line between Merge2 and the Foreground of Merge3 (so the connection line turns blue at the base of Merge2) and choose Add Tool > Color > Color Curves. A Color Curves tool is automatically connected between Merge2 and Merge3. RMB-click the connection line between ColorCurves1 and the Foreground of Merge3 and choose Add Tool > Blur > Blur. A Blur tool is inserted between ColorCurves1 and Merge3. Rearrange the tools so it is easy to see the network. Use Figure 3.30 as reference for the network layout.

Figure 3.30 The output of Merge2 is sent in two directions in order to create a custom glow effect.

9. Select the Color Curves tool and go to the Tools > Controls tab and deselect the Alpha checkbox. Create an S-shaped curve to increase the contrast (Figure 3.31). Connect the Color Curves tool to a Display view to check the results. See Chapter 2 for more information on the Color Curves tool.

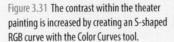

Figure 3.31 The contrast within the theater painting is increased by creating an S-shaped RGB curve with the Color Curves tool.

10. Select the Blur tool and go to the Tools > Controls tab. Increase the Blur Size value to 40. Open the Merge3 tool in the Tools tab. Change the Apply Mode menu to Screen. Connect Merge3 to a Display view. Check the result on several frames. The bright part of the artificial glow, created with the Color Curves and Blur tools, appears over the image without obscuring the taxi, crowd or theater (Figure 3.32). You can reduce the intensity of the glow by reducing the Merge3 tool's Blend value. You can also adjust the Blur tool's Blur Size value to soften or harden the Glow edge.

The tutorial is complete! A finished version of this tutorial is saved as `\ProjectFiles\FusionFiles\Chapter3\AssembleShot.comp`. We will return to this tutorial in Chapter 5 to add animation.

Figure 3.32 The composite as seen on frame 135.

Tracker List

Show

Selected tracker details

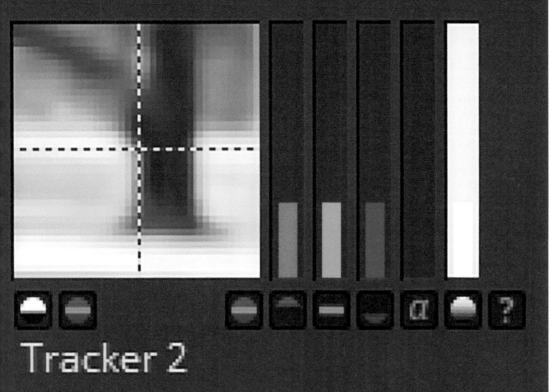

Tracker 2

 Sizes 2

Tracked Center 2

Transforming and Motion Tracking

The ability to transform inputs is a common component of compositing. You can position, rotate, and scale in Fusion using tools within the Tools > Transform menu. You can keyframe animate these parameters over time. Motion tracking, on the other hand, detects motion within a piece of footage so that you can automatically apply that motion to an otherwise static input. Thus, you can impart motion to bitmap art or a 3D render so that it appears to be shot with the original camera. It's important to explore common types of motion tracking: stabilization, transform tracking, and corner-pin tracking.

This chapter includes the following critical information:

- Transforming with transformation tools
- Keyframing transform parameters
- Stabilization and transform tracking with the Tracker tool
- Adjusting motion paths and tracking data
- Linking tracking data and corner-pin tracking

Altering and Animating Transforms

As discussed in Chapter 3, you can transform the Foreground input of a Merge tool. Although this is convenient, you also have access to a set of transform tools through the Tools > Transform menu. Regardless of which transform parameters you use, you can animate them over time. (Keyframing is discussed in th section "Animating Transformations" later in this chapter.)

Using the Transform Tool

The Transform tool (Tools > Transform > Transform) provides parameters for altering the size (scale), angle (rotation), and center (position) of the connected input (Figure 4.1). When the Transform tool is selected, an interactive transform handle appears in the Display views and is identical to the one provided for the Merge tool. To move the input, LMB-drag the center axis handles or the small center axis circle. To rotate, LMB-drag the dotted rotation circle. To scale, LMB-drag the rectangular bounding box edges. By default, the X (left / right) and Y (down / up) dimensions for scale are linked. To scale X and Y separately, deselect the Use Size And Aspect checkbox. The deselection replaces Size and Aspect parameters with X Size and Y Size parameters. If Use Size And Aspect remains selected, the Aspect parameter alters the Y scale while leaving the X scale unaffected. If you reduce the input's scale or move the input so that it falls outside the frame, you have the option of repeating the input with the Wrap, Duplicate, and Mirror buttons (these are described in Chapter 3). The **frame**, in this context, is the area within a Display view that renders, either through the time ruler playback or a render to disk. If the Transform tool is deselected, the overhanging parts of the input are no longer displayed in the Display views; empty, transparent areas of the frames are drawn with the checkerboard pattern.

When you change the input's position, the Center XY parameter updates. The default Center XY value is 0.5, 0.5, which means that the transform handle is in the exact center of the frame when the input resolution matches the frame resolution. (See the next section for more detail on frame resolutions.) The input position within the frame is measured on a 0-to-1 scale, regardless of the input or frame resolution. When Center XY is 0, 0, the transform handle center is placed at the bottom-left corner of the frame. When Center XY is 1.0, 1.0, the handle is placed at the top-right corner of the frame.

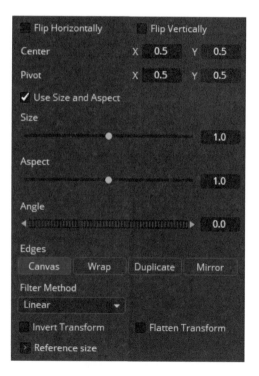

Figure 4.1 Parameters of the Transform tool with default values.

You can use negative Center XY values. Negative X values move the input past the frame left edge while negative Y values push the input below the bottom of the frame edge. By the same token, you can use values above 1.0, which have the opposite affect on the position.

In contrast, the Pivot XY parameter determines the position of the circular rotation / scale handle relative to the input resolution. When Pivot XY is set to 0.5, 0.5, the rotation handle is in the exact center of the input (regardless of the frame resolution). Changing the Pivot XY values offsets the circular rotation / scale handle. When the rotation or scale changes (thus changing the Angle or Size parameter), the rotation or scale occurs around the center the offset handle (Figure 4.2).

The Transform tool provides Flip Horizontally and Flip Vertically checkboxes to create negative scaling in the X or Y directions. You can also invert the current transformation by selecting the Invert Transform checkbox; for example, Center XY values of 1.0, 0.5 are inverted to –1.0, 0.5.

Like other tools, the Transform tool is applied to the RGBA channels. However, you can transform individual channels by selecting or deselecting the Red, Green, Blue, Alpha checkboxes in the Tools > Common Controls tab (this carries a small atom symbol).

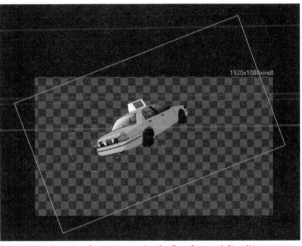

Figure 4.2 A 3D render of a taxi is rotated with a Transform tool. Pivot X is set to 0.25, causing the rotation to happen around the back of the car. The green rectangle represents the bounding box (the outer edges of the render). This project is included with the tutorial files as `\ProjectFiles\FusionFiles\` `Chapter4\Transform.comp`.

Project and Frame Resolutions

As discussed in Chapter 1, you can set the project resolution through the File > Preferences window. However, this resolution is not necessarily used by the Display views. In fact, a Display view defaults to the resolution of the output that is connected to that view. For example, if you connect the output of Loader tool to the Right Display view and the Loader tool's output resolution is 1920×1080, the frame of the Right Display view is set to 1920×1080. (Thus, I will refer to the resolution of a Display view as the **frame resolution**.) If you choose to render a particular tool's output, the full-frame resolution will be the frame resolution. Any given project may use tools that output many different resolutions. Mixing and matching resolutions carries special challenges; these challenges are discussed throughout this chapter.

Note that some procedural tools, located in Tools > Creator menu, generate an output that matches the project resolution. For example, the Background, FastNoise, Mandlebrot, and Plasma tools follow this pattern.

Choosing a Filter Method

Tools that include transform parameters include a Filter Method menu. Filter Method determines what type of algorithm is used to average pixels. The pixel averaging is necessary when the input is rotated, scaled, or positioned in such a way that old pixels must be removed or new pixels must be added. A brief description of available filter options is included in this list below. Note that the variations in filter results is most noticeable when upscaling or downscaling by a significant amount. In either situation, change the Set Viewer Scale menu button to a high value, such as 400%, and activate the HiQ button in the TimeView to properly judge the filter results.

Nearest Neighbor Deletes unneeded pixels or duplicates existing pixels without applying averaging (left side of Figure 4.3). This is the lowest quality but most efficient filter.

Box Efficiently averages values. Tends to create artifacts in the center of resulting pixels.

Linear A quality filter that produces satisfactory results for many situations, such as minor upscaling, minor downscaling, moving, or rotating. This is the default setting of the Filter Method.

Quadratic and Cubic Filters that are similar to Linear but create softer edges.

Gaussian A commonly used filter that adds a slight degree of edge-sharpening.

Catmoll-Rom Similar to the Gaussian filter with an additional degree of edge sharpening. This filter produces good results when downscaling by large amount (right side of Figure 4.3).

Mitchell, Lanczos, Sinc, Bessel Additional filters that produce varying degrees of edge sharpening.

Figure 4.3 A render is downscaled by giving it a Size of 0.1. The Filter Method is set to Box for the left version and Catmull-Rom for the right version. To check the result, the Set Viewer Scale menu button is set to 800%. This project is included with the tutorial files as `\ProjectFiles\Fusion-Files\Chapter4\FilterMethod.comp`.

Transforming with Scale, Resize, and DVE

The Scale tool offers an independent means to change the scale through its Size parameter. By default, X and Y and linked. You can add X Size and Y Size sliders by deselecting the Lock X/Y checkbox. Altering the Size values, however, alters the frame resolution of the Display view. For example, if you connect the 1920×1080 resolution image to the Scale tool's input and change the Size value to 0.5, the frame resolution becomes 960×540. The output resolution is listed at the top-right of the frame when the Scale tool is connected to a Display view.

In contrast, the Resize tools offers Width and Height parameters, which you can adjust independently. The Resize tool offers a Use Frame Format Settings button, which automatically snaps the input to the project resolution. Like the Scale tool, changing the Width and Height values alters the frame resolution of the Display view.

The DVE tool allows you to rotate and position the 2D input within a 3D space (Figure 4.4). The tool includes X/Y/Z Rotation parameters as well as a Z Move slider, which you can use to move the input closer or further from the virtual camera. When the DVE tool is selected, a transform handle is drawn in the Display view; you can use this to move the input in the X and Y directions. A Z Pivot parameter is also included to offset the input from the transform handle in depth. The Perspective parameter adds an additional degree of perspective distortion if there is non-0 X or Y rotation. Changing the Perspective value is similar to changing the field-of-view (focal length) of a camera lens. Note that the DVE tool does not take the tool network into Fusion's full 3D environment (the 3D environment is discussed in Chapter 9). Scale, Resize, and DVE are located in the Tools > Transform menu.

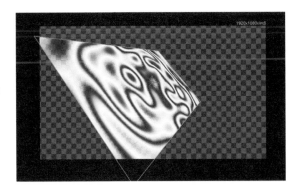

Figure 4.4 The DVE tool rotates the input, a colorful noise created by the Plasma tool, in a virtual 3D space. This project is included with the tutorial files as `\ProjectFiles\FusionFiles\ Chapter4\DVE.comp`. DVE stands for *Digital Video Effects*.

Letterboxing and Cropping

The Letterbox tool lets you crop or stretch the input and thus change the frame resolution. By default the Width and Height parameters are set to the input resolution. If you lower the Height value, the image is cropped vertically. If you raise the Height value, the frame resolution is increased in Y and letterbox bars appear at the top and bottom. These bars are assigned 100% transparency. If you reduce the Width, the image is downscaled to stay within the new frame; hence, letterbox bars are added to the top and bottom. If you raise the Height, the image is upscaled and the top and bottom are cropped.

Figure 4.5 Left: A matte painting has a resolution of 1920x1080. Right: The same image is cropped with the Letterboxing tool by setting Height to 780. This project is included with the tutorial files as `\ProjectFiles\FusionFiles\Chapter4\Letterbox.comp`.

Alternatively, you can adjust the Pixel Aspect XY values. However, this may produce different results, For example, if you raise Pixel Aspect X or Pixel Aspect Y above 1.0, the image and frame is stretched in that direction. The term **letterboxing** refers to the addition of vertical or horizontal bars when a film or video with one aspect ratio is broadcast or projected on a system with a different aspect ratio. An **aspect ratio** is the proportional relationship of image's width to height, where the value is expressed as X:Y (e.g.: 1.78:1 or 1.33:1).

The Crop tool provides a means to crop an input and thereby change the frame resolution. By default, the tool's X Size and Y Size parameters are set to the input resolution. If you reduce the X Size value, the image is cropped on the right. If you reduce the Y Size value, the image is cropped on the top. You can re-center the input after cropping it by altering the X Offset and Y Offset parameters.

Adding Camera Shake

The Camera Shake tool (Tools > Transform > Camera Shake) adds random rotation and positional changes to an input. This may be useful for recreating the motion caused by earthquakes, explosions, and similar phenomena. The tool includes parameters to control positional changes (through X / Y Deviation parameters) and rotation (with Rotation Deviation). The frequency of the motion and rotation (how often changes occur) is set by the Speed parameter, with lower values slowing the motion. The magnitude of the shaking is controlled by the Overall Strength parameter. The degree of randomness of the motion is set by Randomness, with lower values creating less variation in motion.

The Camera Shake tool allows the input to leave the frame edge, creating empty areas within the frame (Figure 4.6). To avoid this, consider upscaling and cropping the output of the Camera Shake tool. For example, in Figure 4.7 the output of a Camera Shake tool is connected to Scale tool. The Scale tool's Size parameter is set to 1.1. The output of the Scale tool is connected to a Crop tool. The Crop tool's X Size is set to 1920 and the Y Size is set to 1080; this is the desired resolution for the final output. To re-center the image sequence so no edge gaps are visible, the Crop tool's X Offset and Y Offset are adjusted.

Figure 4.6 The Camera Shake tool randomly moves and rotates the input, creating an earthquake-like effect. However, this produces gaps at the frame edge.

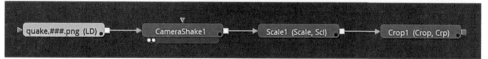

Figure 4.7 To avoid the gap, the output of the Camera Shake tool is connected to a Scale tool and a Crop Tool. This project is included with the tutorial files as **\ProjectFiles\FusionFiles\Chapter4\CameraShake.comp**.

Activating Motion Blur

If the transform parameters of a tool are animated or automatically driven over time, as in the case of the Camera Shake tool, you can activate motion blur. Motion blur streaks moving elements and replicates the blurs captured by real-world motion picture and digital video cameras.

Tools that carry transform parameters also carry a Motion Blur checkbox. This is located in the Tools > Common Controls tab, which you can find to the right of the Controls tab when the tool is selected. (The Common Controls tab carries a small atom symbol.) When the checkbox is selected, the following parameters become available:

Quality Determines the smoothness of the blur. The higher the value, the more iterations of the image along its motion path are blended together. For example, a setting of 6 shows significant improvement of a setting of 2 (Figure 4.8).

Figure 4.8 Left: Motion Blur is activated for a Camera Shake tool with a quality setting of 2. Right: The motion blur smoothness is improved by setting the Quality to 6. Note that the MB (Motion Blur) button must be activated in the TimeView for the blur to be visible in the Display views. This project is included with the tutorial files as `\ProjectFiles\FusionFiles\ Chapter4\MotionBlur.comp`.

Shutter Angle Replicates a virtual camera shutter that affects the blur streak length. With a real-world camera, the duration of a single frame exposure determines the blur streak length. For example, if a video frame is exposed for 1/24th of second, the blur length is equivalent to the distance an object can move in 1/24th of a second. A camera shutter, whether physical or digital, controls the exposure duration. In Fusion, raising the Shutter Angle value extends the blur streak length and reducing the Shutter Angle shortens the blur streak length. The default value of 180 is a common shutter angle for pre-digital motion picture cameras.

Center Bias Determines when in time the blur streak starts and stops. The default value of 0.5 means the blur streak starts earlier on the time ruler and ends later on the time ruler. The total exposure duration is controlled by the Shutter Angle parameter.

Sample Spread Affects the blending of frame iterations and thus alters the overall brightness of the motion blur streak.

Animating Transformations

Within Fusion, you can animate any parameter changing value over time. This includes transforma-
tion parameters, such as Center, Size, and Angle. To set a keyframe, move to a frame on the time ruler
where you'd like to place a keyframe, go to the parameter you wish to key in the Tools tab, RMB-click
over the parameter name, and choose Animate from the menu. The keyframe is indicated by a green
line beside the parameter name and a green parameter field. To create subsequent keyframes, move
to different frames on the time ruler and change the parameter value. Additional changes are au-
tomatically keyframed. You can update an old keyframe at any time by moving to the correct frame
and updating the parameter value.

When two or more keyframes exist for a parameter, an animation spline is created. The spline
determines parameter values for frames that fall in-between keyframes. You can edit animation
splines within the Spline view (this is detailed in Chapter 5). You can delete the animation spline for
a parameter by RMB-clicking over the parameter name choosing Remove *curve name*.

If you animate the Center XY parameter of a tool, a motion path is drawn in the Display views (Figure
4.9). You can interactively update the motion path by LMB-dragging the keyframe points on the
path (drawn as small, hollow squares). This automatically updates the Center XY values stored by the
keyframes. If you select a point in a Display view, you have the option of moving the point's tangent
handles by LMB-dragging. You can move a single tangent handle independent of its partner by Ctrl/
Cmd+LMB-dragging. When you animate a transformation parameter, keyframes are indicated on the
time ruler as green vertical lines so long as the animated tool remains selected.

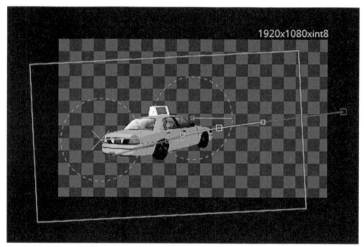

Figure 4.9 A 3D render of a taxi is animated with a transform tool. The Center XY parameter carries
three keyframes, which produces the red motion path in the Display view. The center keyframe is
selected and appears yellow with tangent handles. Note that Pivot X is set to 0.25, causing two ro-
tation handles to appear—one at the original location in the image center and the revised location
at the car rear (the revised location carries the green × in the center). This project is included with
the tutorial files as `\ProjectFiles\FusionFiles\Chapter4\`
`MotionPath.comp`.

Motion Tracking

Motion tracking is the process by which movement within a piece of footage is detected and reapplied to another element within the composite. As such, you can use motion tracking to impart motion to an otherwise static element to make it appear as if it was shot with the original camera. For example, you can apply the motion tracking data to a static 3D render so that the render "fits" within the footage with a moving camera. You can also use motion tracking to make an element follow a particular object within the footage. For example, you can apply tracking data to static art to make the art follow the hand of a gesticulating actor. Motion tracking has several different variants, which are listed here:

Transform Tracking This is the simplest form of motion tracking that detects 2D X and Y (left / right and up / down) motion of a object or pattern within the footage. For example, you might motion track a tape mark on a green screen, a point on an actor's shirt, or an antenna of a building in the background. Transform tracking is suitable for camera motion that is fairly simple, with minimal pans or tilts. Optionally, transform tracking can detect camera rotation (through tilts), zooms (changes in focal length), or Z-axis forward / back motion.

Stabilization This form of tracking takes the transform tracking data and applies it to the original footage so that the footage loses the camera motion and becomes static. Stabilization is useful for removing unwanted camera jitter, shake, bumps, and similar low-level motion.

Corner-pin Tracking Corner-pin tracking builds upon transform tracking by using four tracking points. The points are used to track the corners of a square or rectangular object or pattern. For example, you can use corner-pin tracking to track a door, window, or billboard moving over time. The corner-pin data is then used to distort another element so that it fits the rectangular area. For example, you can use this method to replace the screen of a computer monitor or change the art on a wall poster. Note that transform tracking uses one tracking point when tracking X / Y motion and two points when tracking rotation and / or scale changes (such as those created by a zoom).

3D Camera Tracking This form of motion tracking is used on more complex shots where the camera goes through aggressive changes in position and / or rotation. The tracking detects myriad patterns within the footage, tracks the patterns over time, and creates a 3D camera that recreates the original camera's movement. Other elements, such as art or renders, are then placed within the resulting 3D environment and gain appropriate changes in perspective and distance.

Note the motion tracking is often referred to as **matchmoving**, where the new element's motion is "matched" to the movement within the footage.

Using the Tracker Tool

The Tracker tool (Tools > Tracking > Tracker) provides the primary means to motion track with Fusion. You can use the tool to transform track and detect X / Y motion. You can follow these basic steps:

1. Select the output you wish to track. For example, select a Loader tool. You can use the `\ProjectFiles\Plates\Walkway\walkway.##.png` image sequence as a test. Choose Tools > Tracking > Tracker. A new Tracker tool is connected to the output of the selected tool. Connect the Tracker to a Display view. If the Tracker tool is selected, a green pattern window, named *Tracker 1*, appears as a green box in the Display view. The pattern window represents the pattern of pixels that the Tracker will track over time.

2. Go to the first frame of the time ruler. (Make sure the time ruler duration matches the length of the footage.) Move and scale the Tracker 1 pattern window so that it sits over a pattern in the image that may be suitable for tracking. For example, place the window over the corner of a wall, a street lamp, letters on a sign, the base of a tree trunk, or similar architectural or natural detail (left side of Figure 4.10). You can move the pattern window by LMB-dragging the window from the upper-left corner. When you LMB-drag the window, a zoomed-in view of the pattern is displayed. After you've moved the window, it becomes red. You can adjust the size of the window by LMB-dragging the edges of the window box. You can resize the window so that it surrounds the pattern that you have chosen. When you place the mouse over the window, it displays additional detail. A dotted cross-hair shows the center of the window. A larger, dotted box represents the search window, which is the area the Tracker will go to find a pattern if it gets confused about its exact location. You can adjust the size of the dotted search window by LMB-dragging the edges. The larger the pattern and search windows, the higher the degree of accuracy; however, larger windows are less cost-effective and may significantly slow the tracking.

Figure 4.10 Left: The Tracker 1 pattern window is placed over the corner of a tree trunk. Right: The search window and cross-hair is revealed when the mouse is placed over the pattern window. The Display view is set to 200% so that the window is easier to see. This footage is included with the tutorial files as `\ProjectFiles\Plates\Walkway\walkway.##.png`.

3. Click the Track Forward button (Figure 4.11). The time ruler plays forward and the footage is examined by the Tracker. The pattern window moves in an attempt to stay centered on the pattern. When the end of the time ruler is reached, a Render Completed dialog window opens. Close this window. A motion path for the pattern window is drawn in the Display view as a green line.

Figure 4.11 The Tools > Trackers tab of the Tracker tool. The buttons, from left to right, are Track Reverse, Track Reverse From Current Time, Stop Tracking (with the red line), Track Forward From The Current Frame, and Track Forward.

4. Play back the time ruler using the TimeView's playback controls. Watch how the pattern window follows the selected pattern. Go to Tools > Trackers tab with the Tracker tool selected. Note that Tracker 1 is automatically selected in the Tracker List field. While Tracker 1 is selected, you can see additional details in the Selected Tracker Details section (Figure 4.12). This includes an animated Tracked Center XY parameter, which stores the location of the pattern window. The Tracked Center XY receives a keyframe for every frame of the time ruler. The values fall within the 0-to-1 range, which is the full extent of the current frame resolution. In addition, the pattern, as identified on the initial frame before tracking, is displayed in a flipbook (thumbnail view) at the left side of the tab. A second flipbook, at the rights side, shows the pattern as it appears over time. You can watch the flipbook as you play back the time ruler to gauge the success of the tracking. You can also use the flipbook's small playback controls. If the right view appears to be static, then the tracking is successful.

If the tracking is successful, you can apply the tracking data through the Operation tab. You can add additional Trackers (pattern windows), revise the Tracker settings, and re-analyze the footage. (See the section "Refining Motion Tracking Data" later in this chapter for information on improving the tracking results.)

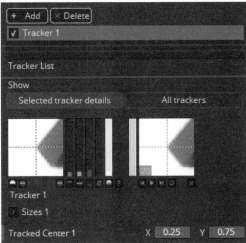

Figure 4.12 The Tracker List and Selected Tracker Details section of a Tracker tool. After footage is tracked, the original pattern (left flipbook) is visible beside the tracked pattern as it appears over time (right flipbook).

Placing a Pattern Window

When placing a tracker's pattern window, keep these things in mind:

- The Tracker tracks all the pixels within the pattern window. It does not identify objects but looks strictly at pixel values.
- High-contrast patterns work well. Hence the bright corner of a wall against a dark background or the dark base of a tree trunk against brighter grass is appropriate.
- Avoid selecting patterns that move independently of the camera. If you are trying to identify camera motion, do not select a moving person or moving prop. By the same token, if the wind is moving tree leaves, do not try to track the leaves.
- Do not select patterns that are occluded, even temporarily, by other objects. Do not select patterns that leave that frame.
- Avoid patterns that may suffer from moving shadows, heavy motion blur, or heavy noise or grain.

Employing a Second Pattern Window to Capture Rotation / Scale

If the footage you are motion tracking suffers from rotational changes (via camera tilt) or scale changes (via lens zooms or alterations in the camera's Z-axis position), you will need to add a second tracker with its own pattern window. A second tracker will allow you to apply rotational and scale animation to the element that receives the tracking data. You do not have to add a second Tracker tool, but can work with the original tool's options. To do so, click the Add button above the Tracker List. The new tracker is named Tracker 2. When Tracker 2 is selected in the Tracker List, its flipbooks and Tracked Center XY parameter values are displayed. The Tracker 2 pattern window appears in the Display views and is independent of Tracker 1.

When trying to capture rotational and scale changes, it's generally best to place the Tracker 2 pattern window over a second pattern that falls at the same vertical level as the Tracker 1 window. As an example in Figure 4.13, Tracker 2's pattern window is placed over the corner of a modern building to the left of Tracker 1.

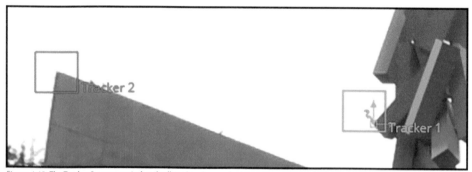

Figure 4.13 The Tracker 2 pattern window (red) is placed over a building corner and is close to the vertical level of Tracker 1 (green). Tracker 1 has been tracked prior to the addition of Tracker 2 and thus has a green motion path.

When you've placed the Tracker 2 window, you are free to re-analyze the footage by using the Track buttons. For example, starting at the first frame of the time ruler, click the Track Forward button. Tracker 2 receives its own motion path and animated Tracked Center XY values.

Using Tracking Data To Stabilize Footage

The most direct method of using tracking data is to apply the data to the footage that was tracked in order to remove the camera motion. This may be useful for removing unwanted camera jitter, shake, or other subtle motion created by a hand-held camera. To do this, you can follow these steps:

1. Switch to the Tools > Operation tab of the Tracker tool. Click the Match Move button near the top of the tab.
2. Click the BG Only button in the Merge section see (Figure 4.16 later in this chapter). This section determines what the Tracker tool outputs.
3. Play back the time ruler. The footage is stabilized and the original camera motion is neutralized.

When you select the BG Only button, the motion tracking data is applied to the tracked footage and the Tracker's output gains positional, rotational, and scale animation. Note that this method may reveal the edges of the footage due to changes in position, rotation, and scale. To avoid seeing the empty gaps at the frame edges, it may be necessary to subsequently scale or crop the Tracker's output (this technique is demonstrated in the section "Adding Camera Shake" earlier in this chapter). In addition, the stabilization technique is unable to remove lens distortion (due to wide or otherwise inexpensive lenses) or camera motion blur. For example of Tracker stabilization, refer to the `\ProjectFiles\FusionFiles\Chapter4\Stabilization.comp` project included with the tutorial files.

With a similar technique, you can reduce and smooth the camera motion but not remove it completely. For example, in Figure 4.14 and 4.15 a shot featuring a walkway possesses a camera movement with a significant "bump" midway through the duration. Using a Tracker with two tracker pattern windows, the camera motion is removed. This leads to a significant gap along the left and bottom edge as the output of the Tracker is moved, rotated, and scaled. As an alternative, the camera motion is reduced with the following steps:

- The Match Move Settings section of the Tracker tool's Operation tab is expanded. The Start & End button, under the Reference parameter, is selected (see Figure 4.16).
- The Reference Intermediate Points value is raised above 0.

With these settings, the camera motion remains but the sudden motion caused by the camera bump is removed. An edge gap remains but it is significantly reduced in size. The higher the Reference Intermediate Points is raised, the less stabilization occurs.

Figure 4.14 A shot includes a moving camera with a "bump" midway through the duration. Two trackers are used. The Tracker 1 window is placed over the base of a tree on the left. Tracker 2 is placed over the base of a sidewalk lamp post in the center. When the shot is stabilized, gaps open up at the left and bottom of frame, as is seen the checker pattern. This project is included with the tutorial files as `\ProjectFiles\FusionFiles\Chapter4\SmoothCamera.comp`.

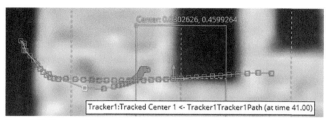

Figure 4.15 Close-up of the motion path created for Tracker 1. You can reveal the motion path keyframe boxes by placing your mouse over the path. Note the distance between several keyframes on the left—this is where the camera bump occurs. The current frame is indicated by the small transform handle (at the base of this tree in this figure).

Applying Transform Tracking

You can apply tracking data so that a new element is transformed tracked. It's possible to do this with the following steps:

1. Connect the new element's output to the Tracker tool's Foreground input. The element might be a 3D render or static bitmap imported through a Loader, a procedural pattern generated by a Tools > Creator tool, or some other section of a complex tool network.
2. Go to the Tracker tool's Operation tab. Select the FG Over BG button under the Merge parameter (Figure 4.16).
3. Make sure that the Reference parameter is set to Start. Connect the Tracker to a Display view.

When you play back the time ruler, the Foreground input gains the same motion as the original camera. By default, the position, rotation, and scale of the Foreground is animated. However, you can choose to deselect these transformations through the checkboxes with the same name located in the Operation tab. (Rotation and scale animation requires the use of two trackers.)

The pivot around which the Foreground is rotated and scaled is set by the Pivot Type parameter. If Pivot Type is set to Tracker Average, the average motion path position for all trackers is used as the pivot. If Pivot Type is set to Selected Tracker, the pivot is matched to the motion path to the tracker selected in the Tracker drop-down menu. If Pivot Type is set to Manual, you can enter your own X and Y values. In general, Tracker Average produces the best results.

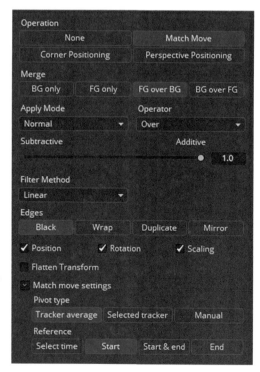

Figure 4.16 The Operation tab of the Tracker tool.

The original position of the Foreground does not change. That is, the Foreground input does not suddenly jump over to the Tracker motion paths. If the Foreground element does not appear in the correct area of the frame, you can offset its position adjusting the X Offset and Y Offset parameters at the bottom of the Tracker tool's default Trackers tab. There is one set of X and Y Offset parameters per tracker.

As an alternative solution, you can insert a Transform tool before the Tracker connection (Figure 4.17). For example, in Figure 4.18, motion tracking data applied to a Loader tool places the taxi render in the center of the frame, which is the render's original position within the frame. When a Transform tool is added between the Loader and Tracker tools, the relative position and scale of the taxi is adjusted so that it appears in the center of the sidewalk. This process does not affect the accuracy of the motion tracking and may be helpful if the Foreground input is a different resolution than the footage that has been tracked. Note that this example applies the Position and Rotation motion tracking data, but ignores the Scaling data through the deselection of the Scaling checkbox in the Operation tab. As the camera pans and tilts but does not change the focal length or move in the Z direction this is a suitable choice.

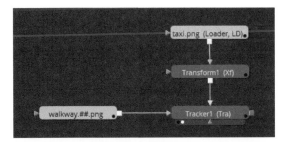

Figure 4.17 A Transform tool is inserted between the Loader tool and the Tracker tool, allowing the tracked taxi's position to be offset.

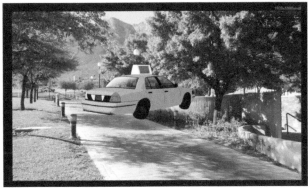

Figure 4.18 The position of a motion tracked taxi render is offset so that the car appears to be sitting on the sidewalk (as opposed to floating in the air). This project is included with the tutorial files as `\ProjectFiles\FusionFiles\Chapter4\TransformTrack.comp`.

Adding Motion Blur to Motion Tracking

You can activate motion blur for a Tracker tool's Foreground input by selecting the Motion Blur checkbox in the Common Controls tab. See the "Activating Motion Blur" section earlier in this chapter for more information regarding motion blur options.

Refining Motion Tracking Data

You are not required to use the initial motion path or paths created by the Tracker tool. If the paths appear inaccurate, where the tracker windows fail to follow the selected patterns, you can make adjustments and re-analyze (re-track) the footage. You can use any combination of the following options:

Re-analyze You can re-analyze any potion of the time ruler. Re-analyzing the footage updates any associated motion paths.

Track Forwards and Backwards You can track the footage going forward or backward, either one frame at a time, or to the start / end of the time ruler using the various track buttons (illustrated by Figure 4.11 earlier in this chapter). For example, if there is heavy motion blur on the first frame, move to a central frame, such as 36, track forward to the end, and track from 35 to the beginning.

Adjust Pattern and Search Windows If initial tracking appears inaccurate, feel free to adjust the sizes of the pattern or search windows. You can also move the pattern window and select a brand new pattern (in this case, re-analyze the full duration of the time ruler). Changes to the pattern window size and position produce variations in the motion tracking. As such, it pays to experiment to see what window sizes and positions produce the best results.

Manually Position If the motion path appears accurate with the exception of a few frames, you can manually position the pattern window. To do so, move the time slider to a bad frame, place your mouse over the path so that the keyframes are visible, and LMB-drag the small transform handle that appears over the current keyframe. If necessary, set the Display view's Set Viewer Scale to a high value so that the pixels are more easily seen. This technique is useful when there is heavy motion blur, heavy noise or grain, or brief object occlusion.

Aside from these options, the Selected Tracker Detail section of the Tracker's tool's Trackers tab offers additional choices. Once again, the flipbooks offer a means to gauge the accuracy of the tracking. Using the small playback controls under the tracked pattern flipbook on the right, you can see the stability of the tracked pattern over time. If the pattern appears static, the tracking is successful. If the pattern drifts, rotates, or changes in the scale, the tracking is inaccurate.

By default, the Tracker examines red, green, blue, alpha, and luminance values of the selected pattern and tracks the channel that the tool considers the best for tracking. In general, the Tracker prefers a channel with the highest degree of clarity (contrast between sub-patterns). The luminance channel is grayscale version of the RGB that indicates overall pixel intensity. The channels are indicated by bars between the left and right flipbooks (Figure 4.19). The order, from left to right, is red, green, blue, alpha, and luminance. At any time, you can manually choose a different channel by clicking the small buttons below the bars. Selected channels are drawn with a white bar. At the same time, the relative strength of an individual color channel is indicated with a shorter colored bar.

Figure 4.19 Close-up of left pattern flipbook and channel bars. Red, green, and blue channels are selected, as is indicated by the white vertical bars.

You can choose all three color channels by clicking the small Full Color button to the left of the red bar. You can force an automatic channel selection by clicking the small Automatic button (featuring a question mark to the right of the luminance bar). When you select a color channel, the pattern flipbook displays only that channel and the pattern appears in grayscale. Tracking with a different channel often creates slight variations in the resulting motion paths. This is particularly true when one channel includes heavier noise, which is a common byproduct of both motion picture and digital video cameras. Selecting a single color channel may also be useful when tracking an object with heavy saturation. For example, tracking a red beach ball against a blue sky may be more successful when using only the red channel. Choosing the alpha channel may be useful when tracking an alpha matte or a 3D render that includes alpha transparency. Note that each tracker carries its own set of channel options. To switch to a different tracker, click the tracker name in the Tracker List field.

By default, the pattern that you establish by placing the pattern window is the pattern that the Tracker seeks out with each frame. However, if the pattern is created by an object that changes shape due to deformation or goes through profile changes due to rotation, the tracker may fail. You can allow the tracker to adapt the pattern with every frame by selecting the Every Frame button of the Adaptive Mode parameter in the Trackers tab. Alternatively, you can select the Best Match button, which allows adaption but compares every new frame with the original pattern. If the variation between the original pattern and the new pattern exceeds the Match Tolerance parameter value, a new, adapted pattern is acquired for that frame. The Every Frame option is best suited for objects with shapes that constantly shift, such as a falling water balloon or a flying bird. The Best Match option is best suited for objects that go through temporary shape changes, such as the head of a seated person that turns slightly and then turns back to the original position.

By default, the Tracker lays down a keyframe of every frame of the time ruler. However, you can skip frames by raising the Frames Per Path Point parameter value. This may be useful if the footage contains camera shaking or jitter. This parameter is located below the track buttons.

Tracking Multiple Patterns

You may discover that the footage you are tracking does not include a pattern that stays in the frame for the entire duration of the time ruler. In this situation, you can track multiple patterns. Follow these basic steps:

1. Select the initial pattern by placing and scaling the tracker pattern window. Track forward until the pattern goes out of frame, is occluded, or is otherwise lost. You can stop the tracker at any time by clicking the Stop Tracking button.
2. Select the Track Center (Append) button of the Path Center parameter in the Tracker tool's Trackers tab. Move the time slider to the frame where the tracking becomes inaccurate. Move and scale the pattern window so it sits over a new pattern. Track forward. With this setting, the original motion path is appending even though the new pattern is offset from the initial pattern.

Linking Motion Tracking Data between Tools

Fusion gives you the option to link parameters between unconnected tools. Linking is a type of mathematical expression, where one parameter automatically drives the values of another parameter. As such, you can link the motion tracking data of a Tracker to another Tool that carries transformation parameters. This allows you to use the tracking data without relying solely on the capabilities of the Tracker tool. To link two parameters, follow these steps:

1. Go to the tool whose parameter will receive values. Open the tool in the Tools tab.
2. RMB-click over the name of the parameter that will receive values and choose Connect To > *tool* > *parameter*. The menu lists tools in the project that have valid and available parameters. The link is created and the values are transferred with each frame of the time ruler.

If the parameter supplying values is updated with new values, the new values are automatically passed to the linked parameter. To remove a link, RMB-click over the parameter name and choose Remove *linked tool*.

With motion tracking, you can link a Tracker to a Transform or similar tool in the Tools > Transform menu. The Tracker supplies several variations of tracking data. These are listed under Connect To > Tracker*n* menu. Several options are designed for stabilization. You can connect Steady Position to Center XY. If you are using two trackers that produce two motion paths, you can connect Steady Size to Size and Steady Angle to Angle. Each of the Steady options connects an inverted spline to the selected parameter; this has the effect of neutralizing the original camera motion. The Connect To > Tracker*n* menu also offers Unsteady Position, Unsteady Size, and Unsteady Angle options. These are designed for transform tracking, where the linked output picks up the original motion of the camera. That said, if you are using more than one tracker and have the Tracker tool's Pivot Type set to Tracker Average, make the following connections:

* Connect Steady Axis to Center XY
* If rotation is present, connect Unsteady Angle to Angle
* If scale changes are present, connect Unsteady Size to Size

Steady Axis is the averaged center of all the motion paths created by the Tracker tool. As an example, Figure 4.20 illustrates a tool network where a Transform tool (Transform1) has its Center XY linked to Steady Axis and its Angle linked to Unsteady Angle. The second Transform tool, Transform2, is added to position and scale the taxi render before it receives the tracking data through Transfrom1. In order to recombine the taxi with the background, the final tool of the network is a Merge.

Figure 4.20 Motion tracking data is passed to Transform tool through parameter linking. This project is included with the tutorial files as `\ProjectFiles\FusionFiles\Chapter4\LinkedTrack.comp`.

The Connect To > Tracker*n* menu offers the same Steady and Unsteady options for each tracker listed in the Tracker List field of the Tracker tool (e.g: Tracker *n*: Steady Position). The Steady and Unsteady options function in the same manner discussed but only use the motion path data for the selected tracker. If you wish to link a parameter directly to a motion path without any filtering, choose Tracker *n*: Offset Position. For example, if you connect Tracker1: Offset Position to the Center XY parameter of a Transform tool, the Transform tool's output jumps to the motion path of Tracker 1. Tracker*n*: Offset Position works in the same way as the Connect To > Tracker*n*Tracker*n*Path > Position menu option.

Expressions, which provide their own form of linking, are discussed in Chapter 11.

Chapter Tutorial: Corner-pin Motion Tracking

Transform tracking detects the X / Y motion within a piece of footage by tracking the pattern established by a tracker window. Another form of tracking, corner-pin, uses four pattern windows to follow the four corners of a moving rectangular object. The tracking data is then applied to another element to distort that element's corners to fit the tracked object. This form of tracking allows you to replace rectangular features such as billboards, posters, television screens, phone screens, and the like. For this tutorial, we'll use corner-pin tracking with Tracker tool to fill a blank painter's canvas.

1. Create a new project. Choose File > Preferences. In the Preferences window, switch to the Frame Format section. Set the Frame Rate to 30 and the Default Format menu to HDTV 1080. This is the frame rate and the resolution of the footage we will motion track.
2. Add a Loader tool. Import the `\ProjectFiles\Plates\Canvas\canvas.##.png` footage. (See the Introduction for more information on the tutorial files provided for this book.) Connect the Loader to a Display view and play back the time ruler. The video image sequence features a hand-held view of a painter's drafting table with a blank canvas. Note that the sequence is 72 frames in duration. Set the Global Start Time to 0 and Global End time to 71.
3. With the Loader tool selected, choose Tools > Tracking > Tracker. A Tracker too is connected automatically. Connect the Tracker to a Display view. Select the Tracker and go the Tools > Operation tab. Select the Corner Positioning button under the Operation parameter. This adds four trackers, numbered 1 to 4, to the tool. Note that the Mapping Type parameter is switched automatically from Bi-Linear, used to stabilization and transform tracking, to Perspective. Each tracker is listed below the Perspective button with its associated corner. In the Display view, the four pattern windows are tied together with "rubber band" lines.
4. While on the first frame of the time ruler, interactively position and scale the tracker pattern and search windows so their centers touch the corners of the canvas (Figure 4.21). High-contrast corners, as is the case with this footage, are ideal for corner-pin tracking. Return to the Trackers tab and click the Track Forward button. The footage is tracked. When complete, the tool opens a Render Completed window. Close the window. Play back the time ruler to examine the resulting four motion paths. If the tracking is accurate, the red lines joining the tracker windows stay along the edges of the canvas. To better judge the results, feel free to manually drag the time slider to examine each frame.

Figure 4.21 A Tracker tool is switched to Corner Positioning, creating four tracker pattern windows. The windows are positioned at the corners of the blank canvas.

5. If necessary, re-position and re-scale the tracker pattern windows and re-analyze the footage using any of the track buttons. (See the section "Refining Motion Tracking Data" earlier in this chapter for other options you can use to improve the tracking.) If the motion paths are suitably accurate, create a second Loader tool. Import the `\ProjectFiles\Art\painting.tif` bitmap. This is a digital reproduction of a painting. Connect the output of the new Loader to the Foreground input of the Tracker. If the Tracker is connected to a Display view, the foreground input is distorted automatically so that its corners line up with the canvas corners. Play back the time ruler. The painting "sticks" to the canvas and goes through appropriate perspective shifting (Figure 4.22).

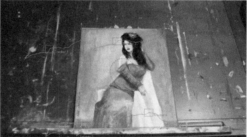

Figure 4.22 When a bitmap of a painting is connected to the Foreground of the Tracker tool, its corners are distorted to follow the centers of the four tracker pattern windows. The top image is from frame 0 and the bottom image is from frame 71.

6. To add an extra degree of realism, switch to the Tracker tool's Common Controls tab and select the Motion Blur checkbox. Raise the Quality slider to 10. The painting is blurred.

The tutorial is complete! A finished version of this tutorial is saved as **\ProjectFiles\ FusionFiles\Chapter4\CornerPin.comp**. Note that the Tracker also offers the Perspective Positioning button as an Operation parameter option. This option creates four trackers. However, Perspective Positioning is designed to remove the perspective of a rectangular object by stretching the tracked corners to the corners of the frame.

Keyframing and Adjusting Animation Splines

Keyframing is the process by which the values of parameters are stored for particular frames of the time ruler. When more than two keyframes exist for a parameter, an animation spline is generated, thus providing in-between frame values and semi-automating the animation process. You can keyframe transformation parameters to create motion. You can also keyframe parameters to affect filter styles or strengths. There are many ways to fine-tune keyframes and animation splines in the Timeline and Spline views.

This chapter includes the following critical information:

- Keyframing parameters
- Altering timing in the Timeline view
- Altering animation splines in the Spline view
- Working with spline tangent handles

Keyframing Parameters

As discussed in Chapter 4, you can set a keyframe on any parameter in Fusion that carries a value. The resulting keyframe stores the parameter value for the frame at which the keyframe was set. If two or more keyframes exist for a parameter, an animation spline is constructed so that other, non-keyframe frames on the time ruler receive in-between values from the spline. In this way, the process of animation for a parameter is semi-automated. Note that the words **key** and **keyframe** are interchangeable when discussing animation. A simple parameter animation may only require two keyframes (start and end values), while a more complex or erratic animation may require a keyframe every few frames. (Animation splines are also referred to as **animation curves**.)

To set a keyframe for a parameter, move the time slider to a frame where you want to place a keyframe, open the tool you wish to keyframe in the Tools tab, RMB-click over the parameter name, and choose Animate (Figure 5.1). The keyframe is created and is indicated with a green parameter field and a green line beside the parameter name (Figure 5.2). In addition, a green vertical line is added to the time ruler while the animated tool remains selected.

Figure 5.2 Top: Green fields indicate a parameter keyframe. Bottom: Blue fields indicate in-between values derived from the associated animation spline.

Figure 5.1 Animation menu options available when RMB-clicking over a parameter name in the Tools tab.

To remove a single keyframe, move the time slider to the frame that carries the keyframe, RMB-click over the parameter name, and choose Remove Key. In-between frames are indicated with a blue parameter field and a blue line beside the parameter name. To remove all keyframes for a parameter, RMB-click over the parameter name and choose Remove *parameter name*. If you wish to reset a parameter to its default value, RMB-click over the parameter name and choose Set To Default. You can overwrite an existing keyframe by moving the time slider to the correct frame and updating the parameter value.

You can also animate parameters that carry checkboxes. If the checkbox is selected, the keyframed value is 1.0. If the checkbox is deselected, the keyframed value is 0. In this way, you can create an on / off or off / on switch. To add a keyframe, RMB-click over the checkbox parameter name and choose Animate. Although the checkbox parameter receives an animation spline when there are two or more keyframes, the parameter rounds values between 0 and 0.49 to 0 and values between 0.5 and 1.0 to 1.0.

In a similar fashion, you can animate parameters that feature menu options or buttons. Each menu option or button is numbered from top to bottom or from left to right. Thus, when you keyframe the Filter Method parameter, the first menu option produces a keyframe value 0, the second menu option produces a keyframe value of 1.0, the third menu option produces a keyframe value of 2, and so on. With menus and buttons, however, the values are not rounded off; the menu or button only changes when a whole value is produced by the animation spline. For example, the menu changes when the values go from 1.9 to 2 or 2.9 to 3.

Approaches to Keyframing

When setting keyframes in Fusion, there are three basic approaches you can take:

Straight-ahead You start with the first frame and set a keyframe. You move forward on the time ruler, change the parameter value, and set a new keyframe. You continue to move forward in a predictable manner and set additional keyframes. This approach is suitable when creating a value change that is steady or linear. For example, if you are animating a piece of static art that is moving in a straight line with a Transform tool, you can use the straight-ahead technique to keyframe the Center XY. At the same time, this technique may work for complex value changes where a keyframe is required every 2 or 3 frames; in this situation, the automatic in-betweens created by the program may not be accurate enough and numerous manually-set keyframes may be necessary.

Bisecting This style is related to straight-ahead. However, this pattern is followed: first frame, last frame, middle frame, frame between first and middle, frame between middle and last, and so on. Pairs of previous keyframes are bisected to determine the location of new keyframes. The process continues until the animation is acceptable. This style of keyframing is suitable for animations where the total number of needed keyframes is not known. Bisecting allows you to add greater levels of detail to the animation spline as you go. With bisecting, 3, 11, 23, or any other odd number of keyframes may be suitable, depending on the parameter animated and the type of value-change that is needed.

Key Poses This approach replicates traditional, hand-drawn animation. With hand-drawn animation, key poses for a particular animation are identified and drawn first. Additional, in-between drawings are added only after the key poses have been drawn. You can animate in the same fashion in Fusion by identifying the most important values changes and keyframing those frames first before adding additional keyframing. Additional keyframes may be added to secondary, less-critical value changes or simply added through bisecting or straight-ahead techniques.

Shifting Keys and Altering Speed with the Timeline

The Timeline view, which is included as a default tab to the right of the Flow and Console view tabs, displays the keyframes set for one or more tools. To see the keyframes, select an animated tool or tools in the Flow view and switch to the Timeline tab. The selected tools are listed in the left column. Below each tool name, the animated parameters are listed. For example, if you keyframe the Blur Size parameter of a Blur tool named Blur1, Blur1 > Blur Size is listed in the left column (Figure 5.3). You can expand or contract the small arrow beside the tool name to display or hide the animated parameters.

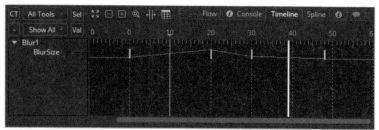

Figure 5.3 The Timeline view tab. A Blur tool, Blur1, is selected in the Flow view. Blur Size carries four keyframes, as indicated by the green vertical dashes. The white vertical line is the time slider. The cyan vertical line establishes the view's zoom focus.

Keyframes are drawn as green vertical dashes. The associated animation spline is drawn through the keyframes. You can LMB-drag the keyframe dashes left or right and thereby alter the animation timing. Keyframes that are close together create more rapid value changes. Keyframes further apart create value changes that are slower. For example, if you animate the Angle parameter of a Transform tool and spread the keyframes further apart, the rotation slows down.

You can zoom in or zoom out of the view by clicking the associated + and – buttons at the top left of the view. You can also zoom in or out by placing the mouse of the top bar that carries frame numbers and LMB-dragging left or right. The focus of the zoom is established by the vertical cyan line, which you can reposition by LMB-dragging. You can scroll left or right along the view's time ruler by LMB-dragging the horizontal bar at the bottom of the view. To automatically fit all of the keyframes to the view, click the Fit button to the left of the zoom out button. You can use your camera short-cuts to change the view within the keyframe field.

You can delete a keyframe in the Timeline view by LMB-clicking the keyframe dash so that it turns white and pressing the Delete key. You can set a new keyframe, using a current in-between curve value, by placing the mouse over an animation spline at the desired frame number, RMB-clicking, and choosing Set Key. Although the animation splines are displayed in the Timeline view, you cannot alter their shape beyond moving, adding, or deleting keyfra. Fusion provides several methods adding keyframes.

Altering Animation Splines with the Spline View

Although the Timeline view provides a convenient means to change the timing of keyframes, you cannot make subtle changes to animation splines. Hence, Fusion provides the Spline view, which is located in a tab to the right of the Timeline.

Much like the Timeline, the Spline view lists selected tools and associated animated parameters in the left column (Figure 5.4). You can select or deselect the checkbox beside any parameter or channel to display or hide its animation spline. To further refine the visibility of splines you can select a tool, parameter, or channel name in the left column. For example, you can select *Center* to show both the X and Y channel splines or *X* to show only the X spline.

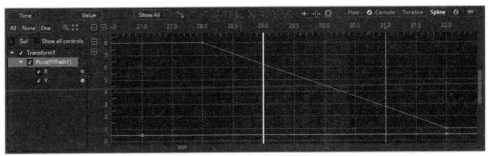

Figure 5.4 The Spline view tab. A Transform tool, Transform1, is selected. Pivot X and Y carry several keyframes, as indicated by the hollow boxes on the animation splines. The white vertical line is the time slider. The cyan vertical line establishes the view's zoom focus.

To automatically fit all the keyframes for visible splines to the view, click the Fit button at the top-left (this features four small arrows that point outwards). Alternatively, you can use the Zoom In Vert Zoom Out Vert, Zoom Out Hort, and Zoom In Hort buttons at the top-left of the spline field. These buttons feature + and – symbols. The vertical scale is the keyframe value and the horizontal scale is the time ruler frame value. The view also provides horizontal and vertical scroll bars at the bottom and right of the spline field. You can use your camera shortcuts to change the view within the Spline field.

Working with Displacement Splines and XY Paths

By default, when you keyframe the Center XY or Pivot XY parameter of a Transform or similar tool, a single animation spline is created for the parameter and is named *Pathn:Displacement*. This spline represents the current position on the motion path created when the parameter is keyframed. Hence, there is no separate X or Y spline. The Displacement spline value runs between 0 and 1.0 where 0 is the motion path start and 1.0 is the motion path end. Hence, the best way to adjust the animated transform is to either interactively shape the motion path in a Display view or change the values in the parameter fields.

If you would like to work with X and Y splines, RMB-click over the parameter name and choose Modify With > XY Path. X and Y splines are created. In the Timeline and Spline views, X and Y appear as channels under the parameter name. If previous keyframes exist, you will have to remove the animation before applying XY Path.

Adjusting, Adding, and Deleting Keyframes

In the Spline view, keyframes are drawn as hollow boxes. You can move a keyframe in time (left / right) or value (down / up) by LMB-dragging the boxes. The associated animation splines update to follow. When moving a keyframe in time, the mouse "sticks" to whole frame numbers. You can over-ride this action by entering a value in the Time field at the top-left of the view. You have the option of entering a new value in the nearby Value field.

To add a new keyframe, LMB-click on a spline. To delete a keyframe, select the keyframe box so that it turns white and press the Delete key.

Working with Tangent Handles

By default, spline segments are linear. You have the option to shape the segments and alter the keyframe tangent handles (also called **direction lines**). To do this, select a keyframe so that it turns white. Initially, the tangent handles lie on the spline. LMB-drag the tangent hollow-box ends. The handles ends move in unison, like a see-saw. However, you can move each end independently by Ctrl/Cmd+LMB-dragging a single end. You can LMB-drag the tangent ends to lengthen or shorten the handle segment, which gives you additional control over the spline shape.

In addition, you can change the tangent to one of several tangent types. To do this, select a key-frame, RMB-click in the spline field, and choose the tangent type from the menu. You can also change groups of tangents by LMB-dragging a selection marquee over multiple keyframe boxes, RMB-clicking in the spline field, and choosing the tangent type from the menu. A description of commonly used tangent types follows:

> **Linear** Creates a linear transition between neighboring keyframes (top left of Figure 5.5). This is the default state of the tangent handles.

> **Flat** Forces the tangent handles to lie flat so the splines take on smoother peaks and valleys (top right of Figure 5.5).

> **Smooth** Creates a smooth transition between neighboring keyframes (bottom left of Figure 5.5). The Smooth option may produce results similar to the Flat option, but the tangents handles are not given identical rotations.

> **Step In / Step Out** Step In cre-ates a "kink" in the spline so that the value does not change *until* the next keyframe is reached (bottom right of Figure 5.5). Step Out creates the opposite result. This option is suitable for creating an on / off value switch.

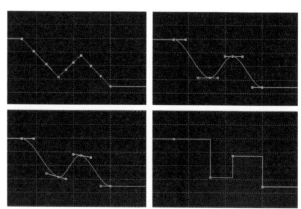

Figure 5.5 Clockwise, from top left: linear tangents, flat tangents, step in tangents, and smooth tangents. Note that Step In and Step Out tangent options remove the tangent handles.

Mini-Tutorial 4: Fine-tuning a Keyframe Animation

Fusion provides an easy means to interactively transform and keyframe an input. However, initial animations are rarely suitable as a final product. Hence, it's necessary to spend time in the Timeline and Spline views to refine the keyframe placement and animation spline shapes. In this tutorial, we'll create a simple animation of a square moving and rotating and adjust the animation so that it appears as if the square is dropping and bouncing off the frame edges.

1. Create a new project. Choose Edit > Preferences. In the Preferences window, switch to the Frame Format section. Set the resolution to 1280×720 and the frame rate to 24.
2. Choose Tools > Creator > Background. This tool creates a solid-colored rectangle or square. With the tool selected, switch to the tool's Tools > Image tab. Set the Width to 100 and Height to 100. Switch back to the Tools > Color tab and set the RGB sliders to a bright color, such as yellow.
3. Connect the Background tool to a Display view. Note that the frame resolution is 100×100. Create a second Background tool. Leave the size of Background2 set to the project resolution. Set the Background2 color to a sky color, such as light blue.
4. Create a Merge tool. Connect Background2 to the Background input. Connect Background1 to the Foreground input. Connect the Merge tool to a Display view. A smaller square now appears within a 1280×720 frame (Figure 5.6). We will animate the small square moving and rotating.

Figure 5.6 A 100x100 solid, generated by a Background tool, is merged with a 1280x720 solid, generated by a second Background tool.

5. In the TimeView, set the Global Start Time to 1 and the Global End Time to 48. Select the Merge tool. While on frame 1, interactively move the small square to the top-right of the frame. Select the Merge tool and go to the Tools > Merge tab. RMB-click over the Center XY parameter name and choose Modify With > XY Path. This creates an X and Y spline and sets the first keyframe with the square at the current location. RMB-click over Angle and choose Animate.

6. Go to frame 12. Interactively move and rotate the square so that it contacts the left side of the frame. Pretend that the frame edge is a wall. Go to frame 24. Move and rotate the square so that it contacts the bottom of the frame. Pretend that the frame bottom is a floor. Go to frame 36. Move and rotate the square so that it comes to rest at the right-bottom side of the frame. With three keyframes, a motion path is drawn in the Display view. Play back the time ruler. The square appears to be thrown through the air, hitting a wall, and falling to the ground. However, the animation is very linear and unnatural.

Figure 5.7 The Center XY and Angle parameters of the Transform tool receive keyframe animation. Three Center XY keyframes produce a motion path that makes it appear as if the square is thrown through the air and bounces off a wall and floor.

7. With the Merge tool selected, go to the Timeline view tab. Expand the arrow beside the Merge1 name in the left column. The Angle and Center parameters are revealed. The Center parameter is broken into two splines—Center:XYPath1:X and Center:XYPath1:Y. The X spline is colored red and the Y spline is colored green. LMB-drag a marquee box around all the keyframes dashes at frame 12. LMB-drag the selected dashes to the right so that they fall at frame 18. This lengthens the time it takes the square to travel over the first segment of the motion path. Select all the keyframes at frame 24 and move them to frame 28. This also slows the movement between the first and second set of keyframes. Play back the time ruler and note the difference in the motion. Feel free to experiment with timing by altering keyframe locations.

8. Switch to the Spline view tab. Select the Center parameter checkbox in the left column so that the X and Y splines become visible. Click the Fit button so that the keyframes are fit within the view. At this point, the movement between the keyframes is linear. You can add arcs to the motion by adjusting tangent handles. Move the time slider to frame 10. You can use the slider within the Spline view or use the slider in the TimeView. Select the keyframe box for the Y curve that sits at frame 18. The tangent handles become visible. LMB-drag the left side of the handle upwards. Note that the square moves up in the Display view. Select the keyframe box for the Y curve on frame 1. LMB-drag the tangent handle to smooth the spline segment between frame 1 and 18 (see Figure 5.8). (Only the right side of the handle is visible because no keyframes exist before frame 1.) Play back the time ruler. The square now arcs from the start to the contact with the virtual wall.

9. Using the technique described in step 8, give the square an arcing motion between frames 18 and frame 28 (Figure 5.8). In this situation, you'll need to create a sharp bend in the Y curve at frame 18. You can achieve this by Ctrl/Cmd-LMB-dragging the right side of the tangent handle without affecting the left side of the tangent handle.

Figure 5.8 The Center Y spline is given two arcs by adjusting the tangent handles at frames 1, 18, and 28. You can Shift+select multiple keyframes to display their tangent handles simultaneously. This adjustment causes the square to move in small arcs as opposed to straight lines.

10. Deselect the X and Y checkboxes to hide the X and Y splines. Select the Angle parameter. Experiment with the rotation of the square by adjusting the value and frame positions of each Angle keyframe. Moving a keyframe up in Y increases the rotational values while moving the keyframe down has the opposite effect. Play back the time ruler to gauge any changes. The final example of the tutorial uses the following Angle values:

 Frame 18: 15
 Frame 28: –45
 Frame 36: –90

The tutorial is complete! A finished version of this tutorial is saved as **\ProjectFiles\ FusionFiles\Chapter5\Animation.comp**. Note that you can use negative Center or Angle values if necessary. In addition, It's possible to set keyframes on frames with negative (pre-0) values, although that is not required for this tutorial.

Using Specialized Spline Options

Fusion provides additional tools and options for manipulating keyframes, tangents, and splines. These include Reverse, Reduce Points, Smooth Points, ease options, and loop options. In addition, the Spline editor supports copy and paste functions. These tools, options, and functions are accessible by RMB-clicking in the spline field of the Spline view. They are described briefly in this section.

Reverse This menu option reverses the order of selected keyframes and essentially mirrors the associated spline in the horizontal direction. For example, you can use Reverse to make an object rotate in the opposite direction.

Reduce Points This tool simplifies and splines by reducing the number of selected keyframes. When you choose this menu option, the Freehand Precision dialog window opens. The lower the Precision parameter value you enter, the fewer keyframes will remain after clicking the window's OK button.

Smooth Points This tool averages the values of selected keyframes. If you RMB-click in the spline field and choose Smooth Points > Default, a default averaging occurs (Figure 5.9). This allows you to simplify a spline and remove "bumps" (high peaks and low valleys). If you choose Smooth Points > Dialog, you can refine the averaging by adjusting the Sample Width, Order, and Sample Spacing parameters in the pop-up dialog box. The larger the Sample Width value, the stronger the averaging and the more likely that keyframes will share similar values.

Figure 5.9 Left: A group of keyframes forming tall peaks and deep valleys along the spline. Right: Same set of keyframes after the application of Smooth Points > Default.

Ease Menu If you select two side-by-side keyframes, RMB-click, and choose Ease > *style*, you can automatically affect the transition between the keyframes. The styles fall into *ease in* and *ease out* categories. **Ease out** refers to the slowing down of a value change between the first and second keyframe. **Ease in** refers to the speeding up of the value change between the first and second keyframe. Ease in and ease out transitions are common in professional animation as they replicate the change of speed of many real-world objects. For example, a fast rolling ball eventually slows to a stop. In Figure 5.10, two keyframes with linear tangents are given ease ins and ease outs.

Figure 5.10 Left: Two selected keyframes carry linear tangent handles so that the change in value is consistent over time. Middle: Same keyframes after the application of Ease > In Cubic. Right: Same keyframes after the application of Ease > Out Cubic.

Set Loop Menu You can repeat a portion of a spline so that the motion repeats over and over. This may be useful for animation requiring repetitive motions, such as a walking character, a flapping butterfly, or a bouncing ball. To create a loop, select the keyframes that cover the motion you'd like to repeat, RMB-click, and choose Set Loop > Loop. The looped portion of the spline receives a dotted line (Figure 5.11). The first loop starts at the last selected keyframe. To generate a smooth transition between each loop, it's necessary to give the first selected keyframe and last selected keyframe the same value. Optionally, you can choose Set Loop > Ping-Pong, which causes each loop to become a mirror of the previous loop (much like applying the Reverse menu option).

Figure 5.11 Four keyframes forming a peak in the spline are looped with Set Loop > Loop. The new loops are given a dotted line and do not have keyframes or tangent handles. If you alter the original keyframes, however, the loops update to match.

Copying and Pasting You can copy a keyframe value by selecting the keyframe, RMB-clicking, and choosing Copy Points. You can also press Ctrl/Cmd+C. You can paste the value and thus insert a new keyframe by placing the mouse over a spline at the desired frame number, RMB-clicking, and choosing Paste Points / Value. You an also press Ctrl/Cmd+V. You can copy and paste multiple keyframes and thus replicate a portion of the spline.

Chapter Tutorial: Fixing Animation and Adding a Camera Move

In the Chapter 3 tutorial, we combined the 3D render of a taxi and a walking man with a static matte painting of a theater. We can improve this composition by adding animation to the 3D render. In addition, we can fabricate a camera movement by extending the frame, cropping into the frame, and animating the Crop tool's offsets. You can follow these steps:

1. Open the `\ProjectFiles\FusionFiles\Chapter3\AssembleShot.comp` project. Connect the Merge3 tool to a Display view. Play back the time ruler to gauge the animation. The 3D man exits the taxi and walks toward the theater. However, his feet slide as he walks; this is due to the 3D animation being created without the benefit of a 3D set. You can correct with additional Center XY keyframes.
2. Go to frame 110. This is the frame where the man's left foot touches the ground at the end of a step. With the Merge2 tool selected, RMB-click over the Center XY parameter and choose Modify With > XY Path. A keyframe is laid down for the X and Y channels.

3. Move the time slider to frame 128. Note how the man's left foot slides a significant distance (Figure 5.12). Interactively move the man (via the Merge2 tool) so that his left foot remains planted in the original frame 110 position. Use the diagonal line on the sidewalk as a reference. Move the time slider back and forth to gauge to degree of slide. A Center XY of roughly 0.58, 0.27 works well for frame 128.

Figure 5.12 Left: The 3D man's left foot reaches the diagonal line on the sidewalk on frame 110.
Right: The man's left foot remains in the correct position on frame 128 after the Center XY of Merge2 is
animated; the resulting motion path has uses three keyframes to minimize sliding between frames 110
and 142. Note the change in scale.

4. Move the time slider between frame 128 and the last frame, 142. Note that the man slides right during the next step. On frame 142, position the man to remove the sliding (Figure 5.13). Center XY values of 0.61, 0.26 work well.
5. Play back the time ruler. The movement of the man is improved; however, he diminishes in size too rapidly during the last two steps. Although you can keyframe the Size parameter of the Transform2 tool, the scale change occurs from the pivot. With a Transform tool, there is no Pivot XY parameter. As a workaround, insert a new Transform tool between the Loader importing the render (labeled *taxi.##.png*) and Merge2. You can do this by selecting the Loader and choosing Tools > Transform > Transform.
6. Go to frame 110. Change the new Transform tool's Pivot XY so that the rotation handle sits over the man's left foot (Figure 5.13). Use the XY values 0.4, 0.25. RMB-click over the Transform tool's Pivot XY parameter and choose Animate. We will need to shift the pivot over time to keep up with the man's walk. RMB-click over the Transform tool's Size parameter and choose Animate (the default value is 1.0).

Figure 5.13 The Pivot XY of a new Transform tool
is animated to follow the man's left foot. Frame
110 is shown on the left while frame 142 is shown
on the right. The new pivot location is indicated
by the rotation circle with the green center ×.
The original position of the transform handle is
indicated by the circle with the red axis handle.

7. Go to frame 142. Update the Pivot XY values so that the rotation handle stays over his left foot (Figure 5.13). Use 0.26, 0.37 as XY values. A new keyframe is created automatically. Increase the Size slider so that the man keeps a size consistent with frame 110. A value 1.15 works well for frame 142. Play back the time ruler to judge the result. Because the size change occurs from the pivot point, which stays at his feet, he becomes taller without causing any additional sliding or drifting. Feel free to further refine the result. For example, insert additional keyframes at frames 116 and 135 to prevent the man's slight slide toward the right of frame. To see the play back without the transform handles, deselect all the tools but leave Merge 3 connected to a display view.

8. In addition to correcting the motion of the 3D render, you can also use keyframing to create a camera move as part of the composite. Before we can do this, however, we must extend the frame. With this project, we can extend the sky and then create a camera tilt-down. With no tool selected, choose Tools > Creator > Background. A new Background tool is added to the Flow view. Change the tool's Color to the same color as the matte painting sky. To achieve this, click the Pick button (in the Color section of the Tools > Color tab). This opens the Color window. Click the Pick Screen Color button and use the mouse cross-hair to sample the sky in a Display view (connect the Loader importing the theater matte painting directly to a Display view first). Click the OK button to close the Color window. Switch to the Background tool's Image tab. Change the Height parameter to 2000.

9. Select the Loader that imports the theater matte painting. Choose Tools > Composite > Merge. A new Merge tool, Merge4, is inserted between the Loader and Merge1. The Loader is connected automatically to the Background of Merge4. This connection will not work. Disconnect the Loader from Merge4 and connect it to the Foreground input instead. Connect the Background tool to the Merge4 tool's Background input. Use Figure 5.14 as reference for the final tool network.

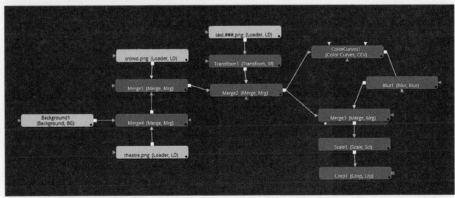

Figure 5.14 The final tool network for this tutorial.

10. Connect the Merge4 tool to a Display view. The frame is adjusted, becoming 1920×2000. The theater matte painting remains centered in frame. (There is a noticeable line at the top edge of the painted sky—we will remove this in chapter 7 through masking.) Altering the resolution of the Merge1 Background input unduly affects the integration of the Foreground input. Hence, the crowd art appears too high in frame when viewing the output of Merge2. To fix this, lower the theater matte painting by changing the Center XY of the Merge4 tool to 0.5, 0.4 (Figure 5.15).

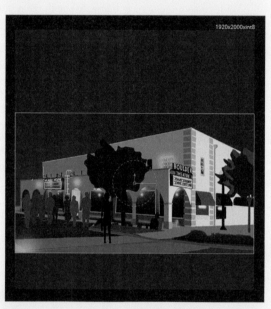

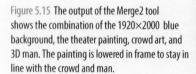

Figure 5.15 The output of the Merge2 tool shows the combination of the 1920×2000 blue background, the theater painting, crowd art, and 3D man. The painting is lowered in frame to stay in line with the crowd and man.

11. Connect the Merge3 tool to a Display view. The frame remains 1920×2000, which is the largest resolution employed by the tool network. To return to a 1920×1080 final frame, we can use a Crop tool. To give us flexibility with the final framing, we can also add a Scale tool. Connect the output of Merge3 to a Scale tool. Connect the output of the Scale tool to a Crop tool. Use Figure 5.14 as reference for the final tool network. Both tools are located in the Tools > Transform menu. Set the Size propriety of the Scale tool to 1.1. A small upscale, in general, does not harm the quality final output (a large upscaling leads to pixelation or excessive softness). Set the Crop tool's X Size to 1920 and Y Size to 1080. Connect the Crop tool to a Display view. The frame is cropped, although it reveals the unwanted lower portion of the frame where there is extra blue generated by the Background tool.

12. To better frame the final result, and to create a camera move, animate the Crop tool's X Offset and Y Offset over time. For example, on frame 0, keyframe X Offset at 114 and Y Offset at 781. On frame 40, keyframe X Offset at 37 and Y Offset at 310. This creates a tilt down at the start of the shot (Figure 5.16). Experiment with additional keyframes to give the camera extra motion, such as small pans and "bumps." Feel free to use the Timeline and Spline views to adjust the timing. Use the sections earlier in this chapter for tips and tricks when using these views. For example, add ease ins and ease outs to make the camera motion less linear.

The tutorial is complete! A finished version of this tutorial is saved as `\ProjectFiles\FusionFiles\Chapter5\ShotAnimate.comp`. We'll return to this tutorial in Chapter 6 to add masking.

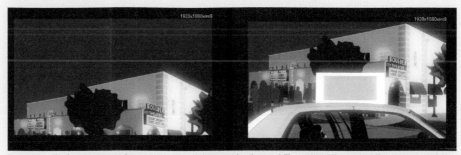

Figure 5.16 The frame is returned to a 1920×1080 resolution with a Crop tool. The tool's X Offset and Y Offset are animated to create a fake camera tilt-down. Frame 0 is shown on the left of this figure and frame 40 is shown on the right.

animation

shape animation

X 0.44427 Y 0.55185

X 0.44791 Y 0.53518

X 0.45312 Y 0.44907

X 0.46562 Y 0.41851

X 0.49166 Y 0.43333

X 0.47760 Y 0.53518

Masking and Rotoscoping

Masking allows you to generate new alpha mattes by creating polyline shapes or examining pixel values within an image. Masking is an integral part of compositing as it is often necessary to divide a frame up into multiple parts or to isolate a particular element. Rotoscoping takes masking one step further by animating the mask position or shape over time. This lets the mask follow a particular feature, like a moving actor or a shifting prop. Fusion offers a wide variety of masking tools, many of which provide a means to interactively draw or paint masks within the Display views.

This chapter includes the following critical information:

- Creating and connecting primitive masks
- Drawing and editing polyline masks
- Generating masks from pixel values
- Animating masks to undertake rotoscoping
- Applying advanced rotoscoping techniques with polyline tools

Masking

In digital compositing, a **mask** is a device that "cuts out" an image in the shape of the mask. The image may be a video file, image sequence, static bitmap, or a procedural pattern generated by a tool. There are various goals of masking, including the following:

- Separating a section of an image so that it can carry a unique set of filters or filter values
- Removing unwanted items, such as lights or rigging, from a frame
- Separating an element within a frame so that other elements may be placed "behind"

The process of animating a mask so that it changes shape over time is called **rotoscoping**. A mask affects the alpha channel of the image that's connected to it. A mask establishes what areas of the frame are given opaque alpha values and what areas are given transparent alpha values. Alpha channels are sometimes referred to as **alpha mattes**. You can think of a **mask** as the device that creates a unique alpha matte, wherein some areas are transparent and other areas are opaque.

Adding and Connecting a Primitive Mask

Fusion provides several methods you can use to mask. These are discussed throughout this chapter. A common method of masking uses a polyline tool. The Tools > Mask menu includes several polyline-based masking tools, including BSpline, Polygon, Ellipse, Triangle, and Rectangle. A polyline mask is composed of control points with spline segments running between the points.

The Ellipse and Rectangle tools create primitive mask shapes. When you create one of these tools, the resulting mask appears in a Display view when the tool is selected. This includes a central transform handle that you can interactively adjust to make changes in the mask position, size, or rotation. You can also adjust the size of the mask by LMB-dragging the yellow mask edges.

A mask is not functional until you connect its output to the Effect Mask input of another tool. This input appears as a purple triangle. For example, if you connect a Rectangle tool mask to the Effect Mask input of a Loader tool, the imported footage is cut out in the shape of a rectangle. If you connect the mask to the Effect Mask input of a filter, such as Color Curves, the effect application only occurs within the interior of the mask (Figures 6.1 and 6.2).

Figure 6.1 A Rectangle mask tool is connected to the Effect Mask input of a Color Curves tool, causing the effect of the Color Curves tool to only appear within the Rectangle mask shape.

Figure 6.2 When selected, the Rectangle mask carries a transform handle.

When you connect a mask to the Effect Mask input of a Merge tool, the Foreground connection is affected. For a mask to function, it must be "closed," where the first point and last point of the spline are at the same position within the frame. Ellipse, Rectangle, and Triangle masks are closed by default. The Triangle tool does not carry a transform handle; nevertheless, you can LMB-drag the corner points in a Display view to affect the mask's size and shape.

Drawing a Polygon or BSpline Mask

With the Polygon tool, you can interactively draw the mask in a Display view. To use this tool, follow these basic steps:

1. Connect the tool you wish to mask to a Display view. For example, connect a Loader that carries an image sequence.
2. Choose Tools > Mask > Polygon. A Polygon tool is created and appears in the Flow view. While the new tool is selected, LMB-click in the Display view. Each time you LMB-click, a new polyline control point is added and a spline forms. (Control points are also referred to as **vertices**.)
3. To make the mask functional, you must close the spline. Place the mouse of the first point. The mouse icon changes to a small circle. LMB-click to close the spline. Optionally, RMB-click in the Display view and choose Polygon*n*:Polyline > Closed, which adds a final spline span between the first and last point.
4. To activate the mask, connect the output of the Polygon tool to the Effect Mask input of the tool you wish to mask.

If you connect the mask to a Merge tool, the area of the Foreground inside the closed mask receives 100% opaque alpha values while the area outside the mask becomes 100% transparent. If you connect the mask to a Loader, the loaded footage receives 100% transparent alpha outside the mask (Figure 6.3).

With a Polygon tool mask, you can LMB-drag a point to reposition it. When a point is selected, its tangent handle becomes visible. You can LMB-drag the tangent handle ends to affect the curvature of nearby polyline spans. You can LMB-drag tangent handle ends to make them longer or shorter and thus affect smoothness or sharpness of nearby spline segments. To "break" a tangent handle so you can move one side of a tangent handle without affecting the opposite side, Ctrl/Cmd+LMB-drag. To "unbreak" the handle so both sides of the handle are aligned, select the point, RMB-click in the Display view, and choose Polygon*n*:Polyline > Smooth.

Figure 6.3 A mask drawn with the Polygon tool cuts out an actor. The Polygon tool output is connected to the Effect Mask input of a Loader tool. Note the tangent handles—some handles are left in their default state while others have been moved to create smoother spline spans.

You can convert any point to a linear or smooth state, thus affecting the surrounding spline spans. To do so, select one or more points, RMB-click in the Display view, and choose Polygon*n*:Polyline > Linear or > Smooth. When you convert the points to smooth, the tangent handles are flattened to maximize span smoothness. When you convert points to linear, the handles are broken and each tangent end is aligned with its associated span. Linear is the default state of the points when you first draw the mask. You can select multiple points by LMB-dragging a selection marquee in a Display view.

To add a new point to a Polygon mask, LMB-click on a spline segment. To delete a point, select it and then press the Delete key. The Polygon tool provides a transform handle for moving, scaling, and rotating the entire mask.

The BSpline tool works in a similar fashion to the Polygon tool. However, with the BSpline tool, the final spline takes on a smooth shape with the linear polygon spans serving as a b-spline hull.

Using the Polygon Toolbar

When you select a Polygon tool, a toolbar is integrated into each Display view (Figure 6.4).

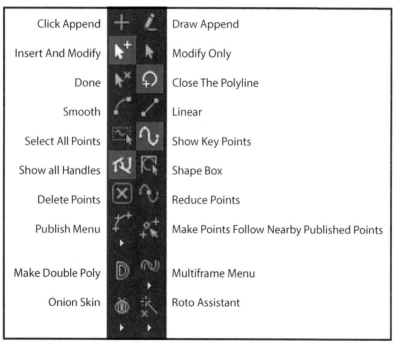

Figure 6.4 The Polygon tool's toolbar.

Although it's not mandatory to use the toolbar when drawing and adjusting a mask, there are many useful options that can make the masking process more efficient. The options are briefly described in this section.

Click Append Provides a crosshair mouse icon with which you can draw a new mask by LMB-clicking in a Display view to lay down points. If a mask already exists, this button does not function.

Draw Append Allows you to interactively draw a smooth mask by LMB-clicking and dragging in a Display view. You can close the mask by ending the polyline where you started. When you release the mouse button, a number of points are added automatically to maintain the smooth polyline shape. If a mask already exists, this button does not function.

Insert And Modify Allows you to insert new points by LMB-clicking on a spline span. This is activated by default.

Modify Only Prevents the insertion of new points. This deactivates Insert And Modify.

Done Hides points so that additional manipulation cannot be carried out. You can deactivate this option by activating Insert And Modify or Modify Only.

Close The Polyline When activated, indicates a closed mask (if the mask was closed when it was drawn). You can open a mask by deactivating this button, in which case the final spline span is removed. If a mask was never closed, you can activate this button; a final span is added to connect the first and last point.

Smooth When clicked, converts selected points to smooth tangent handles.

Linear When clicked, converts selected points to linear tangent handles.

Select All Points When clicked, selects all mask points.

Show Key Points When deactivated, hides the mask points.

Show All Handles When activated, displays the tangent handles of selected points. This button is activated by default.

Shape Box When activated, creates a transform box around selected points. You can move the selected points as a unit by LMB-dragging one of the transform box edges. You can scale the points as a unit by LMB-dragging one of the transform box handles (drawn as smaller hollow boxes). To remove the transform box, deactivate the Shape Box button.

Delete Points When clicked, deletes selected points.

Reduce Points When clicked, pops open the Freehand Precision dialog window. You can interactively move the Precision slider in the window to remove points and simplify the polyline. The reduction is made permanent when you click the window's OK button. This option is designed for polylines drawn with the Draw Append option, which produces point-dense polylines.

The buttons at the bottom of the toolbar, which include Publish Menu, Make Points Follow Nearby Published Points, Multiframe Menu, Onion Skin, and Roto Assistant, are designed for rotoscoping tasks and are discussed in the section "Using Advanced Polygon and Mask Paint Rotoscoping Tools" later in this chapter. The Make Double Poly button is described in the next section.

Adjusting the Polyline Matte Edge

Polyline-based masking tools include several parameters that you can use to adjust the resulting alpha matte (Figure 6.5). These include Level, Soft Edge, and Border Width. Level controls the degree of matte opacity. Level values below 1.0 introduce transparency to the opaque portion of the matte. Soft Edge feathers the matte edge. When Soft Edge is set to 0, there is a 1-pixel transition from the opaque to transparent part of the matte. The quality of the soft edge is set by Filter buttons. Box is the crudest yet most efficient filter while Gaussian produces the highest quality. Border Width allows you to expand or contract the matte. Values below 0 contract and values over 0 expand.

You can invert the alpha matte by selecting the Flip checkbox. With Flip, opaque becomes transparent and vice versa. You can combine multiple masks, and thus create single alpha matte, by connecting the output of the first mask tool to the Effect Mask input of a second mask tool.

Figure 6.5 Alpha matte parameters shared by Polygon, BSpline, Rectangle, Ellipse, and Triangle mask tools.

If you create a mask with the Polygon tool, you have the option of creating a double-line mask that allows the edge to carry variable softness. To add the extra line, select mask points in a Display view and click the Make Double Poly button in the toolbar (see the previous section). A second, dotted line is added but overlays the original polyline. To move the new line, Ctrl/Cmd+LMB-drag one or more points. When the new line is moved away from the original polyline, a soft transition at the matte edge occurs (Figure 6.6). The new line is referred to as the outer shape. By default, the shapes of both polylines are automatically keyframed via the Polyline parameters (marked with the phrase *RMB-Click Here* at the bottom of the Tools > Controls tab).

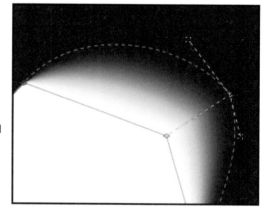

Figure 6.6 Close-up of Polygon mask that is converted to a double polyline. The outer line, dotted, is moved away from the original inner line, colored green. This creates a soft matte edge in a small area. Note the outer line carries its own tangent handles.

Employing Bitmap Masks

It's possible to create a mask using the pixel values of a bitmap image. The Bitmap tool (Tools > Mask > Bitmap) is designed to pass the alpha values contained within a bitmap to an Effect Mask input. For example, in Figure 6.6, the output of a Text+ tool is connected to the Image input of a Bitmap tool. The output of the Bitmap tool is connected to the Effect Mask input of a Loader tool. The end result is an image sequence cut out in the shape of the text (Figure 6.7).

Figure 6.7 A Text+ tool is connected to a Bitmap tool, which in turn is connected to a Loader tool. Thus, the alpha channel of the Text+ tool is transferred to the Loader.

Figure 6.8 The result of the Figure 6.5 network—an image sequence is cut out in the shape of the word *Alpha*. The checkerboard pattern indicates the transparent area. This project is saved as `\ProjectFiles\FusionFiles\Chapter6\BitmapMask.comp`.

Mini-Tutorial 5: Creating a Luma Mask

You can transfer values from a color channel, such as red, to an alpha channel using the Channel Booleans tool. This type of masking is often called **luma masking**. **Luma** refers to luminance or intensity of pixels. To create a luma mask, you can follow these steps:

1. Identify what you would like to mask. This might be the output of a Loader or the Foreground input of a Merge tool. Identify what you would like to use as a source for a mask. You can use the red, green, or blue channel of any tool in Fusion. For example, create a new project and import one of the image sequences included in the `\ProjectFiles\Plates\` directory. We will mask this image sequence. Choose Tools > Creator > DaySky. The DaySky tool creates color gradient that emulates a daytime blue sky (Figure 6.9). However, the tool outputs an extra-wide frame. With the DaySky tool selected, switch to the tool's Image tab. Change the Width and Height parameters to match the image sequence resolution. The DaySky tool will serve as the mask source.

Figure 6.9 Sky gradient generated by DaySky tool.

2. Choose Tools > Color > Channel Booleans. The Channel Booleans tool is designed to copy, re-order, and mix incoming channels. Connect the output of the DaySky tool to the Background input of the Channel Booleans tool. Connect the output of the Channel Booleans tool to the Effect Mask input of the Loader (Figure 6.10). Connect the Loader to a Display view. At this point, there is no change. The image sequence maintains a 100% opaque alpha channel.

Figure 6.10 A network designed to transfer channel values output by the DaySky tool to the Loader tool's Effect Mask input, which uses those values as an alpha matte.

2. Select the Channel Booleans tool. Note the default parameter values in the Tools > Color Channels tab. The Operation menu is set to Copy and the To Red, To Green, To Blue, and To Alpha menus are set to the matching FG (Foreground) channels. Connect the Channel Booleans tool to a Display view. The sky appears the same. In this case, there is no Foreground input, so the tool outputs the Background input as is. Change the To Red menu to Red BG, the To Green menu to Green BG, the To Blue menu to Blue BG, and the To Alpha menu to Alpha BG. Once again, there is no change to the sky because the channels are matched up (red to red, blue to blue, and so on). However, if you want a different result, you can change the menus so the channels don't match. For example, change the To Green menu to Blue BG. The sky becomes aqua-green as the incoming blue channel values are copied to the outgoing green and blue channels and the incoming green channel is ignored.

3. For the purpose of this tutorial, we need to transfer one of the color channels to the Effect Mask input of the Loader. Connect the Loader to a Display view. Change the Channel Booleans tool's To Alpha menu to Red BG (Figure 6.11). The image sequence is cut out in the shape of the red channel, where the bottom and lower edges of the frame are opaque and the center and upper part of the frame is semi-transparent. Change the To Alpha to Green BG and Blue BG and compare the results. If you return the To Alpha menu to Alpha BG the image sequence regains its opaque alpha channel because the DaySky tool generates a sky gradient with an opaque alpha channel.

The tutorial is complete! A finished version of this tutorial is saved as `\ProjectFiles\Fusion-Files\Chapter6\LumaMask.comp`. If you need to visualize what type of alpha matte a color channel might produce, examine the channel, by itself, in a Display view by switching the view's Color menu to the channel name, such as Red.

Operation	Copy
To Red	Red BG
To Green	Green BG
To Blue	Blue BG
To Alpha	Red BG

Figure 6.11 Channel Booleans tool parameters set to transfer the incoming red channel as the outgoing alpha channel.

Creating Primitive and Polyline Masks with Mask Paint

The Mask Paint tool (Tools > Mask > Mask Paint) provides a set of interactive masking sub-tools that allow you to draw or paint a mask in a Display view. When you create and select a Mask Paint tool, a special toolbar is added to the Display views (this appears to the right of the Right Display view and the left of the Left Display view). The toolbar includes polyline-based paint masking tools, as well as selection and copy tools (Figure 6.12).

The Circle and Rectangle sub-tools create primitive mask shapes. To use one of these, connect the Mask Paint tool to a Display view, LMB-click the toolbar Circle or Rectangle button, and LMB-drag in a Display view. When you release the mouse button, the mask shape size is set. By default, the shape is solid white.

To make the mask drawn with the Mask Paint tool functional, you must connect the Mask Paint tool's output to the Effect Mask input of another tool.

You can alter a pre-existing rectangle or circle mask shape by selecting it. To do this, click the Select sub-tool in the toolbar and LMB-click the mask in a Display view. A selected mask receives a transform handle, which you can use to interactively move the mask. To scale the mask, LMB-drag its outer edge. When a mask shape is selected, additional parameters become available in the Tools tab. These include Width, Height, and Color.

To delete any mask created with the Mask Paint tool, press the Delete key while the mask is selected. A single Mask Paint node can carry multiple masks drawn or painted with multiple masking tools. Multiple masks are combined into single alpha matte when the Mask Paint tool output is connected to the Effect Mask input of another tool. To switch between masks and thus access each mask's set of parameters, use the Select sub-tool.

Select
MultiStroke
Clone MultiStroke
Stroke
Polyline Stroke
Circle
Rectangle
Copy Polyline
Copy Ellipse
Copy Rectangle
Fill
Paint Group

Figure 6.12 Mask Paint toolbar.

You can Shift+LMB-click multiple masks, regardless of the sub-tool used to draw them, and move them as a single unit (Figure 6.13). Alternatively, you can click the Paint Group button while the masks are selected and convert them to a group. As a group, they are given a single central transform handle. The parameters of the group, which are visible in the Tools > Controls tab for the Mask Paint tool, include a Size and Angle slider. To ungroup the masks, click the UnGroup button in the same tab.

Figure 6.13 Two masks, created with the Circle and Rectangle tools, are selected. While selected, they can be moved as a single unit with either transform handle. Note that masks can be moved past the edge of the frame.

The Copy Ellipse and Copy Rectangle sub-tools are designed to copy mask values so you can reposition those values in another part of the frame. For example, to apply the Copy Rectangle sub-tool, click the associated button in the toolbar and LMB-drag in a Display view. When you release the mouse button, the size of a drawn rectangle is set. Any portion of any mask within the rectangle is copied. If you LMB-drag the rectangle via its transform handle, those mask portions follow the rectangle. When you reposition the rectangle, the copied contents within the rectangle supersede any other masks within that area. You can delete a Copy Ellipse or Copy Rectangle mask by using the Select tool to select the mask and pressing the Delete key.

The Polyline Stroke sub-tool operates in the same fashion as the Polygon tool (discussed in the section "Drawing a Polygon or Spline Mask" easier in this chapter). However, when you draw a polyline with the tool, a thin mask is created along the polyline as a line (Figure 6.14). You can adjust the thickness of the line by adjusting the Size parameter, which is in the Brush Controls section of the Tools > Controls tab (Figure 6.15). You can adjust the softness of the line edge with the Softness slider. You can also switch to different line types by clicking the Brush Shape buttons.

Figure 6.14 A thin mask drawn with the Polyline Stroke tool, which is included as one of the Mask Paint masking tools.

Figure 6.15 The Brush Controls section provided for a Polyline Stroke mask.

Filling a Polyline Stroke Mask

You can fill the center of a closed Polyline Stroke mask with the following additional steps:

1. Select the Polyline Stroke mask by using the Select sub-tool. You can LMB-drag a selection marquee over a portion of the mask to make the selection easier.
2. Go to the Tools > Controls tab of the Mask Paint tool. Click the Brush Square button listed under Brush Shape. This removes softening from the edges of the mask and prevents semi-transparent alpha values.
3. Click the Fill tool in the toolbar. Note that the Fill tool's icon moves when you use the Polygon Stroke tool (the toolbar expands into two columns). If you let your mouse hover over a button in the toolbar, the button's identity is listed in a small dialog box. With the Fill tool activated, LMB-click in the center of the closed Polygon Stroke mask. The mask becomes solid with no gap between the original line and the filled area.
4. If you move or rotate the Polygon Stroke mask, the fill area updates to follow the changes. However, if you move the Polygon Stroke mask past the farthest edge of the fill, the fill disappears.

Painting a Mask with Mask Paint

You can interactively paint a mask with the Multistroke sub-tools provided by the Mask Paint tool. Follow these steps to paint a multistroke mask:

1. Select the Mask Paint tool. Click the Multistroke button (see Figure 6.11 in the previous section).
2. LMB-drag in a Display view. Release the mouse button to end the stroke.
3. You can draw multiple strokes with a single Mask Paint tool. The resulting alpha matte is the net sum of all the strokes and all other masks created with the tool. The strokes become functional if the Mask Paint tool output is connected to the Effect Mask input of another tool.

To adjust the strokes, you can follow these basic guidelines:

- If you wish to adjust the width or edge softness of a stroke, adjust the Size and Softness sliders in the Controls tab *before* drawing the stroke.
- If you wish to use a different brush shape, select a brush shape button *before* drawing the stroke. The buttons, from left to right, are Soft, Circular, Image, Pixel, and Square. The Image button uses a bitmap texture that is established by the Image Source section.
- By default, the strokes are colored white, which is often useful when creating an alpha matte. However, you can change the color through the Color section of the Controls tab. For example, changing the color to gray makes the resulting alpha matte semi-transparent where the stroke lies. You can also adjust the Opacity parameter to create a semi-transparent mask.
- To select a stroke, choose the Select sub-tool and LMB-click the stroke in a Display view. When selected, a red polyline is revealed along the center of the stroke (Figure 6.16). To select multiple strokes, LMB-drag a selection marquee in a Display view with the Select sub-tool.
- You can delete a selected stroke by pressing the Delete key.

Figure 6.16 Four strokes are drawn with the Multistroke sub-tool and are selected with the Select sub-tool. Their red polylines are revealed. The Mask Paint tool is connected to a Display view.

In addition to the Multistroke button, the Mask Paint toolbar carries a Clone Multistroke button (see Figure 6.11 in the previous section). This button activates the Clone button in the Apply Controls section, which is described later in this section. The Stroke button, below the Clone Multistroke button, creates strokes similar to the Multistroke button but offers the advantage of a transform handle. The handle appears when the stroke is selected; you can use this to interactively move or rotate. Both Multistroke- and Stroke-style strokes carry Size and Angle parameters in the Stroke Controls section of the Tools > Controls tab. This section also provides a Spacing parameter, which determines how closely primitive circles are placed to form the stroke lines. High Spacing values create a series of separated circles.

Each Multistroke- and Stroke-style stroke carries an Apply Controls section in the Tools > Controls tab (Figures 6.17 and 6.18). By default, the Apply Mode parameter is set to Color via the Color button, which creates a solid-colored stroke. However, you can switch to other stroke types by selecting a different Apply Mode button and drawing a new stroke with the Multistroke or Stroke sub-tool.

Figure 6.17 The Apply Controls section of the Tools > Controls tab carried by a Mask Paint tool.

Figure 6.18 Apply Mode buttons.

The various Apply Mode buttons are described here:

Color The default mode that creates solid-colored line.

Clone Clones areas of the frame and uses the cloned pixel values to color the stroke line. To sample an area of the frame, Alt/Opt+LMB-click.

Emboss Adds shading to the line so that overlapping strokes appear to have depth with bright and dark edges. Although not particularly useful as a mask, this mode may be useful for creating stylized motion graphics.

Erase Creates holes in other strokes that the Erase stroke overlaps. This mode offers a means to "break" pre-existing strokes into parts. To see the Erase mode function, connect the Mask Paint tool to the Effect Mask input of another tool and connect that tool to a Display view.

Merge By default, multiple, overlapping strokes are added together by the Mask Paint tool. Hence, if you overlap two, semi-transparent stokes, the point at which they overlap becomes more opaque (the alpha values are added together). If you draw strokes with the Merge mode, you can alter this behavior by adjusting the Subtractive / Additive parameter, which is added when you click the Merge button. If you lower the Subtractive / Additive parameter value, the edges of the new Merge stroke are subtracted from strokes it overlaps. This results in darker edge lines where the strokes overlap.

Smear Distorts other strokes that the Smear stroke overlaps.

Stamp Renders the stroke line as a series of overlapping, shaded circles. Much like Emboss, this mode may be suitable for creating stylistic effects.

Wire Removal This mode is designed to remove wires and other vertical elements over time and is a form of a paint fix. This mode is discussed in Chapter 10.

Combining Masks

You can combine multiple masks by connecting the output of one mask to the Effect Mask input of another mask. The mask tools do not have to match. You can also combine two masks using the Matte Control tool, described in Chapter 7.

Converting Sampled Values into a Mask

The Ranges and Wand tools (in the Tools > Mask menu) can convert specific pixel values into a mask. The Ranges tool targets a specific range of values in one of the RGBA channels or within the RGB luminance. To use the Ranges tool, follow these basic steps:

1. Connect the tool that will provide the pixel values to the Image input of the Ranges tool.
2. Connect the output of the Ranges tool to the Effect Mask input of another tool. You can use the same tool for the Image input and the Effect Mask input; however, you must use two iterations of that tool (Figure 6.19).

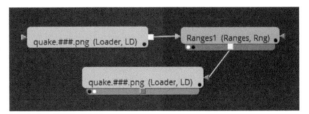

Figure 6.19 Two loaders importing the same image sequence are used with a Ranges tool. One supplies pixel values to the Ranges tool and one accepts the resulting alpha matte.

3. Select the Ranges tool. Choose the value range you wish to target by clicking the Shadows, Midtones, or Highlights button (Figure 6.20). For example, if you want to target a bright sky, click the Highlights button.

Figure 6.20 The range buttons, Channel buttons, and range graph of the Ranges tool. The Preset Simple button is selected, creating a linear falloff.

4. Choose the channel you wish to use by clicking one of the buttons offered by the Channel parameter. Available channels include Lumin (Luminance), Red, Green, Blue, and Alpha.

5. After choosing a channel, you have the option to click the Preset Simple button or Preset Smooth button. Both buttons affect a graph that controls the falloff of the targeted value range. Preset Simple creates a linear falloff and Preset Smooth creates a smooth falloff. The falloff affects the subtlety with which the resulting alpha matte transitions from opaque to transparent pixels. With these buttons, you can interactively LMB-drag the tangent handles within the graph. If you connect the Ranges tool to a Display view, you can see the alpha matte. If you connect the tool with the Effect Mask input to a Display view, you can see the result of the alpha matte (Figure 6.21). Optionally, you can invert the matte by selecting the Invert checkbox.

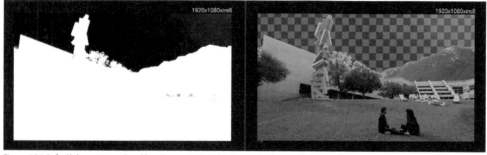

Figure 6.21 Left: Alpha matte produced by a Ranges tool. Right: the result when the Ranges tool is connected to the Effect Mask input of a Loader. With this example, the footage providing pixel values is identical to the footage that is masked. In order to remove the bright sky, the Ranges tool's Highlights and Blue buttons are selected. To remove the sky, and not save it, the Invert checkbox is selected. This project is included with the tutorial files as **\ProjectFiles\FusionFiles\Chapter6\RangesMask. comp.**

In comparison, the Wand tool allows you to interactively select a color value that will become the central value of a range targeted for mask conversion. To use the Wand tool, follow these basic steps:

1. Connect the tool that will provide the pixel values to the Image input of the Wand tool.
2. Connect the output of the Wand tool to the Effect Mask input of another tool. You can use the same tool for the Image input and the Effect Mask input; however, you must use two iterations of that tool (this requires a network similar to the one illustrated in Figure 6.19).
3. Connect the Wand tool to a Display view. A small, red handle with two axis arrows appears over the Image input. This is a value selection handle. LMB-drag the handle in the Display view to place it over a value you want to select. For example, you can place it over a bright sky, a green patch or grass, or a gray concrete wall.
4. The value selected is targeted by the tool and other values are discarded. That is the selected value produces an opaque alpha matte and other values produce a transparent alpha matte. To see the result, connect the tool with Effect Mask input to a Display view.

You can invert the resulting matte by selecting the Invert checkbox in the Wand tool's Controls tab. To expand or contract the value range that is targeted, adjust the Range and Range Soft Edge parameters. To further soften the matte edge, raise the Soft Edge value.

With the Wand tool, you can base the matte on a particular color space and channel via the parameters with the same name. Available color spaces include RGB, HLS (Hue, Lightness, Saturation), YUV (value separated from color), and LAB (luminance separated from color). The ability to select values in a non-RGB channel, such as lightness / value / luminance, hue, or saturation gives you additional options for generating a matte, with each color space and channel producing different results.

Rotoscoping

As discussed, rotoscoping is the process by which a mask is animated over time. The animation may allow a mask to follow a moving object or element. The animation may also change the shape of the mask over time to follow a changing feature. For example, if you rotoscope an actor walking across the frame, the mask can take into account the bending of arms and legs. Fusion's set of masking tools, in the Tools > Mask menu, provides various means to add animation.

Rotoscoping with the BSpline and Polygon Tool

To rotoscope with the Polygon or BSpline tool, follow these steps:

1. Go to the frame where you'd like to add the first keyframe. Draw a Polygon or BSpline mask. A keyframe is automatically added that stores the positions of all the mask points. The function is carried out by the Shape Animation parameter at the bottom of the tool's Controls tab, which is labeled *Right-Click Here For Shape Animation* (Figure 6.22).
2. Move to a different frame on the time ruler. Alter the mask shape by moving points, utilizing the transform handle, or moving tangent handles. A new keyframe is added and the mask becomes animated over time. In-between frames receive interpolated values.

Figure 6.22 Shape Animation parameter and RMB-click animation menu.

If you'd like to remove the animation, RMB-click over the Shape Animation parameter and choose Remove *mask_name*Polyline. You can also remove a current keyframe by choosing Remove Key or force a new keyframe by choosing Set Key.

Rotoscoping with the Mask Paint Tool

The Mask Paint tool is composed of multistroke, stroke, and polyline masking sub-tools, each of which carries its own unique rotoscoping options. These options are discussed in this section. (Note that the Circle and Rectangle tools have no built-in means to animate their transformations, although you can keyframe their Width, Height, and Radius parameters.)

Multistroke

By default, a stroke you draw with the Multistroke sub-tool lasts for a single frame. You can make a multistroke last multiple frames by increasing the Stoke Duration parameter, located in the Tools > Controls tab (below the Apply Modes section). For example, if you set Stroke Duration to 30, the multistroke appears on the frame it was drawn and continues to appear until a point on the time ruler that is 29 frames later. In terms of animation, you are free to keyframe the multistroke's Angle or Size parameter, located at the bottom of the Tools > Controls tab.

Clone Multistroke

Strokes created with the Clone Multistroke sub-tool also last a single frame unless you raise the Stroke Duration parameter, found at the bottom of the Apply Controls section. By default, the cloned pixels are sampled from the current frame. However, you can offset the cloning in time by changing the Time Offset parameter, in the Apply Controls section, to a non-0 frame number. Negative numbers cause the sample to be taken at an earlier frame. Positive numbers cause the sample to be taken from a later frame.

Polyline Stroke and Stroke

By default, a stroke made with the Polyline Stroke or Stroke sub-tools lasts the entire duration of the time ruler. This is due to the Stroke Animation menu, which is set to All Frames by default. The menu is located in the Stroke Controls section of the Tools > Controls tab (Figure 6.23).

Figure 6.23 The Stroke Controls section of the Tools > Controls tab of a stroke drawn with the Stroke sub-tool. The majority of parameters are shared by strokes drawn with the Polyline Stroke tool.

If you set the Stroke Animation menu to Limited Duration, the stroke lasts the number of frames set by the Duration parameter. If you set the menu to Write On, Write Off, or Write On Then Off, the stroke lines appear to grow or shrink over time as if a hand-written pen mark. To set the duration of the line growth, you must keyframe the Start and / or Write On End fields of the Write On parameter. To make the line grow from the line start to line end, you can follow these steps:

1. Set the Duration to the total number of frames you wish the stroke to appear on the time ruler.
2. Set the Stroke Animation menu to Write On. The Write On End parameter is automatically key-framed with a value of 0. This means that the stroke line is not drawn. 0 is considered the start of the stroke line and 1.0 is considered the end of the stroke line.
3. Go to the frame where you would like the line to be fully drawn. Set the Write On End field to 1.0. Play back the time ruler. The line incrementally grows from nothing to its full length.

If you set the Stroke Animation to Write Off and animate the Write On End value, the animation is reversed and the line incrementally disappears over the set duration. If you set the Stroke Animation to Write On Then Off, the stroke appears then disappears; however, you must keyframe the Write On End field changing from 0 to 1.0 to 0.

By default, the points that make up a stroke drawn with the Stroke sub-tool are unaccessible. However, if you click the Make Editable button at the bottom of the Tools > Controls tab when the stroke is selected, the points are revealed (Figure 6.24). You are free to LMB-drag the points to reshape the stroke. You can animate the points moving over time by RMB-clicking over the Polyline parameter (which is marked with the phrase *Right-Click Here For Shape Animation)* and choosing Animate.

Figure 6.24 The points of a stroke drawn with the Stroke tool are revealed by clicking the Make Editable button.

In contrast, the points of a stroke created with the Polyline Stroke sub-tool are always visible. To animate the Polygon points moving over time, RMB-click over the phrase *Right-Click Here For Shape Animation* and choose Animate. Note that you cannot edit the points of strokes created with the Multistroke tool.

Using Advanced Polygon and Mask Paint Rotoscoping Tools

When you use the Polygon tool, a two-column toolbar is added to the Display views. This is illustrated by Figure 6.4 earlier in this chapter. When you use a Mask Paint tool and choose the Polyline Stroke button, the Mask Paint toolbar expands into two columns, adding the same set of buttons offered by the Polygon tool. Several of these buttons are designed for rotoscoping tasks and are described in this section.

Publish Menu

When you keyframe a Polygon or Polyline Stroke mask, the positions of all the mask points are stored within a single keyframe. As such, you cannot access the motion path of an individual point. As a workaround you can publish a point. To do so, select one or more points in a Display view, LMB-click the Publish Menu button in the toolbar, and choose one of the menu options. The point is added to the bottom of the Controls tab and has X and Y position fields added (Figure 6.25). To unpublish all the points within a mask, LMB-click the Publish Menu button and choose Unpublish Points.

Figure 6.25 Two points are published with the Publish To XYPath option. Each point receives keyframed X and Y fields at the bottom of the Controls tab.

Here are descriptions of the Publish Menu menu options:

Publish Points Adds X and Y fields for each selected point to the bottom of the Controls tab. Each animated point receives a displacement animation spline, which is accessible in the Spline view. To add keyframes, RMB-click over the point name and choose Animate.

Publish To Path Keeps prior animation stored by mask shape animation but allows updated animation of selected points. To add keyframes, RMB-click over the point name and choose Animate.

Publish To XYPath Provides X and Y splines for the selected points. The X and Y fields automatically receive keyframes.

Make Points Follow Nearby Published Nearby Points

When activated, the button causes the selected point to follow the motion paths of surrounding published points.

Onion Skin

When activated, adds red lines to indicate mask span positions on frames before and after the current frame (Figure 6.26). This serves as a reference when making animation adjustments to the mask. To adjust the way in which surrounding frames are displayed, LMB-click the small arrow below the Onion Skin button and choose Onion Skin Settings. In the Onion Skin pop-up window, you can choose the number of frames to display (Skin Count) and whether to show prior frames (Prev checkbox), future frames (Next checkbox), or all surrounding frames (All checkbox).

Figure 6.26 A mask is animated so that two published points (yellow) move over time. The motion path for each point is drawn as a green line. With the Onion Skin button activated, the prior mask edge positions are drawn in red.

Roto Assist

When activated, automatically snaps points to high-contrast edges. To use this option, follow these steps:

1. Connect the Polygon or Mask Paint tool output to the Effect Mask input of a tool you wish to rotoscope. For example, connect a Polygon tool output to the Effect Mask input of a Loader tool that imports an image sequence.
2. Connect the tool with the Effect Mask input to a display view. Select the Polygon or Mask Paint tool so that the toolbar appears in the Display view. Click the Roto Assist button to activate it. (If you are using Mask Paint, you must first select the Polyline Stroke tool.)
3. Proceed to draw the polyline mask in the Display view. When you LMB-click near a high-contrast edge, the point jumps to the edge. If you hold the mouse button and LMB-drag, you can reposition the point along the detected edge, which is indicated with a yellow line. By default, the edge must be within 8 pixels for the point to make its jump. You can expand this region up to 16 pixels by clicking the Roto Mask button menu arrow, choosing Distance, and entering a new value in the Autoroto Distance pop-up window.

Chapter Tutorial A: Color Grading within a Mask

In the Chapter 2 tutorial, we color graded an underexposed nighttime shot. We can take the grading further by isolating an area with rotoscoping. Follow these steps:

1. Open the `\ProjectFiles\FusionFiles\Chapter2\ColorGrading.comp` project. Examine the tool network. The network branches in two directions, ending with the Hue Curves tool and the Color Curves tool. Connect the Hue Curves tool to the Left Display view and the Color Curves tool to the Right Display view. The Hue Curves output appears brighter and more green; the noise is also more visible in this version. The Color Curves output retains more red and is slightly darker.

2. We can combine both outputs with Polygon and Merge tools. With no tools selected, choose Tools > Mask > Polygon. Select the new Polygon tool, but leave the Hue Curves tool connected to the Left Display view. The Polygon toolbar appears in both Display views. You can draw a new mask in either view, but we'll use the Left Display view.

3. Move the time slider to the last frame of the time ruler. LMB-click in the Left Display view to draw a mask. Draw the mask to loosely surround the screen-right side of the man in the foreground (Figure 6.27). Close the mask by adding the last point where the first one is located. Feel free to add points past the top or bottom edge of the frame. The mask shape is keyframed automatically.

4. Create a new Merge tool. Connect the output of the Hue Curves tool to the Foreground of the Merge tool. Use Figure 6.28 as a reference. Connect the output of the Color Curves tool to the Background of the Merge tool. Connect the Polygon tool to the Effect Mask input of the Merge tool. Connect the Merge tool to the Right Display tool. Deselect the Polygon tool so the mask is hidden. The Merge tool combines a cut-out piece of the Hue Curves output and places it on top of the Color Curves output. In this way you can mix different color grading operations. With these steps, a greenish cast is returned to the man's right side.

Figure 6.28 The final tool network for this tutorial.

Figure 6.27 A mask is drawn with the Polygon tool to isolate the right side of the man. This mask is used to cut out a piece of the Hue Curves tool output, which makes the image bright with a green cast, as is seen in this view.

5. At this point, the edge of the mask is clearly visible because there is a sudden change in color. To avoid this, raise the Polygon tool's Soft Edge value. You can also expand the mask by raising the Border Width parameter (Figure 6.29).

Figure 6.29 The final frame. The soft edge of the mask disguises the combination of two different color effect tools.

6. Go to the first frame of the time ruler. Due to the motion of the man, the mask no longer fits. Move the mask points to fit his new shape. Proceed to check other frames and shape the mask to add additional keyframes. As few as 6 keyframes are needed to make the mask follow his motion. Once again, the mask can remain loose. Play back the time ruler to test the result.

The tutorial is complete! A finished version of this tutorial is saved as `\ProjectFiles\FusionFiles\Chapter6\RotoColor.comp`. To see what the composite looks like with and without the masked Hue Curves added to the Foreground, you can temporarily reduce the Polygon tool's Level parameter to 0. Feel free to adjust the Hue Curves tool. The goal is to keep the man's arms visible against the dark sky. We'll return to this tutorial in Chapter 10 to reduce the presence of noise.

Chapter Tutorial B: Masking a New Art Element

In the Chapter 5 tutorial, we continued working with our stylized animation to add a camera move and to correct the original 3D animation of the walking man. We can use masking to add a new element—a driver for the taxi. You can follow these steps:

1. Open the `\ProjectFiles\FusionFiles\Chapter5\ShotAnimate.comp` project. Connect the Crop1 tool to a Display view. Play back the time ruler. The taxi 3D render lacks a driver.

2. Go to frame 75, where the taxi has stopped. Connect the Loader that imports the taxi render to a Display view. The taxi render appears over an empty background. We can add a driver by masking out a solid color generated by a Background tool. With no tools selected, choose Tools > Creator > Background. Select the new Background tool and go to the Tools > Image tab. Check to see that the Width and Height are 1920 and 1080 respectively. This is the same resolution as the taxi render.

3. Disconnect the taxi Loader from the Transform1 tool. Create a new Merge tool. Connect the Background tool output to the Background input of the new Merge tool (Merge5). Connect the taxi Loader output to the Foreground input of Merge5. Use Figure 6.30 as reference. Connect the Merge5 tool to a Display view. The taxi appears over the black Background.

Figure 6.30 New section of the tool network that eventually connects to the Transfrom1 tool.

4. Choose Tools > Mask > Polygon. With the taxi Loader connected to a Display view and the new Polygon tool selected, LMB-click to draw a mask in the connected Display view. Draw the mask to emulate the silhouette of a driver sitting behind the steering wheel. Close the mask. Connect the output of the Polygon tool to the Effect Mask input of the Background tool. The solid black is cut out in the shape of the driver (Figure 6.31). Feel free to fine-tune the mask shape using the suggestions throughout this chapter (e.g.: moving points, moving tangent handles, inserting new points, and so on).

Figure 6.31 A mask created with a Polygon tool cuts a black Background solid into the shape of the missing driver.

5. At this stage, the driver silhouette appears behind a gray line formed by the interior or the 3D taxi. This is not detrimental, however, because the final framing does not show this area. Connect the output of the Merge5 tool to the input of Transform1. Connect the Crop1 tool to a display view (Figure 6.32).

Figure 6.32 The driver mask, as seen in the final frame.

The tutorial is complete! A finished version of this tutorial is saved as **\ProjectFiles\ FusionFiles\Chapter6\MaskDriver.comp**. If you play back the time ruler, you'll see that the driver mask does not follow the taxi. We can motion track the taxi and apply the tracking data to the mask. However, this will be difficult due to the taxi entering and leaving the frame. A workaround solution requires the time warping of the taxi image sequence so that it starts in frame. After time warping, adding matching animation to the driver can be more easily undertaken. We will return to this tutorial in Chapter 7 to apply this technique.

Altering Outputs with Filters

Fusion includes numerous tools designed to alter outputs with a filter. Filters apply mathematical operations to an input to create a specific effect, such as a blur or color shift. Some filters are designed to replicate real-world phenomena, including as lens flares or glows. Some filters create stylistic results while others undertake important compositing tasks such as the combination of alpha mattes. While any given tool network may only need to utilize one or two filter tools, other networks can benefit from entire strings of filters.

This chapter includes the following critical information:

- Applying blur and sharpen filters
- Recreating camera artifacts with filter tools
- Fine-tuning alpha mattes with filters
- Time warping footage
- Combining multiple filter tools

Overview of Filters

In Fusion, filter tools are designed to alter the outputs of other tools. You can group the filters into the following categories:

Blurs and Sharpens Blur filters soften or average the pixels. Sharpen filters accentuate edges.

Camera Effects Replicate optical artifacts of real-world cameras. These include lens blurs, glows, halation, lens flares, sun glitter, and similar effects.

Alpha Matte Tools Adjust the edge quality of mattes.

Time Warping Tools Alter frame rates, either speeding up or slowing down footage.

Distortion Tools Warp the input in a variety of patterns and styles of animation.

Stylistic Effects Create fantastic or non-realistic results. These may be useful in combination with other filters to create more complex results.

Color Tools Designed for color grading and other color adjustment tasks. (Color tools are discussed and demonstrated in Chapter 2.)

Blurring and Sharpening

Blur and sharpen filters employ various forms of **convolution filters**, which are numeric grids that are "slid" over each pixel of an input. The resulting convolution math produces new pixels values, which may average old pixel values or exaggerate specific areas of the image, such as edges. In Fusion, these filters are grouped in the Tools > Blur menu. The tools are described in the following sections.

Blur

The Blur tool has two main parameters: Blur Size and Blend. Blur Size controls the size of the convolution grid, with larger values creating a larger grid, additional averaging, and a greater degree of blurriness. The Blend parameter, if reduced below 1.0, blends the blurred result with the original, unblurred input. Reducing the Blend value with the Blur tool creates a foggy, glow-like result. The Blur tool, like many filters, carries a single input.

Directional Blur

The Directional Blur tool is similar to the Blur tool but streaks the blur in a particular direction (Figure 7.1). The Length parameter sets the degree of blurriness and Angle sets the blur direction. Directional Blur also includes a Glow parameter, which creates a glow by adding a brighter version of the output on top of itself. By default, the blur is linear; however, you can change the Type parameter to Radial (circular, as if the camera is spinning), Zoom (scale-change blur), or Centered (similar to linear, but distributes the blur streak equally ahead and behind streaked element). Note that you may need to activate the HiQ button in the TimeView to see a smooth result.

Figure 7.1 A 3D render of a taxi, which lacks motion blur, gains a blur from the Directional Blur tool. This project is saved as `\ProjectFiles\FusionFiles\Chapter7\DirectionlBlur.comp`.

VariBlur

The VariBlur tool allows you to blur the input by using values of another image connected to its Blur Image input (Figures 7.2 and 7.3). The strength of the blur is set by the Blur Size parameter. The blur quality is determined by the Quality parameter, with higher values producing smoother results, and the selected Method button. The Soften button applies a box-style filter that is efficient but may create vertical and horizontal streaking. The Multibox button creates a medium-quality, Gaussian-style blur. The Defocus button emulates the optics of a real-world camera but is the most computationally expensive. The VariBlur tool also includes a Blur Limit parameter that places a limit on the blur quality, with lower values simplifying the blur. The tool uses a single channel of the Blur Image input for the blur; this is established by the Blur Channel parameter buttons, which include RGBA and Luma (luminance). The higher the pixels values within the Blur Image, the stronger the blur in those areas. (VariBlur offers an alternative way to apply a blur in depth, similar to the Depth Blur tool discussed in Chapter 3.)

Figure 7.2 A VariBlur network. A black-and-white bitmap of a logo is connected to the Blur Image input, while a video image sequence is connected to the Input.

Figure 7.3 Result of the VariBlur network. The areas of the logo that are white create a heavy blur, while areas that are black receive no blur. This project is saved as `\Project-Files\FusionFiles\Chapter7\VariBlur.comp`.

Sharpen

The Sharpen tool enhances the input by increasing the contrast around area detected edges. The Amount parameter controls the degree of sharpening. In general, it's best to keep the Amount value low.

Unsharp Mask

The Unsharp Mask creates a high-contrast, blurry version of the input and merges it with the original input. Although similar to the Sharpen tool, you have more control over the result by adjusting the Size, Gain, and Threshold parameters. Size sets the size of the convolution filter and the degree of blur added to the high-contrast version of the input. Gain sets the degree of contrast with high values increasing the contrast. Threshold determines what areas receive additional contrast with low values including more of the image.

Replicating Camera Artifacts

Several Fusion filter tools are designed to replicate specific qualities of real-world cameras and their lenses. The tools are discussed in the following sections. The Defocus, Glow, and Soft Glow tools are located in the Tools > Blur menu. The Highlight, Hot Spot, and Rays tools are located in the Tools > Effect menu. Lens Distort is included in the Tools > Warp menu.

Defocus

The Defocus tool recreates the out-of-focusness of a lens by employing **bokehs**, which are the shapes that small out-of-focus points of light make (Figure 7.4). The Defocus Size parameter sets the blur strength. Bloom Level replicates halation (see "Glow" below). When Bloom Level is higher than 0, a glow is added to the brightest areas of the frame. The Bloom Threshold parameter controls what areas receive the bloom, with lower values applying bloom to greater portions of the frame. The shape of the bokeh used by the tool is set by the Lens Type, which includes four different aperture shape options: NGon Solid, NGon Shaded Out, NGon Shaded in, and Circle. The *NGon* options creates polygon-shape bokehs with the number of sides set by the Lens Sides parameter. Shaded Out softens the exterior edge of each bokeh, while Shaded In softens the interior or each bokeh (making them hollow).

Figure 7.4 Close-up of 5-sided polygon bokehs. This project is saved as `\ProjectFiles\FusionFiles\Chapter7\Defocus.comp`.

Glow

In the real world, **glow** appears when light bounces off **participating media**, which is composed of small, suspended particles in the air (such as dust, smoke, fog, and so on). Glow manifests itself with photography and videography as **halation** when lights bounces through a lens mechanism and spreads light beyond the edges of bright objects. The Glow tool replicates either type of phenomena by placing a blurred, brightened copy of the input back on top of itself (Figure 7.5). The Glow Size parameter sets the softness of the blur while Glow determines the brightness of the glow. The filter uses for the blur is set by the Filter parameter. Aside from Box, Multibox, and Gaussian filters (discussed earlier in this book), you also have the option to use Bartlett (produces slightly sharper edges), Hilight (shrinks glow to brightest areas), Solarize (diffuses glow and reduces overall contrast), and Blend (similar to Solarize, but with brighter values). The Glow tool provides a Glow Mask input, which accepts any type of mask tool. The Glow Mask input limits the area of the glow, but allows the glow to softly extend past the mask edge. If you connect a mask to the tool's Effect Mask input, the glow suddenly stops at the mask edge.

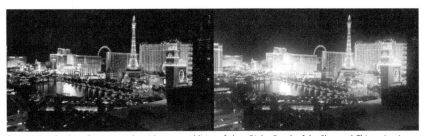

Figure 7.5 Left: Shot of a city at night without any addition of glow. Right: Result of the Glow tool. This project is included with the tutorial files as \ProjectFiles\FusionFiles\Chapter7\Glow.

Soft Glow

The Soft Glow tool functions in the same manner of the Glow tool but produces smoother results. Soft Glow is designed to reproduce atmospheric glow created by participating media. The tool includes a Threshold parameter to control what areas of the frame are glowing and a Gain parameter to set the glow intensity.

Choosing a Clipping Mode and a Domain

A variety of filter tools that employ some form of a blur carry a Clipping Mode parameter with three options: None, Domain, and Frame. The parameter controls the way in which the filter affects the frame output by the tool. If Clipping Mode is set to Frame, the entire frame is used and any blur extends to the edge of the frame. If Clipping Mode is set to Domain, the domain of definition receives the blur. **Domain of definition** is the area of input that is used for compositing calculations. Although the domain of definition generally matches the resolution of an input, it can be altered to a be a portion of the resolution. The current domain is indicated in a Display view as a dotted-line box (that is added by the view's DoD button). Two tools, Set Domain and Auto Domain, are designed to alter domains and are discussed in Chapter 11. If the Clipping Mode parameter is set to None, any applied blur will not reach the frame edge as the calculations are not permitted to extend past the frame edge.

Highlight

The Highlight tool recreates **sun glitter**, which is intense specular reflection that appears off numerous points on a surface (Figure 7.6). For example, choppy water produces this type of glitter. The glitter often appears with star points, which are streaked edges caused by the internal mechanism of lenses. The Highlight tool's Length, Number Of Points, and Angle parameters control the style of star point that appears. The Low and High fields set the value range that produces the glitter. The Curves parameters determines the intensity of the glitter. If the tool is applied to footage that changes over time (for example, a shot of rolling surf), the glitter changes with each frame and star points wink in and out of existence. The Tool also provides a Highlight Mask input to limit the area of the filter. The star points are white by default, but you can shift the color by adjusting the Red / Green / Blue / Scale sliders in the Tools > Color Scale tab.

Figure 7.6 Close-up of star points created with the Highlight tool. This project is saved as `\ProjectFiles\FusionFiles\Chapter7\Highlight.comp`.

Hot Spot

The Hot Spot tool replicates a **lens flare**, which is an intensely bright area of the frame created when an intense light source bounces through the physical elements of a lens. You can interactively position the flare by LMB-dragging its transform handle (Figure 7.7). You can scale the flare core of flare outer edge by LMB-dragging the handle circles. Intensity is set by Primary Strength. You can alter the flare shape by adjusting the Aspect, Aspect Angle, Lens Aberration, and Aberration parameters. (**Lens aberration** is unwanted distortion of lights rays that causes color defects or other visible flaws in the resulting image.) By default, the flare is white; however, you can shift its color by shaping RGB color curves in the Tools > Color tab.

Figure 7.7 Close-up of a lens flare created with the Hot Spot tool. This project is saved as `\ProjectFiles\FusionFiles\Chapter7\HotSpot.comp`.

Choosing a Filter Apply Mode

Some tools that combine a brighter version of an input with the original input, such as Glow and Hot Spot, include their own built-in Apply Mode parameter. The Apply Mode options vary per tool. Here are a few examples:

Normal: The effect occludes input except where alpha surrounds the effect.

Add (Burn): The effect color is added to input color, but result is not permitted to exceed a color range maximum of 1.0.

Subtract (Dodge): The effect color is subtracted to input color, leading to a back "hole."

Threshold: The effect appears in the color range area as determined by Low and High parameter fields.

Similar filter tools, such as Highlight and Rays, simply carry a Merge Over checkbox. When the checkbox is deselected, the filter effect appears by itself and the input is ignored.

Rays

The Rays tool can create a large lens flare or a set of god rays. **God rays** appear when light streaks through participating media but is partially shadowed by clouds, trees, buildings, and similar obstacles. You can interactively set the origin of the rays by LMB-dragging the transform handle. The Decay parameter controls the ray diffusion with lower values creating softer rays. Weight, Exposure, and Threshold control the ray intensity.

Lens Distort

The Lens Distort tool is designed to add the distortion that often occurs with real-world lenses. Applying such a distortion to an undistorted source, such as a 3D render, may help the source match film or video footage. Many of the parameters assume that you are aware of the specific lens distortion parameters you are trying to match. For example, the tool's Camera Settings section includes focal length, film gate, lens shift, and aperture fields. However, if you do not have access to the camera information, you can interactively move sliders and see the distortion in a Display view. The tool warps the image edges inwards or outwards, creating concave or convex distortions. The strength of the distortions is set by the parameters within the Len Distortion Model section.

Filtering Alpha Mattes

As discussed in Chapter 2, you can limit the effect of many filter tools by deselecting RGBA channel checkboxes in the tool's Controls or Common Controls tab. If you deselect the red, green, and blue checkboxes, the filter is applied solely to the alpha matte. For example, if you connect an output to a Blur tool and limit the blur tool to the Alpha channel, you can soften the alpha matte edge without altering the color channels.

In addition, Fusion supplies the Erode / Dilate tool (in the Tools > Filter menu) for affecting mattes. With this tool, you can expand or contract the alpha matte by using the Amount slider, which blurs the input. To avoid blurring the RGB channels, deselect the Red, Green, and Blue checkboxes at the top of the Controls tab. Several tools in the Tools > Matte menu are designed for alpha matte manipulation. These are described in the next two sections.

Alpha Divide and Alpha Multiply

The Alpha Divide tool undertakes unpremultiplication by dividing RGB values by alpha values. Although premultiplied RGBA channels are generally desirable to maintain alpha edge quality, some tools or tool networks produce better results when unpremultiplied (for example, certain chroma keyer operations). The Alpha Multiply tool undertakes premultiplication of RGB and alpha. Each tool has an Input and Effect Mask input. Neither tool carries parameters within the Controls tab. See Chapter 3 for more detailed information on the premultiplication process.

Matte Control

This tool has the ability to combine the alpha mattes of two inputs connected to the tool's Background and Foreground inputs (Figures 7.8 and 7.9). This offers an alternative to connecting mask tools together through Effect Mask inputs. For the alpha combination to occur, the Matte Combine parameter must be set to Combine Alpha and the Combine Op (Combine Operation) parameter must be set to Add (Figure 7.10). Combining mattes is often useful for rotoscoping; for example, if you are rotoscoping a moving actor, you can animate one matte for the head, one matte for the torso, one matte for the legs, and so on. (See Chapter 6 for more information on rotoscoping.)

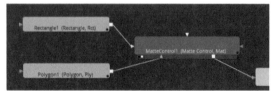

Figure 7.8 A Rectangle and Polygon mask are combined into a single alpha matte with a Matte Control tool. The Matte Control output is connected to the Effect Mask input of another tool.

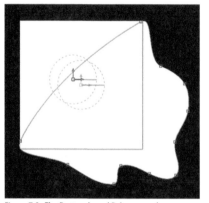

Figure 7.9 The Rectangle and Polygon mask are combined, as is seen with the Matte Control tool connected to a Display view. This project is saved as `\ProjectFiles\FusionFiles\Chapter7\MatteControl.comp`.

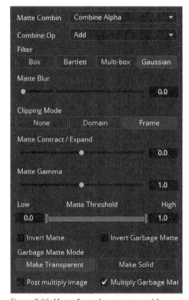

Figure 7.10 Matte Control parameters with Matte Combine and Combine Op set to add together the Foreground and Background input alpha.

Optionally, you can also choose different mathematical operations for the combination by changing the Matte Op menu. For example, set the menu to Subtract to remove the Foreground matte shape from the Background matte shape. The tool also carries a Matte Expand / Contract parameter to alter the size of the combined matte. (To use Matte Expand / Contract, the Matte Blur parameter must have a non-0 value.) The Matte Gamma parameter applies a gamma function to the alpha channel.

If the combined matte has a soft edge, you can erode the matte edge or make the soft area more opaque by adjusting the Matte Threshold parameter's Low and High fields. The tool carries a Garbage Matte input in addition to a standard Effect Mask input. A **garbage matte** or **garbage mask** is a mask designed to remove unwanted elements (such as video equipment, crew members, effects rigging, and so on). Connecting a mask tool to the Garbage Matte input automatically cuts a hole into the combined matte wherever the garbage matte and combined matte overlap. You can invert the matte, as output by the tool, by selecting the Invert Matte checkbox. You can invert the garbage matte by selecting the Invert Garbage Matte checkbox. You can soften the matte, as output by the tool, by raising the Matte Blur value.

Time Warping

By default, the frame rate interpretation of imported footage is set by the Frame Rate parameter of the Preferences window. When the time ruler plays back at a real-time speed, the frames-per-second of the playback matches the Frame Rate parameter setting. When compositing, it's sometimes necessary to alter the frame rate interpretation of a piece of footage independent of the Preferences window settings. For example, you may wish to speed up the motion within footage that is too slow or slow down the motion within footage that is too fast. The speeding or slowing down is known as **time warping**. Fusion provides a set of tools in the Tools > Optical Flow and Tools > Miscellaneous menus to carry out such tasks. The tools are described in the following sections.

Time Speed

To slow down or speed up a piece of footage, you can use the Time Speed tool. You can follow these basic steps:

1. Choose Tools > Miscellaneous > Time Speed. Connect the output of the tool you wish to time warp to the input of the new Time Speed tool.
2. Open the Time Speed parameters in the Tools > Controls tab. To speed up the footage so that it lasts for fewer frames, raise the Speed value above 1.0. For example, setting the speed to 2.0 makes the footage half the length and any contained motion twice as fast. To slow down the footage, lower Speed below 1.0.
3. Connect the Time Speed tool to a Display view. Play back the time ruler. Changes in speed are visible in the Display view. However, the time ruler's Global End Time is not updated.

If you slow down footage, the footage may extend past the end of the current time ruler duration. If you speed up the footage, the footage may no longer fill the current time ruler duration, in which case black frames are added where the footage no longer exists. If you enter negative Speed values, the frame order is reversed. You can delay the start of the time-warped footage by raising the Delay value, which represents the delayed number of frames.

When you speed up footage, frames are discarded. When you slow down footage, new frames must be generated to fill the gaps. There are two ways to do this with the Interpolation parameter: Nearest and Blend. The Nearest mode simply duplicates existing frames, which may be visible as **judder** (slight hesitation in motion). The Blend mode averages neighboring frames to generate new, in-between frames.

Optical Flow Tools

The free version of Blackmagic Fusion does not include the ability to apply optical flow techniques to time-warped footage. **Optical flow**, which motion tracks myriad patterns within footage, can help synthesize new, in-between frames that are virtually indistinguishable from the originals.

A general optical flow workflow in Fusion Studio follows:

- Footage is connected to an Optical Flow tool (in the Tools > Optical Flow menu).
- The output of the Optical Flow tool is connected to a Saver tool, which renders the output to an OpenEXR image sequence on disk. The Optical Flow tool produces forward and backward motion vectors, which are stored in auxiliary channels in the OpenEXR format.
- The OpenEXR sequence is re-imported and connected to a Time Speed tool. With Fusion Studio, the Time Speed tool includes a Flow button, which uses the motion vectors to synthesize new, in-between frames.

For more detailed information on the Optical Flow tool, see the "OpticalFlow" section of the Fusion 8 User Manual, available at the Blackmagic Design website (`www.blackmagic-design`).

Time Stretcher

The Time Stretcher tool (in the Tools > Miscellaneous menu) builds upon the Time Speed tool. However, Time Stretcher gives you an option to create a non-linear change in time that may include freeze frames, ease-ins, or ease-outs. This is achievable by setting keyframes on the Source Time parameter and editing the matching animation spline in the Spline view. You can follow these basic steps:

1. Go to the first frame of the time ruler. Choose Tools > Miscellaneous > Time Stretcher. Connect the output of the tool you wish to time warp to the input of the new Time Stretcher tool. For example, connect a Loader tool that imports an image sequence. Connect the Time Stretcher to a Display view.

2. Select the Time Stretcher tool. Note that the Source Time parameter is animated and a keyframe has been added to the current frame of the time ruler. Go to the Spline view. Select the Source Time parameter name in the left column. Frame the Source Time animation spline by clicking the Zoom To Fit button. The animation spline is flat. Play back the time ruler. The first frame of the input is repeated over and over, creating a freeze frame.

3. To restore normal motion to the input, go to the last frame of the time ruler. Enter the current frame number into the Source Time field in the Tools > Controls tab. A new keyframe is automatically added. In the Spline view, the animation spline forms a linear curve that slopes upwards (Figure 7.11). Play back the time ruler. The input regains its normal motion. The Source Time animation spline determines what frame of the input is used for each frame of the Time Stretcher tool's output. With a linear curve we created, there is a 1-to-1 relationship. For example, on frame 25 of the time ruler, the animation spline value is 25.

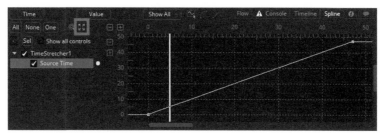

Figure 7.11 A linear up-sloping Source Time spline causes the input to play back at a normal speed. The right-hand keyframe value matches the last frame of the time ruler. (The Zoom To Fit button is outlined in red.)

4. If you wish to slow down the input in a linear fashion, LMB-drag the right-hand keyframe downwards. For example, if the left-hand keyframe has a value of 0 and the right-hand keyframe has a value of 47, dragging the right-hand keyframe down to 23 slows the footage down to half its previous speed (in this situation, 24 total frames are spread out over the 48 frame time ruler duration). For more precise keyframe positioning, select the keyframe and enter a new value in the Value field at the top-left of the Spline view.

5. To speed up the input in a linear fashion, give the right-hand keyframe a higher value. For example, changing the value from 47 to 95 doubles the speed. When speeding up footage, the Time Stretcher tool will repeat the last frame of the input to fill any empty space at the end of the time ruler.

6. You can vary the speed change over time by shaping the Source Time animation spline. For example, to create an ease-in, where the motion starts slow and then speeds up over time, adjust the left-hand curve tangent handle to create a curved span (Figure 7.12). To create an ease-out, where the motion starts fast and then slows down over time, create an opposite slope by moving the tangent handle of the right-hand keyframe.

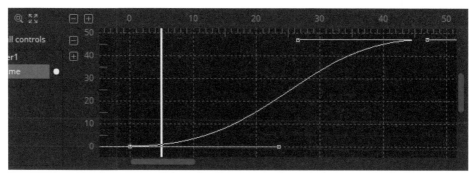

Figure 7.12 An ease-in and ease-out are added to the Time Source curve by adjusting keyframe tangent handles. This project is included with the tutorial files as `\ProjectFiles\FusionFiles\Chapter6\TimeStretcher.comp`.

The steeper the curve slope, the faster the motion. The more shallow the slope, the slower the motion. Any part of the curve that is absolutely flat creates a freeze frame; that is, the frame that occurs at the start of the flat segment is repeated until the flat segment ends. If the slope direction is reversed, the frame order is reversed and the input plays backwards. You are free to edit the Source Time animation spline using any of the tools or techniques available through the Spline view. For more information on the view, see Chapter 5. The Time Stretcher tool synthesizes new frames in the same manner at the Time Speed tool. If you are using Fusion Studio, you have three Interpolation Mode options: Nearest, Blend, and Flow.

Adding Distortion

Fusion includes a set of distortion tools in the Tools > Warp menu. The distortions shift pixel values left / right and up / down to create streaking, pinching, or shifting. Distortion tools may be useful in the following situations:

- **Positional Adjustment** You can alter the position of an element within an image. For example, you can push a flapping flag within a 3D render a little higher or a little lower with a distortion tool and thus avoid a re-render.
- **Air or Water Turbulence** You can distort a piece of footage to create the illusion of heat waves, water ripples, or other naturally occurring turbulence. In this situation, you would animate the distortion parameters over time.
- **Random Motion** A distortion tool can add random fluctuations to an effect that is generated by multiple tools arranged in a network. For example, you might use a distortion tool to add undulations to a science-fiction portal created with Fractal Noise, Blur, and Color Curves tools (this is demonstrated at the end of this chapter).
- **Motion Graphics** Many of the distortion tools are suitable for creating or accentuating motion graphics tasks, such as titles, animated logos, and video transitions.

The various distortion tools are discussed here:

Corner Positioner Offsets the four corners of an input. You can interactively drag the corner points of an overlaid rectangular handle. This tool may be useful for adding artificial perspective to an image. For example, you can use this tool to move the corners of an image sequence so that it fits within the screen of a television screen. This process is similar to corner-pin motion tracking but without any automation. That said, you can manually animate the Offset X and Y parameters for each of the four corner points.

Perspective Positioner Removes perspective of an input through virtual rotation. This tool may be useful for removing the perspective of a particular element, such as a billboard that was shot at an angle. The interactive controls are similar to those provided by the Corner Positioner tool. However, the points do not sit directly on the input corners. Essentially, the input is distorted to take on a shape *opposite* that of the rectangular handle.

Displace Distorts the tool's Background input using the values within the Foreground input. The result is similar to embossing (Figure 7.13). The pattern that appears within the embossed area is a scaled version of the Background input; the degree of scaling is set by the Refraction Strength parameter. You can offset the pattern by interactively moving the tool's transform handle. The quality of the embossed edge is determined by the Spread, Light Power, and Light Angle parameters.

Figure 7.13 A Text+ tool and a Displace tool are connected to create an embossed, metallic-looking word. This project is included with the tutorial files as `\ProjectFiles\FusionFiles\Chapter7\Displace.comp`.

Dent Pinches or pulls the image at the center of its interactive handle. The width of the distorted area is set by the Size parameter. The intensity is controlled by Strength, with negative values pinching and positive values pulling. High or low values may cause the image to invert within the handle area, where left pixels jump to the right and top pixels jump to the bottom.

Vortex Uses the same interactive handle as the Dent tool. However, Vortex twists the pixels in a circular fashion (Figure 7.14). The extent of the twist is set by Angle parameter. The Power parameter sets the width of each circular revolution.

Figure 7.14 The Vortex tool twists the input in a circular fashion.

Drip Creates a ripple, like a drop of water hitting a puddle. The center of the ripple is set by the interactive Center handle. The size of the ripple rings is set by the Frequency parameter, with smaller values creating larger rings. The ripple strength is set by Amplitude. Ripple shape, whether circular or oval, is set by Aspect. However, you can switch to other mathematically based distortions, such as rectangular, random, or exponential, by changing the Shape menu (Figure 7.15). You can fade out the ripples by raising the Dampening value. If you'd like to make the ripple rings move outward over time, animate the Phase parameter increasing in value.

Figure 7.15 The Drip generates a stylistic distortion when the Shape menu is set to Exponential.

Chapter 7

Vector Distortion Distorts the input in the X and Y directions. The intensity in each direction is determined by the values of the channels assigned to X and Y, plus the Scale parameter (that serves as a multiplier). The channels are provided by the tool connected to the Vector Displace tool's Distort input. You can choose among red, green, blue, vector X, and vector Y channels by clicking the buttons with the same names below the X Channel and Y Channel parameters. To access a vector X or vector Y channel, it may be necessary to use an image format that supports auxiliary channels, such as OpenEXR, or transfer channels with the Channel Booleans tool. For example, you can use a motion vector render pass as a source for the X and Y vectors. For a demonstration of the Channel Booleans tool, see Chapter 3. For more information on auxiliary channels, see Chapter 2.

Coordinate Space Remaps the input to a polar coordinate space, which may be useful for preparing images for HDR (High-Dynamic Range) lighting tools, either within Fusion's 3D environment or external 3D programs. Fusion's 3D environment is discussed in Chapter 9.

Grid Warp Lays an interactive grid on top of the input, allowing you to selectively distort portions of the frame (Figure 7.16). Grid points occur where grid lines intersect. You can move these points by LMB-dragging the circular brush that appears over the mouse pointer. The distortion is naturally tapered and diminishes with distance from the point you are moving. You can choose the number of X and Y grid lines via the X Grid Size and Y Grid Size. The size of the brush, referred to as a *magnet*, is controlled by the Magnet Distance. The strength of the distortion is determined by the Magnet Strength. The Subdivision Level parameter affects the overall quality of the distortion, with higher values creating smoother transitions between distorted and non-distorted pixels. By default, tangent handles are not visible. However, if you click the Selected button, the magnet brush is hidden and you can LMB-click a point to reveal its tangent handles (Figure 7.17). You can LMB-drag the tangent handle ends to adjust the curvature of surrounding grid spines. To return to the magnet brush, click the Magnetic button.

Figure 7.16 The Grid Warp tool's interactive grid in its default configuration with X and Y Grid Size set to 4. The magnet brush appears as a green circle.

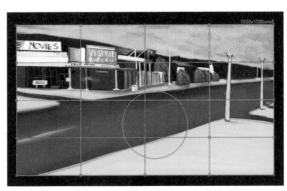

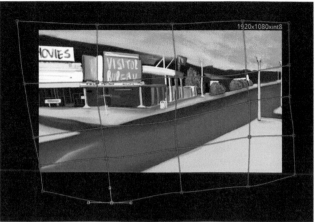

Figure 7.17 A Grid Warp tool's grid is adjusted to change the perspective of a road in a stylistic matte painting. A selected grid point, in yellow, reveals its tangent handles. This project is included with the tutorial files as `\ProjectFiles\Fusion-Files\Chapter7\GridWarp.comp`.

Mini-Tutorial 6: Morphing with the Grid Warp Tool

A **morph**, as applied to digital compositing, is a transition between two images that distorts one image to match the second image. In the early days of digital compositing, morphs were used to switch between effects and non-effects plates. For example, you can use a morph to subtly switch from an actor wearing no make-up to an actor wearing monster make-up. In recent years, morphing has been replaced by more advanced 3D animation approaches (such as detailed scans of actors and complex rigging tools). Nevertheless, morphing continues to offer a way to fit one image to another while avoiding re-renders or re-shoots. For example, you might morph the arm of a real-life actor so that it matches the arm of a rendered digital stunt double over the space of several frames; as such, the transition from the actor to the stunt double will appear less noticeable. To practice morphing with the Grid Warp tool, you can follow these steps:

1. Create a new project. Set the Global Start Time to 1. Set the Global End Time to 36. Create a Loader and import `\ProjectFiles\Art\faceSrc.tif`. Create a second Loader and import `\ProjectFiles\Art\faceDest.tif`. Each TIFF file features a photo of a sculpted face. We will create a morph to transition from one face to the next.
2. Create a new Merge tool. Connect the output of Loader1 (with the `faceSrc.tif` file) to the Background of the Merge tool. Connect the output of Loader2 (with the `faceDest.tif` file) to the Foreground of the Merge tool. Connect the Merge tool to a Display view. The Foreground input occludes the Background input.

3. Select the Merge tool and go to the Tools > Merge tab. While on frame 1 of the time ruler, set the Blend parameter to 0. This makes the Foreground 100% transparent. RMB-click over the Blend parameter name and choose Animate. A keyframe is added. Go to frame 36 on the time ruler. Set Blend to 0.5. A new keyframe is added and the Foreground is once again visible. Play back the time ruler. The Foreground fades in to 50% opacity. A fade is a necessary transition to make the morph function. Choose Tools > Warp > Grid Warp. Rearrange the tool network so that Loader1 is connected to the input of the Grid Warp tool and the output of the Grid Warp tool is connected to the Background of the Merge tool. Use Figure 7.18 as a reference.

Figure 7.18 A Grid Warp tool is inserted between the source footage and a Merge tool.

4. Select the Grid Warp tool. Note that the Destination button is selected at the top of the Tools > Controls tab. The tool carries two grids: a source grid and destination grid. The tool distorts the input, as framed by the source grid, so that it matches the destination grid. You have the option to select the Source button and thus see the source grid in the Display view. You can alter the shape of the source and / or destination grid. Each grid carries its own set of parameters. However, it's not mandatory that you change the source grid. (Altering the source grid may allow you to align the grid lines with important features, such as the horizon or edge of a wall.) Change the X Grid Size and Y Grid Size to 4. This simplifies the grid. A higher-resolution grid may make the distortion more accurate but a simpler grid will be easier to manipulate. Return to frame 1. Activate mesh animation for the Destination grid by RMB-clicking over the phrase *Right-Click Here For Mesh Animation* at the bottom of the Tools > Controls tab and choose Animate.

5. Go to frame 36. Click the Selected button (below the Destination button). Interactively move grid points and tangent handles of the Destination grid to force the source face (the painted sculpture) to line up with the destination face (the gray stone sculpture). See the previous section for information on manipulating points and tangent handles. If necessary, adjust the Blend parameter of the Merge tool to see more or less of the destination face. The grid points do not match the location of the eyes, nose, mouth, chin and so on, but you can softly push different areas of the face (Figure 7.19).

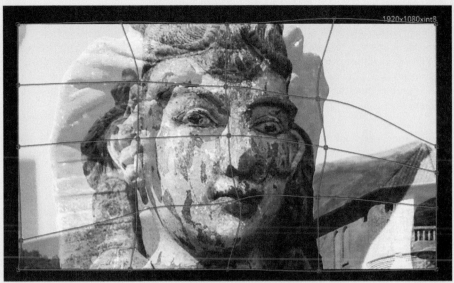

Figure 7.19 The destination grid is altered so that the features of the source face align with the features of the destination face. At this stage, the Blend parameter of the Merge tool is set to 0.5.

6. When you're satisfied with the shape of the Destination grid, set the Blend value of the Merge tool to 1.0. With no tools selected, play back the time ruler. The morph occurs and the source face slowly deforms to match the destination shape while there is a dissolve between the two images (Figure 7.20).

Left photo by Sophie Riches (Own work) [CC BY-SA 3.0 (http://creativecommons.org/licenses/by-sa/3.0)], via Wikimedia Commons. Right photo by Chatsam (Own work) [Public domain], via Wikimedia Commons.

Figure 7.20 Left to right: Morph as seen on frames 1, 18, and 36.

The tutorial is complete! A finished version of this tutorial is saved as `\ProjectFiles\FusionFiles\Chapter7\Morph.comp`. It's possible to create a similar morph using image sequences. You can animate the source and / or destination grid over time, and thus force the grids to follow moving characters or objects.

Adding Stylistic Effects

A handful of Fusion filter tools are not intended to create any realistic result but are designed to create fantastic or abstract designs, patterns, or variations. These may be suitable for motion graphics tasks, such as video transitions, or may be use in combination with other tools to generate unique results not available to any single tool. The stylistic tools are discussed briefly in this section. Duplicate and Pseudo Color tools are available through the Tools > Effect menu. Create Bump Map, Filter, Rank Filter, and Custom Filter are available through the Tools > Filter menu.

Duplicate Creates one or more copies of the input and places the copies on top. The copies become possessively smaller with the degree of change set by the Size parameter. The number of copies is set by the Copies parameter. The copies form a virtual stack, with the stack center determined by the interactive Center handle.

Pseudo Color Alters the input colors to create a psychedelic or otherwise unnatural color palette (Figure 7.21). The color shift is undertaken with the application of a waveform. Each color channel, along with the alpha channel, of the input receives its own sub-tab in the Tools tab with Frequency, Phase, Mean, and Amplitude parameters. These proprieties shape the color-shifting waveform and thereby alter the output colors.

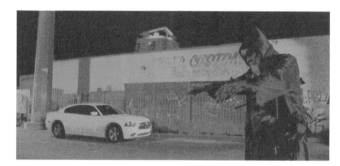

Figure 7.21 The Pseudo Color tool stylistically shifts colors.

Filter Contains a set of common convolution matrix filters (Figure 7.22). You can choose the filter type through the FilterType menu. Filters include Relief (embossed edges), Emboss Over (Photoshop-style emboss), Defocus, Laplacian (edge detection and separation), Sobel (edge detection and softened separation), Noise, and Grain. To avoid applying the tool to the alpha channel, deselect the Alpha checkbox.

Figure 7.22 Left: Filter tool's Relief filter. Right: Filter tool's Laplacian filter.

Create Bump Map Applies an emboss-stye filter to the input, converting the colors to those appropriate for a tangent-space normal map. Normal maps are used by 3D programs to add bumpiness to a surface at the point of render. You can use this tool in conjunction with a Bump-Map texture tool, which is discussed in Chapter 9.

Custom Filter Allows you to create your own convolution matrix filter by designing the matrix **kernel** (a table of values that is multiplied by each pixel within the input). You can choose the size of the matrix through the Matrix Size menu. (The larger the matrix, the more intense the result.) You can enter values directly into the matrix fields and see the result in a Display view. For example, you can create your own sharpen filter by entering the values illustrated in Figure 7.23. You can replicate other common filters with the matrices illustrated by Figure 7.24.

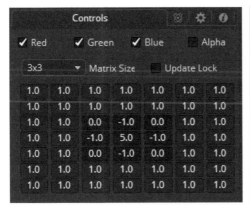

Figure 7.23 The matrix of a Custom Filter tool. With a 3×3 matrix, you can enter values into the central 9 fields. (Fields set to 1.0 have no affect on the input.) With this example, a custom sharpen filter is created.

Figure 7.24 Top left: 3×3 convolution matrix that creates a custom blur. Middle-right: Matrix that undertakes edge detection. Bottom-left: Matrix that generates an emboss filter.

Rank Filter Examines pixel values within a convolution filter kernel and replaces those pixel values with a single detected value that has been ranked. The ranked value is set by the Rank parameter. The size of the kernel matrix is set by the Size parameter. This filter is able to simplify an image pattern while maintaining relatively sharp edges.

Review of Procedural Tools

Throughout this book, various procedural tools are used to help demonstrate other tools. Procedural tools are those that are generated by the program using a mathematical algorithm without the need for external footage or other input. In Fusion, these tools are included in the Tools > Creator menu. A brief review follows:

Background Creates a solid-colored rectangle.

DaySky Generates a wide gradient that replicates a daytime sky with the horizon at the bottom of the frame.

FastNoise Creates a Perlin-based fractal noise with alpha values matching the RGB channel values.

Mandlebrot Draws a fractal pattern based on the mathematics of a Mandlebrot set. A Mandlebrot set creates a pattern where the same edge detail is repeated at all scales.

Plasma Use fractal noise to create a colorful, undulating pattern.

Text+ Produces text. You can control the font, size, and color.

Chapter Tutorial A: Time Warping a 3D Render

In the Chapter 6 tutorial, we drew a mask to add a missing taxi driver. We can further improve this project by time warping the taxi render and animating the driver mask. You can follow these steps:

1. Open the `\ProjectFiles\FusionFiles\Chapter6\MaskDriver.comp` project. Connect the Crop1 tool to a Display view. Play back the time ruler. The taxi drives in and out of frame but the driver, created with a mask, does not move. We can time warp the taxi render so that it starts in frame.
2. Choose Tools > Miscellaneous > Time Stretcher. Rearrange and reconnect the tool network so that the output of the Transfrom1 tool connects to the input of Time Stretcher and the output of the Time Stretcher connects to the Merge2 tool. Use Figure 7.25 as a reference.

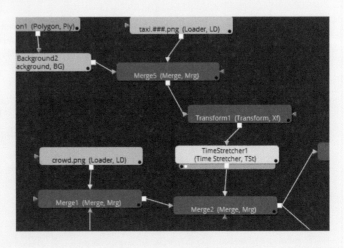

Figure 7.25 A Time Stretcher tool (selected) is inserted into the network.

3. Select the Time Stretcher tool and switch to the Spline view. Note that all the animatable tools are listed in the left column. To list only selected tools, click the Sel (Selected) button at the top left of the column. At this point, the Time Stretcher's Source Time spline is flat, indicating that a freeze frame exists with the first frame repeated over and over.

4. Go to the last frame of the time ruler. Go to the Tools > Controls tab and enter 142 into the Source Time field. A new keyframe is added. The speed of the render is now normal. Play back the time ruler. Note that the taxi comes to a stop after entering on frame 24. While the time ruler is on frame 24, RMB-click over the Source Time parameter name and choose Set Key. This stores the current value in a new keyframe at frame 24. Go to the first frame (0). Enter 24 into the Source Time field. This has the effect of creating a new freeze frame (Figure 7.26). Frame 24 is repeated for the first 24 frames of the time ruler. Thus, instead of entering the frame, the taxi starts in frame and eventually drives off.

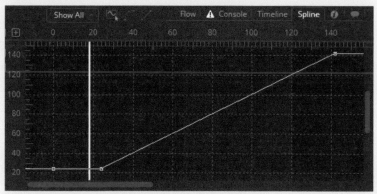

Figure 7.26 A temporary freeze frame is created by adding an additional keyframe at frame 24. The keyframes at frame 0 and frame 24 carry the same value of 24, which causes frame 24 to be repeated for the first 24 frames of the time ruler. Frames 0 to 23 are ignored.

5. Return to the Flow view. Insert a new Transform tool between the Background2 tool and the Merge5 node. This allows us to animate the driver mask so that it follows the taxi. Go to frame 91. This is one frame before the taxi begins to drive off. RMB-click over the new Transform tool's Center XY parameter and choose Animate. Go to frame 98. This is the last frame where the driver should be visible. Interactively drag the transform handle, moving the driver to keep him in the front seat. Use the render's window frame and car seat as a reference. Go to frame 99. Move the driver further to the right so that he falls out of the frame.

6. Scrub the time indicator between frame 91 and 99 to judge the animation. The taxi does not accelerate in a linear fashion; hence, the driver motion does not match. Go to frame 94. Update the driver's position. Go to other frames between 92 and 98 and repeat this process.

7. After you are satisfied with the animation of the driver mask, connect the Crop1 tool to a Display view. Play back the time ruler to see the complete shot (Figure 7.27). As a final step, choose Tools > Mask > Rectangle. Connect the Rectangle tool to the Effect Mask input of the Loader that imports the theater matte painting. Interactively position and scale the rectangle mask to cut off the top of the sky integrated in the theater artwork. Raise the rectangle tool's Soft Edge value. These steps help disguise the transition from the theater sky to the blue sky color generated by the Background1 tool. Make sure the rectangle is large enough to encompass the lower part of the theater.

The tutorial is complete! A finished version of this tutorial is saved as `\ProjectFiles\FusionFiles\Chapter7\WarpTaxi.comp`.

Figure 7.27 The final shot, seen on frames 0, 72, and 142.

Chapter Tutorial B: Creating Complex Results with Multiple Effect Filters

You can create complex results by adding multiple filter tools to a single network. For example, you can use Blur, Glow, and Pseudo Color tools in conjunction with Matte Control and Displace tools to generate a pulsing, science-fiction style portal. Follow these steps:

1. Create a new project. Create a new Loader and import `\ProjectFiles\Plates\Walkway\walkway.##.png`. Set the Loader tool's Hold First Frame parameter to 48. This is a quick way to create a freeze frame. We will only use the first frame of the image sequence in this tutorial. Set the Global Start Time to 1 and Global End Time to 48.
2. Choose Tools > Warp > Displace, Tools > Creator > FastNoise, and Tools > Composite > Merge. Connect the output of FastNoise to the Foreground of Displace. Connect the output of Displace to the Foreground of the Merge tool. Connect the output of the Loader to the Background of Displace. Connect the output of the Loader to the Background of the Merge tool. Use Figure 7.28 as a reference. Connect the Merge tool to a Display view. These connections distort one copy of the walkway footage and place the distorted version back on top of the undistorted original. The distortion is based on the values generated by the FastNoise tool.

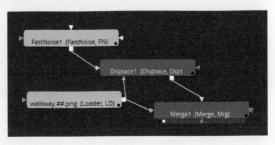

Figure 7.28 The initial network.

3. Select the FastNoise tool and connect it to a Display view. Adjust the FastNoise parameters to create a medium-sized noise with additional contrast. By default, the noise pattern is not animated. To add animation, go to frame 1, RMB-click over the Seethe parameter name, and choose Animate. Go to the last frame. Set Seethe to 6. Play back the time ruler. The noise shifts as if the camera is flying through a 3D noise mass. RMB-click over the Angle parameter and choose Animate. While on the last frame, set Angle to 360. Go to the first frame and set angle to 0. Play back. The noise rotates around the tool's transform handle.
4. Connect the Merge tool to a Display view. Select the Displace tool. Increase the Refraction Strength. Play back. The walkway is distorted by the Displace tool and the distortion changes over time (Figure 7.29).

Figure 7.29 Close-up of Displace distortion.

5. At this stage, the distorted version of the walkway occludes the original version. To avoid this, add a mask to the Effect Mask input of the Merge tool. For example, create a Ellipse tool, scale the mask circle to sit in the center of the sidewalk, raise the Ellipse tool's Soft edge value, and connect it to the Effect Mask input. The distortion is thereby limited to the mask area. This will serve as the center of the portal.

6. We can reuse the FastNoise output to create a secondary effect, such as a smoky ring that can serve as the edge of the portal. Choose Tools > Effect > Pseudo Color, Tools > Blur > Blur, and Tools > Blur > Glow. Connect the output FastNoise to the input of Pseudo Color (do not remove the original output connection). Connect the output of Pseudo Color to the input of Blur. Connect the output of Blur to the input of Glow. Use Figure 7.30 as reference. Connect the Glow tool to a Display view. Adjust the Pseudo Color, Blur, and Glow tool parameters to create a saturated, bright version of the noise.

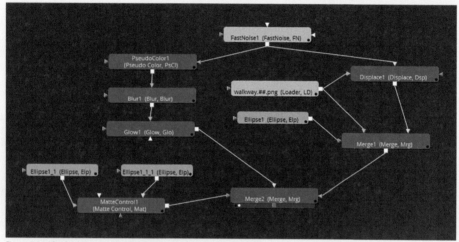

Figure 7.30 The final network for this tutorial.

7. Create a new Merge tool. Connect the output of Merge1 to the Background of the new Merge tool, Merge2. Connect the Glow tool to the Foreground of Merge2. Connect Merge2 to a Display view. The saturated noise occludes the walkway. Once again, you can add a mask. Select the Ellipse tool. Press Ctrl/Cmd+C. Deselect the tool. Press Ctrl/Cmd+V two times to paste two copies of the Ellipse tool. Choose Tools > Matte > Matte Control. Connect one of the Ellipse copies to the Background of the Matte Control tool. Connect the second Ellipse copy to the Foreground of the Matte Control tool. Set the Matte Control tool's Matte Combine menu to Alpha Combine and Combine Op menu to Subtract. Connect the Matte Control tool to a Display view. The foreground ellipse is subtracted from the Background ellipse. However, the two masks are the same size so the masks disappear. Select the Ellipse tool connected to the Matte Control Foreground. Interactively scale the selected Ellipse mask so that it becomes smaller. The ellipse is cut out of the center of the Background ellipse, creating an O matte shape.

8. Connect the output of the Matte Control tool to the Effect Mask input of Merge2. Connect Merge2 to a Display view. The brighter, more saturated version of the noise appears as a ring around the area of distortion. Play back the time ruler. A stylized portal undulates over time (Figure 7.31).

Figure 7.31 The final portal effect.

The tutorial is complete! A finished version of this tutorial is saved as **\ProjectFiles\ FusionFiles\Chapter7\Portal.comp.** Feel free to experiment with parameter settings or parameter animation for any of the tools used in the network,.

Auto Comp

Select Background Color

Clean Background Noise

Clean Foreground Noise

Spill Sponge

Matte Sponge

Restore Detail

Make Foreground Transpare

Spill (+) Spi

Chapter 8

Chroma Keying

The removal of green screen is a common task of visual effects compositing. Once removed, the screen is replaced with transparent alpha. This allows a new background to be placed behind the remaining non-screen foreground (such as an actor). Tools designed to remove green screen, blue screen, and other solid colors, are referred to as **chroma keyers**. Fusion includes the Primatte tool, which is an advanced keyer, plus several additional keyers that are suitable for specialized situations.

This chapter includes the following critical information:

- Overview of the chroma key process
- Application and adjustment of the Primatte tool
- Chroma keying workflow ideas
- Functionality of additional Fusion keyers

The Chroma Key Process

Chroma key refers to any process by which specific colors within an image are converted to transparent alpha. Chroma key tools are most often applied to screen or blue screen footage, where the green or blue are targeted. However, you can apply a chroma key tool to any color or color range. You can also apply a chroma key tool to a non-RGB channel, such as luminance. Successful application of the chroma key process prevents the need for manual masking or rotoscoping.

Keying with Keyer Tools

Fusion provides a variety of chroma key tools, which are located in the Tools > Matte menu. Of these, Primatte includes the most advanced set of parameters. In addition, the Primatte tool includes several interactive or automatic options to simplify the keying process. **Keying**, in this case, refers to the application of a keyer tool. Along similar lines, a **key** is the resulting alpha matte generated by the keyer. When discussing the keying process, **foreground** refers to the part of the image that is saved (such as an actor). **Background** refers to the part of the image that is removed by assigning transparent alpha values. Hence, a green screen backdrop is the background.

Applying the Primatte Tool

To apply the Primatte tool, follow these basic steps:

1. Connect the tool that you want to key to the Foreground input of the Primatte tool. This is the tool's default input. The input triangle is orange. Connect the Primatte tool to a Display view.
2. With the Primatte tool selected, click the tool's Auto Compute button (Figure 8.1). The button automatically detects the background color (for example, the green of a green screen). The alpha in the detected background area receives a transparent alpha value. The result is visible in the Display view.

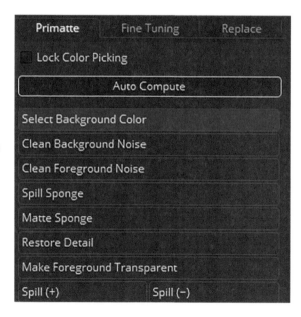

Figure 8.1 Top set of automatic and interactive buttons provided by the Primatte tool.

3. You can examine the resulting alpha matte by changing the Display view's Color menu to Alpha (Figure 8.2). If noise exists in the form of gray pixels in the background area, click the tool's Clean Background Noise button. Proceed to LMB-drag in the Display view over gray pixel areas of the background. A red line forms under the mouse. You can do this multiple times. Each time you release the mouse, the matte is updated with additional transparency. (Note that the Clean Background Noise button is not designed to remove unwanted objects, such as light equipment or rigging—these must be removed with masks.) While viewing the alpha channel, black pixels are 100% transparent, white pixels are 100% opaque, and gray pixels are semi-transparent. When the Primatte tool is selected, a small toolbar is added to the Display view. The default sampling mode is activated by the Line button. If you choose the Box button, you can sample pixel values by LMB-dragging a box in the Display view. If you activate the Median button, the median value of sampled pixels is applied (as opposed to the average value).

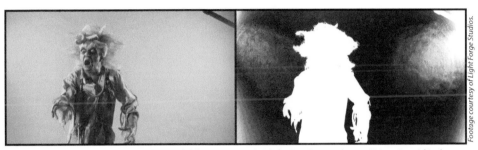

Footage courtesy of Light Forge Studios.

Figure 8.2 Left: Green screen footage. Right: Initial alpha matte created with the Auto Compute button. Noise exists within the background area. This footage is included with the tutorial files as `\ProjectFiles\Plates\Ghost\ghost.##.png`.

4. If gray pixels appear in the foreground area, click the tool's Clean Foreground Noise button. Proceed to sample gray, foreground pixels in the Display view. The matte updates with additional opaqueness. To check the RGB channels, change the Display view's Color menu to Color.

These four steps will generate a rough alpha matte (Figure 8.3). However, these steps may not address issues with matte edge quality of spill. Edges may suffer from pixelation or stairstepping. **Spill**, which is the appearance of the background color within the foreground, generally requires specialized options to remove. These issues are discussed in the following two sections.

Figure 8.3 Alpha matte after the application of the steps discussed in this section. Additional work must be undertaken to improve the matte edge by removing remaining noise and unwanted objects from the background.

Removing Spill with Primatte

When shooting an actor or object in front of green or blue screen, it's common for spill to appear in the foreground. This is due to light bouncing off the green or blue screen material. You can remove or minimize the spills with these additional steps when working with the Primatte tool:

1. While looking at the color channels in a Display view, click the Primatte tool's Spill Sponge button. Proceed to LMB-drag in the Display view over the areas of the foreground that carry the greatest degree of spill color. Each time you release the mouse, the foreground is updated and the spill color is reduced (Figure 8.4).
2. if the spill removal is too aggressive, press Ctrl/Cmd+Z to undo. You can also add back the spill color by clicking the Spill(+) button and LMB-dragging in a Display view. To remove spill color in a less aggressive manner, use the Spill (-) button and LMB-drag in the Display view.

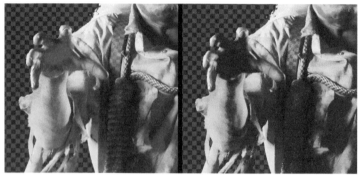

Figure 8.4 Left: Green spill seen on the white make-up and clothing of an actor. Right: The green is removed with the application of Spill Sponge and Spill buttons.

When the spill color is removed form the foreground, the color balance between RGB channels is adjusted. When you are using the free version of Fusion, the spill color is replaced by a complimentary color. For example, when removing green, the red-blue ratio is increased and the foreground receives a purplish color cast. If you are using Fusion Studio, you have the option to switch to Image replacement, which uses color contained within a blurred version of the original input, or Color replacement, wherein you are free to choose your own replacement color. You can switch between these replacement modes by going to the Tools > Replace tab and selecting a Replace Mode button.

Adjusting the Matte Edge with Primatte

The matte edge produced by the Primatte tool is rarely perfect after the first few steps of the tool's application. Hence, Primatte includes additional buttons for interactively refining the matte edge. These buttons operate is the same fashion as previously described buttons: Use the Line mode and LMB-drag in the Display view or use the Box mode to draw a box in the Display view. You are free to use any of the buttons in any order. The buttons are described here:

Matte Sponge Restores opaqueness to semi-transparent areas of the foreground. You can sample semi-transparent pixels of the matte edge to reduce the edge transparency. You can also sample pixels within the interior of the foreground shape to remove any remaining transparency.

Restore Detail Restores semi-transparency to background areas. You can sample pixels along the matte edge to increase the width of the semi-transparent transition. This is particularly useful for restoring softness to the edge of hair.

Figure 8.5 Left: Close-up of matte edge along hair. There are few semi-transparent pixels, causing small hairs to be lost. Right: Result after the application of Restore Detail. The edge is softer and many small hairs are once again visible. This project is included with the tutorial files as \ProjectFiles\FusionFiles\Chapter8\PrimatteMatte.comp.

Matte(-) and Matte(+) With Matte(-), the matte transparency is increased in the areas that share the color of sampled pixels. With Matte(+), the matte opaqueness is increased in the areas that share the color of sampled pixels. The Matte(+) button is useful for removing semi-transparency from areas that contain heavy spill.

Detail(-) and Detail(+) With Detail(-), the matte transparency is increased in the areas that share the color of the sampled pixels. Sampled colors are considered part of the background. Detail(+) moves the sampled colors back into the foreground. Of all the buttons, Detail(-) and Detail(+) produce the most subtle results.

In addition to the buttons in the Tools > Primatte tab, there are additional matte parameters in the Tools > Matte tab. These include Matte Blur, which softens the resulting matte edge, and Matte Contract / Expand, which undertakes its namesake operation.

Note that the use of the buttons described in this section might cause noise to reappear in the background. If you are unable to remove this noise while maintaining a good alpha matte edge, you have the option to mask or rotoscope the background to minimize the area that the Primatte tool is working with (Figure 8.6). In fact, you can connect a mask tool to the Primatte tool's Garbage Matte input for this purpose. You must invert the connected mask, however, by selecting the Primatte tool's Invert Garbage Matte checkbox, located in the Tools > Matte tab.

Figure 8.6 A Polygon tool mask is drawn around the foreground actor. This removes unwanted noise and objects from the background. With such a set-up, it may be necessary to animate the mask changing shape over time to follow the actor's motion. This project is included with the tutorial files as `\Project-Files\FusionFiles\Chapter8\PrimatteMask.comp`.

Choosing a Primatte Algorithm in Fusion Studio

In Fusion Studio, the Primatte tool offers three different algorithms for undertaking the task of keying. These are set by the Algorithm buttons in the Primatte tab and are described here:

Primatte The default system that views the colors contained within an input as a series of three-dimensional polyhedrons. This is the most advanced but most computationally expensive mode. Primatte is the only mode available when using the free version of Fusion.

Primatte RT Uses a simpler, two-dimensional representation of incoming colors. This mode is efficient but may not produce a quality matte edge. This mode is suitable for green screen shots that contain a high level of saturation.

Primatte RT+ Combines the Primatte RT and Primatte modes to offer average efficiency and quality. Neither Primatte RT nor Primatte RT+ offer the option to replace spill color with a complementary color.

Using Additional Primatte Options

Additional options are available in the Primatte tool's Primatte tab. They are described in this section. Note that several of these options are only available in Fusion Studio.

Select Background Color Although the Auto Compute is often successful in selecting the correct background color, you have the option of manually selecting the background color with this button. This may be appropriate when working with a background area that is fairly small or working with an unusual key color, such as red.

Lock Color Picking When this checkbox is selected, the background color is "frozen." This prevents the accidental selection of a new background color.

Hybrid Rendering When this checkbox is selected in Fusion Studio (Figure 8.7), the Primatte operation is divided into two separate mattes: the foreground edge and foreground body (interior of the foreground). Although the mattes are combined for the final output, the initial separation helps maintain a quality edge while avoiding transparency within the body. When using hybrid rendering, the basic workflow follows:

- Select the background color with the Auto Compute or Select Background Color buttons.
- Select the Hybrid rendering checkbox.
- Use Clean Foreground Noise to sample any noise in the foreground body.
- Apply other buttons, such as Restore Detail, to fine-tune the edge.

The Hybrid Blur parameter softens the foreground body matte while the Hybrid Erode parameter erodes the combined matte.

Adjust Lighting When this checkbox is selected in Fusion Studio, Primatte averages the background in an attempt to create even lighting and even values in that area. This helps reduce noise that might otherwise remain in the background due to uneven lighting, shadows, and so on. Before selecting Adjust Lighting, you must select the background color with the Auto Compute or Select Background Color buttons. The Lighting Threshold slider determines the aggressiveness of the background averaging.

Figure 8.7 Bottom set of parameters included in the Tools > Primatte tab.

Crop When this checkbox is selected in Fusion Studio, a rectangular, integrated garbage mask is activated. You can interactively size the crop mask without affecting the frame size of the output.

Reset Sets the Primatte tool back to its default state (the alpha matte is destroyed).

Soft Reset Resets the tool, but keeps the background color that was last selected. The initial alpha matte remains intact.

The Primatte tool also provides the Tools > Fine Tuning tab, which you can use to fine-tune specific colors within the foreground RGB. You can select a target color by using the Pick button or choosing a color through the built-in color wheel. The Spill parameter, when raised above 0, removes additional background color from areas of the foreground that contain the target color. You can adjust the foreground transparency with the target color area by adjusting the Transparency parameter value. The Detail parameter restores or removes detail within the target color area and produces results similar to the Detail(-) and Detail(+) buttons.

Optional Primatte Tool Inputs

The Primatte tool includes a Background input. If you connect a new background image to this input, you'll take advantage of Primatte's high-quality edge-blending algorithm. If you do not use this input, Primatte outputs the alpha matte with a transparent background; you are then free to add a new background using an additional Merge tool.

Primatte also includes an Effect Mask input. Although this input is not useful as a garbage mask input, it may be used to restore an element of the foreground that the Primatte operation inadvertently removed.

Keying with Other Fusion Keyers

Fusion includes additional keyers in the Tools > Matte menu, including the Chroma, Ultra, Luma, and Difference Keyer. Although not as advanced as the Primatte keyer, these keyers are nevertheless useful in specialized situations. They are described briefly in the following sections.

Keying with Chroma Keyer

The Chroma Keyer is designed to key any color and is not optimized for green or blue screen. To select a background color, LMB-drag in a Display view to create a selection marquee. You can fine-tune the selected color range by adjusting the sliders within the Color Range section. To soften the transition for transparent background to opaque foreground, raise the Soft Range parameter value. The keyer has two modes, set by buttons at the top of the Tools > Chroma Key tab: Chroma and Color. Chroma interprets the background color via RGB values while Color interprets the background color by examining specific hues. Due to the simplicity of the tool, it is best suited for solid color backgrounds with little spill or soft edges (such as hair). For example, you might use the tool to remove a cloudless sky against a row of buildings (Figure 8.8).

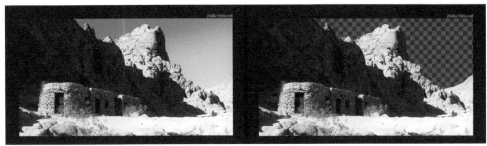

Figure 8.8 A blue, cloudless sky is removed quickly with the Chroma Keyer tool. This project is included with the tutorial files as \ProjectFiles\FusionFiles\Chapter8\ChromaKeyercomp.

Keying with Ultra Keyer

The Ultra Keyer targets blue or green screen, as is set by the buttons with the same name at the top of the Tools > Pre Matte tab. To select a background color, LMB-drag in a Display view to create a selection marquee. You can fine-tune the background color range by adjusting the sliders in the PreMatte Range section. You can remove spill through the Tools > Image tab. The degree of Spill suppression is set by the Spill Suppression slider and the Spill Method buttons, which range from None (no suppression) to Burnt (aggressive suppression). You can adjust the resulting edge in the RGB channels by adjusting the Fringe parameters. For example, you can softly tint the RGB edge by altering the Fringe Gamma, Fringe Size, Cyan, Magenta, and Yellow sliders. The ability to tint the RGB edge is sometimes useful for disguising edge artifacts created by some digital video cameras when shooting green screen.

Keying with Luma Keyer

The Luma Keyer operates on a specific channel, as is set by the Channel menu at the top of the Tools > Controls tab. Optional channels include those that make up RGBA, luminance, saturation, hue, and depth (Z-buffer). Targeting a specific channel may produce superior results in some situations. For example, you can target the luminance when removing a bright white marquee of a theater. You can target saturation if a foreground object is deeply saturated (Figure 8.9). You can also avoid a particular color channel that might carry too much camera noise (that can interfere with the matte edges).

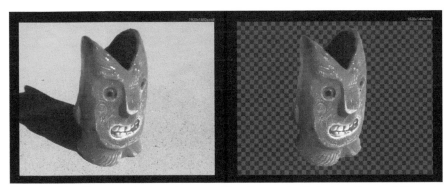

Figure 8.9 A heavily-saturated red mug is separated from the ground with the Luma Keyer tool. This project is included with the tutorial files as \ProjectFiles\FusionFiles\Chapter8\LumaKeyer.comp.

The Luma Keyer includes a Matte Blur, Matte Contrast, and Matte gamma parameters which you can use to adjust the resulting alpha matte.

Keying with Difference Keyer

The Difference Keyer operates by noting the differences between two inputs. For example, a plate with an actor is compared to a **clean plate** (a plate that lacks the actor but is otherwise identical). For this tool to function, the camera and background must be in the same exact position for each input. The areas of the inputs that are identical are converted to transparent alpha. This tool may be useful when a green or blue screen is not available and the camera is fixed to a tripod. To use the Difference Keyer, follow these steps:

1. Connect the plate that contains the foreground to the Foreground input of the Difference Keyer.
2. Connect the plate that only contains the background (the clean plate) to the Background input of the Difference Keyer (Figure 8.10). In the absence of a clean plate, you can use a solid color. For example, use the Background tool and set the color to match the green of a green screen contained in the Foreground input. The alpha matte is automatically generated (Figure 8.11).
3. Adjust the Low and High parameter values to remove more or less of the background. The Low and High parameters set the tolerance when identifying differences between the Foreground and Background input.
4. Fine-tune the resulting matte by adjusting the Matte Blur, Matte Contrast, and Matte Gamma sliders.

Figure 8.10 A clean plate is connected to the Background input of a Difference Keyer. The plate containing the foreground is connected to the Foreground input.

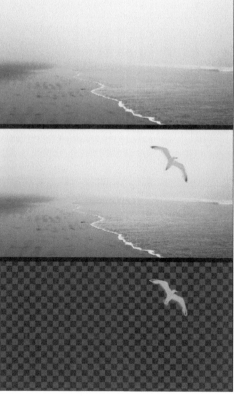

Figure 8.11 Top: Clean plate featuring a foggy beach. Middle: Foreground plate that includes a flying bird. Bottom: Output of the Difference Keyer. This project is included with the tutorial files as `\ProjectFiles\Fusion-Files\Chapter8\DifferenceKeyer.comp`.

Taking Additional Steps to Improve the Matte

A single keyer tool may not generate an acceptable alpha matte. Therefore, it may be necessary to add other tools to the network or take additional steps to improve the result. Here are a few ideas for making an improvement:

- Mask or rotoscope to remove an unwanted areas of the background. For example, connect a mask tool to the Garbage Matte input of a Primatte tool or connect a mask tool to the Effects Mask input of a Chroma Keyer tool.
- Mask or rotoscope to restore a missing part of the foreground body (interior). For example, connect a Polygon tool to the Effects Mask input of a keyer and invert the Polygon mask.
- Connect the output of the keyer to one or more color correction tools and set the tools to operate on the alpha channel (but not the color channels). Adjust the color tools to make the foreground more opaque and the background more transparent.
- Use the Erode / Dilate tool (in the Tools > Filter menu) to erode or expand the matte. Avoid large erosion or expansion values as they tend to produce noticeable edge artifacts.
- Break the input into several pieces through masking or rotoscoping. For example, if you are keying an actor against green screen, mask the head and body so they become two separate branches of the tool network. Apply unique keyers and settings to each branch. Recombine the branches by using a Merge tool.

Chapter Tutorial: Keying a Green Screen

Each green screen shot carries its own unique qualities. Although you can follow the same basic process when applying chroma key tools (as described in this chapter), the exact parameters values and application of keyer options will vary with each shot. To practice keying a green screen, follow these steps:

1. Create a new project. Choose Files > Preferences. In the Preferences window, set the Frame Rate to 24. Create a new Loader and import `\ProjectFiles\Plates\Woman\woman.##.png`. Set the Global End Time field to 23. Connect the Loader to a viewer. Play back the time ruler. An actress moves in front of a green screen backdrop. Motion tracking marks and the edge of the screen are visible in the frame.
2. Choose Tools > Mask > Polygon. With the new Polygon tool selected, draw a mask that loosely surrounds the actress. Choose Tools > Matte > Primatte. Connect the output of the Loader to the Foreground input of the Primatte tool. Connect the output of the Polygon tool to the Garbage Matte input of the Primatte tool. Open the Primatte tool in the Tools tab. Switch to the tool's Matte tab. Select the Invert Garbage Matte checkbox. Connect the Primatte tool to a Display view. The closed mask cuts out the majority of the green screen and removes the unwanted tracking marks and edge of screen (Figure 8.12).

Figure 8.12 A Polygon mask, connected to a Primatte tool's Garbage Matte input, limits the green screen area.

3. Play back the time ruler. The actress moves, which requires rotoscoping. Return to the frame where you drew the mask. Open the Polygon tool in the Tools tab. RMB-click over the phrase *Right-Click Here For Shape Animation* and choose Animate. Proceed to other frames and update the shape of the mask so that it does not cut off the actress but continues to remove the majority of green screen.

4. Open the Primatte tool in the Tools tab. Return to the Primatte tab. Click the Auto Compute button. The green screen is removed. However, a white, semi-transparent highlight remains at the top of the mask. In addition, the pants and backpack become extremely black (Figure 8.13).

5. With the connected Display view selected, press the A key to display the Alpha channel. Play back the time ruler. Note the problem areas of the alpha matte. There is gray noise around the top and bottom of the background. Although the foreground is mostly solid, there are areas of the handkerchief that are gray; this is due to a high level of green in the handkerchief color.

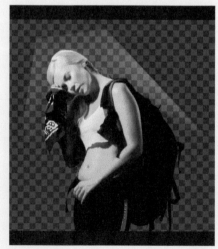

Figure 8.13 Initial result of the Auto Compute button.

6. Return to the first frame. Click the Primatte tool's Clean Background Noise button. LMB-drag multiple times in the Display view to remove unwanted gray noise in the background. Click the Clean Foreground Noise button. LMB-drag multiple times in the Display view to remove unwanted gray noise in the handkerchief area.

7. Set the Display view's Color menu back to Color. Play back the time ruler. Note that the restoration of the opaque matte to the area of the handkerchief has returned the missing green to the pants and backpack. However, there is significant green spill around the edge of the backpack and, to a lesser degree, the hair (Figure 8.14).

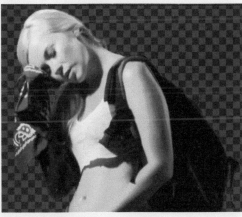

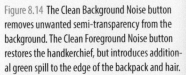
Figure 8.14 The Clean Background Noise button removes unwanted semi-transparency from the background. The Clean Foreground Noise button restores the handkerchief, but introduces additional green spill to the edge of the backpack and hair.

8. While the Display view continues to display the RGB channels, click the Spill Sponge button. LMB-drag once or twice along an edge of the backpack where the green is the most intense. Release the mouse button. The green is reduced; however, the pants and backpack quickly become black. Press Ctrl/Cmd-Z to undo the Spill Sponge. Click the Spill(-) button. LMB-drag over the green edge. Because the Spill(-) button is less aggressive, the removal of green is more incremental. Try to balance the reduction of the green along the edge with a good color balance for the pants and backpack. You can restore green spill to any area by clicking the Spill(+) button and LMB-dragging.

9. To gauge the result of the green screen removal, you can add a new background. This may take the form of a different image sequence or a piece of static art. You can also add a solid color background as a temporary means to test the key. To do so, choose Tools > Creator > Background. Set the Background tool's Color to a bright color unlike the colors contained in the green screen footage. For example, choose red. Connect the output of the Background tool to the Background input of the Primatte tool. Play back the time ruler and examine the quality of the green screen key.

10. Zoom into the hair. This is one area that may lose detail through the keying process. To restore additional softness and detail to the hair edge, click the Restore Detail button and LMB-drag along the hair edge wherever a soft transition to transparency doesn't exist. The Restore Detail adds back a narrow area of semi-transparency and helps prevent the loss of small hairs. Feel free to disconnect or connect the Background tool at any time to judge the progress of the key.

11. While you are examining the hair edge, look for remaining green spill. At this stage, the green is most likely subtle. To remove additional spill from the hair edge, return to the Spill Sponge or Spill(-) tool (Figure 8.15). Zoom out and examine the overall impact. Play back the time ruler.

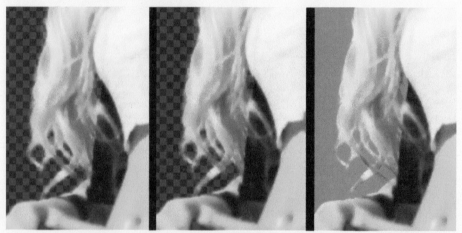

Figure 8.15 Left: Close-up of hair, as seen on frame 22. The Restore Detail adds softness back to the edge. Middle: Remaining green spill is reduced with the Spill Sponge tool. Right: A red Background tool is connected to the Primatte tool's Background input to test the quality of the key.

12. Adjusting the hair edge can easily lead to new noise in the background (in this case, near the bottom of the frame). Another way to remove background noise is to switch to the Primatte tool's Matte tab and raise the Matte Threshold Low field value. The Low field clips the background whereby any alpha value below the Low value is pushed down to 0-black (100% transparency). For example, with this tutorial you can change the Low value of 0.1 to remove remaining background noise (Figure 8.16). Using a higher Low value will erode into soft areas of the hair.

The tutorial is complete! A finished version of this tutorial is saved as \ProjectFiles\ FusionFiles\Chapter8\Greenscreen.comp. Feel free to experiment with Primatte parameter settings. You can use the interactive Primatte buttons multiple times and in any order.

Figure 8.16 **The final key, as seen on frame 19.**

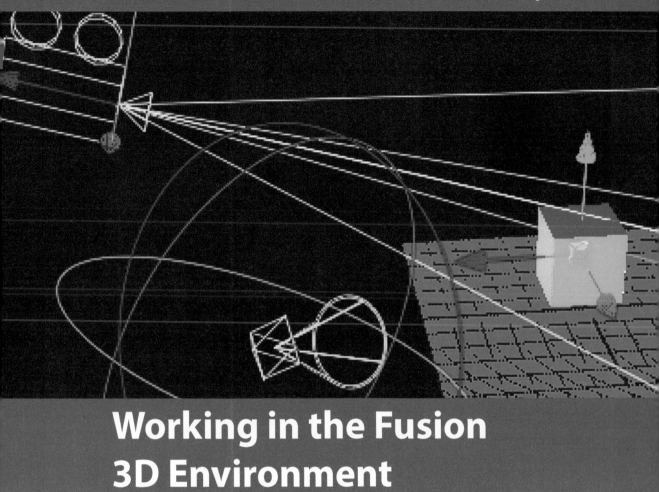

Working in the Fusion 3D Environment

In the past, 2D and 3D programs were distinct and separate. However, in recent years 3D environments and tools have found there way into 2D compositing programs like Fusion. The ability to create an import 3D geometry, as well as generate materials, textures, lights, and particle simulations within a composite adds a great deal of flexibility to the compositing process. Fusion's 3D environment, along with a vast array of 3D and particle tools with myriad parameters, is difficult to cover in a single chapter. Nevertheless, we will touch on the most critical information to give you a strong start.

This chapter includes the following critical information:

- Adding primitive geometry, cameras, and lights
- Navigating and transforming within the 3D views
- Assigning materials and textures
- Importing geometry, cameras, lights, and animation splines
- Setting up particle simulations

Overview of the Fusion 3D Environment

Thus far, we've discussed tool networks that operate in a 2D space. Footage is interpreted as 2D, with a resolution read in width and height. Merge tools operate in 2D space, where the foreground sits on top of the background. Nevertheless, Fusion includes a complete 3D environment with X, Y, and Z axes. This environment operates like many 3D programs, such as Autodesk Maya, Maxon Cinema 4D, or Blender. You can create a 3D portion of a tool network and combine it with 2D portions. You can create or import 3D geometry. You can add 3D cameras, lights, materials, and textures.

Constructing a Basic 3D Scene

To create a working 3D scene inside Fusion, you need a minimum of four tools:

- A geometry tool
- Merge 3D tool
- Camera 3D tool
- Renderer 3D tool

Tools designed for the 3D environment are located in the Tools > 3D menu. The Merge 3D tool combines multiple 3D elements, such as geometry, cameras, and lights, so they can be rendered. The Renderer 3D tool produces a 2D render of the 3D scene as seen by the connected 3D camera. The Camera 3D tool provides a 3D camera. A geometry tool may come in the form of a primitive geometry generator or a geometry importer. The required tool connections are illustrated by Figure 9.1.

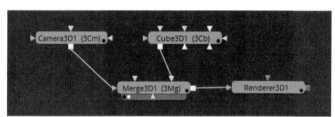

Figure 9.1 A basic 3D scene requires a geometry tool (with this example, a Cube 3D tool), along with Camera 3D, Merge 3D, and Renderer 3D tools. Note that many 3D tools are colored blue-gray. This project is included with the tutorial files as `\Project-Files\FusionFiles\Chapter9\Basic3D.comp`.

The Merge 3D tool provides an unlimited number of SceneInput inputs, each of which are numbered. The order in which you connect 3D tools to the SceneInput inputs does not matter. Each time you make a connection, a new SceneInput input appears on the Merge 3D tool. The Merge 3D tool carries a Transformation tab (the tab carries a 3D axis icon). You can alter the tab's Translation, Rotation, and Scale parameters and thus transform all the tools connected to the Merge 3D tool as a single unit. You can use multiple Merge 3D tools in a scene to create parent / child hierarchy relationships (a common task with 3D programs).

A 3D scene must pass through a Renderer 3D tool before it can be connected to a 2D portion of a tool network. For example, if you want to combine a 3D scene with footage imported through a Loader tool, the 3D scene must first pass through a Renderer 3D tool before it is connected to a Merge tool.

Controlling Camera Views in 3D Space

The 3D environment includes a default 3D camera with which you can view the scene in 3D space. This camera does not appear as a tool, but is permanent to the system. The camera is named *Perspective*. When you connect a 3D tool, such as a Merge 3D tool, to a Display view, the view through the Perspective camera appears automatically.

To alter the perspective view, you can use the following shortcuts:

- To pan, MMB-drag.
- To orbit, Alt/Opt+MMB-drag.
- To dolly, LMB+MMB-drag left or right.

You can also dolly by scrolling a MMB scroll wheel while pressing Ctrl/Cmd.

You can switch to a different camera by selecting the Display view, RMB-clicking in the view, and choosing Camera > *camera*. Each Camera 3D tool in the project is listed in the Camera menu. In addition, Fusion provides a full set of standard orthographic views, such as Front and Top. You can alter the views of these cameras using the same shortcuts described for the Perspective camera.

By default, you can view one camera at a time in a Display view. However, you can switch to a quad view by RMB-clicking in the view and choosing Views > Quad View. The quad view layout is determined by the Views > Quad Layout > *layout* options. To return to a single camera view, choose Views > Quad View again to deselect the quad option.

Note that new geometry and camera tools place their respective objects at 0, 0, 0 in 3D space. As such, the geometry often intersects the camera. Hence, it may be necessary to dolly the Camera 3D camera backwards or move the geometry away from 0, 0, 0 to properly see the scene.

Transforming Cameras and Geometry

You can also view a camera icon through a Perspective or orthographic camera view and interactively LMB-drag the XYZ axis handle (Figure 9.2). The handle is provided by the Move button, which appears at the top-left or top-right of the Display view. To rotate the camera, click the Rotate button and interactively LMB-drag one of the rotation handle circles. The buttons appear when the Camera 3D tool is selected.

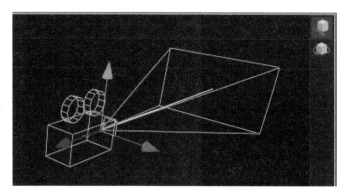

Figure 9.2 A Camera 3D camera, as seen form the Perspective camera. The Move axis handle is visible. The Move and Rotate buttons appear at the top-right of the Right Display view.

You can transform a Camera 3D camera while looking through it by using the MMB-drag (dolly left or right), Alt/Opt+MMB-drag (rotate), and LMB+MMB-drag (dolly forward or backward) shortcuts in the selected Display view.

The transformations are stored in the camera's Transformation tab (marked with a 3D axis icon). Position is carried by the XYZ Offset parameters and the rotation is stored by the XYZ Rotation parameters. You can manually change the values of the parameter fields. The parameters are animatable. By default, the camera does not use a target or similar "look at" controller. However, you can select the Target checkbox and the camera will point automatically toward a position in 3D space set by the XYZ Target Position parameters.

Each camera can carry a unique focal length, as set by the Focal Length parameter in the Tools > Controls tab. This parameter is measured in millimeters, emulating a real-world lens size. A small millimeter value is equivalent to a wide lens (such as a "fish eye" lens) and a large millimeter value is equivalent to a long lens (such as a telephoto lens). Note that the Focal Length and Angle Of View parameters are linked. Angle Of View represents the angular extent of the lens view, as represented by the pyramidal frustum at the front of the camera icon (see Figure 9.2 on the previous page).

You can transform geometry by selecting the matching geometry tool and using the interactive handles in a Display view. When you select a geometry tool, three buttons appear at the top-left or top-right of the Display views: Move, Rotate, and Scale. The transformation values are stored by matching parameters in the tool's Transformation tab.

Rendering the 3D Scene

As discussed, you must render a Fusion 3D scene with a Renderer 3D tool in order to use the scene with other 2D sections of the tool network. To view the output of a Renderer 3D tool, connect it to a Display view. Empty 3D space is rendered as transparent alpha.

The Renderer 3D tool includes three renderers, which you can choose through the Renderer Type menu. They are described here:

Software Renderer Provides maximum render quality and is not dependent on the system graphics card.

Open GL Renderer Uses the graphics card GPU to render the scene. This renderer may be significantly faster than the Software Renderer but may not produce equivalent quality. This renderer may be useful for creating tests.

Open GL UV Renderer "Bakes" projected textures into texture maps. Texture projection is discussed in the "Projecting Textures" section later in this chapter.

By default, the Software Renderer ignores lights and renders geometry with flat lighting (Figure 9.3). To activate lighting, select the Enable Lighting checkbox at the bottom of the Renderer 3D tool's Controls tab. By default, the renderer ignores shadows cast by lights unless you select the Enable Shadows checkbox.

Figure 9.3 A cube generated by the Cube 3D tool, as seen through a Camera 3D camera and rendered by the Renderer 3D tool. Enable Lighting is deselected, creating a flat look.

By default, the Software Renderer renders a beauty pass that includes RGBA channels. You can select additional or alternate channels, such as Z (Z-depth) or Normal (polygon surface normal orientation) by selecting or deselecting checkboxes in the Output Channels section.

You can choose an output resolution and bit-depth quality for the Renderer 3D tool through the tool's Image tab. For example, you can change the Width and Height parameters while switching the Depth parameter from Default (the bit-depth set by the Preferences window) to 32bit Float. You can alter the output color space through the Source Color Space section and output gamma curve through the Source Gamma Space section. (For information on bit depths and gamma, see Chapter 2.)

Working with Geometry

Fusion includes a set of tools that create primitive geometry. These include Cube 3D, Shape 3D, and Text 3D. The Shape 3D tool creates a plane, cube, sphere, cylinder, cone, torus, or ico (polyhedron), based on which button you select at the top of the tool's Controls tab. Each primitive shape carries its own set of transformation parameters, such as Size, Radius, and so on. The complexity of any given primitive is set by Subdivision Level parameters. Note that the default Size value of each primitive is 1.0. You are free to change any Size parameter above the default slider limit of 1.0 by entering a value into the parameter field. The Text 3D tool includes Size and Font parameters, plus a Stylized Text field in which you can type text. By default, the text is a flat cut-out. However, you can add depth to the text by altering values in the Extrusion section. Cube 3D, Shape 3D, and Text 3D tools include a Tools > Transformation tab.

3D Display Modes

The Display views carry four buttons that determine how the 3D view is displayed by the Perspective or other Camera 3D cameras. These are Wire (wireframe), Light (lighting from 3D lights), Shad (shading/shadows), and Fast (low-quality). You can turn these on and off in different combinations. The buttons affect the Display view when a camera, geometry, or Merge 3D tool is connected to the view; however, the buttons do not affect the output of the Renderer 3D tool. The buttons are to the immediate right of the Quad button. You can force a geometry tool to display as a wireframe, regardless of the button settings, by selecting the geometry tool's Wireframe checkbox.

Mini-Tutorial 7: Creating a Flying Logo

You can build and animate a flying logo (a 3D logo designed for motion graphics) with Fusion's built-in 3D tools. Follow these steps:

1. Create a new project. Using Tools > 3D menu, create a new Merge 3D, Camera 3D, Renderer 3D, and Text 3D tool.
2. Connect the output of the Camera 3D tool to the SceneInput input of the Merge 3D tool. Connect the output of the Text 3D tool to a second SceneInput input of the Merge 3D tool. Connect the output of the Merge 3D tool to the input of the Renderer 3D tool. Use Figure 9.4 as reference.

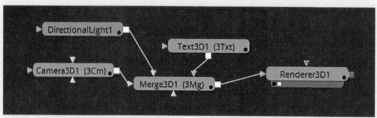

Figure 9.4 The final tool network for this tutorial.

3. Connect the Merge 3D tool to a Display view. By default, the view of the Perspective camera is displayed. Using the camera shortcuts described earlier in this chapter, dolly, scroll, and orbit the Perspective camera so that you can see the Camera 3D camera, named *Camera3D1*, in its entirety.

4. Select the Text 3D tool. In the Tools > Text tab, enter text in the Styled Text field that represents a company logo (for example, *ABC Co.*). The text remains small compared to the camera icon. Scale the text up by increasing the Text 3D tool's Size parameter (Figure 9.5). You can enter a value, such as 100, directly into the parameter's field. While the Text 3D tool is selected, interactively move the text away from the camera in the negative Z direction. Feel free to choose a different font through the Font menu.

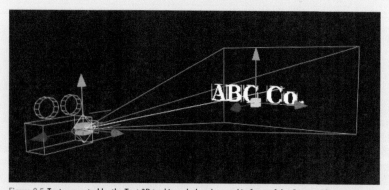

Figure 9.5 Text generated by the Text 3D tool is scaled and moved in front of the Camera 3D camera.

5. In the Display view, RMB-click and choose Camera > Camera3D1. You can continue to adjust the position of the text while the Text 3D tool is selected. However, the frame edge is not visible. Connect the Renderer 3D tool to a Display view. The frame edges, and transparency of empty 3D space, are displayed. However, the transform handles are inaccessible. Nevertheless, you can fine-tune the text position by adjusting parameter values in the Text 3D tool's Transformation tab.

6. Set the Global Start Time to 1 and Global End Time to 36. Go to frame 1. Return to the Text 3D tool's Transformation tab, RMB-click over Y Rotation, and choose Animate. Go to frame 36. Change the Y Rotation field to 359. Play back the time ruler. The logo rotates a single time.

6. At this stage, the logo geometry is flat. Return to the Text 3D tool's Text tab. Expand the Extrusion section. Raise the Extrusion Depth value. The letters become three-dimensional with depth in the Z direction. However, there is no lighting information and the logo appears solid white.

7. Select the Renderer 3D tool. Select the tool's Enable Lighting checkbox. The logo turns black because no lights are present. Choose Tools > 3D > Light > Directional Light. Connect the output of the Directional Light tool to the third SceneInput input of the Merge 3D tool. The logo is lit with variations in surface brightness and darkness (Figure 9.6). Feel free to adjust the rotation of the light to fine-tune the lighting.

Figure 9.6 The extruded and lit logo, as seen via the Renderer 3D output.

The tutorial is complete! A finished version of this tutorial is saved as `\ProjectFiles\FusionFiles\Chapter9\FlyingLogo.comp`. We'll return to this tutorial at the end of this chapter.

Altering Geometry

Several Fusion tools are designed to alter 3D geometry within the 3D environment. You can place these tools between the geometry tool and the Merge 3D tool (Figure 9.7). The tools are briefly described here:

Bender 3D Bends, tapers, twists, or shears the input geometry (Figure 9.8). To choose one of these distortions, choose a button with the same name at the top of the Tools > Controls tab. The strength of the distortion is set by the Amount slider. Each distortion includes additional parameters to affect the distortion quality and shape. This tool only affects existing vertices; if you are distorting a Cube 3D or Shape 3D output, increase the geometry tool's Subdivision Level value.

Duplicate 3D Creates copies of the input. The number of copies is set by the Last Copy field (minus the first Copy field). By default, the copies are the same size and in the same position as the original. However, you can offset the copies by adjusting the XYZ Offset, XYZ Rotation, and Scale parameters. Each copy is offset by the values of these parameters (Figure 9.8).

Override 3D Allows you to override settings carried by the connected geometry tool. The tool includes a long list of display, visibility, lighting, and rendering parameters. For example, you can force the input to display in the camera views as a wireframe by selecting the Do Wireframe and Wireframe checkboxes (Figure 9.8).

Figure 9.7 The output of a Shape 3D tool is altered by Duplicate 3D, Bender 3D, and Override 3D tools before it is connected to a Merge 3D tool.

Figure 9.8 A cylinder created with the Shape 3D tool is copied two additional times with the Duplicate 3D tool. The copies are offset, getting smaller each time. The cylinders are twisted with the Bender 3D tool. A wireframe view, as opposed to a shaded one, is forced by the Override tool. This project is included with the tutorial files as `\ProjectFiles\FusionFiles\Chapter9\GeometryTools.comp`.

Displace 3D Distorts an input based on the values contained within a 2D image (Figure 9.9). Connect the geometry to the SceneInput input. Connect the image to the Input input. The image channel used for the distortion is set by the channel buttons at the top of the Tools > Controls tab. You can adjust the scale and bias (offset) of the image pattern by adjusting the parameters with the same name. This tool only affects existing vertices.

Figure 9.9 A cylinder created with the Shape 3D tool is distorted by a Displace 3D tool. A FastNoise tool supplied the distorting image. This project is included with the tutorial files as `\ProjectFiles\FusionFiles\Chapter9\Displace.comp`.

Replace Normals 3D Updates normal values for the input. A **normal** is a vector that is perpendicular to a polygon face. Angles between normals are used to determine if a surface is shaded with **faceting** (hard transitions between faces), shaded smoothly, or shaded with both smooth and faceted transitions. (This shading is visible in a camera view if the Display view's Shad button is selected.) This tool is useful for adjusting imported geometry. The Smoothing Angle parameter controls the degree of smoothing, with a value of 90 smoothing all faces, a value of 0 faceting the entire surface, and other values employing faceted or smooth transitions between adjacent faces based on the angle between them (Figure 9.10). In addition, you can select the Flip Normals checkbox to invert the surface. Note that imported surfaces are interpreted as single-sided unless you select the Two Sides checkbox of the geometry tool (located in the Materials tab).

Figure 9.10 Left: Imported geometry is faceted by setting the Replace Normals 3D tool's Smoothing Angle to 0. Right: The same geometry with Smoothing Angle set to 90. This project is included with the tutorial files as `\ProjectFiles\Fusion-Files\Chapter9\ReplaceNormals.comp`.

Transform 3D Allows you to transform an input. You can change or animate the transformation parameter values of this tool separate from the transformation parameter values carried by geometry tools—this is sometime useful when working with projected textures.

Triangulate 3D Converts geometry with quadrilateral faces to triangular faces. This may help create a smoother surface when importing geometry.

Weld 3D Merges together unmerged, overlapping vertices. This tool is designed to fix geometry errors on imported geometry. Unmerged vertices may cause shading and rendering errors within Fusion. if you select the tool's Fracture button, each vertex splits into multiple vertices and each polygon face is separated.

Adjusting Geometry Materials

By default, geometry is assigned to a gray material that's similar to a Blinn or Phong material used by 3D programs such as Autodesk Maya. (A **material**, or **shader**, is an algorithm that defines the surface shading quality of a piece of geometry.) The gray material is carried by the geometry tool. You can alter its parameters by switching to the tool's Materials tab. The parameters are described here:

Diffuse Color Color of the surface without specularity.

Opacity Surface transparency.

Specular Color Color of the **specular highlight**, which is an intense, coherent reflection that generally appears as a "hot spot."

Specular Intensity Strength (brightness) of the specular highlight.

Specular Exponent Size of the specular highlight, with low values creating a wide highlight and high values creating a small highlight (Figure 9.11).

In addition, the Materials tab carries a Transmittance section, which emulates light passing through semi-transparent surfaces (Figure 9.12). In Fusion, transmittance requires cast shadows, which are generated by the Spot Light tool. (Lights are discussed in the section "Lighting and Shadowing" later in this chapter.)

Figure 9.11 Left: Specular Exponent with a low value. Right: Specular Exponent with a high value. This project is included with the tutorial files as `\ProjectFiles\FusionFiles\Chapter9\Specular.comp`.

The Transmittance section includes three parameters, which are described here:

Attenuation Controls the amount of light passing through a surface. If this parameter is set to the color white, all light passes though the surface and its as if the surface is 100% transparent. Gray or other non-white colors allow a portion of the light to travel through the surface, which creates semi-transparent, colored shadows.

Saturation Sets the degree of saturation for the shadow color with a 0-value creating a gray of black shadow.

Figure 9.12 A colored shadow is created with transmittance. The semi-transparent logo is a bitmap texture connected to a material, which in turn is connected to a Shape 3D tool's primitive plane. This project is included with the tutorial files as `\ProjectFiles\FusionFiles\Chapter9\Transmittance.comp`.

Alpha Detail If the material assigned to the shadow-casting geometry includes an alpha channel, this parameter determines whether the alpha values are used for the transmittance. A value of 1.0 causes the alpha to be used where the transmitted color only appears where there is solid alpha. (For more information on alpha channels and textures maps, see the section "Adding Textures" later in this chapter.)

Color Detail Determines the amount of color inserted into the shadow, with high values making the shadow more colorful. If Attenuation is gray, the shadow color is derived from the material color assigned to the shadow-casting geometry. if Attenuation is a non-gray color, where RGB values are not equal, the shadow color is a combination of the material color and the Attenuation color.

Bitmap Transparency

Fusion understands the alpha transparency of texture bitmaps, as well as layer transparency information contained with Photoshop PSD files. The transparency is automatically applied to geometry that the textures are connected to.

Connecting Material Tools

You have the option to connect a separate material tool and thus override the geometry tool's built-in material. You can find the material tools in the Tools > 3D > Material menu. To use a material tool, connect the tool's output to the geometry tool's MaterialInput input.

Material tools include materials commonly used by 3D programs. These include Blinn, Phong, Cook-Torrance, and Ward. These materials share parameters with the geometry tool, although CookTorrance and Ward materials carry unique parameters for adjusting specularity. Fusion also includes several unique materials, which are described here:

Reflect Adds a simulated reflection to the surface. The color of the reflection is determined by the connection made to the tool's Reflection Color Material input. (For a demonstration, see the "Using Environment Textures" section later in this chapter.)

Material Merge Blends two materials together. The material connected to the Material Merge tool's Foreground input occludes the material connected to the Background input unless you lower the Material Merge tool's Blend parameter. A Blend value of 0.5 mixes the two materials equally. For example, you can add a Reflection material to a Blinn material using Material Merge.

Replace Material 3D Replaces the materials of all geometry connected to its SceneInput input. You can connect the new material to the MaterialInput input. For example, connect the Replace Material 3D tool between a Merge 3D tool and a Renderer 3D tool to temporarily override the materials of the rest of the network.

Channel Boolean Lets you combine two materials by mixing their channels using mathematical formulas (Figure 9.13). The materials connect to the Foreground Material and Background Material inputs. The values are mixed one channel at a time using mathematical formulas set by each channel's Operation menu. The Channel Boolean tool provides a means to develop unique material appearance that would otherwise be unavailable to a single material.

Figure 9.13 A unique material created by combining a Blinn tool and Ward tool via a Channel Boolean tool. You can view a material on a generic sphere by selecting the material tool and connecting it to a Display view. This project is included with the tutorial files as `\ProjectFiles\FusionFiles\Chapter9\ChannelBoolean.comp`.

Adding Textures

Material tools carry multiple inputs that allow you to map parameters with the same name. (The material built into geometry tools lacks this functionality.) The inputs include Diffuse Color Material, Specular Color Material, Specular Component Material, and Specular Intensity Material. Mapping the parameters allows you to vary the parameter values across the surface of connected geometry. This also allows you to use a painted bitmap texture as the surface color.

As an example, in Figures 9.14 and 9.15, two textures are connected to a Blinn material tool. The Blinn material is connected to the MaterialInput input of a FBX Mesh 3D tool, which imports geometry of a cartoon bug. A color bitmap texture, in the form of a TIFF file, is connected to the Blinn's Diffuse Color Material input. A noise texture, generated by a FastNoise tool, is connected to the Blinn's Specular Intensity Material input; this has the effect of "breaking up" or adding variations the specular highlights.

Figure 9.14 Two textures, a bitmap and a procedural noise, are connected to a Blinn material tool. This project is included with the tutorial files as `\Project-Files\FusionFiles\Chapter9\BugTexture.comp`.

Figure 9.15 Result of the material and texture network—an imported 3D bug is given color and specular textures inside Fusion.

Texture tools are located in the Tools > 3D > Texture menu. Descriptions of the standard texture tools follow:

Bump Map Creates the illusion of surface bumpiness by perturbing surface normal as during the render (Figure 9.16). This texture tool accepts an image input as a source for the bump intensity. You must connect the Bump Map tool's output to the Bumpmap Material input of a material tool for the bump to appear. The tool operates in two modes, as set by the The Source Image Is parameter buttons: Heightmap and Bumpmap. The Heightmap mode converts the pixel intensities of the input image into bump height and can accept any bitmap image. The Height Scale parameter serves as a multiplier for the bump height when the Heightmap mode is chosen. The Bumpmap mode expects a tangent space normal map. You can prepare a tangent space normal map by using the Create Bump Map tool (described in Chapter 7). A tangent space normal map stores normals vectors in the RGB channels of an image with resulting colors that range from purple to cyan.

Figure 9.16 Left: Blinn material with a diffuse color texture but no bump map texture. Right: Same material with a bump map texture. In this case, the bump map is a grayscale copy of the color bitmap. This project is included with the tutorial files as `\Project-Files\FusionFiles\Chapter9\BumpMap.comp`.

Texture 2D Controls the UV tiling for a bitmap texture. The tool includes UV Translation (UV offset) and UV Scale parameters. **UV texture space** is a coordinate system that relates pixels within a bitmap to points in a geometry surface. A **UV layout** is a specific UV texture space mapping carried by a piece of geometry. For a bitmap texture to function in Fusion, the connected geometry must carry a valid UV layout. Imported geometry maintains its UV layout through the importation process. Primitive geometry has a default UV layout. To use the Texture 2D tool, connect the output of the Loader that imports the bitmap to the input of the Texture 2D tool. Connect the output of the Texture 2D tool to a material input on a material tool.

Falloff Blends two texture tools together based on the angle between the connected geometry surface and the rendering camera. A texture tool connected to the Face On Material input appears wherever the surface faces the camera. The texture connected to the Glancing Material input appears wherever the surfaces *does not* face the camera.

Working with 3D Textures and Projections

Several texture tools are able to create their texture in 3D space with UVW dimensions (W is the depth dimension in UV texture space).

The Gradient tool creates gradient pattern where the colors are spread along the W direction. The colors of the gradient are set by the handles along the horizontal gradient bar in the Tools > Controls tab. You can change a handle color by selecting it and altering the matching color controls. You can insert new handles by LMB-clicking on an empty area of the bar. You can alter the style of gradient pattern by choosing different pattern buttons at the top of the Tools > Controls tab.

The FastNoise Texture tool creates a procedural noise specifically designed for texturing. It can create a three-dimensional noise if you switch the Output Mode parameter to 3D.

The three-dimensionality of the Gradient and FastNoise Texture tools is not initially visible. When the tools are connected, the UV layout of the geometry determines how the colors are laid on the surface. However, if you project the texture, the third dimension is utilized. Projecting a texture allows you to override the current UV layout of the geometry. It also allows you to create UV coordinates for geometry that lacks a UV layout.

To project a texture, follow these steps:

1. Connect a material tool to the MaterialInput input of the geometry tool. Connect a texture to the Diffuse Color Material input, or similarly visible input, of the material tool. At this point, the native UV layout of the geometry is employed.
2. Choose Tools > 3D > UV Map 3D. Insert the UV Map 3D tool *between* the geometry tool and the Merge 3D tool (Figure 9.17). The texture is projected.

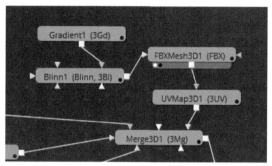

Figure 9.17 A UV Map 3D tool is placed between a FBX Mesh 3D geometry tool and a Merge 3D tool.

When you create the tool, the UV Map 3D tool uses a planar projection. However, you can change the projection type via the Map Mode buttons at the top of the Tools > Controls tab. The tool also creates a matching projection icon in the camera views (but not the Renderer 3D output). If the projection is smaller than the geometry, the edge pixels of the texture are repeated to fill the surface beyond the projection. You can move, rotate, and scale the projection by altering the XYZ Center, XYZ Rotation, and Scale parameters of the tool.

If you connect a texture that places its pattern in 3D space, such as Gradient and FastNoise Texture, the orientation of the 3D pattern is set by the orientation of the projection. For example, the Gradient tool places the colors of the gradient along the W axis, which corresponds to the projection's Y axis (Figure 9.18).

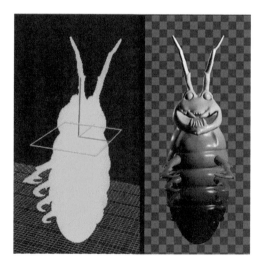

Figure 9.18 Left: The projection icon of a UV Map 3D tool, as seen through the Perspective camera. The Map Mode is set to Planar. The projection's Y axis is indicated by the blue line. Right: Result of the projection when a Gradient tool is projected. The gradient runs from black to red to yellow to white. The gradient type is linear. This project is included with the tutorial files as `\Pro-jectFiles\FusionFiles\Chapter9\UVMap3D.comp`.

If you project a 2D texture, the texture is "streaked" though the geometry. For example, if you use a planar projection, the front and back of a sphere receives the same color values.

Projecting Animated Geometry

If you animate geometry that is using a projected texture, the geometry will "slide" through different parts of the texture. To avoid this, you can add the animation to a Transform 3D tool. Place the Transform 3D tool between the UV Map 3D tool and the Merge 3D tool.

Using Environment Textures

An additional method of applying projections is through the use of environmental textures. Environmental textures emulate immersive environments where color information arrives from all directions from a infinitely far source. In the real world, an outdoor sky is equivalent to an environmental texture.

In Fusion, you can create such a texture with the SphereMap or CubeMap textures. SphereMap and CubeMap are well suited for creating reflections. You can connect one of these textures to the Reflection Color Material of a Reflect material tool (Figure 9.19). To avoid a white surface where the reflection is weak, you can connect another material, such as a Blinn, to the Reflect tool's Background Material input. SphereMap and CubeMap accept a texture via their Image input. For example, in Figure 9.20, an image sequence of a walkway is connected to a SphereMap Image input. A virtual reflection appears on the sides of a cube generated by a Shape 3D tool.

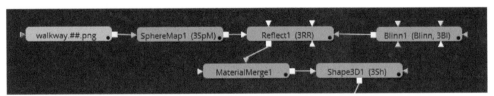

Figure 9.19 SphereMap and Reflect tools create an environmental texture, which appears as a virtual refection.

Figure 9.20 The virtual reflection appears on a primitive cube. This project is included with the tutorial files as \ProjectFiles\FusionFiles\Chapter9\SphereMap.comp.

The SphereMap tool offers a Angular checkbox, which is designed to work with specially prepared HDR bitmaps. Angular bitmaps (also called **light probes**) capture real-world environmental reflections in chrome spheres. In a similar fashion, the CubeMap texture is designed to work with HDR images that are mapped as cubic crosses (a six-sided cube unfolded into a cross).

The strength of the reflection is set by the Reflect tool's Glancing Strength and Face On Strength parameters. These parameters take into account the relationship of the surface and the camera position. The Falloff parameter determines how quickly the reflection fades off.

Lighting and Shadowing

You can add one or more lights to a 3D scene. Fusion provides four light types though the Tools > 3D > Light menu (Figure 9.21). The lights are described here:

Ambient Light A light that has equal intensity at all points in the scene. This light is suitable for recreating **fill light** (secondary bounce light) but is generally not used as a **key light** (the strongest light).

Directional Light A light that possesses direction but no true position. This light emulates infinitely far light sources, such as the sun.

Point Light An omnidirectional light that emanates from a point, much like a light bulb.

Spot Light A light that diverges from a point in a cone shape, replicating a stage light. Spot lights are the only lights that create shadows in Fusion.

Figure 9.21 Left to right: Ambient, directional, point, and spot lights.

For a light to function, you must connect it to a Merge 3D tool. In addition, Enable Lighting must be selected for the Renderer 3D tool. You can move or rotate directional and spot lights as you would a camera or piece of geometry: select the light tool icon in the Flow view or in a 3D camera view and use the interactive Move and Rotate buttons and handles. The rotation of a directional light affects its light quality—its position does not. In contrast, the position of a point light affects its light quality—its rotation does not.

The four light types share several parameters, including Color (light color) and Intensity (light strength). You can raise the Intensity above 1.0 by entering a value into the parameter field. In addition, point and spot lights include a Linear and Quadratic decay, which allows the light intensity to diminish over distance. (Quadratic emulates decay in Earth's atmosphere.) Spot lights include three parameters to control the light cone: Cone Angle (diameter of cone), Penumbra Angle (size of soft transition at cone edge), and Dropoff (light decay from cone center to cone edge).

To create shadows with a spot light, select the Enable Shadows checkboxes for the Spot Light and Renderer 3D tools. The Spot Light tools provides several parameters for adjusting the shadows:

Shadow Color Color of shadow independent of lights in the scene.

Density Shadow opacity.

Shadow Map Size Fusion shadows employ depth maps (Z-buffers rendered from the point-of-view of the shadow-casting light). This parameter sets the depth map bitmap resolution. The larger the values, the larger the bitmaps and the smoother the shadow edges. Small bitmaps are efficient but crude, while large bitmaps are accurate and less efficient.

Shadow Map Proxy Sets size of the shadow depth map when the proxy mode is activated through the Prx or APrx buttons in the TimeView. A value less than 1.0 uses a reduced-size version of the map.

Multiplicative Bias and Additive Bias If shadow render errors occur, where a shadow is only partially rendered or receives noisy artifacts, adjust these two parameters. These parameters "push" and "pull" surfaces closer or further from the light during the shadow calculation in an attempt to resolve errors.

Softness By default, shadows are hard-edged. However, you can select the Constant button to add a soft edge to the shadow that is consistent over the entire edge. Alternatively, you can select the Variable button, which varies the shadow softness based on the edge distance from the shadowing light (Figure 9.22). Variable is the most accurate of shadow types, but slows the render significantly.

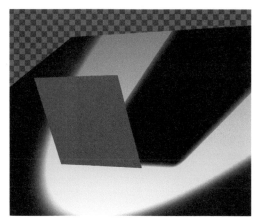

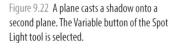

Figure 9.22 A plane casts a shadow onto a second plane. The Variable button of the Spot Light tool is selected.

Importing Geometry and Cameras

You can import geometry through one of two tools: Alembic Mesh 3D and FBX Mesh 3D. When you create one of these tools, a File Browse window opens. You can also load a file through the tools' Filename or FBX File parameter at a later time.

The Alembic file format (`.abc`) supports animated 3D meshes, such as character animation, wherein the rig is removed and the geometry deformation is "baked" and made permanent. You can import an Alembic file by choosing File > Import > Alembic Scene. Fusion creates an Alembic Mesh 3D tool and a Transform 3D tool automatically (Figure 9.23). If you connect the Transform 3D tool to a Display view and play back, the imported geometry undergoes the deformation or transformation dictated by the Alembic file. You can create your own Alembic Mesh 3D tool by selecting it from the Tools > 3D menu. You can import Alembic geometry by clicking the Filename browse button.

Figure 9.23 Bottom: Alembic 3D Mesh (named *pHelixShape1*) and Transform 3D tools created by the File > Import > Alembic Scene option. Top: Six-tool network created by the File > Import > FBX Scene option. A test Alembic file is included with the tutorial files as `\ProjectFiles\3D\helix.abc`. A test FBX file is included with the tutorial files as `\Project-Files\3D\cameralights.fbx`.

The FBX format is an Autodesk interchange format that can carry geometry, materials, lights, and cameras, along with any matching animation splines. You can import all these elements at one time by choosing File > Import > FBX Scene. For each geometry, material, light, and camera node that Fusion detects in the FBX file, a new matching tool is created (Figure 9.23). For example, a Maya directional light is converted to a Directional Light tool, a Maya camera is converted to a Camera 3D tool, and a polygon surface node is imported through its own FBX Mesh 3D tool. The new tools are connected to a Merge 3D tool (Figure 9.24). Pre-existing tools in the project are unaffected. Animation splines are imported along with the other elements. (At the time of this writing, supported FBX files must be in the 2014/2015 FBX format.)

Figure 9.24 An imported FBX scene with two lights, a camera, and polygon helix. The camera's transform animation is represented by the green motion path.

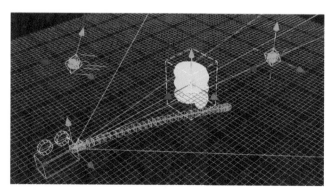

180

You can create your own FBX Mesh 3D tool by selecting it from the Tools > 3D menu. You can import FBX geometry by clicking the FBX File browse button. FBX Mesh 3D supports a wide variety of 3D file formats, including FBX, 3DS, DXF, and OBJ. FBX 3D Mesh is used for the examples shown in Figures 9.11, 9.14, and 9.18 earlier in this chapter.

You can also import a 3D camera by clicking the Import Camera button at the bottom of a Camera 3D tool's Controls tab. Supported file formats include Maya `.ma`, 3ds Max `.ase`, and Lightwave `.lws`. If more than one camera exists in the file, you can select one through the Select Camera window that pops open. (At the time of this writing, camera animation may fail to import when using the Import Camera button; if this is the case, use the File > Import > FBX Scene option to bring in a animated camera.)

Simulating Particles

Fusion includes a complete set of particle simulation tools, which are located in the Tools > Particles menu. Although the particles are simulated in 3D space, they do not occur in the 3D environment that's been discussed thus far. In fact, the particles use their own unique renderer tool: pRender. Particle simulations are useful for emulating complex natural phenomena that incorporates numerous small elements. For example, you can use particles to create a shower of sparks, rain, smoke, fire, and so on.

Creating a Basic Particle Scene

To create a working particle simulation inside Fusion, you can use three tools:

- pEmitter
- pRender
- Camera 3D

The pEmitter tool emits particles and is connected to the pRender tool, which renders the scene (Figure 9.25). A Camera 3D tool is connected to the pRender tool's Camera input.

Figure 9.25 Tools required for a basic particle set-up: pEmitter, pRender, and Camera 3D. This project is included with the tutorial files as `\ProjectFiles\FusionFiles\Chapter9\BasicParticle.comp`.

To simulate the particle motion, play back the time ruler from the first frame. You can also click the Pre-Roll button in the Tools > Controls tab of the pRender tool to force the recalculation of particle transformations from the first frame to the current frame. (If you click the Restart button, a new simulation begins from the current frame of the time ruler.)

To view the particles, connect the pRender tool to a Display view. The pRender tool has two viewing modes: 2D and 3D. You can choose the mode by clicking the 2D and 3D buttons at the top of the tool's Controls tab. The 3D mode functions in a manner similar to the default Perspective camera that's provided when you connect a Merge 3D tool to a Display view (see Figure 19.26 in the next section). You can use the default camera shortcuts to scroll, dolly, or orbit in this mode. The 2D mode presents the 2D render output as seen through the connected 3D camera.

To choose how many particles are born on each frame of the time ruler, change the Number value in the pEmitter tool's Controls tab. By default, each particle lives 100 frames before dying (disappearing). You can reduce or lengthen this duration by altering the Lifespan parameter.

If you wish to combine the particle render with a scene that uses 3D geometry, you can connect the output of the pRender tool to a SceneInput input of a Merge 3D tool so long as the pRender tool is in the 3D viewing mode. In this situation, you can connect the Camera 3D tool to the Merge 3D tool and not the pRender tool. If you need to combine the particles generated by two or more pEmitter tools, connect the pEmitter tools to a pMerge tool and connect the output of pMerge to the pRender.

Changing the Particle Style, Size, and Color

By default, particles are drawn as 1-pixel points. The points are suitable for testing the simulation but are not useful for final renders. You can change the particle render style by switching to the pEmitter tool's Style tab. The Style menu sets the particle type with the following options:

Bitmap Uses an image file, as set by the Style Bitmap field (at the bottom of the Style field).

Brush Uses an image file stored in the program's Brushes directory, as set by the Brush menu.

Blob Creates soft-edged, spherical particles, suitable for snow, smoke, or other atmospheric effects (Figure 9.26).

Line Produces line-like particles, suitable for falling rain (Figure 9.26).

NGon Creates an *n*-sided polygon (Figure 9.26). The polygon shape is set by the NGon type buttons. The number of polygon sides is set by the NGon Sides parameter.

Point Cluster Replaces each particle with a small cluster of 1-pixel sub-particles. The number of sub-particles per cluster is set by the Number Of Points parameter. This style offers a way to create greater complexity with fewer particles.

Figure 9.26 Left to right: Blob particles with default color, 8-sided NGon Shaded Out particles colored yellow, and Line particles colored red with no rotation or spin. This project is included with the tutorial files as `\ProjectFiles\FusionFiles\Chapter9\ParticleStyles.comp`.

Each particle style carries it own unique set of parameters, which appear in the Style tab when you change the Style menu. In addition, all particle styles share a few common parameters, which include Size and Color. Note that particles are unaffected by 3D lights and do not react to shadows. Thus, they may require additional adjustment after they are rendered with the pRender tool.

Hiding the Checkerboard

To more accurately gauge a render of the 3D environment, whether you are working with geometry or particles, hide the Display view's checkerboard by deselcting the view's Show Checkerboard Underlay button (with a checkerboard icon near the right side of the view).

Moving, Rotating, and Spinning Particles

When you add a pEmitter to a scene, the particles do not stray from the emitter. To impart motion, you can adjust velocity parameters carried by the pEmitter tool. These are located in the Velocity Controls section. The parameters include Velocity (initial speed), Angle (initial direction along the XY axis), and Angle Z (Initial direction along the Z axis). When making changes to particle parameters, re-play the time ruler from the first frame to see an accurate simulation.

In addition, you can alter the initial rotation of the particles through the Rotation Controls section. By default, particles are oriented toward the camera; however, you can deselect the Always Face Camera checkbox to defeat this motion. You can then alter Rotation XYZ parameters. The pEmitter tool also provides a Spin section. Spin varies from rotation in that the amount of spin set by the Spin XYZ parameters is added to each frame of the time ruler. In other words, raising the Spin parameters above 0 causes the particles to continuously rotate.

Adding Randomness with Variance

By default, particles generated by a single pEmitter tool all share the same lifespan, velocity, rotation, size, color, and so on. You can insert randomness into the simulation, where each particle has unique traits, by raising the *Variance* parameters above 0. Numerous parameters have a Variance counterpart. For example, Velocity has a matching Velocity Variance.

Affecting Particles with Forces

You can alter the motion of particles by adding forces to the scene. Forces (also known as **fields**) emulate specific natural phenomena, such as gravity, wind, friction, turbulence, and so on. Forces are required to create a higher degree of realism when simulating events that occur in the real world. You can connect one or more force tools between the pEmitter and pRender tools.

The following force tools are available in the Tools > Particles menu:

pDirectional Force Useful for emulating gravity or wind. You can set the XY orientation with the Direction parameter and Z orientation with the Direction Z parameter. The Strength parameter sets its namesake.

pFriction Offers a means to add resistance to velocity and spin with two friction sliders.

pGradient Force Affects particle movement by extracting values from an image alpha channel connected via the tool's Image input. Particles accelerate as the alpha channels values transition from white to black in the U (horizontal) direction. With this tool, you can add randomness to the particle motion or goad particles in a specific direction.

pPoint Force Creates an omnidirectional force that emanates from a single point. When the Strength parameter is positive, the force is attractive. When Strength is negative, the force is repellent. The Power parameter sets the strength falloff, with a value of 0 creating no falloff over distance.

pTangent Force Applies a force that is perpendicular to the vector between the particle and the force position in space. You can vary the strength along three axes with the XYZ Strength parameters.

pTurbulence Adds randomness to motion through a three-dimensional noise. The force strength is divided into XYZ directions.

pAvoid Repulses particles. When you select the pAvoid tool, a transform handle is revealed in the Display view. If you LMB-drag the handle, it splits into two parts. The part of the handle you LMB-drag away from the start position becomes the center point of the repulsion. You can set the distance and strength of the repulsion with same-named parameters. This tool is useful for splitting particle streams into multiple tributaries.

pCustomForce Allows you to create a custom force. This is a complex tool that requires advanced programming knowledge.

pFlock Emulates flocking, swarming, and school motion or animal, insect, and fish systems. Each particle is given a "desire" to follow nearby particles and / or keep a particular distance from nearby particles. The desire is set by the Follow, Attract and Repel Strength parameters.

pVortex Creates a circular force similar to a tornado or whirlpool. The Power parameter sets the strength falloff.

Figure 9.27 demonstrates the effect of a pVortex force. With this example, the particle style is set to Line. The lines are oriented to the direction of particle motion by changing the Rotation Mode menu, in the pEmitter tool's Controls tab, to Rotation Relative To Motion (as opposed to Absolute Rotation, which is the default). The particles move upwards because the pEmitter's Angle, within the Velocity Controls section, is set to 90. The Size of the pEmitter region is set to 1.0 via the Region tab. (See the next section for information on regions.) The pVortex tool's region is set to a cube shape with a size of 8×8×8. The size determines the vortex width. The pVortex Strength is set to 25 and the Power is set to 0. The 3D camera is pointing downwards towards the vortex center.

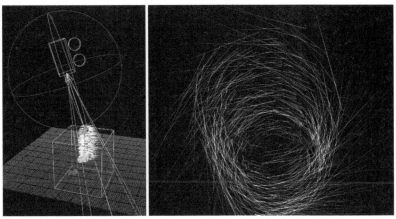

Figure 9.27 Left: The Perspective camera view, as seen via the 3D mode of the pRender tool. A 3D camera points down at a vortex of line particles. The green cube is the pVortex tool region. Right: 3D pRender view through the 3D camera. Note that 3D rendition of the particles is only approximate; to see the true quality, you must switch to the 2D view. This project is included with the tutorial files as `\ProjectFiles\Fusion-Files\Chapter9\pVortex.comp`.

Working with Force Positions and Regions

While the position of the pDirectional, pFriction, pGradient Force, pTurbulence, and pFlock forces in world space do not alter the quality of their force, the remaining force tools are position-sensitive. When you select a position-sensitive force tool, an interactive transform handle is shown in the Display view. Matching XYZ Offset parameters are included in the tools' Control tab. The pVortex tool includes a Size parameter, which affects the overall width of the vortex.

By default, the strength of a force does not degrade with distance (with the exception of the pPoint Force, pVortex, and pAvoid tools, which carry falloff parameters). However, you can contain a force by a 2D or 3D shape by activating the force tool's region. To do so, switch to the tool's Region tab, change the Region menu to the shape, and set the Region Mode menu to region style. The region style determines whether the force is active when a particle is inside, outside, or crossing the region boundary. The shape you choose is represented in the Display view with an icon. (The icon is only visible if the force tool is connected to a pRender tool.) Each 3D shape carries parameters for size and rotation. The Bitmap shape carries a Region Bitmap field that you can use to load a bitmap. When you change the Region menu to Mesh, a MeshInput input is added to the tool; you can connect a geometry tool directly to this input and thus have the geometry shape become the force container.

As example of a force region, in Figure 9.28, three pDirectional Force tools are added to a vertically rising stream of point particles. The force tools are given cube regions and unique Direction and Direction Z settings. As a result, the particle stream bends and twists as it moves through the regions. When outside of the regions, the particles maintain their momentum but continue to move in a straight line.

Additional 3D Tools and Techniques

Additional 3D tools and techniques are described in Appendix A.

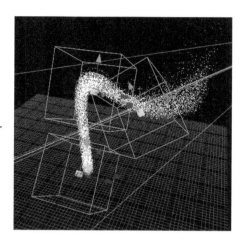

Figure 9.28 Three pDirectional Force tools are given cube regions, which causes the particle steam to bend over time. This project is included with the tutorial files as `\ProjectFiles\Fusion-Files\Chapter9\Regions.comp`.

Changing the pEmitter Shape and Using pKill and pBounce

The pEmitter tool carries its own Region tab, which you can use to set the 2D or 3D style of emitter. You can change the size, position, and rotation of the 3D emitters with matching parameters. You can emit particles from the surface or from within the volume of geometry by changing the Region menu to Mesh, connecting a geometry tool to the MeshInput input, and selecting the Surface or Volume button for the Region Type parameter.

The pKill tool serves as a destructive counterpart to pEmitter. Instead of giving birth to particles, pKill kills off particles that enter its region, as set by the Region tab parameters. The pBounce tool causes particles to "bounce" or deflect off its region. Connect the pKill or pBounce tool between the pEmitter and pRender tools.

Generating Sub-particles and Sub-styles

The pSpawn tool converts each particle that falls under its influence into its own emitter. Thus, each particle creates a set of sub-particles. The tool carries the same parameters as the pEmitter tool, allowing you to choose the sub-particles' size, color, style, and so on. pSpawn can quickly and exponentially increase the overall number of particles in the scene. Hence, it may be best to limit the tool to a region, through its Region tab, and keep the Number parameter, in the Controls tab, at a low value. Nevertheless, the pSpawn tool is ideal for creating events that produce sub-events, such as fireworks, explosions, and so on.

The pChangeStyle tool changes the particle style as the particle enters the tool's influence or region. The new style is set by the tool's Style menu. For example, you can force a particle that is born as a line to change to a blob. Connect the pSpawn or pChangeStyle tool between the pEmitter and pRender tools.

Emitting Particles from an Image

The pImageEmitter tool generate particles in a 2D plane that matches the pixels contained within an input image. The color of each particle is inherited from the closest image pixel. You can connect an image, via a Loader, Creator tool, or a branch of a 2D network, to the tool's Image input. You can adjust the pixel density by altering the tool's XY Density parameters. This tool is useful for creating motion graphics effects. For example, you can force a logo to dissolve into a shower of sparks.

Chapter Tutorial: Adding Textures and Particles to a Flying Logo

In Mini-Tutorial 7, we created a rotating line of text. We can improve the result by adding materials, textures, and a particle simulation. You can follow these steps:

1. Open `\ProjectFiles\FusionFiles\Chapter9\FlyingLogo.comp`. Connect the Renderer 3D tool to a Display View. At this stage, the 3D logo has a default color.
2. Note that the Text+ tool does not include a material input. As a workaround, choose Tools > 3D > Replace Material 3D. Connect the output of Merge 3D to the Replace Material 3D SceneInput input. Connect the output of Replace Material 3D to the input of Renderer 3D. Replace Material 3D overrides all upstream materials and thus imparts a new material to the text geometry.
3. Create Blinn and Reflect tools (in the Tools > 3D > Material menu). Create a Sphere Map tool (in the Tools > 3D > Texture menu). Create Blur and Loader tools. Import the `\Project-Files\Plates\Walkway\walkway.##.png` image sequence into the Loader. Connect the output of the Loader to the input of the Blur. Set the Blur tool's Blur Size to 10. We'll use the blurred image sequence as a source for a reflection.
4. Connect the output of the Blur tool to the input of the Sphere Map. Use Figure 9.29 as reference. This projects the image sequence from an infinitely distant sphere. Connect the output of Sphere Map to the Reflection Color Material input of the Reflect tool. Connect the output of the Reflect tool to the MaterialInput input of the Replace Material 3D tool. The Reflect material is assigned to the text and the reflection appears on the surface.
5. Raise the Reflect tool's Face On Strength to make the reflection more visible on the surfaces facing the camera. Experiment with different Glancing Strength values to fine tune the reflection on parts facing away from the camera. At this stage, the text is white wherever there is a weak reflection. Connect the Blinn material tool to the Reflect tool's Background Material Color input. Change the Blinn's Color and specular parameters. The Blinn material now provides the surface color wherever the reflection is weak (Figure 9.30).

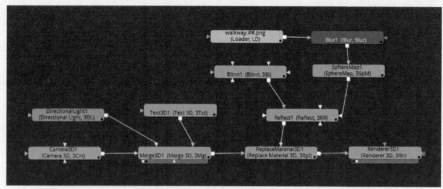

Figure 9.29 New tools added to texture the text geometry.

Figure 9.30 Result of the new, reflective material.

6. Create pRender and pEmitter tools (in the Tools > Particles menu). Branch the Camera 3D output and connect it to the Camera input of the pRender tool. See Figure 9.32 as reference. Connect the output of the pEmitter to the input of the pRender. Connect the pRender to an unused Display view.

7. Click the pRender tool's 2D button. Use the camera shortcuts to frame the Camera 3D camera. The pEmitter currently sits at the base of the camera lens and thus the particles cannot be seen. Select the pEmitter tool and move it backwards so it comes within the camera view. Switch to the pEmitter's Region tab. Raise the Size value to 1000. The region sphere becomes large enough to surround the area the text is in. Play back the time ruler. Point particles are born within the region, but do not move (Figure 9.31).

Figure 9.31 The Perspective camera view, as seen via the pRender tool in the 3D mode. The green sphere is the scaled, spherical region of the pEmitter.

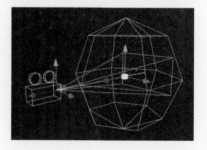

8. Set the pEmitter tool's Number to 10, Velocity to 5, and angle to –90. Switch to the Style tab. Change Color to Green, Size to 15, and the Style menu to NGon. Select the NGon Star button near the bottom of the tab. Play back. The star-shaped particles slowly drift downwards.

9. Select the pRender tool's 3D button. Connect the output of the pRender to the Merge 3D tool. See Figure 9.32. The particles become visible in the Renderer 3D view. However, due to the Replace Material 3D tool, the particles take on the reflective material and lose their star shape. Select the Replace Material 3D tool and go to the Tools > Controls tab. Select the Limit By Object ID checkbox. The material replacement is thus limited to the geometry that carries the object ID (identification number) listed by the parameter with the same name. In this scene, the Text+ tool has an object ID of 1. (Although assigned automatically, you can change the object IDs of Shape 3D, FBX Mesh 3D, and Alembic Mesh 3D tools through their ObjectID parameter.) With this technique, the original colors and shapes of the particles are restored. Play back the time ruler. The particles drift in front of and behind the text (Figure 9.33).

Figure 9.32 The Camera 3D tool is connected to the Merge 3D and pRender tools. The pRender tool is connected to the Merge3D tool, thus combining the particles and text in the same 3D space.

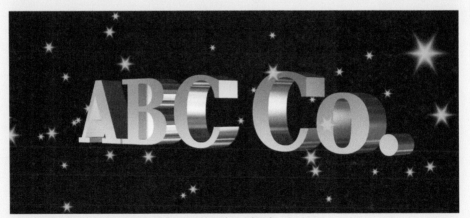

Figure 9.33 The final Renderer 3D output with text and particles combined.

The tutorial is complete! A finished version of this tutorial is saved as **\ProjectFiles\ FusionFiles\Chapter9\FlyingLogoTexture.comp**. Feel free to experiment with particle settings or add additional force tools.

> Stroke1

> Stroke2

> Stroke3

> Stroke4

> Stroke5

> Stroke6

> Stroke7

> Stroke8

> Stroke9

> Stroke10

> Stroke11

> Stroke12

> Stroke13

> Stroke14

> Stroke15

> Stroke16

Repairing, Painting, and Distressing

Footage may come to a compositor in a distressed state and suffering from such artifacts as dust, scratches, grain, or noise. You can use noise-reduction techniques, along with Fusion's Paint tool, to apply "fixes" to the footage. At other times, it's necessary to add artifacts to footage that is artifact-free. This may be necessary to match non-distressed renders to distressed footage. This may also be useful for creating a stylized look that emulates old or low-quality media.

This chapter includes the following critical information:

- Removing noise and grain
- Adding grain, noise, interlacing, and ghosting
- Removing dust and dirt with the Paint tool
- Removing scratches with the Wire removal mode

Repairing and Distressing Footage

As discussed in earlier chapters, it is sometimes necessary to replicate artifacts created by real-world cameras, such as lens flares, glows, and so on. Adding these artifacts may be considered "distressing." By the same token, it's sometimes necessary to remove camera artifacts that may interfere with the final quality of the composite. For example, footage derived from motion picture film may suffer from grain, scratches, dirt, or dust. Digital video footage may suffer from noise, compression degradation, or drop-out. SDTV (analog Standard-Definition Television) has it own unique traits, including interlacing and ghosting. As such, footage may require "repairing" to remove these artifacts.

Artifact Terminology

Grain is a product of the silver halide particles embedded in motion picture film substrate. The grain pattern changes with each frame and is unique to the film stock employed. **Noise**, as it applies to video artifacts, is a 1-pixel variation in color or luminance created by photons randomly striking a digital sensor or random electrical interference within the camera system. In terms of video compression, each of the compression schemes creates distinct patterns as the scheme attempts to compress the image into a smaller number of bytes. In particular, footage shot in low light or with inexpensive or inferior equipment is prone to noise and compression degradation. **Dropout** occurs with both digital and analog video and is the result of missing data. Analog drop-out appears as horizontal lines of noise. (Video noise is often referred to as **static**.) Digital dropout appears as colored blocks where the original pixel values are missing. **Interlacing**, as used by SDTV, splits each frame into two fields, with fields broadcast or displayed one at a time. **Ghosting** appears as overlapping copies of the same image when broadcast SDTV is plagued by interference. Although SDTV is no longer used for television, similar artifacts may be visible with closed-circuit television and low-grade security systems.

Reducing Grain and Noise

Film grain and video noise can interfere with compositing operations, such as motion tracking. In addition, grain and noise can interfere with the aesthetic quality of a shot whereby the artifacts may impact the overall color or contrast and distract from the action of the scene.

You can reduce grain and noise with the Remove Noise tool (in the Tools > Film menu). The tool blurs the input channels, compares the blurred version to the original input, and removes pixel variations between the two. The tool operates in two modes, as set by the Method parameter: Color and Chroma. Color operates on the separate RGB channels and Chroma operates on the color component and the luminance component separately. Each mode includes Softness and Detail parameters for the selected channels. Softness parameters blur the channel, with a higher value creating a greater degree of softness. The Detail parameters sharpen the channel with an unsharp-style sharpen. Resharpening the image is generally required when the Softness slider values are high and the grain and noise is aggressively removed. For example, in Figure 10.1, the noise contained within a shot of a mountain is significantly reduced. In this case, Method is set to Chroma.

Figure 10.1 Top: Close-up of footage suffering from noise. Bottom: Result of the Remove Noise tool. This project is included with the tutorial files as `\Project-Files\FusionFiles\Chapter10\RemoveNoise.comp`.

Adding Grain and Noise

Maintaining film grain and noise might be appropriate when a particular stylistic look is required. For example, you may try to replicate an old motion picture newsreel or vintage home video. As such, you can add grain and noise to footage that lacks the artifacts or entire sections of the tool network. Fusion includes several tools to undertake this task, which are briefly discussed in this section.

Grain Adds a generic film grain to the input. The Power parameter sets the intensity by increasing the grain's opacity. The Red / Green / Blue Difference parameters set the grain contrast between channels. Grain Size, Grain Softness, and Grain Spacing set their namesakes. In general, the grains produced by motion picture film are larger and more randomly dispersed than video noise. The grain pattern is animated to changes with each frame.

Film Grain Adds grain but strives to more accurately replicate the grain patterns of modem motion picture film stock. The tool layers multiple noise patterns with different scales on top of one another. The number of layers is determined by the Complexity parameter. The Roughness parameter, when raised, increases the contrast and apparent randomness of the grain pattern (Figure 10.2). Grain and Film Grain tools are located in the Tools > Film menu.

Figure 10.2 Grain is added to a shot with the Film Grain tool. A high Roughness value causes the grains to "clump" together and appear more random. This project is included with the tutorial files as `\ProjectFiles\FusionFiles\Chapter10\FilmGrain.comp`.

Filter When the Filter tool's FilterType menu is set to Noise, it adds a 1-pixel, animated noise to the input. Filter is located in the Tools > Filter menu.

FastNoise You can create a 1-pixel noise with the FastNoise tool by raising the Scale value to a large number, such as 150, and raising the Detail value. To make the noise shift with each frame, raise the Seethe Rate to a high value. These steps produce a grayscale noise that is similar to analog television static. To combine the result with other footage, connect FastNoise to the Foreground of a Merge tool, connect the footage to the Merge tool's Background, and adjust the Merge tool's Blend slider to make the noise stronger or less intense. FastNoise is located in the Tools > Creator menu. FastNoise and Filter are also discussed in Chapter 7.

Adding Television Artifacts

SDTV carries its own unique artifacts, including interlacing and ghosting. You can create both of these with the TV tool (in the Tools > Effect menu). The tool throws out every other horizontal **scanline** (row of pixels) and replaces them with 100% transparency. This replicates interlacing. To create additional distortion, raise the tool's Skew parameter, which vertically distorts the output using a sine wave. You can offset the output left / right or up / down by adjusting the Horizontal and Vertical parameters.

Because the TV tool replaces every other scanline with transparency, its output should be combined with the original input with a Merge tool. For example, in Figures 10.3 and 10.4, a Loader is connected to the Background of a Merge tool and to the input of the TV tool. The TV tool's output is connected to the Foreground of the Merge tool. The Merge tool's Size slider is set to 1.2, scaling up the TV input. The end result is ghosted image of the mountain on top of the original footage. To replicate television interference, animate the various TV parameters changing rapidly over time.

Figure 10.3 Footage is connected to a Merge tool and the TV tool. The TV tool output is connected to the Merge tool's Foreground. This project is included with the tutorial files as **\ProjectFiles\ FusionFiles\Chapter10\TV.comp**.

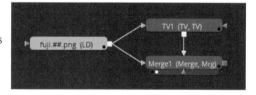

Figure 10.4 Interlacing and ghosting created by the TV tool.

Although not strictly designed to create a television artifact, the Trails tool (Tools > Effect) creates its own form of ghosting by repeating preceding frames and blurring them. The degree of blur is set by the Blur Size parameter. Additional parameters allow you to offset position, scale, and rotation of each repeated frame. The tool is sensitive to playback direction and adjustment of parameter values. To see an accurate output, click the tool's Restart button and play back from the first frame.

Cineon Tools

Two tools, Cineon Log and Light Trim, are designed to work with the Cineon and DPX file formats. Cineon (`.cin`) and DPX files are logarithmic and are specifically designed for footage derived by scanning motion picture footage. Cineon Log converts a logarithmic input to a linear color space. (All the examples in this book work with linear footage.) You can also use the tool to convert a linear input to a logarithmic one by selecting the Lin To Log button. The Light Trim tool increases or decreases the relative brightness of a logarithmic input. Both tools are located in the Tools > Film menu.

Making Paint Fixes

Paint fixes are corrections made to footage using digital paint tools. The fixes may remove scratches, dust, lens flares, dropout, or 3D rendering errors. Paint fixes may also involve the removal of unwanted elements, such as video gear, rigging used for stunts, or stand-in actors.

Using the Paint Tool

The Paint tool (Tools > Paint > Paint) is virtually identical to the Mask Paint tool discussed in Chapter 6. Whereas Mask Paint is designed to create masks, the Paint tool is designed to make paint fixes. The tool can emulate a variety of digital brushes offered by common paint programs, such as Adobe Photoshop. The Paint tool is stroke-based. Essentially, each stroke lies on top of the input image, thereby covering what's below the stroke (thus, it functions like virtual paint). You can alter the duration of each stroke, from one frame to the entire duration of the time ruler.

To apply the Paint tool, you can follow these basic steps:

1. Connect the footage you wish to paint to the Paint tool's input. Connect the Paint tool to a Display view. Go to the frame where you'd like to paint stroke.
2. When you select the Paint tool, a Paint toolbar is embedded at the side of the Display view (see Figure 10.5). Choose the sub-tool type by selecting one of the toolbar buttons (for example, click the Stroke button).
3. Through the tool's Controls tab, choose a Brush Shape, Size, and Softness. In the Apply Controls section, choose an Apply Mode button. The buttons include Color, Clone, Emboss, Erase, Merge, Smear, Stamp, and Wire Removal (Figure 10.6).
4. If you are using the Color mode, select a color through the Color section. If you are using the Stamp mode, Alt/Opt+LMB-click in the Display view to select a clone source.

Select	
MultiStroke	
Clone MultiStroke	
Stroke	
Polyline Stroke	
Circle	
Rectangle	
Copy Polyline	
Copy Ellipse	
Copy Rectangle	
Fill	
Paint Group	

Figure 10.5 The Paint toolbar, which is identical to the Mask Paint toolbar.

Color	
Clone	
Emboss	
Erase	
Merge	
Smear	
Stamp	
Wire Removal	

Figure 10.6 The Paint tool Apply Mode buttons, which is identical to the Mask Paint tool. The buttons are arranged horizontally in the Controls tab.

5. LMB-drag to draw a stroke in the Display view. By default, the stroke lasts for the entire duration of the time ruler. If you are using the Multistroke or Clone Multistroke sub-tool, you can alter the stroke duration by changing the Stroke Duration parameter value. If you are using the Stroke sub-tool, you can change the Stroke Animation menu to Limited Duration and change the Duration value.

The Paint tool can carry an unlimited number of individual strokes, each with its own unique color, mode, and duration. To select a stroke and access its parameters, choose the Select button in the toolbar and LMB-click on the stroke in the Display view. You can delete a selected stroke by pressing the Delete key. You can LMB-drag a marquee in the Display view to select multiple strokes. Each stroke you draw is listed in the Modifiers tab along with all its unique parameter settings. You can also delete a stroke by RMB-clicking over the stroke name in the Modifiers tab and choosing Delete.

The Paint Toolbar and Paint Apply Modes

For more detailed information on the button functionality of the Paint toolbar and the various Apply Mode buttons, see the sections "Creating Primitive and Polyline Masks with Mask Paint" and "Painting a Mask with Mask Paint" in Chapter 6.

Removing Wires

Wire removal is the type of paint fix where wire, rigging, scratches, and other linear elements are removed from footage. The Wire Removal mode available to the Mesh Paint and Paint tools repeats adjacent pixels when you draw a line. Like other modes, you can make the stroke last as many frames as you prefer.

The Wire Removal mode has two styles, Cross Fade and Edge Blend, which are set by buttons underneath the Apply Mode (Figure 10.7). Cross Fade extends pixels from the left and the right (or top and bottom) of the stroke and cross-dissolves their values. Edge Blends averages the values of the two sides. The width of the cross-dissolve or blend area is set by the Distance parameter. You can further adjust the overall stroke size by changing the Size value in the Brush Controls section. To further fade the stroke edges, alter the Softness value (also in Brush Controls). You can offset one side of the sampled pixels and thus avoid horizontal or vertical streaking by altering the Angle parameter. The Bias slider alters the balance of one side of the stroke with the opposite side; a value of 0.5 means that each side is used equally.

Because the Wire Removal modes averages pixels values, the area within the stroke is essentially blurred and detail is lost. You can reinsert some variation by raising the Noise value above 0. Where the noise appears is based on the Noise Threshold value, with higher values inserting a greater degree of noise.

Animating Stroke Positions

You can animate the positions of Mesh Paint and Paint strokes by keyframing the Center XY parameter, which is located in the tool's Stroke Controls section. This is particularly useful for wire removal where the wire, rig, or scratch may stay vertical but only drift left or right.

Figure 10.7 The Apply Controls section as it appears when using the Stoke tool and setting the Apply Mode to Wire Removal.

Chapter Tutorial A: Reducing Noise Per Channel

In Chapter 6, we color graded a night-time shot with the use of a mask. The color adjustments reveal a heavy noise caused by a low exposure. We can reduce the noise by employing the Reduce Noise tool. Follow these steps:

1. Open `\ProjectFiles\FusionFiles\Chapter6\RotoColor.comp`. Connect the Merge1 tool to a Display view. Zoom into the frame so you can clearly see the noise. Play back the time ruler. Note that the noise is most noticeable around the rotoscoped part of the man.
2. Choose Tools > Film > Remove Noise. Connect ColorCurves1 tool to the input of the Remove Noise tool. Connect the output of the Remove Noise tool to the Background of the Merge1 tool. Connect the Remove Noise tool to a Display view. This branch of the network displays the footage without the rotoscoping.
3. Select the connected Display view and press the R key to display the red channel. Note the intensity of the noise. Press the G key to display the green channel. The noise is less intense in the green channel. Press the B key to display the blue channel. The noise is the most intense in this channel (Figure 10.8). It's not unusual for noise to have different degrees of intensity in different channels, whether you are working with digital video, analog video, or scanned motion picture film.

Figure 10.8 Left to right: Close-up of noise seen in the red, green, and blue channels.

4. Select the Remove Noise tool. With the Color button selected, move the Blue Softness slider to its maximum value of 0.01. The blue channel is blurred. Press C in the Display view to return to the RGB channels. The softening of the blue channel by itself has little effect on the end result.
5. Raise the Softness Red and Softness Green sliders to mid-values (about 0.005). The image is softened and the noise is reduced. However, all the other detail is softened at the same time. Slowly raise the Detail Red and Detail Green sliders until sharpness returns to the shot (Figure 10.9). Values about 0.08 work fairly well. There's no need to raise the Detail Blue value because the blue channel is so heavily blurred. Play back the time ruler. The noise is significantly reduced. Continue to fine-tune the Softness Red, Softness Green, Detail Red, and Detail Green values. To properly judge the results, activate the HiQ button in the TimeView.

Figure 10.9 Top: Raising the Softness Red and Softness Green value removes the noise but blurs all the other detail. Bottom: Raising the Detail Red and Detail Green values restores detail while minimizing the noise.

6. Select the Remove Noise tool and press Ctrl/Cmd+C to copy. Press Ctrl/Cmd+V to paste. Connect the new Remove Noise tool between the HueCurves1 output and the Foreground input of the Merge1 tool. Use Figure 10.10 as reference. Connect the new Remove Noise tool, RemoveNoise1_1, to a Display view. RemoveNoise1_1 is copied with the previous settings; however, it is not as successful due to the color adjustments of the HueCurves1 tool.

7. Open RemoveNoise1_1 in the Tools > Controls tab. Select the Chroma button. Raise the Softness Luma value to its default maximum of 0.01. The shot is softened. However, some of the colored noise is still visible. Set Softness Chroma to 0.005. The colored noise is softened. Slowly raise the Detail Luma value until the detail returns. A value about 0.15 works fairly well. Note that this Remove Noise tool does not remove as much noise as the first iteration.

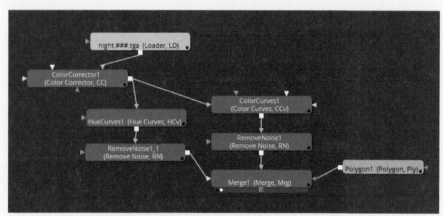

Figure 10.10 Final tool network for this tutorial.

8. Connect the Merge1 tool to a Display view and play back. Although less noise is removed with the second Remove Noise tool, the area it affects is minimized by the rotoscoping. Ultimately, there is far less noise throughout the shot (Figure 10.11).

The tutorial is complete! A finished version of this tutorial is saved as `\ProjectFiles\FusionFiles\Chapter10\ColorNoise.comp`. Feel free to experiment with different Remove Noise settings. Another approach would require you to connect a single Remove Noise tool *after* the Loader but *before* the color correction tools.

Figure 10.11 The final output using two Remove Noise tools. The noise is significantly reduced.

Chapter Tutorial B: Paint Fixing Dirt, Dust, and Scratches

You can use the Paint tool to remove dust, dirt, and scratches for old motion picture film. To practice this technique, follow these steps:

1. Create a new project and a new Loader. Import `\ProjectFiles\Plates\Scratches\scratches.##.png`. Set the Global End Time to 89. Choose File > Preferences and set the Frame Rate to 30. The footage is taken from a vintage scan of film that converted the frame rate to 30 fps.
2. Connect the Loader to a Display view and play back. The footage features a black-and-white shot of a man at a table. Dust, which appears as sizable black or white spots, appears randomly on the frame. In addition, several large scratches appear as vertical black lines that waver left and right (Figure 10.12).

Video clip from Wartime Nutrition (1943) *via the Prelinger Archive.*

Figure 10.12 Close-up of footage showing black and white dirt and dust spots, as well as vertical black scratches.

3. Go to a frame where a dust / dirt spot is clearly visible, such as frame 40. With the Loader selected, choose Tools > Paint > Paint. The new Paint tool is connected automatically. Connect the Paint tool to a Display view. The Paint toolbar appears at the side of the Display view. Select the Stroke button (fourth button from the top).
4. Zoom into the Display view to enlarge the dust spots. Expand the Paint tool's Brush Controls section and adjust the Size value so the brush is slightly larger than a single dust or dirt spot. Select the Clone button under Apply Modes. Alt/Opt+LMB click in area near the dust spots that carries a similar value. When you move the brush away, the red x stays at the place where you clicked. LMB-drag a short stroke that covers the dust / dirt spots.
5. Expand the tool's Stroke Controls section. Note that the Stroke Animation menu is set to All Frames. Change the menu to Limited Duration. Note that the Duration parameter is set to 1.0. This is an appropriate value because dust spots tend to last for a single frame.

6. Move forward and backward on the time ruler and search for other dust and dirt spots. Remove those spots by repeating steps 4 and 5. Any given frame may require one to a dozen strokes (Figure 10.13).

Figure 10.13 All the strokes on frame 40 are selected by LMB-dragging a selection marquee. The long stroke is the first one created with the Wire Removal mode. The short strokes remove dust and dirt spots.

7. Return to frame 40. Select the Wire Removal button under Apply Modes. Select the Edge Blend button. LMB-drag in the Display view to create a vertical stroke that runs over the left-most scratch. Adjust the Angle, Distance, Bias, Noise, and Noise Threshold to best hide the scratch. For example, set Angle to 80 and Distance to 0.01, while leaving the other parameters set to their default values. You can also fine-tune the brush size by returning to the Stroke Controls section and changing the Size value.

8. RMB-click over the Wire Removal stroke's Center parameter and choose Animate. Move a few frames ahead on the time ruler. Switch to the Modifiers tab. The stroke is listed as the newest stroke name at the bottom of the stroke list. In addition, a path is listed and carries the motion path for the animated Center parameter. Click on the stroke name to see the stroke's transform handle in the Display view. LMB-drag the handle to cover the scratch. Proceed to other frames and adjust the transform handle to keep the scratch hidden.

9. Repeat steps 7 and 8 to add additional strokes to cover other large scratches (Figure 10.14).

The tutorial is complete! A version of this tutorial is saved as `\ProjectFiles\Fusion-Files\Chapter10\PaintFix.comp` with paint fixes for frames 40 to 45.

Figure 10.14 The majority of large scratches and dirt and dust spots are removed with the Clone and Wire Removal modes of the Stroke sub-tool offered by the Paint tool.

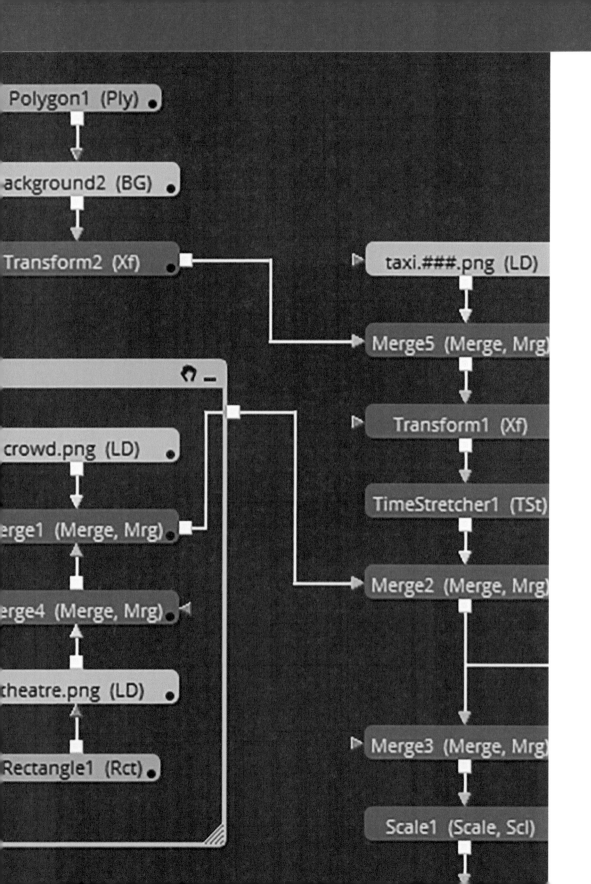

Rendering, Scripting, and Customizing

Fusion includes numerous options for making your compositing project easier to undertake. This includes interface customization and workflow shortcuts. In addition, Fusion provides a powerful set of tools to create and read scripts that can help automate tools, parameters, and other common compositing steps. In a similar fashion, modifiers, expressions, and linking can reduce the need to manually keyframe. As a bonus, Fusion Studio includes a full set of tools for working with stereoscopic projects and provides a render manager. After all, rendering is a final but critical step for any project. Last, Fusion's domain tools allow for additional processing efficiency.

This chapter includes the following critical information:

- Rendering with the Saver tool and Render Manager
- Customizing bins and toolbars
- Building groups and macros
- Applying modifiers, linking, and writing expression
- An overview of scripting in Fusion
- An overview of Fusion's stereoscopic support
- Working with domains

Rendering

Thus far, we've used the TimeView to play back composites within Fusion. When you are ready to export a tool network, you must render it to disk. To do so, you can add a Saver tool to the network. In fact, you can render the output of any tool within a network in this fashion. To render, follow these steps:

1. Choose Tools > I/O > Saver. The Save File windows open. Navigate to a directory where you wish to render to. You can create a new folder by using the Create New Folder button at the top-right of the window. Choose a file format through the drop-down menu at the bottom-center of the window. Note that you can a render an image sequence or a self-contained movie, such as a QuickTime MOV. Enter the name of the rendered file into the name field. If you are rendering an image sequence, such as TIFF or PNG, add a **0** for each numeric placeholder. For example, if you are rendering a 48-frame sequence, enter **name.00.png**. Click the Save button.
2. Connect the tool whose output you wish to render to the Saver input. Select the Saver tool. The file name and directory path is listed in the tool's Filename field. You can update this if necessary.
3. Click the green Render button beside the playback controls in the TimeView. The Render Settings window opens (Figure 11.1). By default, the window is set for a high-quality, full-resolution render but you can change the settings if you wish by clicking *Preview* under Configurations. Note that the Frame Range field is set to the same range as the Render Start Time and Render End Time fields in the TimeView. You can change the range by clicking in the Frame Range field and updating the values, where the format is *start_frame..end_frame*.

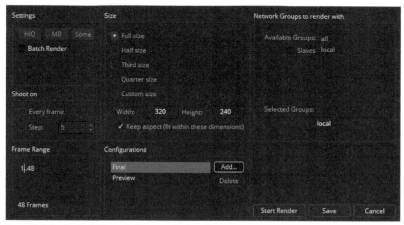

Figure 11.1 The Render Settings window set to Final quality.

4. Click the Start Render button. The time ruler plays back and the frames are rendered. At completion, a Render Completed window pops up. The window includes statistics on total render time and average render time per frame.

After you've included a Saver tool in your network, you are free to disconnect it and connect it to other tools. You can update the Filename field at any time or change the various settings in the Render Settings window whenever you would like to render again.

You can view a recent render by importing it through a new Loader. You can also choose File > Import > Footage and browse for the render. A new project is created automatically with a new Loader. After viewing the footage by connecting the Loader to a Display view, you can close the project and discard the Loader. For more information on resolution and quality settings within the Render Settings window, see Chapter 1.

Using the Fusion Studio Render Manager

Fusion Studio includes a render manager with which you can queue multiple renders. To activate the manager, choose File > Render Manager. The Render Manager window opens (Figure 11.2). It operates by loading and ordering saved project `.comp` files.

Figure 11.2 The Render Manager window with two comps in the queue.

To add a `.comp` file, click the Add Comp button at the top-left and browse for the file. The file is parsed and listed in the queue field. If you add two or more comps to the queue, you can order them by LMB-dragging the comp name up and down the queue stack. You can remove a comp by selecting it and clicking the Remove Comp button.

The render manager is dependent on a single render "master" and render "slaves." Hence, the manager can render across multiple, networked machines. You can add a slave machine by choosing Slave > Add Slave through the window menu. Note that each slave machine must have a licensed copy of Fusion Studio. In addition, the machine's name and I.P. address must be identified through the Preferences window's Global And Default Settings > Network section. The render master machine can also be chosen through this section.

To properly prepare compositions for the render queue, extra care must be taken with directory paths. Either UNC (Universal Naming Convention) naming or mapped drives should be used to guarantee that the slave machine can locate image sequences, bitmap images, and so on.

After comps are added to the queue and a master machine and slave machines exist on the network, renders are automatically launched in the queue order. For more detailed information on setting up and maintaining a render network, see the "Network Rendering and Licensing" section of the "Fusion 8 User Manual" available at the Blackmagic design website (`blackmagicdesign.com`).

Customizing Your Workspace

Fusion offers several approaches for customizing your workspace. Although these methods have not been employed up to this point, they are worth investigating as they may save you time while working on future projects.

Main Toolbar

The Fusion program window includes a main toolbar along the top with a number of shortcut buttons (Figure 11. 3). From left to right, these include view layouts, a Bins button, common tools, 3D tools, filter tools, and masking tools. Clicking a toolbar button changes the view layout, opens the bin window, or adds a tool to the Flow view. You can also LMB-drag a tool button into the Flow view to create a new tool. Each tool has a two- or three-letter abbreviation. The same abbreviation appears within the parenthesis on the tool's icon in the Flow view.

BG	FN	Txt+	3Im	3Sh	3Cm	3SL	3Rn	pEm	pRn	Blur	BC

Figure 11.3 A portion of the default toolbar. The green buttons are Creator tools. The light blue buttons are 3D tools. The purple buttons are 3D particle tools. The white buttons are filter tools.

You can add or remove layouts, tools, and settings buttons from the toolbar by RMB-clicking the toolbar and opening the Customize Toolbar window. To add a new button, select a button set name in the left column, select a category name in the center column and double-click an item in the right column. If you wish to rename the button, click the Edit button while the item name is selected (you are limited to three letters or numbers). By default, buttons are divided into a View Bar set (with view layouts) and a Common Tools set, as listed in the left column. You can hide a set by deselecting its checkbox. You can add a new, empty set by clicking the New button. The toolbar configuration is stored as a text file (on a Windows system, this is located at `\ProgramData\Blackmagic De-sign\Fusion\Profiles\Default\Fusion8.prefs`.

Bins

Bins offer easy access to commonly used tools, compositions, footage, settings, or macros. Bins are sharable over a network if the network machines have Fusion Studio installed. To access the bins, choose File > Bins or press Ctrl/Cmd+B. The bins window includes a bin hierarchy column on the left and a bin contents field at the right (Figure 11.4).

Figure 11.4 A portion of the bins window. The Favorites folder contains three custom item. From left to right, these are a Defocus tool with custom parameter values, an image sequence named *Test*, and a Maya `.ma` geometry file.

The Tools bin includes all the tools that the current installation of Fusion carries. To see the tools, click on *Tools* in the left column and then a sub-folder, such as Blur. Each tool is represented by an icon. To add a tool to the Flow view, double-click its icon.

The Clips (footage), Compositions, Favorites, and Settings (tool settings) folders are empty until you add your own items. To add an item, click on a folder, RMB-click in the contents field at the right, and choose Add Item. The file browser window opens and you can browse for any supported file format, including supported image sequences, video move files, Fusion `.comp` files, and importable files such as Maya `.ma` or a FBX file. You can add a tool, with its current settings, by LMB-dragging it from the Flow view to the bin window; the Save File window opens and asks you to save the settings in the Fusion `.setting` format. When you double-click a footage icon, the footage is added to the Flow view via a new Loader. When you double-click a comp icon, the project is opened without closing previously open projects. You can create sub-folders in the bins window by RMB-clicking and choosing New Folder. You can remove an item by selecting its icon and pressing the Delete key. You can move an item to a different folder by LMB-dragging its icon into the folder name.

Organizing the Flow View

Complex Fusion projects can create a tangle of connected tools that is difficult to comprehend. Hence, the program offers several techniques for organizing the Flow view and making the result more understandable.

Grouping Tools

You can simplify the Flow view by grouping tools together. The grouped tools are hidden and replaced by a single group tool. To create a group, Ctrl/Cmd+LMB-click multiple tools or LMB-drag a selection marquee around multiple tools, and press Ctrl/Cmd+G. You can expand the contents of a group by selecting it and pressing Ctrl/Cmd+E. The tools are displayed within a group box (Figure 11.5). You can select and move the grouped tools within the box. You can resize the box by LMB-dragging its edges. To re-collapse the group, press Ctrl/Cmd+G again. To ungroup the tools, RMB-click over the Group tool and choose Ungroup.

Figure 11.5 Three tools sit inside an expanded group box. Bottom, a collapsed group tool that contains five other tools. Note that group tools carry all the necessary inputs and outputs to maintain the original network.

209

Adding Macros

Macros are similar to groups. However, they can be customized and saved to disk to allow sharing with other compositors. To create a macro, select one or more tools, RMB-click over a selected tool and choose Macro > Create Macro. The Macro Editor window opens. It lists the selected tools, their inputs and outputs, and their parameters. You can rename the macro by changing the Macro Name field. You can select and deselect input, output, and parameter checkboxes for each tool to determine what is "exposed" by the macro. When you click the Close button, the file browse window opens and you can save the macro to disk with the `.setting` extension. If you save the macro to the default Macros directory, the macro is then listed in the Tools > Macro menu. You can add a macro to the Flow view by choosing it from this menu.

Exposed inputs and outputs appear along the edge of the macro tool when it is added to the Flow view. The user can connect or disconnect the exposed inputs and outputs to and from other tools. Exposed parameters appear in the Tools tab when the macro tool is selected. Unexposed inputs, outputs, and parameters are hidden. Thus functionality allows for a streamlined and secured workflow when sharing macro tools. You can edit a pre-existing macro by RMB-clicking in the Flow view and choosing Edit Macro > *macro*.

Finding Tools

You can search for a tool by RMB-clicking in the Flow view and choosing Find. With the Find Tools window, you can search for incomplete or full tools names. When you click the Find Next button, the first matching tool is selected and the Flow view is refocused to bring the tool into view.

Flow Display Options

The Flow view includes additional display and organization options under the RMB-click > Options menu. These include Orthogonal Pipes (right-angle connection lines), Show Grid (deselect to hide the grid lines), and Show Navigator. The navigator is an inset window that appears at the top-right of the Flow view. The navigator shows all the tools in the current project, even if the current Flow view only displays a portion of those (Figure 11.6). You can LMB-drag in the navigator to refocus the Flow view or move to a different group of tools within a large or expansive tool network. You can adjust the size of the navigator window by LMB-dragging its corner.

Figure 11.6 A network displayed with orthogonal pipes next to the navigator window.

Adding and Reading Comments

Each tool includes a Tools > Comments tab. This is the furthest tab to the right with the *i* symbol. You can type directly into the Comments field. This is useful for explaining settings to other compositors or reminding yourself how the tool network functions.

Automating Parameter Values

Fusion provides several methods with which you can automate the value change of parameter values. These include the use of modifiers, expressions, links, and scripting.

Applying Fusion Modifiers

In Fusion, modifiers control parameters. Existing modifiers for a selected tool are listed in the Modifiers tab (to the right of the Tools tab). Some tools, such as Mask Paint and Paint, produce modifiers automatically as you employ them. In contrast, standard keyframe animation does not produce a modifier. Nevertheless, you can add a modifier to a parameter by RMB-clicking a parameter name and choosing Modify With > *modifier*. Each modifier carries its own set of parameters, which you can access by expanding the modifier's section in the Modifiers tab (Figure 11.7). You can keyframe modifier parameters.

Sample modifiers are described here:

Calculation Allows you to supply a value to a parameter that's based on a mathematical operation between two other values. You can enter values into the modifier's First Operand and Second Operand fields and choose the mathematical operation through the Operation menu. You can also connect the Operand parameters to other parameters via expressions.

Expression Adds its namesake to a parameter, which allows you to create a mathematical formula that will automatically supply values. Expressions are discussed in the next section.

Gradient Color Derives parameter values from a gradient. The modifier's Start Time and End Time parameters determine the duration over which the gradient is read from left to right. You are free to alter the gradient colors or insert additional gradient handles.

Offset Angle and Offset Distance Adds an Offset modifier that you can use to offset the Center or Angle parameter. The modifier includes horizontal and vertical flip options that invert the X or Y values (Figure 11.7).

Figure 11.7 The Modifiers tab with Offset Distance and Perturb modifiers applied to the Center and Angle parameters of a Transform tool.

Perturb Adds random fluctuations to the parameter. The modifier includes options to alter the perturbation strength and speed (see Figure 11.7).

Shake Adds random value change to the parameter. However, the value changes are larger and smoother than the Perturb modifier.

The list of available modifiers changes with the selected parameter in order to maintain mathematical compatibility. To delete an existing modifier, RMB-click over the modifier name in the Modifiers tab and choose Delete.

Working with Expressions and Linking

Expressions allow you to relate one parameter value to another. In this way, one parameter automatically drives another. You can add an expression to a parameter by RMB-clicking over the parameter name and choosing Expression. An expression field is added below the parameter and a yellow bar appears to the left of the parameter name. Initially, the expression field displays the current value of the parameter. To relate the current parameter to a different parameter, click the + button beside the expression field and LMB-drag. A "pick whip" string is drawn (Figure 11.8). Drop the string on top of another parameter name. The parameter name is added to the field and a 1-to-1 relationship is created. When the "pick whipped" parameter changes, the parameter with the expression is automatically updated with the new value.

Figure 11.8 An expression is added to an Angle parameter. A pick whip string is extended from the + button.

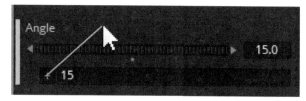

You can alter the expression so the relationship is no longer 1-to-1. For example, if you add **+10** to the end of the expression, the expression value is equal to the "pick whipped" parameter plus 10. The expression field supports common mathematical operators, including – (minus), * (multiply), and / (divide).

You can manually reference the parameters of other tools by following this syntax : *tool.parameter*. For example, if you type **Blur1.XBlurSize** into the expression field, the expression value is equal to the Blur Size parameter of the Blur1 tool.

Expressions support scripting that can access system or project properties, such as current time and various metadata. The scripting uses Lua as a language. For more information on Lua and its syntax, see the "Fusion 8 Scripting Guide" available at the Blackmagic Design website. Note that Expressions are referred to as *SimpleExpressions* in the Fusion documentation.

As demonstrated in Chapter 4, linking allows you to create a 1-to-1 relationship between parameters of different tools. To create a link, RMB-click over the name of the parameter that will receive values and choose the parameter that will provide values via the Connect To > *parameter* menu option. If the parameter name you desire does not exist in the menu list, you can publish the parameter so that is visible to the Connect To menu option. To publish a parameter, RMB-click over the parameter name and choose Publish. If the parameter is not animated, the Publish option adds a flat animation spline to the parameter.

Scripting Overview

FusionScript refers to all scripting within Fusion. Fusion supports Lua and Python scripting.
Scripting, as a general term, refers to a programming language designed to carry out the internal
functionality or API of a program (as opposed to constructing a separate program). The Lua lan-
guage is used widely in the video game and science simulation industries. The Lua library is bundled
with Fusion. The Python language is widely used in the animation and visual effects industries and is
supported by many 3D programs. The Python 2 and Python 3 language libraries require installation
and are not bundled with Fusion.

You can divide FusionScript into several categories:

Comp Scripts Operate on the entire project. They are accessible via the Script menu of the main
program menu set.

Tool Scripts Operate on individual tools. They are accessible via the Script menu when you
RMB-click over a tool icon.

Utility Scripts Carry our program duties, such as saving, opening, or importing files. They are
accessible via the File > Script menu.

In addition to opening or editing scripts through the various Script menus, you can work with scripts
in the Console view. The main message field of the Console view displays program error and script
output messages. The narrow field at the bottom of the view accepts new script lines. The chosen
scripting language is set by the Lua, Py2 (Python 2), and Py3 (Python 3) buttons at the top-left of the
view.

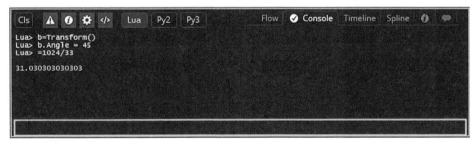

Figure 11.9 The Console view. The yellow box indicates the field where you can type new script lines.

Lua Scripting Examples

To create a simple Lua script, enter a mathematical formula into the script field at the bottom of
the view. Follow the syntax = *number operator number*. For example, enter **=1024/33**, which is
equivalent to 1024 divided by 33. The console functions like a calculator and prints the result in the
message field:

```
Lua> =1024/33
31.030303030303
```

You can clear the message field at any time by clicking the CIS (Clear Screen) button at the top-left of the view.

You can add new tools to the Flow view with Lua; however, this requires the use of a variable. For example, if you enter **a=Blur()** , the variable *a* is made equal to a Blur tool object. When you enter **==a**, a Blur tool is added to the Flow view. The == is a Lua shortcut that returns the value of the listed variable. You can discover the scripting name of any existing or yet-to-exist tool within Fusion by hovering your mouse over the related Flow icon or menu entry and viewing the printout at the bottom-left of the program window.

In a similar fashion, you can identify the scripting name of a parameter by hovering the mouse over the parameter name. For example, the Size parameter for a Transform tool may be listed as **Transform1.Size**. The majority of parameter names are the same whether they are scripted or listed in the Tools tab. You can use Lua to set a parameter value. For example, the following two lines establish the *b* variable as equal to a Transform tool object, add the Transfrom tool to the Flow view, and set the new tool's Angle value to 45:

```
b=Transform()
b.Angle = 45
```

You can reference an existing tool by typing its name. You can create connections between tools by using input and output names. For example:

```
Blur1.Input = Transform1.Output
```

In this case, the tool receiving input is on the left and the tool providing output is on the right. As previously discussed, you can discover the proper name of an input or output by letting your mouse hover over the connection stubs on the tool icons.

The complexities of Lua and Python scripting are far beyond the scope of this book. Hence, if you'd like to learn more on this topic, please refer to the "Fusion 8 Scripting Guide" available at the Blackmagic Design website (**blackmagicdesign.com**).

Using Plug-ins and Fuses

Plug-ins are scripted modules that add extra capability to Fusion. Plug-in tools are automatically listed in the Tools menu under an appropriate category. For example, the standard installation of Fusion includes such plug-ins as Paint and those that support the importation of FBX and Alembic 3D files. Fusion plug-ins carry the **.plugin** extension and are located in the **C:\Program Files\ Blackmagic Design\Fusion 8\Plugins** directory in a Windows system.

In Fusion, a Fuse is a special form of Lua scripting that acts like a plug-in. Fuse files carry the **.fuse** extensions and are located in the **C:\Program Files\Blackmagic Design\Fusion 8\ Fuses** directory in a Windows system. For example, the standard installation of Fusion includes the Fuse plug-ins FastNoise and FastNoise Fuse. Fuse tool plug-ins are automatically listed in the Tools menu under an appropriate category.

Hacking `.comp` Files

As discussed, Fusion project files are saved as a text file with the `.comp` extension. You can manually edit these files with a text editor. This is especially useful if the project file has been moved to a different machine or drive and the program can no longer find image sequences, movies, bitmaps, and so on. Such files are hard-coded with a line similar to this:

```
Filename = "C:\\ProjectFiles\\Art\\canyon.png",
```

To update the directory paths , use a search and replace function within the text editor. For example, use Windows Notepad. When saving the file, choose a plain text format (no formatting) and manually type in the `.comp` extension.

Stereoscopic Overview

Fusion Studio supports a stereoscopic workflow, whereby there is a left eye and right eye view. **Stereoscopic** refers to the process by which two pieces of footage of the same object are taken at slightly different angles, yet are viewed together, thus creating an impression of three-dimensional depth. Stereoscopic projects requires specialized camera rigs to shoot the stereo footage. In addition, specialized glasses, projectors, and/or monitors are required to properly view a stereoscopic project.

A basic stereoscopic workflow in Fusion follows:

- Left eye and right eye footage is loaded through two Loader tools.
- The left eye footage is connected to the Left input of a Disparity tool. The right eye footage is connected to the Right input of a Disparity tool. The Disparity tool generates an XY disparity map, which encodes the difference in pixel coordinates of similar features between the left and right eye views. The disparity map is stored in X and Y auxiliary channels.
- The alignment of left and right views are adjusted using the Stereo Align tool. Any aesthetic adjustments to the left and right portions of the network are undertaken by standard filter tools; for example, a color correction tool may be added to the left view, the right view, or both views.
- The adjusted stereoscopic output is exported. The left and right views may be rendered with Saver tools as separate image sequences or as stereo auxiliary channels within single OpenEXR image sequence. The stereo image may also be collapsed into an anaglyph image using the Anaglyph tool before it is rendered. The Anaglyph tool tints the left and right views (most often with red and cyan) and merges them together. You can view anaglyph stereoscopic images with anaglyph glasses.

The Display views include options for viewing stereoscopic tool networks. If you RMB-click within a Display view and choose Stereo, you'll see options for choosing anaglyph color pairs, stereo view formats (such as anaglyph, interlaced, left or right eye only), and stereo layouts (such as left / right "Stacked Image" or left / right eye swap), You can view a disparity channel by selecting a tool that carries the channel and switching the view's Color menu to Disparity X or Disparity Y. You can create a stereoscopic 3D camera, with left and right eye views, by connecting the output of a Camera 3D tool to the Right Stereo Camera input of a second Camera 3D tool. The connected camera becomes the right view and is offset from the left view camera (Figure 11.10). You can adjust the offset by adjusting the Eye Separation and Convergence parameters of the left view camera. **Stereoscopic separation** is the world distance between the left and right camera. **Convergence** is the angle formed between left and right cameras and the viewed feature; adjusting the convergence makes objects in the footage appear closer or farther from the viewer. You can use a stereoscopic camera to create a stereoscopic render 3D geometry. You can also use a stereoscopic camera to adjust the left and right eye alignment of existing stereoscopic footage; in this situation, the 3D camera takes advantage of the disparity map to create a new synthesized view.

Figure 11.10 A stereoscopic camera pair.

You can convert a disparity map to Z-buffer depth information by connecting a Disparity tool to a Disparity To Z tool. You can use the new depth information to apply a filter. For example, if you connect the output of the Disparity To Z tool to the input of a Fog 3D tool, a fog effect is placed "into" the shot with the fog behind some features within the footage. For additional information on the stereoscopic process in Fusion, see the "Stereoscopic and Optical Flow" section of the "Fusion 8 User Manual," available at the Blackmagic Design website (`blackmagicdesign.com`).

Working with Miscellaneous Tools

The Tools > Miscellaneous menu includes various tools to help increase efficiency. The tools are discussed here.

Auto Domain and Set Domain As discussed in Chapter 7, a domain of definition, or simply **domain**, is the area of a frame that is considered valid and is affected by a tool. You can alter the current domain with the Auto Domain and Set Domains tools. This may increase the speed to tool calculations. The Auto Domain tool automatically adjusts the input domain size on every frame based on the frame contents. Areas that are empty and do not contain RGB values are clipped. For example, you can use Auto Domain to limit the domain area of a 3D render of an object over empty space. In addition, Auto Domain includes Left, Right, Bottom, and Top parameters you can use to further crop the domain. The Set Domain tool includes the same parameters but does not automatically adjust the domain based on the frame contents. The Set Domain tool has two modes of operation: Adjust, which lets you adjust the current domain, and Set, which lets you set an absolute domain size.

Run Command This tool executes an external command or external script during a render. When connected to the output of another tool, the Run Command tool does not execute until the connected tool has finished its render calculation. For additional information on the Fusion scripting environment, see the "Fusion 8 Scripting Guide," available at the Blackmagic Design website.

Fields This tools adds interlacing to or removes interlacing from an input. (The removal is referred to as **deinterlacing**.) Interlacing is a technical legacy of SDTV whereby each frame is broken into two fields. Each field contains every other scanline. Fields are transmitted one at a time. Although interlaced footage is fairly rare in the current world of compositing, it might be encountered when working with legacy or historical footage. In general, it is better to work with **progressive** (non-interlaced) footage when compositing. Whether the tool interlaces or deinterlaces is set by the Operation menu.

Using MetaData

MetaData is data that describes other data. For example, a digital photo may contain metadata that details the lens, F-stop, location, and date the photo was taken. When working in Fusion, you can read the metadata of imported footage or metadata added to portions of the network by other compositors. You can also add your own metadata. When compositing, metadata aids in communication, can help automate scripts, and lends to better organization of complex projects.

If a tool carries metadata, you can examine it in a subview. Connect the tool to a Display view, click the SubV button, and change the SubV menu to Metadata. The data is displayed in the SubV gray window.

You can add a metadata data pair to a portion of the network by connecting a Set Metadata tool. Enter a data name into the Set Metadata tool's Field Name field. Enter the data value into the Field Value field. For example, a Field Name might be *Revision Date* and the Field Value might be *6/15/2017*. Metadata is cumulative; that is, when you display the metadata of a tool in the Display view, all the metadata attached to upstream tools is also displayed. Metadata tools are located in the Tools > Metadata menu.

You can merge the metadata carried by two portions of the network by adding a Copy Metadata tool. The tool has two inputs. You can add timecode, a form of metadata that indicates time by using the Hour:Minute:Second:Frame format by adding a Set Time Code tool (also in the Tools > Metadata menu). For more information on subviews, see Chapter 2.

Book Wrap-up

You made it to the end! Thank you for reading the book. Blackmagic Design Fusion is a complex program with many tools, parameters, and workflow approaches. I've touched on the most critical elements but have not come close to exploring every potential of the software. Nevertheless, I'm confident that you can take this basic knowledge and produce your own creative and impressive compositing projects. That's the beauty of digital compositing—there are numerous approaches to every problem and no single one is wrong so long as your satisfied with the final product. So, have fun!

Final Tutorial: Creating the Cover Art

This tutorial is the longest and most complex of this book. It covers many of the topics covered by the book's eleven chapters. When completed, it creates the artwork featured on this book's cover. This tutorial includes all the steps you need to undertake this task, so you can attempt it before completing the other chapters. You can follow these steps:

1. Create a new Fusion project. You can choose File > New. If you wish to close an old project, switch to the project's tab at the top-left of the program window and choose File > Close.
2. Create new Loader tool. You can choose Tools > I/O > Loader from the main toolbar. You can also RMB-click within the Flow view and choose Add Tool > I/O > Loader. As a third approach, you can click the green *LD* button at the left side of the toolbar. Import the following image sequence: `\ProjectFiles\Plates\Ghost\ghost.##.png`.
3. Connect the Loader to a Display view. With the tool selected, you can press the 1 or 2 key. You can also LMB-drag the tool into the viewer. As a third approach, you can click directly on one of the display dots at the bottom-left of the tool icon.
4. The default duration of the time ruler is 1000 frames. Because the footage is only 72 frames long, a gray footage bar appears at the left side of the time ruler. When you import the footage, the Render End Time field is automatically set to the last frame of the image sequences. Change the Global End Time field from 1000 to 71. Click the Fit button of the Display view to which the Loader is connected. Play back the time ruler. The footage features an actor dressed as a gray ghost against a green screen. We will remove the green screen, add a new background, and eventually add color, distortion, and particle effects. The footage is provided by Light Forge Studios in Las Vegas, Nevada.
5. Note the resolution of the footage (that is printed at the top-right of the displayed frame): 3840×2160. Choose File > Preferences. The Preferences window opens. Switch to the Frame Format section in the left column. Change the Width field to 3840 and the Height field to 2160. Change the Frame rate field to 24, which matches the frame rate of the original digital video footage. Click the Save button to close the window.

6. With the Loader tool selected, Choose Tools > Matte > Primatte. The new Primatte tool is connected automatically to the Loader. Connect the Primatte tool to a Display view. To simplify our green screen removal, we can add a mask to cut off the majority of green (and the microphone boom pole at the top right). Choose Tools > Mask > Polygon. Zoom out of the Display view to see the edges of the frame. Go to the first frame of the time ruler (frame 0). With the Polygon tool selected, LMB-click in the Display view to add points and form the polygon mask. Loosely encompass the actor. You are free to extend the mask beyond the edge of the frame. To close the mask, LMB-click on the first point (Figure F.1).

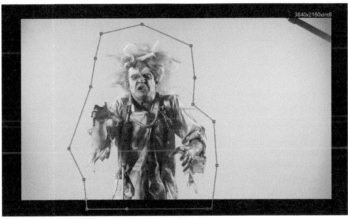

Figure F.1 A polygon mask is drawn loosely around the actor.

7. Due to the motion of the actor, the mask will require shape animation. When you draw the initial mask shape, the first keyframe is added automatically. This is indicated by a green line on the time ruler. In addition, the phrase *Right-Click For Shape Animation* at the bottom of the Polygon tool's Tools > Controls tab has a green line to its left. Proceed to other frames and update the mask shape to make the mask follow the actor. Avoid cutting off the actor's arms and hair. Because the actor's motion is fairly simple and the fact that the mask will serve as a garbage matte, only a few additional keyframes are required.

8. The mask is not functional until it is connected. Connect the Polygon output to the Primatte tool's Garbage Matte input. The input has a light-colored triangle input stub. You can identify inputs by letting the mouse hover over the input stubs. The mask cuts out the man but keeps the green screen. Return to the Polygon tool and select its Invert checkbox. The mask saves the actor and discards the majority of the green screen.

9. Select the Primatte tool. Click the Auto Compute button. The green is removed. However, green is removed from the actor as well and becomes more red-blue. To examine the alpha matte, change the Display view's Color menu to Alpha. You can also press the A key when the Display view is selected. Although the actor is assigned white alpha, there is a fair amount of noise in the background (Figure F.2). Feel free to zoom into the view to see better.

10. Click the Clean Background Noise button. Proceed to LMB-drag in the Display view to sample areas of the background noise. You can draw short strokes. Each time you release the mouse button, the matte updates and the noise starts to dissipate. Continue to draw strokes until the noise disappears (Figure F.2).

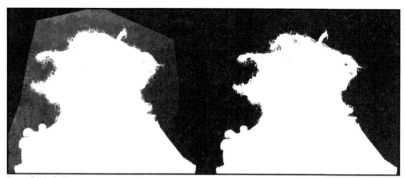

Figure F.2 Left: Noise seen as gray pixels in the alpha channels. Right: The application of the Clean Background Noise button removes the noise.

11. Aggressive background noise removal can erode into the matte edge, especially along the hair. In addition, it can create holes in the foreground (the actor). To restore these areas, click the Clean Foreground Noise button and LMB-drag in the Display view. For example, LMB-drag over gray areas in the center of the foreground. You can also LMB-click along the edge of the hair. Return to RGB by changing the Display view's Color menu to Color by pressing the C key while the view is selected. Using the Clean Foreground Noise button will restore the green balance of the actor. However, this leads to the presence of green spill.

12. Click the Spill Sponge button. LMB-drag over a green portion of the actor. For example, his right outstretched hand has high-degree of green spill that has bounced off a green floor. The Spill Sponge button can be very aggressive and can easily erode into the actor in such a way that areas become pixelated. You can undo any stroke by pressing Ctrl/Cmd+Z. As an alternative, you can use the Spill(-) button, which has more subtle effect. That said, it is not mandatory to use a spill tool. You have the option to apply color-grading tools to reduce the green spill. We will discuss this in a later step.

13. Zoom into the hair edge. Click the Restore Detail button and LMB-drag along the hair edge to restore a soft matte edge. This reveals small hairs that may have been lost. If you apply the Restore Detail button too aggressively, the background may gain back noise. Go back and forth between the Clean Background Noise, Clean Foreground Noise, and Restore Detail buttons until you have balanced the result between an opaque foreground, a transparent background, and a soft hair edge that maintains small hairs and avoids blockiness or jagginess. It may not be possible to produce a perfect alpha matte, but you can generally get close enough to produce a functional result. Deselect the Display view's Show Checkerboard Underlay button to see what the keyed green screen looks like over black. Check other frames on the time ruler. Feel free to further adjust the Primatte tool.

14. Choose Tools > Color > Hue Curves and Tools > Color > Color Corrector. We will use these two tools to remove the green spill. Connect the output of the Primatte tool to the input of the Hue Curves tool. Connect the output of Hue Curves to the input of the Color Corrector tool. Connect the Color Corrector to a Display view. Use Figure F.11 at the end of this tutorial as reference. Select the Hue Curves tool. Select the Green checkbox while deselecting the other channel checkboxes. Pull the points below the green band downwards (Figure F.4). You can adjust the point tangent handles to create smooth transitions along the curve. This reduces the amount of spill and increases the balance of red and blue. This gives you finer control than relying on the spill tools within Primatte. Select the Color Corrector tool and change the Master - Saturation parameter to 0.7. This reduces the amount of remaining green spill and any new purple cast without turning the actor into grayscale (Figure F.5).

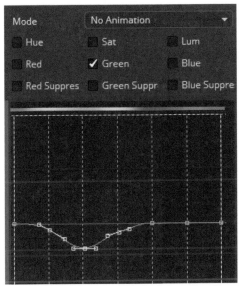

Figure F.3 Adjusted Green curve of the Hue Curves tool used to reduce green spill.

Figure F.4 Result of the Primatte, Hue Curves, and Color Corrector tools.

15. Applying the Primatte and color tools reveals and exaggerates some of the noise and grain contained within the original video footage. Choose Tools > File > Remove Noise. Connect the output of the Color Corrector tool to the input of the Remove Noise tool. Connect the Remove Noise tool to a Display view. Select the Remove Noise tool's Chroma button. Slowly raise the Softness Luma and Detail Luma sliders. Softness Luma blurs the image, thereby removing noise. Detail Luma restores lost detail by applying an unsharp mask. A Softness Luma value of 0.002 and Detail Luma value of 0.01 works well.

16. At this point, the matte edge may remain a little rough. For example, some small hairs may suddenly pop on or off. In addition, there may be a thin band of green around his left arm. Leave the Remove Noise tool connected to a Display view. Select the Primatte tool, switch to the tool's Matte tab, and adjust the Matte Contract / Expand and Matte Blur parameters. For example, setting Matte Contract / Expand to –0.25 and Matte Blur to 0.4 contracts the matte slightly while softening it. This has the effect of removing stray hairs and any remaining edge lines.

17. Add a new Loader tool and import `\ProjectFiles\Plates\Walkway\walkway.##.png`. This will become the new background. Set the new Loader tool's Hold First Frame parameter to 7. This creates a freeze frame where the first frame is used for the entire time ruler duration. Choose Tools > Composite > Merge. Connect the output or Remove Noise to the Foreground input of the Merge tool. Connect the output of the new Loader to the Background input of the Merge tool. Connect the Merge tool to a Display view. The frame is cropped to the resolution of the walkway footage, which is 1920×1080. To maintain the resolution of the green screen footage, we can resize the walkway footage. Although it's generally not advisable to scale up footage by a significant amount, it will suffice with this project (we will intentionally blur the background in a later step). Choose Tools > Transform > Resize. Insert the Resize tool in-between the new Loader and the Merge tool. By default the Resize tool's Width and Height are set to the resolution set by the Preferences window. Therefore, the frame once again shows the green screen footage correctly.

18. To center the actor in the frame, select the Merge tool and set the Center X parameter to 0.6. The Merge tool's built-in transformation parameters affect the Foreground input. Place the mouse over the connection line between the Resize tool and the Merge tool so that the line turns blue. RMB-click and choose Add Tool > Color Corrector. A new Color Corrector is inserted between the Resize tool and the Merge tool. Follow the same process to insert a Defocus tool between the new Color Corrector tool and the Merge tool. The Defocus tool is computationally expensive. For the moment, set the Defocus tool's Filter to Gaussian Blur. This speeds up the processing. Set the Defocus Size to 5 and Bloom Level to 0. This emulates a camera with a narrow depth-of-field but avoids the additional glow created by the Bloom parameters. Select the new Color Corrector. Set the Gain to 0.6. This darkens the background. LMB-drag the circular handle in the center of the color wheel towards the orange area. This alters the Tint and Strength values and adds an orange color cast to the background. These steps are suitable for emulating a time of day that is closer to sunset.

19. Insert a Glow tool (in the Tools > Blur menu) in-between the Remove Noise tool and the Merge tool. Use Figure F.11 at the end of this tutorial as reference. Set the Glow tool's Glow Size to 75, Glow to 0.85, and Blend to 0.2. This adds a ghostly, atmospheric glow to the top of the actor. Deselect the Green and Alpha checkboxes at the top of the tool's Controls tab. The tool ignores the green and alpha channels and only alters the red and blue channel values. This creates a red-blue glow instead of a white one (Figure F.5). Select the Merge tool and change the tool's Blend parameter to 0.8. This makes the Foreground input, the actor, semi-transparent and even more ghost-like.

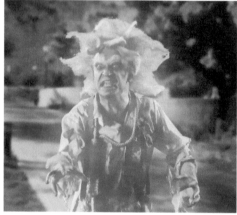

Figure F.5 The actor is merged over a new background and is given a purple glow with the Glow tool.

20. We can further alter the opacity of the actor by connecting an animated mask to the Effect mask input of the Merge tool. Choose > Creator > FastNoise. Connect the FastNoise tool to the Effect Mask input of the Merge tool. The noise immediately cuts holes into the actor. Try different noise parameter settings. For example, set Detail to 1.0, Contrast to 0.5, Brightness to 0.7, and Scale to 9. To undulate the noise over time, animate the Seethe parameter. On frame 0, set Seethe to 0. RMB-click over the property name and choose Animate. On frame 71, set Seethe to 8. Play back the time ruler to see the result.

21. We can add additional randomness to the ghostly glow by creating our own "god rays" that extend in a radial fashion from the center of the actor. Break the connection between the Remove Noise tool and the Glow tool. Choose Tools > Blur > Directional Blur and Tools > Composite > Merge. Connect the output of the Remove Noise tool to both the Directional Blur input and new Merge (Merge2) Background input. (You can connect a tool output to an unlimited number of other tool inputs.) Connect the Directional Blur output to the Foreground input of Merge. Connect the output of Merge2 to the input of the Glow tool. Use Figure F.11 at the end of this tutorial as reference.

22. Select the Directional Blur tool. Set the tool's Type parameter to Radial. This repeats the actor's input multiple times with each iteration scaled larger. This streaks the actor outwards, creating the virtual god rays. Set the Length parameter to 0.2 to length the resulting radial blur. Interactively move the tool's transform handle to center the radial blur in the center of the actor. Select the Merge2 tool. Set Blend to 0.5 to reduce the blur strength. Set the Apply Mode menu to Screen. This accentuates the whites and makes the actor brighter. Play back the time ruler to see the fluctuations of the new god rays (Figure F.6). This concludes the 2D portion of the network. Arrange the tools in neat fashion. Optionally, RMB-click in the Flow view and choose Arrange Tools > To Grid.

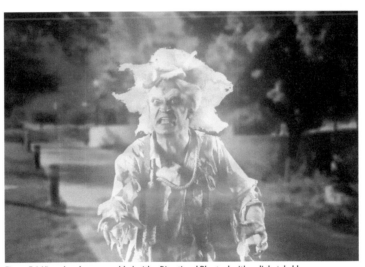

Figure F.6 Virtual god rays are added with a Directional Blur tool with radial-style blur.

23. Choose Tools > Particle > pEmitter, Tools > Particles > pRender, and Tools > 3D > Camera 3D. Move the new tools to an empty area of the Flow view. Connect the output of the pEmitter tool to the input of the pRender tool. Connect the Camera 3D tool to the Camera input of the pRender tool. Connect the pRender tool to a Display view. This is a minimal network that is required to generate and render particles. We'll use the particles to create additional ghostly plasma trails.

Speeding Up the Playback

If, at any time, the playback or display of a tool or the tool network becomes too slow, you can increase the scene efficiency by activating the Prx (Proxy) button in the TimeView. If you RMB-click over the Prx button, you can select the proxy resolution. For example, if you set the menu to 4, only every-fourth pixel is displayed. You can also temporarily reduce the quality of various tools. For example, deselect one of the active channels of the Glow tool. To quickly disable an entire tool, select the tool and press Ctrl/Cmd+P. The tools stays disabled until you press Ctrl/Cmd+P again. A disabled tool is given a dark gray icon.

24. Select the Camera 3D tool. While looking through the default Perspective camera, interactively move the Camera 3D camera backwards along the Z axis so that the particles are further from the lens. At this stage, the particles are born at the emitter location but do not move. Play back the time ruler to see the particles appear. RMB-click in the Display view and choose Camera > Camera3D1. The view switches to that of the new camera. Use the camera shortcuts to place the emitter near the bottom of the frame. MMB-drag moves the camera body left / right or up / down. LMB+MMB-drag dollies the camera forward or backward. Initially, the pRender tool is set to 3D. However, it you select the tool's 2D button, the 2D render of the particles is shown and the frame edge is revealed.

25. Select the pRender tool. Switch to the tool's Style tab. Set Style menu to Brush. This switches the particle to a 2D sprites. The sprite image is established by the brush menu at the bottom of the Style tab. Switch the Brush menu to Swirl. The brush images are included within the default program installation and are located in the `\Program Files\Blackmagic Design\ Fusion 8\Brushes\` directory on a Windows system. The Swirl brush is an orange and red circular design. We will alter these particles to create ghostly sparks. In the Size Control section, set the Size to 0.2. Note that the size may not be accurate when viewing the 3D output of the pRender tool. To check the size, click the 2D button in the Tools > Controls tab. In the Tools > Style tab, increase the Size Variance to 1.0 to randomize the particle sizes.

26. Choose Tools > Composite > Merge. Connect the output of the pRender tool to the Foreground input of the new Merge, Merge3. Connect the output of Merge1 to the Background of Merge3. Connect Merge3 to a Display view. Skip ahead on the time ruler to see a later frame. The particles appear over the actor but appear very solid. Select the Merge3 tool and change its Apply Mode to Screen. The Screen mode places the bright areas of the particles over the background while ignoring the dark areas. Reduce the Blend parameter to 0.75 to make the particles semi-transparent.

27. At this stage, the particles are born at the bottom of the screen. Select the pEmitter tool and switch to the tool's Region tab. Set the Region menu to Cube. Set the Width parameter to 0.35 and the Height parameter to 0.95 so that the region volume roughly matches the location of the actor. Select the pRender tool. Set the Blur parameter to 6 and Glow parameter to 0.95. This blurs the particles and adds a glow during the particle render. Select the Kill Particles That Leave The View checkbox. This will increase the efficiency of the network. Return to the Style tab of the pEmitter tool. Change the color to purple (roughly 0.49, 0.7, 1.0 in RGB). This will tint the brush particles so they look reddish-purple when placed over the actor (Figure F.7).

Figure F.7 The particles are changed to sprite-style circles. The particles are blurred, given glows, and are tinted purple. The green box is the pEmitter region, which is a scaled-up cube.

28. The particles possess no motion. Select the pEmitter tool. In the Velocity Controls section of the Controls tab, change Velocity to 0.025, Velocity Variance to 0.1, and Angle to 90. Play back from the first frame. The particles drift upwards with slightly different speeds. To add additional chaos to the motion, we can add a force tool. Choose Tools > Particles > pTurbulence. Connect the new tool in-between the pEmitter tool and the pRender tool (force tools are always connected downstream from the pEmitter tool). Set the pTurbulence tool's XYZ Strength parameters to 0.7. Play back from the first frame. The particles take on random motion with wiggles and random changes in direction. The turbulent noise causes the particles to move further away from the actor. To offset this, return to the pEmitter Region tab and change the Width to a more narrow 0.1 and Height to a shorter 0.3. Experiment with different locations of the pEmitter by interactively moving the emitter box in the Display view. Experiment with different Turbulence noise variations by clicking the tool's Reseed button and replaying from frame 1. Each seed number creates a slightly different underlying noise pattern.

29. As a final touch, we can create stylistic motion trails behind the moving particles. Choose Tools > Effect > Trails. Insert the Trails tool between the pRender tool and the Merge3 tool. Select the Trails tool and set the tool's Blur Size parameter to 8 and Apply Mode to Screen. The Trails tool layers together multiple frames from the input to create motion trails. In this case, older and older iterations received heavier blurs. Select the pEmitter tool. In the Controls tab, raise Number to 15 and Lifespan to 5. This creates more particles but "kills" them sooner. Even after the death of a particle, the motion trail created by the Trails tool slowly fades off. Note that each time you make a change to parameters within the particle portion of the network, the Trails tool must be reset. You can do this by returning to the first frame of the time ruler and clicking the Trails tool's Restart button.

30. As a final adjustment, we can fine tune the colors of the particles and motion trails. Choose Tools > Color > Hue Curves. Insert the new tool between the Trails tool and the Merge3 tool. Connect the new Hue Curves tool, HueCurves2, to a Display view. Deselect the Sat checkbox. Select the Lum checkbox and pull up the red point at the far right (that is connected to the point on the far left). See Figure F.8. This increases the intensity of the red highlights. Select the Red Suppress checkbox and pull the red point downwards to reduce the amount of red, which leads to a slightly more lavender color (Figure F.9).

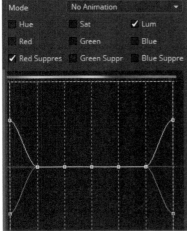

Figure F.8 Adjusted Lum curve (white) and Red Suppress curve (light red) of the HueCurves2 tool.

Figure F.9 Particle motion trails created with the Trails tool and color-corrected with the HueCurves2 tool.

The tutorial is complete! If you've disabled any tools, re-enable them. Activate the HiQ button in the TimeView to see the final quality. Play back the time ruler. Make any adjustments that you feel would improve the final result. The final tool network is illustrated by Figure F.11. Figure F.10 shows my result on frame 9. A finished version of this tutorial is saved as `\ProjectFiles\FusionFiles\FinalTutorial\Cover.comp`.

Figure F.10 Final composite. The particle trails are easy to distinguish when the time ruler is played back.

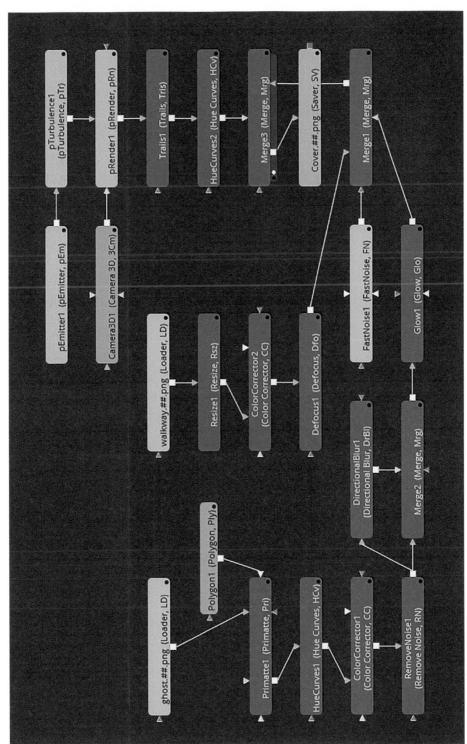

Figure F.11 Final tool network for this tutorial.

Appendix A: Additional 3D Tools and Techniques

Fusion 3D environment is quite vast with a large number of tools and techniques. Hence, this appendix covers additional 3D tools that were not covered in Chapter 9. Unless otherwise noted, the tools are located in the Tools > 3D menu.

Custom Vertex 3D

The Custom Vertex 3D tool allows you to manipulate geometry vertices using mathematical expressions. You can modify such qualities as vertex positions, vertex colors, normal angles, and UV coordinate values. As an example, in Figure A.1 and A.2 the UV layout of a plane's texture is rotated. The Custom Vertex 3D tool is inserted between the Shape 3D tool and the Merge 3D tool. The Custom Vertex 3D tool's U TexCoord Expression field is changed to `1-tu` and the V TexCoord Expression is changed to `1-tv`. This inverts the UV coordinate values along the U and V direction. Ultimately, this rotates the assigned texture, a Text+ tool's *hello*, by 180 degrees.

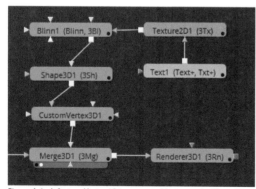

Figure A.1 A Custom Vertex 3D is connected between the Shape 3D toot and the Merge 3D tool.

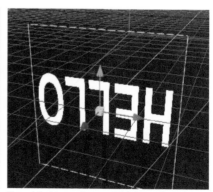

Figure A.2 A texture is rotated 180 degrees by updating the U and V TexCoord Expression fields. This project is saved as `\ProjectFiles\Fusion-Files\AppendixA\CustomVertex.comp`.

228

Locator 3D

The Locator 3D tool generates a **null**, which is a location in space represented by an axis handle (Figure A.3). Locators are not rendered by the Renderer 3D tool. Locators carry their own set of transforms, which you can animate. You can connect these transform parameters to similar parameters carried by geometry, light, or camera tools via expressions or linking and thus make the locater the parent in a parent / child hierarchy. To see the locator, you must connect it to a Merge 3D tool.

Figure A.3 A locator.

Point Cloud 3D

The Point Cloud 3D tool displays a point cloud by placing locators in 3D space. A **Point cloud** is a large array of location coordinates in 3D space. Such clouds may be generated by other 3D programs through the process of modeling or 3D scanning. Point clouds are also generated by 3D motion tracking software. You can use a point cloud inside Fusion as a reference. For example, a point cloud may represent the locations of floors and walls of a real-life location that has been scanned and processed by 3D scanning software. The Point Cloud 3D tool accepts point cloud data through its SceneInput input. The tool accepts data from imported Maya `.ma`, 3DS Max `.ase`, LightWave `.lws`, or SoftImage XSI `.xsi` files.

Image Plane 3D

The Image Plane 3D tool creates a primitive plane that you can transform in the scene. You can connect an image to its MaterialInput. For example, you can connect an image sequence or a bitmap image via a material and texture tool and use the result as a reference while animating or modeling within the 3D environment (Figures A.4 and A.5). If you connect an image sequence, the proper frame is shown in the Display view as you play back the time ruler. If you prefer that the image plane follows a camera, use expressions or linking to connect the camera's transform parameters to the image plane's matching parameters.

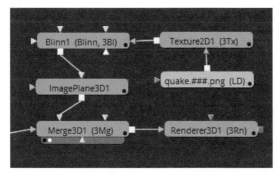

Figure A.4 An Image Plane 3D tool is connected to the Merge 3D tool. It's given an image sequence texture via material and texture tools.

Figure A.5 An image plane displays an image sequence in the 3D environment. This project is saved as `\ProjectFiles\FusionFiles\AppendixA\ImagePlane.comp`.

FBX Exporter 3D

The FBX Exporter 3D tool exports a Fusion 3D scene into a FBX, `.3ds`, `.dae`, DXF, or OBJ file. Fusion cameras, lights, and geometry tools are exported. You can connect a Merge 3D tool output to the FBX Exporter 3D tool's 3D Data input. To export the scene, select the FBX Exporter 3D tool and click the green Render button in the TimeView.

Ribbon 3D

The Ribbon 3D tool produces a line between two points in space (Figure A.6). You can connect materials and textures to the Ribbon 3D tool. However, you must use the OpenGL Renderer via the Renderer 3D tool to see a rendered result. The lines are affected by 3D lights and shadows. When you connect the tool to a Merge 3D tool, two handles appear in the 3D view that you can use to position the start and end of the line. The tool's parameters allow you to generate multiple, parallel lines and adjust the line thickness, width, and subdivision level. The tool is designed to create stylistic effects for motion graphics tasks.

Figure A.6 Three parallel lines are created with the Ribbon 3D tool. This project is saved as `\ProjectFiles\FusionFiles\AppendixA\Ribbon.comp`.

Projecting Textures from a 3D Camera

The Camera 3D tool is able to project a texture when the Enable Camera Projection check-box, in the camera's Projection tab, is selected. The projection is picked up by geometry and is visible in the 3D view when the Display view's Light button is selected. The Renderer 3D tool renders the result so long as its Enable Lighting checkbox is selected. (Note that the Image Plane tool will capture the image connected to the camera even when the Enable Camera Projection checkbox is deselected.) If geometry receiving the texture undergoes transformations, the texture will "slide." You can avoid this by adding the desired animation to a Transform 3D tool and connecting it in-between the Merge 3D tool and Renderer 3D tool. (For more information on the Transform 3D tool, see Chapter 9.)

Projector 3D

The Projector 3D tool serves as a variant of a spot light that projects a texture onto geometry (Figure A.7). You can connect the output of the tool to a Merge 3D tool. You can connect an image or image sequence to the tool's Projective Image input. To see the result, lighting must be activated.

The Projector 3D tool has three projection modes, as set by the buttons with the same names: Light, Ambient Light, and Texture. The Light mode treats the texture as if it is colored light; with this mode, the normal shading associated with lights is maintained. The Ambient Light mode ignores shading and projects the texture onto the surface with its full intensity. The Texture mode is designed for the Catcher tool (see the next section).

The projection has the same limitations as a projection created by a Camera 3D camera. However, you are free to move, rotate, and scale the Projector 3D tool. If multiple projections exist in a scene, you will receive the net lighting from all the projectors.

Figure A.7 A Projector 3D tool, selected, projects a texture onto a Shape 3D sphere. The Projection Mode is set to Ambient Light. This project is saved as `\ProjectFiles\FusionFiles\AppendixA\Projector.comp`.

Catcher

Located in the Tools > 3D > Texture menu, the Catcher tool captures a projected texture and converts it to a 2D space. To apply this tool, follow these steps:

1. Set the Projector 3D or Camera 3D tool's Projection Mode parameter to Texture.
2. Connect a Catcher tool to a material input of a material tool, such as a Blinn or Phong.
3. Connect the output of the material tool to the material input of the geometry tool receiving the projection. An example network is included with the tutorial files as `\ProjectFiles\FusionFiles\AppendixA\Catcher.comp`.

With these steps, the Catcher captures the projected texture and applies it to the material as if it was a 2D texture. The Catcher does not require lighting to function. In addition, the tool is not limited to diffuse color and can be connected to the specular inputs of a material tool. The Catcher tool understands alpha transparency if it's present in the projected image.

SoftClip

The SoftClip tool fades out geometry and particles as they approach the 3D camera. You can connect this tool in-between the Merge 3D tool and the Renderer 3D tool. The tool's Opaque Distance and Transparent Distance parameters set the area of the fade.

Fog 3D

The Fog3D tool places a virtual fog in the 3D scene. You can connect the Fog 3D tool in-between the Merge 3D tool and the Renderer 3D tool. if you display the output of the Renderer 3D tool, the fog is visible over the top of geometry. In fact, the fog-like look is created by adjusting the texture quality of the geometry surfaces. The fog does not appear over empty space in the 3D scene. The placement of the fog is controlled by the Near Fog Dist (Distance) and Far Fog Dist (Distance) parameters. You can change the fog color through the Fog Color section.

Appendix B: After Effects to Fusion Chart

Transitioning from a layer-based compositor to a node-based compositing program can be a little confusing at first. Hence, I've included a chart to help you move from Adobe After Effects, the most widely used compositing program in the world, to Blackmagic Design Fusion.

TASK	AFTER EFFECTS	FUSION
Combining images	The highest layer in the layer outline occludes lower layers except where there is alpha transparency.	Foreground input of Merge tool occludes Background input except here there is alpha transparency.
Premultiplying	When importing footage with alpha, you can interpret the footage as premultiplied or unpremultiplied through the Interpret Footage window.	Premultiplied footage is correctly interpreted on import. You can also premultiply unpremultiplied footage by selecting the Loader tool's Post-Multiply By Alpha checkbox.
Choosing an image-blending mode	Change layer's Blending Mode menu.	Change Merge tool's Apply Mode, which affects the Foreground input.

TASK	AFTER EFFECTS	FUSION
Viewing compositions	Double-click the composition name in the Project tab or click the composition tab in the timeline.	Select the tool you wish to view and press the 1 or 2 key to connect the tool to the Left or Right Display view.
Reloading missing footage	RMB-click over footage name in Project tab and choose Replace Footage.	Browse for new footage via the Loader tool's Filename browse button. You can also manually update the file path by editing the `.comp` text file.
Adding filters	With a layer selected, choose Effect > *effect name*.	Add an effect tool via the Tools menu and connect the tool you want to filter to the effect tool's input.
Creating a mask	Select a layer and use the Pen tool to draw a mask. The mask is functional as soon as it is closed and affects the selected layer.	Draw a mask using one of the mask tools, such as Polygon (Tools > Mask). The mask is only functional when the mask tool's output is connected to the Effect Mask input of another tool.
Chroma keying	Apply the Keylight effect (Effect > Keying), which is the program's most advanced built-in keyer.	Add a Primatte tool (Tools > Matte), which is the program's most advanced built-in keyer.
Motion tracking	Apply the Tracker (Animation > Track Motion).	Add the Tracker tool (Tools > Tracking).
Time warping	There are several methods but the easiest way to apply warping is to choose Layer > Time >Time Stretch and enter a Stretch Factor value.	There are several methods but the easiest way to apply warping is to choose Tools > Miscellaneous > Time Speed and alter the new tool's Speed parameter.
Rendering	Add a composition to the Render Queue, switch to the queue tab, set the output, and click the Render button.	Create a Saver tool (Tools > I/O). Connect the tool you wish to render to the Saver's input. Click the TimeView's Render button. Set the render quality in the Render Settings window and click OK.

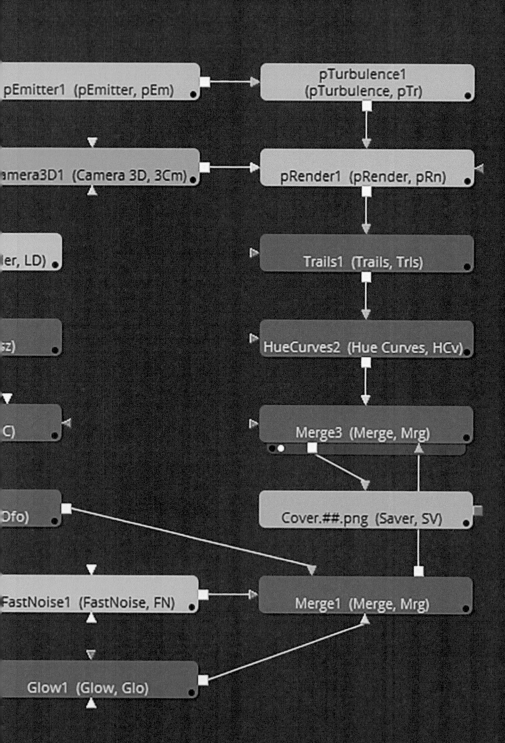

Index

.abc file 180
.ase file 181, 229
.comp file 3
.lws file 181, 229
.ma file 181, 229
.plug–in file 214
.setting file 210
.xsi file 229
0–to–1: channels 54; hue 27; motion tracking 69; Transform tool 60
1–to–1: expressions 212; linking 213
3D camera tracking 67
3D Histogram 27
3DS file 181
8–bit: footage 18; linear color space 20; project settings 4
16–bit: footage 18; linear color space 20; project settings 4
32–bit: footage 18; linear color space 20; motion vectors 53; project settings 4

A

Absolute Rotation parameter 184
Adaptive Mode section 75
Add (Burn) parameter option 126
Add Slave menu option 207
Additive Bias parameter 179
additive color 18
Adjust Lighting parameter 153
Alembic format 180
Alembic Mesh 3D tool 179–180
aliasing 134
alpha: Apply Modes 40–41; auxiliary channels 17; bitmap mask 102; channel 5, 16; Color Curves tool 31; layer- and node-based 38; luma mask 103; LUT Editor 22; masking 98–99; premultiplying 42; Tracker 74–75
Alpha Detail parameter 173
Alpha Divide parameter 42, 127
alpha matte: filter tools122, 127–128; improving 157; keyer tools 148; Luma Keyer tool 156; luma mask 104; Mask Paint tool 105, 107; masking 98; matte edge 102; Primatte 149, 151, 154; sampled values 109–110
Alpha Multiply tool 127
alpha operators 41
Always Face Camera parameter 183
Ambient Light tool 178
ambient occlusion (AO) 45–47
Amount parameter: Bender tool 169; Erode / Dilate tool 127; Sharpen tool 123;
Amplitude parameter: Drip tool 133; Pseudo Color tool 138
Anaglyph tool 215
Angle parameter: Displace tool 132; Highlight tool 125; Mask Paint tool 107; Merge tool 39; motion blur 65; Offset Angle modifier 211; Replace Normals 3D 171; Vortex tool 133; Wire Removal tool 197
Angle Of View parameters 166
Animate menu option: mask 158; parameters 82; stroke 113–114; stroke points 198; Transform tool 66;
animation curve(s) 82
animation spline(s): expressions 213; FBX format 180; keyframing 82–83; Mask Paint tool 113; Spline view 3, 85–86; Time Stretcher tool 130–132; Timeline view 84; transformations 66
anti–aliasing 12
AO *See* ambient occlusion (AO).
aperture: Defocus tool 124; Lens Distort tool 127
Apply Controls section: Clone Multistroke tool 112; Mask Paint tool 107–108; Paint tool 195
Apply Mode menu: filter tools 126; glow 57; Mask Paint tool 108; Merge tool 38, 40–41; Multistroke tool 112; Paint tool 195–196; render passes 47–48 Wire Removal tool 197, 201
APrx (Auto Proxy) button 13
artifacts *See* camera artifacts.
Aspect parameter: Drip tool 133; Hot Spot tool 126

aspect ratio: letterboxing 64; Transform tool parameter 60

Atop menu option 41

Attenuation section 172–173

Auto Compute button 148–149, 153, 158

Auto Domain tool 125, 216

auxiliary channels: channel values 54; Loader tool 17; optical flow 130; render passes 44; stereoscopic 215; Vector Distortion tool 134; Z–depth 49–50

B

background (chroma keying) 148–152

Background input: Apply Modes 41; Background tool 61, 87, 93–94, 118, 139; Channel Booleans 103–104; Depth Blur 49–51; Displace tool 132, 143–144; Matte Control tool 127–128; Merge tool 38–40, 43, 47–48, 55–56, 116; premultiplication 42

Background Material input 173, 177, 187

beauty pass: depth–of–field 52; render pass 17, 44–46; Software Renderer 167

Bender 3D tool 169–170

Best Match button 75

Bi–Linear option 77

bins 208–209

bisecting 83

Bit–depth 15, 18, 24, 26, 30, 167

Bitmap: 3D shadows 172; color space 18; images 7; Mask Paint tool 107; masking 98; particles 182; paths 8; region shape 185; rendering 207; shadow map 179; SphereMap tool 177; Texture 2D tool 175; textures 174; tracking 72; VariBlur input 123

Bitmap tool 102–103

Blend parameter: Blur tool 122; FastNoise tool 194; frame interpolation 129, 132; Glow tool 124; Material Merge tool 173; Merge tool 43; tutorial example 47, 57, 136–137;

blending modes See Apply Mode menu.

Blinn material 171, 173–175, 177, 187

Blob particle 182

Bloom Level parameter 124

Blur Size parameter: aliasing 134; animation spline 84; Blur tool 122; Depth Blur tool 49–50; expression 212; image sequence 187; TV tool 195; VariBlur tool 123

Blur tool: aliasing 134; animation spline 84; channel example 16; network example 5; tool description 122; tutorial example 56–57, 144, 187

bokeh 124

Border Width parameter 102, 117

Box filter 124

brightness See intensity.

Brightness / Contrast tool 25–27

Brush Controls section: Polyline Stroke: 106; Wire Removal tool 197, 201

Brush Shape buttons: Mask Paint tool 106–107; Paint tool 195

BSpline tool 98–100, 102, 111

Bumpmap parameter 174

BumpMap tool 174–175

Burn In parameter 43

Burnt option 155

C

Calculation modifier 211

Camera 3D: 3D lights 178; basic 3D 164; basic particles 181; controlling 165; importing cameras 180–181; rendering 166; tutorial example 167–168, 188–189

camera artifacts 124, 192

Camera Settings section 127

Camera Shake tool 64–65

Canvas button 40

Catcher tool 231

Catmoll–Rom filter 62

Center Bias parameter 65

Center XY parameter: Merge tool 39; stroke animation 197, 202; Transform tool 60; tutorial example 56, 87–88, 92, 141

Center XYZ parameter 176

Centered parameter 122

Change Depth tool 23

channel bars 74

Channel Boolean tool 123, 173–174

Channel Booleans tool: depth–of–field 49–50; motion vectors 53; tutorial example 48, 103–104

channel curve 31–32, 34

channels: alpha 98; apply modes 40; auxiliary 17; deep 54; depth 52; histogram 26; noise 192; numeric values 54; Renderer 3D tool 167; RGBA 22; saturation 27; tool output 5; tracking 74–75, 110; vector 134; working with 16; XY Paths 85, 91

checkerboard 16, 60, 183
Chroma keyer tool 154
chroma keying: description 148; tutorial example:
 157–161
Chroma parameter 192, 199
chromaticity chart 18–19
Cineon file 195
Cineon Log tool 195
Circle option 124
Circle tool 105, 112
Clean Background Noise button 149
Clean Foreground Noise button 149, 153
clean plate 156
Click Append tool 100–101
clipping mode 125
Clips folder 209
Clone apply mode 108, 195
Clone MultiStroke tool 105, 107, 112, 196
Close menu option 4
closed (mask) 99
Close The Polyline tool 100–101
CMYK 18
Color Burn apply mode 41
Color button 16, 19, 54, 104, 149, 215
color channels See channels.
Color Corrector tool: description 24–25, 27;
 tutorial example 28–32
Color Curves tool 28, 30–35, 56–57
Color Detail parameter 173
color filters 23–24
Color Gain tool 24
color grading: color tools 122; description 24;
 LUT (Look-Up Table) 22; tutorial example
 28–35, 115–116; value distribution 26
Color menu 24
color models 18
Color Scale tab 125
color space: Cineon tools 195; converting 19;
 description 18–19; footage 18–22;
 gamma 21; Gamut tool 22; linear 20–21;
 project settings 4; Reneder 3D tool 167
Color Space Type parameter 18
color wheel: Color Corrector tool 27–28; Primatte
 tool 154
Combine Operation (Combine Op) parameter
 127–128, 144
Comments tab 210
Common Controls tab 65, 127
Complexity parameter 193
cone (Shape 3D) 167
Cone Angle parameter 178

Connect To menu option 76–77, 213
connection line 5–6
Console view 2–3, 213–214
contrast: description 25; parameter 26; saturation
 27
control points See points.
Convergence parameter 216
convolution matrix filter 122, 138–139
CookTorrance material 173
Coordinate Space tool 134
Copy Ellipse / Polyline / Rectangle tool 105–106,
 196
Copy Metadata tool 217
Copy Points menu option 91
Corner Positioner tool 132
Corner Positioning button 77–78
Corner–pin tracking: description 67; tutorial
 example 77
Create Bump Map tool 139, 174
Create Macro menu 210
Crop tool: description 64; Primatte 154; tutorial
 example 91, 94, 117, 119, 140
Cross Fade mode 197
Cube 3D tool 164, 166–167, 169
CubeMap texture 177
Cubic: filter 62; tangent 90
cubic cross 177
Curves 30–35, 53, 56–57, 98, 114–117, 125–126,
 132, 163, 180
Custom Filter tool 138–139
Custom Vertex 3D tool 328
cylinder (Shape 3D) 167, 170

D

Dampening parameter 133
Darken apply mode 41
DaySky tool: description 139; tutorial example
 103–104
DCP color space 20
deep image 54
deep pixel: description 54; menu 49, 52
Defocus parameter 123
Defocus Size parameter 10, 124
Defocus tool: description 124; tutorial example 7,
 9–10
deinterlacing 217
Delay parameter 129
Delete Points tool 100–101
Density parameter 179
Dent tool 133

depth *See* Z-depth.
Depth Blur tool 49-52
Depth of Field parameter 51
depth-of-field: description 45; Z-depth 49-51
Destination button 136
destination grid 137
Detail parameter 154
Difference Keyer tool 156
diffuse: channel 17; render pass 44, 47-48
Diffuse Color Material input 176
Diffuse Color parameter 171, 174
direction lines *See* tangent handles.
Directional Blur tool 122-123
Directional Light tool: description 178; imported 180; tutorial example 169
dirt 192
disparity map 215-216
Disparity tool 215
Displace 3D tool 170
Displace tool 132-133
displacement splines 85, 114
Display views: connecting to 6; description 2; reconnecting to 10
distortion, 20, 63, 71, 122, 126-127, 132-134, 136, 143-145, 169-170, 194
distressing 192
Do Wireframe parameter 170
domain of definition (domain) 125, 216
Domain parameter 125
Done tool 100-101
DPX file 195
Draw Append tool 100-101
Drip tool 133-134
Dropout 192
Dropoff parameter 178
Duplicate 3D tool 169-170
Duplicate button 60
Duplicate tool 138
dust 192
DVE tool 63
DXF file 181

E

ease in / ease out 90
Ease menu 90
Edge Blend mode 197, 202
edge detection 138-139
Edit Macro menu option 210

Effect Mask input: Alpha Divide 127; combining

masks 109; description 5; garbage matte 129; Glow tool 124; Mask Paint tool 107; masking 98-99, 102, 105; Primatte 154 Roto Assist 115; tutorial example 103-104, 116, 118, 144-145; value mask 109-110
Ellipse tool 98-99, 102
Emboss apply mode 108
emboss filter 139
Emboss Over option 138
Enable Lighting parameter 166, 169, 178
Enable Shadows parameter 166, 179
environment textures 177
Erase apply mode 108, 195-196
Erode / Dilate tool 127, 157
Every Frame option 75
Expression modifier 211
expressions 212
Extrusion section 167, 169
Eye Separation parameter 216

F

faceting 171
Falloff parameter 178, 185
Falloff texture 175
FastNoise Texture tool 175-176
FastNoise tool: demonstration 40; description 140; noise 194; resolution 61
Favorites folder 208-209
FBX Exporter 3D tool 230
FBX file 180
FBX Mesh 3D tool: demonstration 174, 176; description 180-181
FG Over BG button 72
field of view *See* focal length.
fields *See* forces.
fields (interlacing) 217
Fields tool 217
fill light 178
film gate 127
film grain 192
Film Grain tool 193
Filter Method menu 62
Filter tool 138
filter tools (category) 122
Find tool 207
fish eye lens 166
Fit button 9
Flat menu option 86
Flip Horizontally / Vertically parameters 61

flipbooks 70, 74
Float16 / Float32 options 18, 20
Floating-point: 3D Histogram 27; description 4;
 Loader tool 18; tutorial example 20
Flow view 2–3, 5–6, 209
flying logo 167, 187
focal length: Lens Distort tool 127; motion
 tracking 63, 73
Focal Length parameter 166
focus 49
Fog 3D tool 231
Fog tool 52
footage xiii
forces 183, 185
foreground (chroma keying) 148–152
Foreground input: depth–of–field 49; masking 99;
 Merge tool 5, 38–43; Tracker tool 72–73;
 tutorial example 46–48, 55–56, 78, 87,
 93, 103
Foreground Material input 173
fps (frames-per-second) 10
Frame Format section 4
Frame Rate parameter 4, 7, 10, 129
frame resolution 60–64, 69, 87
freeze frame: Loader tool 12; Time Stretcher tool
 130, 132; tutorial example 141, 143
Fringe Gamma parameter 155
frustum 166
Full Render menu 4
fuses 214
Fusion Studio 130, 132, 150, 153–154, 207–208,
 215
FusionScript 213

G

Gain parameter: Color Corrector tool 24–25;
 28–29, 31; Soft Glow tool 125; Unsharp
 Mask tool 124
gamma 21
Gamma parameter 128
gamut 18
Gamut tool 20–21
garbage matte 129
Garbage Matte input 129, 151, 157
Gaussian Blur button 10
Gaussian Blur filter 62
Gaussian option 102, 124
ghosting 192, 194
Global In / Out parameters 8, 12
Global Start Time / Global End Time: time ruler

ranges 11; tutorial example 8
glow (custom effect) 56–57
Glow tool 124
gradient: Curves tool 32–34; DaySky tool 103
Gradient Color modifier 211
Gradient tool 175–176
grain 192–193
Grain menu option 138
Grain Size / Softness / Spacing parameters 193
Grain tool 193
green screen: description 148; Difference Keyer
 tool 156; Primatte tool 148; tutorial
 example 157–161; Ultra Keyer tool 155
grid (Flow view) 6, 210
grid points 134, 136
Grid Size parameter 134, 136
Grid Warp tool 134–137
Group tool 209

H

HDTV (High-Definition Television) 19
Heightmap parameter 174
Height parameter: Letterbox tool 62; masking
 105; Resize tool 63; resolution 4
Highlight 24–25, 28, 30, 34, 44, 48, 109–110,
 124–126, 158, 171–172, 174
Hilight parameter 124
HiQ (High Quality) button 11–12, 62, 122
histogram: description 25; displaying 26–29
Hold First Frame / Hold Last Frame parameters 12
hot spot 126, 171
Hot Spot tool 126
HSV (Hue Saturation Value) 19–20
hue: Color Corrector tool 27–28; description 19;
 HSV 20
Hue apply mode 41
Hue Curves tool 32–35, 115–117
Hybrid Rendering 153

I

ico (Shape 3D) 167
Image Plane 3D tool 329
image sequences 7–8, 12, 16
Import menu option 180, 207
input / output stubs 5–6
inputs 2, 5
Insert And Modify tool 100–101
integer 4
intensity: pixel 16; saturation 19

Intensity parameters 178
interlacing 191–192, 194, 217
Invert Garbage Matte parameter 129, 151, 157
Invert Matte parameter 129

J

judder 129

K

kernel 139
key (animation) *See* keyframes.
key (chroma) 148
key light 178
key poses 83
keyframes: approaches to creating 82; description 82; motion tracking 72, 74; parameters 82; rotoscoping 112–114; setting 66; Spline view 85–86, 90–91; Timeline view 84; time warping 130–131; tutorial examples 86–87, 92–94, 116, 136
keyframing *See* keyframes.

L

Lanczos filter 62
Laplacian filter 138
layer–based compositing 38
left / right eye 215
Lens Aberration parameter 126
Lens Distort tool 127
lens flare 126–127, 192
lens shift 127
Lens Type parameter 124
Letterbox tool 63
letterboxing 63
Lift parameter 24–25
Light Angle parameter 132
Light Power parameter 132
Light Trim tool 195
Lighten apply mode 41
Lin To Log button 195
linear color space 20–22, 195
Linear filter 62
Linear tangents 86
linking: description 213; motion tracking data 76
live–action xiii
Loader tool: auxiliary channels 17; color space 18; demonstrated 5; description 6–7; gamma 21; time ranges 12; tutorial

example 7–10, 20
Lock Color Picking parameter 153
Look–Up Table (LUT) 22
Lua scripting 212–214
luma: description 27; tutorial example 103
Luma Keyer tool 155–156
luma mask 103–104
luminance: description 27; hue 41; motion tracking 74
LUT button 22
LUT Editor 22–23

M

macros 210
Magnet Strength parameter 134
main toolbar 3, 208
Make Double Poly tool 100–101
Make Editable button 113, 198
Make Points Follow tool 100–101
Mandlebrot tool 140
mapped drive 207
Mapping Type section 77
mask: adding 98; bitmap 102–103; description 98; luma 103–104; Mask Paint 105–109; Polygon and BSpline 99–101; sampled values 109–110
Mask menu 98
Mask Paint tool 105–108, 112–115
masking *See* mask.
master machine 207
Match Move button 71–72
Match Tolerance parameter 75
Material Merge tool 173
MaterialInput input 173–174, 176, 187
materials: descriptions 171–173; tutorial example 187–188
Matrix Size menu 139
matte: render pass 45; *See also* alpha matte.
Matte Blur parameters 129, 151, 156
Matte Contrast parameter 156
matte edge: combined matte 129; polyline 102; Primatte 150–152
Matte Expand / Contract parameter 128
Matte Gamma parameter 128
matte painting 55, 63, 91, 93–94, 135, 140, 142
Maya IFF file 17
MB (Motion Blur) button 11, 13
Merge 3D tool: description 164; tutorial example 167–169
Merge Over parameter 126

Merge tool: apply modes 40–41; chaining together 42; demonstration 38; premultiplication 42; transforming 39–40; tutorial example 46–48, 54–56
merging See Merge tool.
MeshInput input 185–186
metadata 217
midtone ranges 24–25
Midtones button 28–29
Mirror button 60
Mitchell filter 62
modifiers: description 211–212; strokes 196
Modifiers tab 3, 196
Modify Only tool 100–101
Modify With menu 85, 87, 211
morphing 135
motion blur: activating 65; motion tracking 73; motion vector 52–53; render pass 45
motion graphics 137
motion path: Display view 66, 85; imported camera 180; motion tracking 68–75; Onion Skin 114–115; points 114; tutorial example 87–88
motion vector: optical flow 130; render pass 52–53, 134
Multibox button 123–124
Multiframe menu 100–101
Multiplicative Bias parameter 179
Multiply apply mode 41
MultiStroke tool 105, 107–108, 112

N

Navigator window 210
Nearest Neighbor filter 62
Negative menu option 48–49
NGon options: Defocus tool 124; particles 182, 189
nodes See tools.
noise 192–194
Noise Threshold parameter 197
normal (polygon): auxiliary channel 167; description 171
Normal apply mode 40–41, 126
normal map 139, 174
Number Of Points parameter 125, 182

O

OBJ file 181
Offset Angle / Offset Distance modifiers 211

Onion Skin tool 100–101, 114–115
Opacity parameters 107, 171
Open GL Renderer 166
Open GL UV Renderer 166
Open menu option 3
OpenEXR file 17, 49–50, 130, 134, 215
Operation menu: Channel Booleans tool 48; Dissolve tool 138
Operation tab 69–71
optical flow 130
Orthogonal Pipes menu option 210
outputs: connecting with 5–6; description 2
Override 3D tool 170

P

paint fixes 196
Paint Group tool 105
Paint tool 195–196
parameters: description 3; keyframing 82–83
participating media 124–125, 127
particles 181–189, 192
Paste Points/Value menu option 91
pattern window 67–71, 74–75, 78
pAvoid tool 184–185
pBounce tool 186
pChangeStyle tool 186
pCustomForce tool 184
pDirectional Force tool 184–186
pEmitter tool 181–184, 186, 188–189
Penumbra Angle parameter 178
Perspective camera 165
Perspective Positioner 132
Perturb modifier 211–212
pFlock tool 184–185
pFriction tool 184
pGradient Force tool 184
Phase parameters 133, 138
Phong material 171, 173
pick whip 212
pImageEmitter tool 187
Ping–Pong parameter 91
pipe See connection line.
Pivot XY parameter 61, 85
Pixel Aspect XY 64
pixel averaging 62
pKill tool 186
Plasma tool: demonstration 63; description 140
plate xiii
playback controls 10
playback quality 12–13

playback speed 11–12
plug-ins 213
Point Cloud 3D tool 329
Point Cluster particle 182
Point Light tool 178
points: Color Curves tool 30; Hue Curves tool 33–34; masking 98–118; motion path 66; motion tracking 67; splines 89–90
Polygon tool 99–101, 113–114
Polyline Stroke tool 105–106, 112
Post-Multiply By Alpha parameter 42
pPoint Force tool 184–185
Preferences window 4
pRender tool 181–183, 185–186, 188–189
Preview Render 4
Primatte RT mode 152
Primatte RT+ mode 152
Primatte tool 147–148, 150–154, 157–160
procedural tools 139
Projector 3D tool 230
Prx (Proxy) button 10, 13
PSD file 175
Pseudo Color tool: description 138; tutorial example 143–144
pSpawn tool 186
pTangent Force tool 184
pTurbulence tool 184
Publish Menu 100–101, 114
Publish Points menu option 114
Publish To Path / XY Path menu options 114
pVortex tool 184–185
Python scripting 213–214

Q

Quad View menu option 165
Quadratic: decay 178; filter 62
QuickTime movie 7, 206

R

Radial option 122
Radius parameters 112, 167
Randomness 64, 183–184, 193
range graph 109
Rank Filter tool 139
Rays tool 127
re-analyze 69–70
re-track 74
Rectangle tool 98–99
Reduce Points: animation splines: 89–90; stroke

tool 100–101
Reference Intermediate Points parameter 71
Reflect tool: description 173; tutorial example 187–188
Reflection Color Material input 173, 177, 187
reflectivity (render pass) 45
Region Mode menu: forces 185; pEmitter tool 184, 186
Region tab 184–185
Relief option 138
Remove Key menu option 82, 111
Remove Noise tool: description 192–193; tutorial example 198–200
Render Manager window 207
render passes: advantages 46; description 44–45; recombining example 46–48
Render Settings window 11–12, 206–207
Render Start Time / Render End Time fields 8, 11, 206
Renderer 3D tool: basic set-up 164; description 166–167; tutorial example 167–168
rendering: preview 11; to disk 206
repairing 192
Replace Material 3D tool: description: 173 tutorial example 187
Replace Normals 3D tool 171
Reset button 154
Resize tool 62–63
resolution: frame 61; project settings 4; scale tools 62–64
Restart buttons 181, 195
Restore Detail button: description 151; tutorial example 160
RGBA 16
Ribbon 3D tool 230
Right-Click Here For Shape Animation option 111, 113, 198
Rotation Relative To Motion parameter 184
Rotation XYZ parameters 183
Roto Assistant tool 100–101
rotoscoping: application 111–114; description 111; tutorial example 114–117
rubber band 77
Run Command tool 217

S

Sample Spread parameter 65
saturation: description 19; HSV 20
Saturation parameter 27, 137
Save / Save As menu options 3

Saver tool 205–206

Scale parameter: 3D tool 169; Merge 3D tool 164; Shape 3D tool 167; Vector Distortion tool 134; Vector Motion Blur tool 53

scanline 194, 217

SceneInput input: Displace 3D tool 170; Merge 3D tool 164; Replace Material 3D tool 173; tutorial example 167, 169

scratches 192

Screen apply mode 41

SDTV (Standard-Definition Television) 19, 192

Seethe / Seethe Rate parameters 143, 194

Select All Points tool 100–101

Select Background Color button 153

Selected Tracker Details section 69

Selective Update button 13

Set Domain tool 125, 216

Set Key menu option 84, 111, 141

Set Loop menu 91

Set Metadata tool 217

Set Viewer Scale menu button 9, 62

shaders See materials.

shadow: Ranges tool 109; render pass 44; tones 24, 27; See also Enable Shadows parameter.

Shadow Color parameter 179

Shadow Map Proxy parameter 179

Shadow Map Size parameter 179

Shake modifier 212

Shape 3D tool: demonstration 169–170, 172, 177; description 167

Shape Box tool 100–101

sharpen filter 139

Sharpen tool 123–124

shot xiii

Show All Handles tool 100–101

Show Key Points tool 100–101

Show Navigator menu option 210

Shutter Angle parameter 65

SimpleExpressions See expressions.

Sinc filter 62

slave machines 207

Smear apply mode 108

Smooth menu option 86

Smoothing Angle parameter 171

Sobel menu option 138

SoftClip tool 231

Soft Edge parameters 102, 110

Soft Glow tool 125

Soft Light apply mode 41

Soft Reset button 154

Soften button 50, 123

Softness Chroma parameter 199

Softness Luma parameter 199

Softness parameter 106

Softness Red / Green / Blue parameters 199

Software Renderer menu option 166–167

Solarize button 124

source grid 136

Source Time parameter 131–132, 141

Source Time spline 130

Spacing parameter 107

Specular Color parameter 171, 174

Specular Exponent parameter 172

specular highlight 44, 48, 171–172, 174

Specular Intensity parameter 172, 174

specularity See specular highlight.

Speed parameter 64

speeding up / speeding down See time warping.

SphereMap texture 177

Spill Method buttons 155

Spill Sponge button 150, 159–160

Spin XYZ 183

spline (animation) See animation spline.

spline (masking) See BSpline tool.

spline span 99

Spline view 3, 84–86

Spot Light tool 172, 178–179

sRGB color space 18–19, 21

Stacked Image menu option 215

Stamp apply mode 108

Steady Axis / Steady Angle menu options 76

Step In / Step Out menu options 86

Stop Tracking button 68, 75

Strength parameter: Camera Shake tool 63; Color Corrector tool 27; Dent tool 133; particle force tools 184

stroke: apply modes 108; editing 198; Mask Paint 107; Multistroke 107; Paint tool 195–196; rotoscoping 112–113; wire removal 197, 200–201

Stroke Animation menu 112–113, 196, 201

Stroke Duration parameter 112, 196

stubs See input / output stubs.

stylistic effects 122

sub-particles 182, 186

sub-styles 186

Subdivision Level parameter: 3D geometry 167, 169; Grid Warp tool 134

Subtract 126, 128, 144

Subtractive / Additive parameter 42–43, 108

SubV (Subview) button and menu 26–28, 217

sun glitter 125
Super Soften button 50

T

tangent handles: animation splines 86–91; Color Curves tool 30; Grid Warp tool 134, 137; masks 99–102; motion paths 66; Time Stretcher tool 130–131
telephoto lens 166
Text 3D tool 167–169
Text+ tool 38, 102–103, 133, 140, 189
Texture 2D texture 175
Threshold parameter: apply mode 126; Defocus tool 124; Soft Glow tool 125; Unsharp Mask tool 124
time range 11
time ruler 3
Time Speed tool 129–130, 132
Time Stretcher tool 130–132, 140–141
time warping 129–132
timecode 217
Timeline view 2–3, 83
TimeView 2–3
To Red / Green / Blue / Alpha parameters 104
tool networks 2
tool scripts 213
toolbar See main toolbar.
tools: connecting 5–6; description 2
track buttons 70, 74–75, 78
Track Center (Append) button 75
Tracked Center XY parameter 69
Tracker tool 59, 67–79
Trails tool 195
Transform 3D tool 177, 180
Transform tool 60–61
transform tracking: description 67; linking 76; Matchmoving workflow 72–73
transforming: 3D cameras and geometry 165–166; with Merge tool 39–40; with motion tracking 67–76; with other tools 62–63; with Transform tool 60–61
Transmittance section 172–173
TransportView 11
Triangulate 3D tool 171
Trim In / Trim Out fields 12
Two Sides parameter 171, 197

U

Ultra Keyer tool 155

Ungroup: button 105; menu option, 209
Universal Naming Convention (UNC) 207
Unpublish Points menu option 114
Unsharp Mask tool 124
Unsteady Position / Angle / Size options 76–77
utility scripts 213
UV layout 175–176
UV Map 3D tool 176–177
UV texture space 175

V

Variance parameters 183
VariBlur tool 123
Vector Distortion tool 134
Vector Motion Blur tool 52–53
Vectorscope SubV view 27
Velocity Controls 183–184
vertices See points.
Vortex 133–134, 184–185

W

Wand tool 109–111
Ward material 173
Waveform SubV view 27
Weld 3D tool 171
white point 18–19
Width See Height parameter.
wire removal 197
Wire Removal mode 108–109, 196–197, 201–202
wireframes 167, 170
World Position Pass (WPP) 54
Wrap button 40, 60
Write Off / On / On End parameters 113

X

Xor menu option 41
XY Density parameters 187
XY Deviation parameters 64
XY Path modifier 85, 87, 91
XYZ Offset parameters 169, 185
XYZ Rotation parameters 166, 169, 176
XYZ Target parameters 166

Z

Z Channel 51
Z Far / Near Plane parameters 52
Z Scale Parameter 52

Z–buffer *See* Z–depth.
Z–depth: auxiliary channels 17; depth–of–field
 49–54; render passes 45, 49
Zoom Out Hort / Vert parameters 85
Zoom To Fit button 130–131

T - #0973 - 101024 - C262 - 235/191/14 [16] - CB - 9781138668270 - Matt Lamination